Currier & Ives

An Illustrated Value Guide

Craig McClain

Photographs: Glen Malchow
Cover Design: Ann Eastburn
Interior Layout: Anthony Jacobson

Library of Congress Catalog
Card Number 87-050011

ISBN 0-87069-498-7

10 9 8 7 6 5 4 3 2 1

Published by

Wallace-Homestead
publishers of fine books

Wallace-Homestead Book Company
580 Waters Edge
Lombard, Illinois 60148

One of the
ABC PUBLISHING abc
Companies

For Nona,
forever beloved

Contents

Acknowledgments

The Illustrations featured in this book appear through the courtesy of The Travelers Companies, Hartford, Connecticut, and NC McAlmor & Co., Vermillion, South Dakota.

The reference basis for this book is Frederick Conningham's *Currier & Ives Prints, an Illustrated Checklist*. The format devised by Mr. Conningham in his popular *catalog raisonne* has been followed with the kind permission of Crown Publishers, Inc., New York, NY.

Sincere appreciation to Glen Malchow, MA, University of South Dakota School of Medicine, for his excellent photography and production.

Special thanks to Currier & Ives specialist, Robert Wieland, Ormond Beach, Florida, for his many informative letters.

My thanks to William Topaz, General Manager, WH-BC, for his enthusiasm. To Liz Fletcher, Production Manager, and staff, my appreciation for their skills and efforts.

Preface

Discussions concerning the lithographs published by the firms N. Currier and Currier & Ives inevitably include deliberations about the "value" of the prints they produced. Following questions about authenticity, inquiries regarding dollar value are the most frequent. N. Currier and Currier & Ives prints are desirable for countless reasons. Not only do they comprehensively reflect or chronicle the cultural and historical circumstances of nineteenth century America, they also have appeal as decorative items, with quite a number meriting the distinction of artworks.

The author's initial interest arose as the result of a visit in 1975 to The Victorian Shop of Sioux City, Iowa, a specialty shop that provided a Haviland China matching service. The nearly large folio print, *Sunday Morning. In the Olden Time,* hung above the desk of the proprietress, Mrs. Bernice Kundert. The print was impressive for its size, coloration, frame, and age. It was a bright, well preserved, unpriced, and unique curiosity. On request, the price was revealed to be $175. Certainly it must be overpriced, was my initial thought, but wouldn't it be exciting to own and display? Would it also be a "storehouse" of value? Research was necessary. The local public library offered only Frederic Conningham's updated reference *Currier & Ives Prints, an Illustrated Checklist,* then five years old. The estimated value listed by Conningham was $150.

Sunday Morning. In the Olden Time (see Front Cover) was bought because it provided a source of enjoyment and pride of ownership. It was still difficult, however, to decide whether the purchase represented a good value. To this extent, a valuation guide can be a useful tool. Everyone would like to discover a bargain but a desired specimen, fairly priced, is a gratifying find.

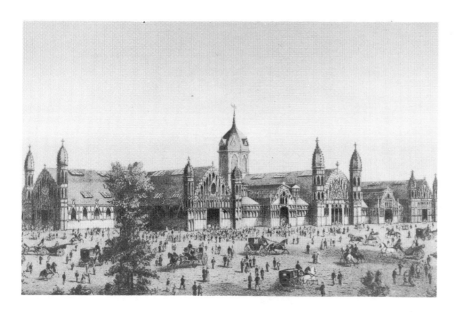

66. *Agricultural Hall* / Grand U.S. Centennial Exhibition.

6

Due to its recognition as the preeminent, popular reference to the lithographs of the N. Currier and Currier & Ives firms, the reference basis for this book is the aforementioned Conningham volume. (The 1983 edition is available from Crown Publishers, Inc., 225 Park Avenue South, New York, NY 10003; the cost is $14.95.) The 1970 edition of this *catalogue raisonne* includes estimated values for each of the nearly 6,900 prints identified. During the intervening years, the values of almost all of the firms' output has appreciated dramatically. Prices have risen because the economic trend has been inflationary. New buyers have entered the marketplace to discover the supply of available specimen continuously decreasing due to loss or impounding in long term or permanent collections. In addition, buyers have become better educated and, consequently, more cognizant of quality when making acquisitions, to the extent that they are quite willing to pay premium prices for high quality prints. Finally, sellers expect to profit through the sale of their holdings.

The mean age of an N. Currier or Currier & Ives hand-colored lithograph is one hundred ten years. As a group they have not fared well over time. High quality prints are not plentiful. Many prints have fallen victim to inherent vices such as acidic content of the paper. Due to their relatively low cost (they were proudly advertised as "Cheap") and a general lack of knowledge of conservation practices, many have suffered greatly from mishandling. Additionally, many issues were not pulled in large editions, primarily because of the costs of production. Today, numerical rarity generates interest; quality generates excitement. The combination of scarcity and quality is price-explosive.

During the past one and one-half decades both economic and collecting factors have put great upward pressure on the prints published by N. Currier and Currier & Ives. Prices have increased most dramatically for rare examples, especially those in top condition. This has precipitated across-the-board increases to all but the most common and least demanded of the firms' prints. This book reflects those changes.

The values cited are based on a careful analysis of retail price offerings, auction sale results, and dealer-to-dealer transactions. The data for this study include 24,210 print offerings — title, description, and price — collected and examined by the author alone during the period June, 1982, through January, 1987. To achieve accurate measurement in determining current dollar values for the prints presented in the Conningham reference, the median and the arithmetic mean were computed for each of the titles in this data base. The objective was to find an "average" price or fair market value. Generally speaking, the arithmetic mean is used in statistical analysis since means can be used with all parametric statistics. In descriptive studies, however, the median is relied on if values are comparatively extreme. Occasionally that was so. For the small folio print *In the Northern Wilds / Trapping Beaver* (C3073), values from four different sources were available: $225, $365, $385, and $395. All four prints were described as "very good" by their offerors. The arithmetic mean for this title is $342.50; the median value is $375. The median value is the "middle value" of a set of values. For example, 6 is the median of the set (4,5,6,7,8). For those sets having an even number of elements, the two midpoint values are averaged to yield the median. Therefore, in the set (5,6,7,8), 6.5 is the median. In the case noted above, the median value, $375, is clearly a more representative "average" of the four values than is the arithmetic mean of $342.50. Median values are ranked data and are not amenable to higher statistical procedures. However, since the object is to represent what is average, their use was appropriate here.

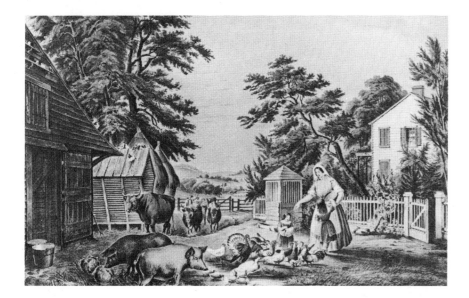

135. *American Farm Scenes #2.*

The method of presenting the print values researched for this book follows the numbers assigned by Frederic Conningham in his 1949 checklist. Space allowing, the Conningham number, print title (and subtitle, where applicable), and a single letter abbreviation indicating the size of the image are presented. The image size (the picture exclusive of margins) has been classified according to four categories: "S" represents the small folio; that is, prints with images measuring approximately 8 × 12 ½ inches. "M" is medium, or about 10 × 14 inches to 15 × 19 inches. "L" equals large folio prints with dimensions exceeding 16 × 20 inches. "VS" represents very small print images — those ranging from as small as 2 × 4 inches upward to 3 × 5 and 6 × 9 inches. Following presentation of the image size is the computed, current dollar valuation. To this comprehensive listing, Colin Simkin appended an addendum for the 1970 printing. Seventeen "unrecorded items" were discovered during the intervening years. The prints of the addendum are similarly listed and valued.

Since 1970, Jacques Schurre has researched and published three listings of previously unrecorded N. Currier and Currier & Ives prints. By the 1984 edition of his reference, *Currier & Ives Prints, A Checklist of Unrecorded Prints,* Schurre had cataloged 495 prints not appearing in the Conningham editions. The format of Schurre's work faithfully follows that of the Conningham books. In addition, he has assigned and entered "approximate" dollar values for all 495 prints. The reader may refer to this checklist if he or she has a print not listed in the pages of this book. It is available from the author (280 9th Avenue, New York, NY 10001); the cost is $7.50.

The Gale Research Company has published a one thousand twenty-nine page, illustrated catalog in two volumes entitled *Currier & Ives, A Catalogue Raisonne.* Certainly this set must now be accorded the distinction of being the definitive single checklist of N. Currier and Currier & Ives prints. It presents 7,450 prints published by the firms. This significant production was given consideration as the standard upon which to base the presentation of the print values in this book. Alternatively, however, the 1970 edition of Conningham's illustrated checklist was selected. There are two reasons. First, due to its recent publication (1984) and a retail cost ($265) that prices many otherwise interested readers out of the market, the Gale set is not in widespread general usage. It is, however, recommended for more serious students and

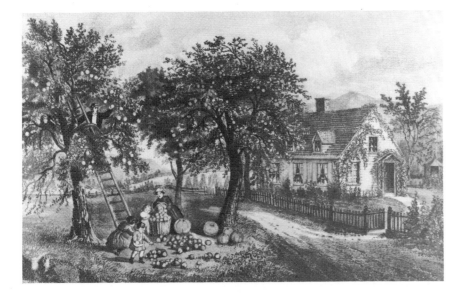

168. *American* *Homestead* *Autumn.*

collectors. (Write to the publisher, Book Tower, Detroit, MI 48226). Second, its format departs from that of its popular, long-standing predecessor, specifically in the methods of alphabetizing and measuring the prints. It is understandable that the compilers of such an extraordinary work would establish their own unique system. However, in the interest of continuity — considering the many Currier & Ives enthusiasts who might come to consult a valuation reference — a familiar or "traditional" form of presentation was selected.

Value is illusive because it has no one source or influence. Every print is unique; so, too, is each transaction. Consequently, the valuations presented in a reference book of this type are not absolutes, nor are they intended as such. Here, they represent estimates or, more appropriately, guides to the fair market values of N. Currier and Currier & Ives prints in "very good" condition. Each value has been objectively and carefully developed from a computerized data base compiled during the four and one-half years of this study. Hopefully, the figures presented here will contribute to the reader's knowledge of the relative values of these prints.

Ewell L. Newman, co-author of *A Guide to Collecting Currier & Ives,* contributed a review to the 1983 updated edition of the Conningham reference, for the Spring, 1984 issue of *Imprint.* (*Imprint* is the semi-annual journal of the American Historical Print Collector's Society.) Mr. Newman noted that although this edition was a photographic reproduction of the 1970 edition, the estimated dollar values therein had been "blocked out." He considered this a limitation and commented, "The inclusion of current approximate values in the new edition of Conningham would have served as helpful guideposts for the next few years to collectors, dealers and historians of popular art."

He concluded by suggesting that current valuations could serve as a basis or foundation for future estimates of value for the prints of N. Currier and Currier & Ives.

These ideas reflect the author's objectives in the research, production, and presentation of this book. It is not a price guide but a value guide. If a figure from this book is used by the reader in making a purchasing decision, it should be considered a unit of datum that contributes to but does not solely influence that decision. Value arises from price. Price is that which a knowledgeable buyer pays the seller to satisfy his or her desire for ownership.

Introduction

The etching or engraving of a stone medium dates to the sixteenth century when stones quarried from the district of Franconia near Solnhofen, Bavaria, were first used as inscription-bearing, commemorative plaques. These stones were calcareous slate, which consisted of calcium carbonate or limestone. Their fine, uniform grain permitted them to be cleaved and polished with relative ease. Rating a "soft" 3 on Mohs' scale of mineral hardness (which begins with the softest minerals such as talc and proceeds in ascending order of hardness to [10] diamond), the surface of these stones was easily decorated using the iron- and steel-faced tools of the period.

By the last half of the nineteenth century, commercial printing of business and advertising cards, letterheads, pamphlets, brochures, handbills, and similar materials could be accomplished quickly and economically. Printing establishments were numerous, available, mechanized, and quite in demand. Civilization was inundated by the printed word in a seemingly unending parade of variety and form. By contrast, eighteenth century printing was considerably less automated and relied on a more craftsmanlike approach. Consequently, printing costs were so prohibitively high that the publication of literary work during this era usually required third-party sponsorship of the litterateur.

Alois Senefelder, who in 1796 was an aspiring twenty-five-year-old playwright in Bavaria, had written a play for the children's theater. Unfortunately, Senefelder found his pocketbook insufficient to cover the cost of having the manuscript printed for distribution to the cast members. (Weddige, p.8) Subsequently, a patron sponsored publication. Senefelder, however, had attempted to print the manuscript himself. He had experimented with creating letters by using woodcut and copperplate engraving methods.

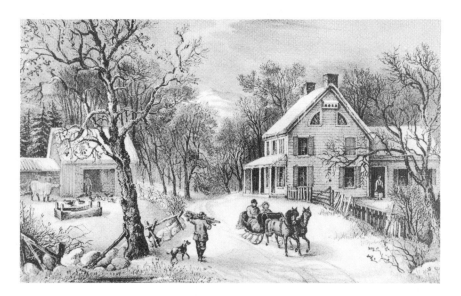

172. American Homestead Winter.

Persistent in his desire to develop a system for reproducing the written word simply and cost efficiently, Senefelder continued his experiments during 1797 and 1798. He employed the stone quarried at Solnhofen and proceeded in the manner of Simon Schmid who, a decade earlier, had transferred a printed image to paper from such an engraved stone. (Knigin, p.11). Senefelder's process was tedious — reproducing characters imitative of printing type on stone and in reverse. Initially, he elected to etch the letters into the stone's surface intending to print the stone by the traditional copperplate method. Later he would opt for reversing this process. He would etch away the field or background areas leaving the letters as slightly raised devices. In effect, this operation would duplicate the engraving and printing techniques of the woodcut. In his *History of Lithography,* Weber comments: "All these experimental techniques...were essentially mechanical. The decisive step forward came when Senefelder developed a purely chemical process, which could first be properly called lithography." (Weber, p.16)

The origin of chemical printing from stone too often has been described as having been an accident or a happenstance. While the events leading to the immediate discovery of the process are certainly anecdotal, they were not accidental. Louis Pasteur remarked, "Chance favors the prepared mind." This statement is applicable to Senefelder.

The anecdote involves Senefelder and the family laundry list. The Senefelder family presumably had sufficient income to hire a laundress. One laundry day she awaited instructions about articles of clothing that required her attention. Senefelder's mother asked him to hurriedly write a list for her. Neither pen nor pencil or paper were immediately available. However, Senefelder did have at hand a small brick of ink — the solid residue left when a batch of homemade printing ink had dried out. The ink consisted of soap (grease), wax (vehicle) and lampblack (color). Also nearby was a smooth-surfaced stone slab called a Kellheim stone. Such stones were commonly used by etchers for grinding their ink. Senefelder had recently obtained it for grinding colors. (Weber, p.16.) Producing the laundry list on the stone was easy, as the piece of waxy brick glided across the surface leaving a rich, greasy deposit. Later, Senefelder recopied the list to paper and the laundry business was completed.

A short time thereafter Senefelder returned to his printing experiments. In attempting to wash the laundry list from the stone with water, he noticed that the stone was moderately water absorbent in all areas save those covered by the letters he had written. They repelled the water wash. He contemplated this smooth, porous Kellheim stone with its wet fields and greasy markings: "It occurred to him that if he used a dilute acid wash he might lower the surface [leaving] the letters in relief. The letters could then be inked like a woodcut and used to obtain a printed image on paper." (Reps, p.24.)

Senefelder prepared a solution consisting of a few drops of nitric acid in water. He flowed the solution over the surface of the stone. The action of the nitric acid (*aqua fortis*) was complete after some few minutes. Next, a "slimy liquid," gum arabic, was poured on the stone to prevent, as Senefelder later wrote, "the greasy ink from sticking." In effect, the gum solution served to desensitize the unwritten areas so that the grease-laden printing ink would not be accepted by them.

When the thin solution of gum had dried the chemical processing of the stone had been completed. Senefelder had succeeded in chemically separating his writings from the unwritten areas. Respectively, they would now capture and reject ink consistently. The fatty content of the ink brick used to write the list had been released as a result of the action of the nitric acid and had combined with the surface of the stone. The gum had formed a stencil or mask that could hold a film of water; this film would, in turn, act as a barrier to the spread of ink to the undrawn areas.

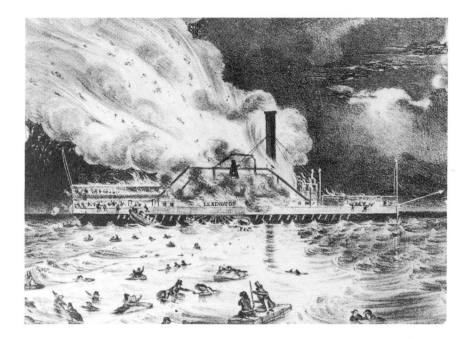

327. *The Awful Conflagration of the Steam Boat Lexington.*

Next, Senefelder lightly charged a roller with a stiff, pastelike ink and passed it over the surface of the stone. The greasy letters began to receive ink; the wetted, nonimage areas repelled the ink and remained clear. The experiment concluded with the placement of a sheet of paper on the stone and the application of pressure to transfer the ink from the letters to the paper. The natural antipathy of water and grease had contributed a new and major printing process.

All writings on the history of the firms N. Currier and Currier & Ives are indebted to the energetic researches of Harry T. Peters that began seventy-five years ago. The volume of information he collected and presented in his books represents the most significant research on the subject. Peters interviewed cartoonist/artist Thomas Worth and lithographer/painter Louis Mauer — the last of the old guard. He commented that with Mauer's death in 1932 "the last strand connecting our time with Currier's heyday was severed."

The trail is now colder. Still, a brief chronology recounting the firms' histories is appropriate in the interests of both clarity and completeness.

1828 Nathaniel Currier, age fifteen, begins an apprenticeship with the commercial lithographic firm, William S. and John Pendleton of Boston.

1833 Currier emigrates to Philadelphia to join the firm, M.E.D. Brown, Lithographers. Brown is noted for his numerous scientific studies commissioned by the *American Journal of Science and Arts*. (Rawls, p.32.)

1834 Currier relocates to New York anticipating a position in the employ of John Pendleton who, in 1831, had established a lithographic business at 137 Broadway. Currier buys Pendleton's business in partnership with Stoddart, a publisher of music. The new firm produces job-printing commissions of various types.

1835 The job-printing firm, Currier & Stoddart, is dissolved. Currier establishes N. Currier's Press at #1 Wall Street. Currier continues sheet music and other made-to-order, commercial printing. The firm issues *The Ruins of the Merchants Exchange...* four days after the great fire in mid-December. The illustration causes a regional sensation.

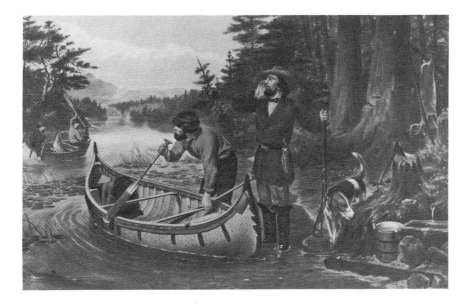

173. American Hunting Scenes /
"An Early Start."

1836 The business expands and is relocated to 148 Nassau Street.

1838 Currier locates his production facility at 2 Spruce Street. A retail outlet is established at 152 Nassau Street. Currier registers his first print with the copyright office in Washington, D.C.

1840 The popular modern steamboat, *Lexington,* burns and sinks in Long Island Sound on January 13. Currier learns of the disaster while at the offices of *The New York Sun,* a widely circulated daily newspaper published by Ben Day, Sr. Day hits upon the idea of illustrating an "Extra" edition he will publish to recount the events and firsthand accounts of the tragedy. Day commissions Currier to lithograph the illustration based on early reportings. Within three days of the disaster the Currier firm completes a small folio size image at the head of a large lithographic stone. The image is a "finely drawn and violently realistic picture of the flaming vessel." (Peters, p.1) A melodramatic two-line title is added followed by an outline map locating the occurrence and seven columns of print detailing the disaster. Day's publication of "The Extra Sun" with Currier's illustration is distributed nationally, receiving extraordinary reviews. Currier gains nationwide recognition.

1852 On the recommendation of his brother Charles, Nathaniel Currier hires James Ives as head bookkeeper. Immediately Ives begins a reorganization of the firm's accounting, merchandising, and inventory systems.

1857 General manager Ives is made a full partner, establishing the firm, Currier & Ives.

1866 The Currier & Ives production facility is relocated to a five-story building at 33 Spruce Street. This facility would be maintained until the dissolution of the firm forty years later.

1872 After a period of thirty-four years at the 152 Nassau Street site, the retail shop is moved to smaller quarters at 125 Nassau Street.

1874 The retail outlet is moved next door to 123 Nassau Street.

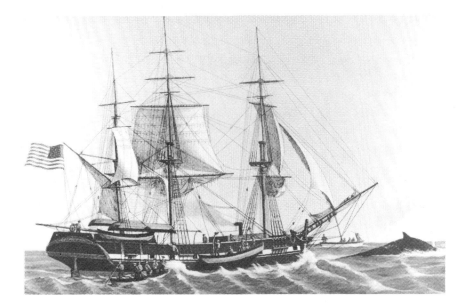

204. American Whaler

1877 Retail activities are now centered at 115 Nassau Street, where they will continue until 1894.

1880 Currier retires and is succeeded by his only surviving son, Edward.

1888 Nathaniel Currier dies of heart disease at his home on West Twenty-seventh Street.

1894 The retail store at 108 Fulton Street opens for business.

1895 James Ives, having remained a nonretired and active member of the firm, dies at his residence in Rye, New York. His business interest and role in the firm are assumed by his son, Chaunsey.

1898 The Fulton Street store is closed and the offices are moved into the "factory" at 33 Spruce Street.

1902 Business activity is further consolidated to one floor of the Spruce Street building. Edward Currier sells his interest in the partnership to Chaunsey Ives.

1907 Chaunsey Ives transfers ownership to Daniel Logan, Jr., son of Daniel Logan, Sr., the firm's general sales manager for forty years. Due to ill health, Daniel Logan, Jr. liquidates the firm at public auction. All the lithographic stones have been effaced except for a few "Darktown Series" stones and some clipper ship subjects. These are bought by Joseph Kohler and Max Williams, respectively, who will reissue these prints under their publication lines. Other stones will find their way to England to be published by the S. Lipshitz firm. The inventory of approximately four thousand lithographic stones is removed to Farragut Woods, Brooklyn, and destroyed. (Schurre, p.10.)

Notes on Collecting: Beginning and Continuing the Enjoyment

Over the course of the past one-and-one-half decades in America, works of art have gained immensely in popularity, fueled by a burgeoning public interest in most areas of Americana. Collecting has rapidly become recognized as a source of great individual satisfaction as well as aesthetic enjoyment. Coinciding with the increase in collecting activities is the increase in scholarship, literature, and media coverage devoted to the variety and diversities encompassed by collecting. More and still more information is being produced and shared. Today the newest wave of collectors is discovering resources that will aid them in becoming better read, more sophisticated, and most discriminating. These possibilities are indeed exciting.

Regardless of your present approach to collecting — be it casual, moderately interested, active, enthusiastic, or passionate — if you want involvement, if you want to raise the level of your experience, if you really want to discover excitement, it is most important for you to seek out educational experiences. Educational considerations include becoming knowledgeable or informed about quality, condition, valuations and market trends, reliable sources, and availability. Obtaining such information involves research and study. Both are really quite enjoyable pursuits, and the reward will manifest itself in acquisitions that possess aesthetic quality with, perhaps, an eye toward appreciation in value.

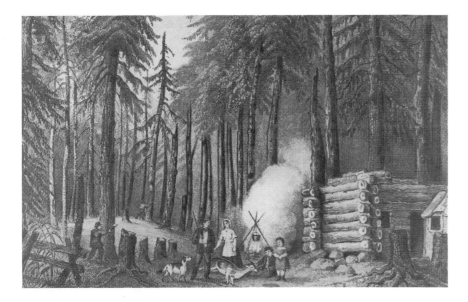

214. Among the Pines / A First Settlement.

15

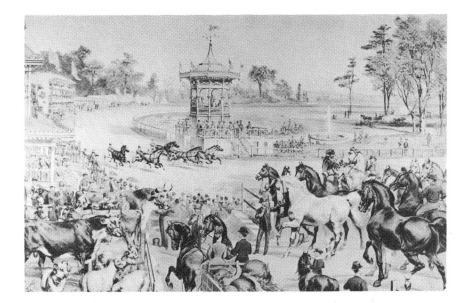

294. At the Fair Grounds.

The objective, then, is to educate yourself as to the scope of the field of collecting that interests you. Education is unquestionably a prerequisite to buying, so much so that the better educated you become, the better buyer you will be. The informed buyer is armed both against overpaying (or overbidding) and accepting inferior quality or second-class merchandise.

A collector should develop a bibliography of available literature in his or her field. Four types of publications should be consulted: (1) those that recount the nature and history of the collectible; (2) those that analyze the aesthetics; (3) publications that estimate value — since collectors are predisposed to collecting things that, at the very least, will hold their value; and (4) publications that detail conservation practices and techniques.

Naturally, the educational process is never completed. The body of knowledge comprising any field of collecting is continuously being expanded via new research, both formal and informal. These investigations may yield new discoveries and fresh data, which, in turn, generate new evaluations, interpretations, opinions, and pronouncements.

Learning the methods and history of one's field can be a most entertaining pursuit. Moreover, important pieces of information that will provide an advantage over other collector-buyers can be discovered. As an example, knowing a work's historical popularity, the number of specimen extant, the typical state of preservation, or the artist who produced the piece can provide an advantage that might translate into the acquisition of a work at a below-the-market price, or the avoidance of second-rate specimen, misrepresentations (both intentional and accidental), and undesired reproductions, restrikes, and reissues.

The objective in gathering information from publications that analyze the aesthetics of one's field is connoisseurship. Learning just what characteristics constitute a quality object and developing the competence to critically judge a work are the most important acquisitions a collector can make. Readings on aesthetics are actually preparatory steps for developing the competence (and confidence) to make critical judgments. Direct contact with pieces that interest you is the action that develops connoisseurship. Simply stated, the more you see, the more you have to compare and, consequently, the better oriented you become. "The most important thing is to train your eye to note subtle differences...and thereby learn the art of comparison. That's an expert's secret: knowing how to spot all the minute differences that make one piece more valuable than another." (Stapleton, p.94.)

375. Bass Fishing / At Macomb's Dam Harlem River, N.Y.

375. Bass Fishing / At Macomb's Dam Harlem River, N.Y.

377. The Battery, New York / By Moonlight.

379. Battle at Bunker's Hill.

562. Blackwell's Island, East River.

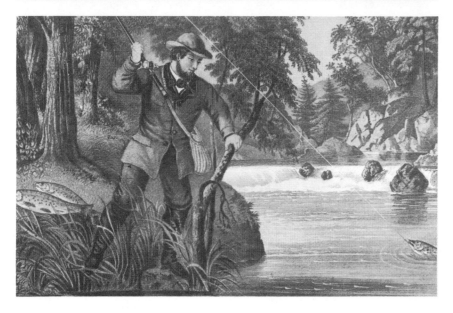

704. Brook Trout Fishing.

768. *California Scenery* / Seal Rocks - Point Lobos.

Take the time and opportunity to accept the modest costs of gaining as many exposures as possible. Don't just look at a piece; view it up close. Scrutinize it. Identify the most attractive features. Determine the condition. Make note of the elements that contribute to the work's aesthetic presence and those which detract from it.

A fair question is where can these exposures be had. Local and state government, libraries, newspapers, and the Yellow Pages directory can provide the names and locations of museums, art galleries, fine art centers, and colleges and universities with collections that are accessible to you. Museums, for example, offer an excellent variety and the highest quality of artworks. These collections are often supplemented by equally excellent research facilities. The new collector should visit as many of these institutions as possible. Museums provide access to top-of-the-line art. They are, therefore, one of the very best places to develop your "eye" for quality. That is, you can establish a set of mental images to which you can compare potential purchases.

The beginner should also establish relationships with curators and staff personnel alike. Museum people are usually extraordinarily enthusiastic about their facility and its offerings, to the extent that they delight in presenting them to new collectors. As a case in point, the author elected to fulfill an undergraduate degree requirement in Art History by choosing William Harnett's late nineteenth century, trompe l'oeil painting, *Music and Good Luck* as his thesis subject. A textbook footnote indicated the painting was in the possession of the Metropolitan Museum of Art in New York. Nothing short of directly confronting the work would suffice so a pilgrimage to New York (from Vermont) was in order. Every detail was carefully planned including the preliminary telephone call, which, first, would confirm that *Music and Good Luck* was on-hand and, second, reserve an appointment to view it if that was the appropriate arrangement to make. Unfortunately, the call was completely forgotten. An early arrival followed by an exhaustive search failed to reveal the Harnett. Perhaps it was on loan to another museum. It obviously wasn't to be found on display. How could anyone have forgotten anything so important as calling in advance? It was probably the look of bewilderment, or perhaps disappointment, but a lady from the museum staff (later discovered to be an assistant curator) approached and asked if she could be of assistance. *Music and Good Luck* was one of her favorites and, yes, it was

775. *Camping Out* / "A Life in the Woods for Me."

part of the permanent collection. When not on display it was stored in the third sub-basement level vault. "Would you like to see it?" A private viewing exceeding an hour's length was permitted. This treat was accompanied by the immensely informative, expert commentary of the museum staff member who so graciously offered her time to a beginner.

This brings up another point. It is most important to solicit opinions and information from people who are knowledgeable or expert in your field of interest. Establishing a rapport with those having greater experience is a significant step toward success in collecting. As noted, museum personnel are enthusiastic about sharing information. This is also very true of art dealers. Not only do dealers offer the pleasures of looking, learning, and buying, they are also appreciative of the opportunity to share their opinions with new collectors who present themselves as serious students. If you have an open mind, an idea of what you are interested in seeing or discussing and a sincere measure of enthusiasm you will be warmly received. Just remember that when you visit a dealer you may be encountering someone who is a collector-at-heart and businessperson secondarily. Consequently, it is appropriate to put aside the "What is it really worth?" or "How much?"; the appropriate time to discuss price is usually later.

Many art dealers are active in the areas of research and scholarship, so ask questions. Listen to their advice. Respect their judgment. Let them know where your interests lie, what your goals are, and what amount you anticipate spending for the prints you buy. A dealer's business is derived primarily from repeat sales so most aren't about to pressure you for an immediate sale. By examining as much as you can and by building relationships with dealers who have earned positive reputations, you will develop a frame of reference — a sense of what constitutes a quality print or other artwork, an understanding of what is available, and the knowledge of how to enjoy collecting.

The beginner should learn to temper his or her enthusiasm. It is very important to learn to politely decline to purchase those offerings that may approach but do not quite fit your particular collecting interest or standards of quality. Every experienced collector, investor or dealer has a private stock of "mistakes." If the situation is right they may recite well embellished and amusing narratives about the ones-that-were-better-off-not-bought. Many prints and artworks that fit into the mistake category are acquired impulsively with too little consideration given to one's collecting objectives and selection criteria. Some judgmental errors are later viewed with amusement. Some are regrettable. Others are regrettably costly.

804. Capture of Andre 1780.

815. Cares of a Family.

948. Central Park in Winter.

1032. Childhood's Happy Days.

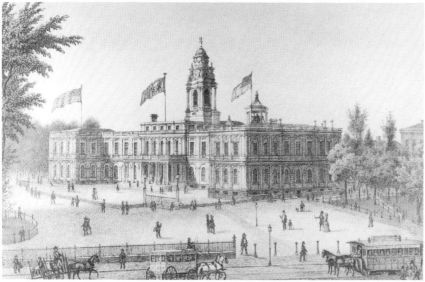

1087. City Hall, New York.

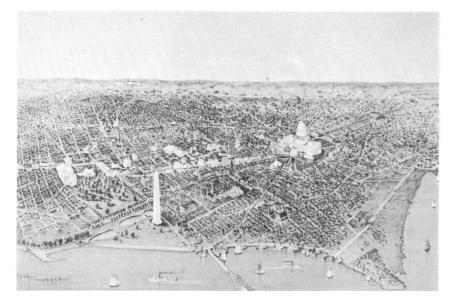

1123. The City of Washington.

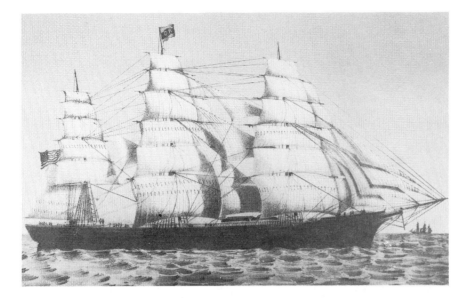

1152. Clipper Ship "Great Republic."

Permit one bit of advice. After you become knowledgeable about collectible works of art and comfortable buying them, remember this: When you see the piece that truly excites you — one that has such qualities that you must possess it — pay the price. Don't let the opportunity escape; it may not come around again. Anyway, the odds are that in a relatively short time you will either become indifferent to or forget the amount you paid while the enjoyment will go on and on.

Just a short note on where not to place your hopes of finding and acquiring Currier & Ives prints. Although major metropolitan auctions must be considered a potential source, the level of competition is often too great even for professionals. For different reasons the stand-up, so-called "country" auction is not a very good source. These sales can be fun to attend and once in a great while a bargain can be had that makes the going (and waiting) worthwhile. Generally, however, the number of decent N. Currier or Currier & Ives prints found here is virtually nil. The same may be said of the typical, general line, antique shop. If a suitable Currier is discovered the price is too often too high. Reproductions innocently offered as originals are a problem. Most antiques dealers are not particularly knowledgeable about Currier & Ives prints and the collector is very likely to see a color, photo-lithographic reproduction offered at a price appropriate for an original. In all fairness, collectors can't expect antiques dealers to be expert with regard to every category in the wide range of merchandise they offer. General line antiques dealers are often specialists in one or two areas who have branched out from necessity. Beyond their own particular interest or specialty, they know something about all the various items they stock but their exposure is usually limited. Other low probability sources include flea markets and thrift shops.

Two other high probability sources of N. Currier and Currier & Ives prints are collectors' clubs and print shows. Collectors' clubs are specialized congregations that afford a wonderful opportunity to make personal contact with people sharing similar interests. Club members can be veritable fonts of information, which they readily share with new collectors. In addition, clubs offer opportunities to attend regional or national print shows. These are excellent sources for viewing and purchasing prints and other artworks, and the education that can be acquired here is remarkable. The advantages of a print show arise from the fact that both quality and quantity are available. Major shows may attract fifty to one hundred or more prominent dealers who come to both buy and sell. Be certain to cover the entire show. Educational displays are typical and they provide a valuable source of information. Visit with each dealer and examine and admire his or her offerings. Don't be reluctant to ask questions or seek an opinion.

2

Identifying Photolithographic Reproductions of Original Currier & Ives Lithographs

Atransaction entered into by willing parties is an event wherein both parties should receive what they bargained for. Unfortunately, such is not always the case. The one thing sadder than witnessing the purchase of a bad print with good money is observing the purchase of a (photographic) reproduction or reprint with good money. In the former instance, the buyer obtains a poorly preserved specimen for an incommensurately high price — a price appropriate for a higher grade or better preserved specimen. In the latter situation, the buyer obtains a reproduction worth a tiny fraction of the value of an original print for the price of an original. Occurrences are too frequent.

Four years ago the author and his wife drove one hundred fifty miles to attend a "country" auction that advertised the offering of thirty-six "original" N. Currier and Currier & Ives lithographs. Experience had taught us to leave nothing to chance. We telephoned the owners on the evening before the sale in the hope of ascertaining whether the prints were really original. They were most cooperative and generous with their time. Their list included *The Village Blacksmith*. Conningham's *catalogue raisonne* lists three prints with

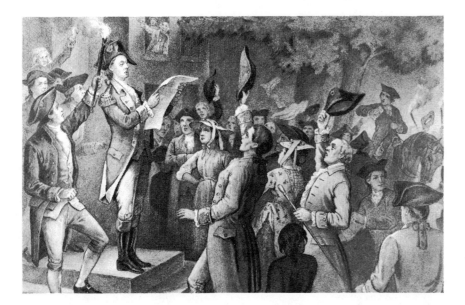

1258. Cornwallis Is Taken!

24

that title — numbers 6460, 6461, and 6462. Also presented are dimensions of the image proper and a brief description of the scene portrayed. Obligingly, the owners measured the image. The measurements of 9⅞ inches high by 15 inches wide indicated a medium folio. From their additional description of the scene, the print was tentatively identified by Conningham's number 6460. Was it an original? Some staining was evident; that was good...and, of course, bad. The four margins were all in excess of 2¼ inches wide. That, too, was good. Most importantly, the image size matched that of the dimensions listed in the Conningham reference. Most reprints of medium and large folio originals are smaller than the originals.

Brook Trout Fishing was also offered. As in the case of *The Village Blacksmith*, the author had seen reproductions of this print. The image measured 8½ by 12½ inches — correct according to Conningham, but also correct for a reprint. The margins measured approximately three inches all around. These broad margins suggested an original, since the great majority of reprints and reproductions have margins ranging in width from ½ inch to 1¼ inches.

The evidence collected to this point weighed heavily in favor of making the long drive. The clincher, however, was the owners' mention of a print depicting a train stalled by snow in a mountain pass. Although the print was not at hand as the others had been (about half had already been removed to the sale barn), they remembered the word "Snowbound" was included in the title. *American Railroad Scene / Snowbound,* Conningham number 187 or 188, and number 2 from the "Best Fifty Small Folio Prints" list (and thus, very desirable) could be safely valued between $1,200 and $1,400 if it were original and in "very good" condition. Reprints from the 1940s did exist. However, the owners stated that an antique dealer in a major city had appraised this print at $850. That sealed the decision to go.

We arrived two hours before sale time to ensure a sufficient period for thorough examinations under magnification. We were escorted into the back room of the sale barn. *Noah's Ark* was just a few steps inside the door. Although badly stained, with severely trimmed margins and faded colors ("poor" condition) it was an original. The floral print beside it had also not received good care, but it too was original. Quickly then, find *American Railroad Scene / Snowbound!*

The "premier piece of father's fifty-year collection" was virtually valueless. Magnification exposed a geometry of multicolored rings and dots that confirmed that the print was a photolithographic reproduction. The paper was a rather stiff grade. Its appearance was mellowed by a slight darkening called "time toning." These two characteristics are often noted with originals. The title, however, was incorrect. The print was simply entitled *Snowbound* and not *American Railroad Scene / Snowbound*.

Thirty-four prints were original N. Currier or Currier & Ives hand-colored lithographs. The other reproduction was of *The Old Farm Gate,* Conningham number 4555. The colored geometric rings and dots were again conclusive. Later, we discovered that the image dimensions of 7½ by 11 inches were incorrect — originals were only printed in a large folio size.

There was a question to be answered. Should we present our findings to the owners? Yes, because we did not want these gracious people to inadvertently misrepresent these two prints during the auction, to the extent of subsequent repercussions from dissatisfied buyers. One can certainly understand the owners' skepticism when two absolute strangers announce that two of their prints — one of which was certainly the most prized and which had been the only one considered worthy of a formal, professional appraisal — were undoubtedly almost valueless.

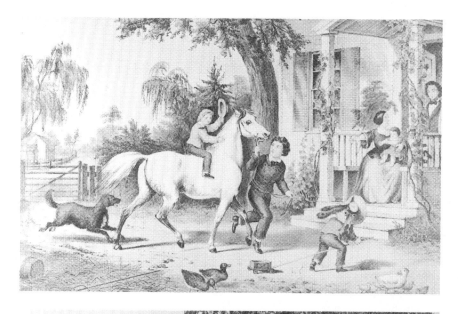

**1265. The Cottage Door-Yard...
Evening.**

1277. Cozzen's Dock, West Point.

**1282. A "Crack Team" at a
Smashing Gate.**

1571. The Destruction of Tea at Boston Harbor.

Just before saletime we were advised that the Curriers would be sold about one hour into the auction. They came to the block three-and-one-half tiring hours later. After approximately half had been sold, the reprint of *The Old Farm Gate* was offered. It was hammered down after brief but spirited bidding for $80. Although we realized this would probably occur, the event was still distressing. Yet, it was not our business to interfere in other parties' transactions. Perhaps the new owner would never discover the price he had paid for not having taken the time to become sufficiently informed.

A few prints later and the *Snowbound* reprint came to the block. Lightning struck twice in the same place — the bidding number was the same for both reprints. The knockdown bid was $120. We were horrified by this outcome. The original owners were too, but for the opposite reason.

As a group, the original Curriers were selling for approximately 65 percent of the amount the author then considered to be their fair market value in "very good" condition. The highest bid to this point was ours — $135 for *The Village Blacksmith*. (It was a "good" condition print which subsequently was professionally cleaned, deacidified and restored at an additional cost of $155.) Unfortunately, the great majority of the thirty-four originals exhibited serious defects. Few merited classification as "very good". The small folio print, *The Great East River Suspension Bridge* (the Brooklyn Bridge) was a virtual uncollectible. It had very small margins, stains, and a disfiguring paper loss near the center of the image that was greater in area than a silver dollar. It still managed to bring $80.

Brook Trout Fishing was next. Its condition was "very good"; it had wide margins. The impression was bright and the colors were fresh. The author estimated its value at $350 and, considering earlier results, was certain it could be bought for $200 or less. Opening at $20 and rising in increments of only $10, the print sold for the surprising figure of $400. The couple who bought it had appeared supremely confident with each decision to raise their bid. They had been consulting a thin, pocket-size book as the bidding progressed — a price guide, perhaps. We tried to speculate how high they would have bid since they seemed absolutely delighted to acquire the print for the significant sum of $400. In fact, they behaved as if this were quite a bargain price.

1585. The Discovery of the Mississippi.

There are two Currier & Ives prints that were published under the title *Brook Trout Fishing*. One is a small folio like the print sold at the auction. The other is an 18½ by 27 inch large folio print that has as its complete title *Brook Trout Fishing / "An Anxious Moment."* Its value is five times greater than that of its small folio counterpart. Did the buyers realize that there were, indeed, two *Brook Trout Fishing* prints of different value? On which did they think they were bidding? It's a matter of education.

There should be a certain amount of skepticism in every purchasing decision. In the final analysis, sales claims notwithstanding, the responsibility for deciding whether you get what you bargain for rests with you. The basis of decision-making is reliable information. Who better to rely on than yourself? Again, this suggests self-education.

A small investment and a simple examination could prevent severe disappointment. The disappointment (perhaps "distress" is more accurate) occurs when it is realized that a reproduction or reprinting was unwittingly bought as an original. The investment is an eight-power or greater magnifying lens. A photographer's contact-print magnifier is recommended. The objective is to determine whether the print offered is genuine, that is, an original stone impression produced N. Currier or Currier & Ives. The examination takes all of three seconds, or less, and is about 98+ percent conclusive in segregating twentieth century photolithographic reprints and reproductions from consideration. (Don't, however, put your lens away yet; the impact of observed defects in a print can be better evaluated using magnification, and unseen defects might also be exposed by the lens.)

For the collector of original nineteenth century hand-colored lithographs such as those produced by N. Currier and Currier & Ives, an image composed of a kaleidoscopelike geometry of contiguous and closely ordered rings and/or dots of color should immediately raise a red flag of warning. (See Color Section for example of dot matrix in a reproduction.) Regardless of how the print is represented or priced, it is a photographic reproduction. You may even find the words, "Reprinted from..." in the margin or another publisher's name may appear in addition to that of N. Currier or Currier & Ives.

Under eight-power magnification the image of an original stone lithograph is characterized by irregular, abstract patterns of variously sized and shaped black colorations. There markings reflect the "grain" of the lithographic stone from which the ink was transferred when the print was "pulled." They

1588. The Disputed Prize.

1745. An English Winter Scene.

1794. The Express Train.

1880. The Farm Yard.

**1890. The Farmer's Home —
Harvest.**

1945. The Fiend of the Road.

2037. The Florida Coast.

look like small, liquefied fragments of black that have exploded upon or splattered randomly across the paper. They display a porosity and texture that resembles the surface of a household sponge. Their concentration may be dense or sparse. In sum, these black colorations of ink that compose the stone-lithographic image exhibit *no* geometric sense or configuration whatsoever.

The second significant diagnostic measure in determining whether a print is an original and not a photographic reproduction is the nature of the colors presented by the image. It is imperative to remember that the color of an original N. Currier or Currier & Ives stone lithograph is *not* inherent within the image. Watercolors were applied to the black-and-white image *after* the print was pulled and dried.

Although Currier & Ives did publish some few large folio chromolithographs, these stone lithographs were not produced at the Currier & Ives factory, but were jobbed out to other printers. Currier & Ives never possessed the technological capability of producing a colored image developed from a process that employed a separate stone for each color of ink and the consequent, multiple pullings to lay the colors of each image. Chromolithography was a more sophisticated and costly process that yielded a superior image. It gained prominence during the 1860s. Its greatest exponent was the art-conscious firm of Louis Prang & Co., Boston. Chromolithography was the forerunner of contemporary photolithography.

Currier & Ives used the finest watercolors available. Their colors were selected for consistency and fastness. However, as new collectors will undoubtedly discover, even these pigments are fugitive in the presence of light and exposure over time. Blues and browns seem to be the least susceptible while carmine (the transparent red pigment used by Currier & Ives) is transformed into a dull orange or red-brown, and gamboge (Currier's yellow) is apt to disappear almost entirely. Consequently, don't be too alarmed if you see beautiful ultramarine-blue trees in the landscape. They once were green — a mixture of blue and yellow pigments. Exposure to light and particularly direct sunlight invariably causes the dissipation of the yellow pigment, which leaves the more stable blue.

For small and many medium folio prints, color application was made by a team of female colorists, each assigned one color in an assembly-line format. A touch-up specialist with a complete palette and colored model, personally approved by Messrs. Currier and Ives, reviewed the completed print. The accent in this process fell primarily on speed and less on accuracy of application. As a result, colors washed over or "ran" onto adjacent objects within the image. Don't expect a "stay-within-the-lines" perfection, here. It doesn't happen frequently.

For large and large-medium folio prints, color work was usually jobbed-out to professional (or aspiring) artists in the New York City area. Working from pre-colored models, the artist could earn $.50 to $1 for each completed print. Naturally, objects and devices comprising these images were more painstakingly painted.

The coloration of any object or device in an original N. Currier or Currier & Ives lithograph will be evidenced by the more-or-less uniform application of a single water-base color on the black ink and white printing paper surface. Commonly, the color will exceed the limits or boundaries of an object or area and "bleed" into an adjacent one. A rose, for example, will possess a red color that has been washed over its black-and-white defined form. Some little amount of red may have found its way onto the leaves surrounding the petals or even into the sky of the background.

It is important to note that "blackouts" are possible. That is, areas with a 95 percent or higher concentration of solid black can be achieved in lithography by direct application of liquefied fats (grease) to the stone using pen or brush. Due to the microscopically uneven surface of the printing paper, close scrutiny will disclose small uninked areas where the white of the paper shines through from beneath the blacked-out area.

The coloration of a photolithographic print, conversely, arises from combinations of different colors that have been either superimposed on each other or that lie in such close proximity that they are mixed or blended into one color by the viewer's eye. The geometric rings and dots of a photolithographic blue sky may indeed be predominantly blue, but red, brown, and yellow may also be present in varyingly small amounts to give depth to the area. The red rose may really be both red and yellow with a light touch of blue. Tree foliage may be green over yellow or green and blue over brown. The point is this: a photographic reprint of an N. Currier or Currier & Ives original is generally identifiable by the appearance of multiple layers of geometrically configured colors (usually) precisely printed within the boundaries of each unique object or device in the picture. Look closely with your lens. There seems to be a little red in almost everything.

Finally, areas within a photolithographic image that appear as white to the naked eye, (e.g., cloud formations, ships' sails, and snowscapes) are the areas that are most likely to have the appearance of an original stone lithograph. These areas, too, are actually composed of any number of the small, colored geometric ring or dot patterns that are visible with eight-power magnification. Interestingly, colors such as yellow, blue, green, and, typically, red may be present. Generally, the brighter the area the *less* dot geometry there is in evidence. Particularly bright passages may appear void of dot or ring color. However, close inspection will usually uncover a telltale trail of minute colored dots. In these areas the geometric patterns exhibited by the overall image have been reduced to individual points or dots. They are spaced in a matrix of columns and rows that have a noticeable diagonal "movement."

An excellent example of what to avoid purchasing as an original is represented by an illustration in the Color Section. This enlargement of a small area in a reproduction print plainly demonstrates the dot matrix employed in modern four-color lithography. If your lens reveals a similar pattern, beware! What you are seeing is not an original N. Currier or Currier & Ives print but a copy. A good lens is a great insurance policy. Do as the commercial suggests, "Don't leave home without it."

To obtain a broader perspective of the characteristics of an original N. Currier or Currier & Ives lithograph, an excellent monograph written by American Historical Print Collectors Society members Barbara and John Rudisill is recommended. Their work is available at this writing. Its price is $4. Orders maybe placed c/o Rudisill's Alt Print House, Medfield, Massachusetts. The title is "Currier & Ives: Is It an Original Print?."

The Catskill Mountains.

Sunnyside — on the Hudson.

The Sleigh Race.

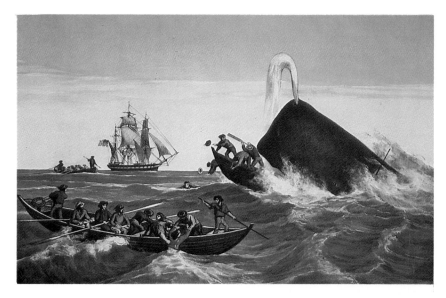

The Sperm Whale / "In a Flurry."

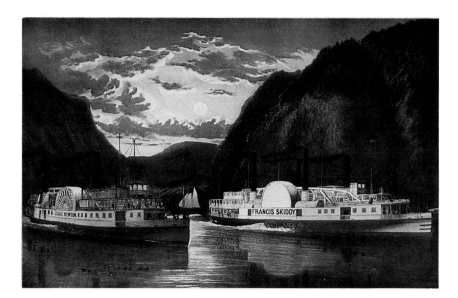

A Night on the Hudson / "Through at Daylight."

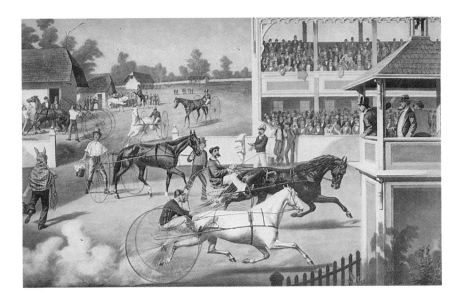

Ready for the Trot ╱ "Bring Up Your Horses."

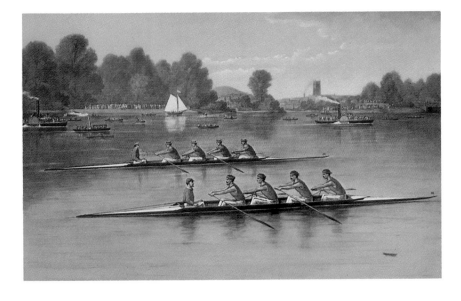

A Four Oared Shell Race.

Black Bass Spearing.

The Life of a Sportsman / "Camping in the Woods."

Robinson Crusoe and His Man Friday.

Farm Life in Summer / "The Cooling Stream."

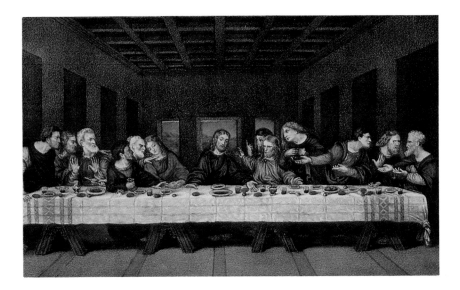

The Last Supper.

American Prize Fruit.

A Rising Family.

37

The American Fireman / "Facing the Enemy."

The American Fireman / "Prompt to the Rescue."

Beatrice Cenci.

The Descent from the Cross.

The Village Blacksmith.

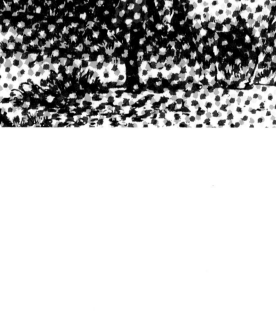

Greatly magnified detail area from a photolithographed, reproduction print of *The Village Blacksmith.* Dot matrix pictured here is typical of a photoengraved, four-color, printed image. If magnified observation reveals this geometric dot pattern, the print cannot be original. All color seen in original N. Currier and Currier and Ives artworks was hand-applied in watercolors after the black-and-white prints were "pulled from the stone."

3

Evaluating the Condition of a Print

During the data collection phase of the research, five grading classifications were noted. "Poor", "good", "very good", "fine", and "mint" are general descriptors currently accepted and used to identify the condition of prints offered in the marketplace. Grading is the subjective pronouncement of the offeror or cataloger regarding the condition of a print. A consensus of professional opinion relating to these classifications was not difficult to compile. General grading standards have evolved over time. These standards are based primarily on a print's state of preservation (or alteration) and on the quality of the impression and coloration.

Grading abbreviations are employed for expediency and cost-effectiveness. It would be impractical to devote paragraphs to each of the numerous prints appearing in a sale list or catalog. Yet, it is essential to accurately portray and communicate the state and attributes of a print. Some terse descriptions are complete of themselves. In most instances, however, the prudent buyer should rely on grade abbreviations or brief statements of grade only to the extent that they are incomplete, very general, and purposely encapsulated for the reasons noted before. Not all "good" prints receive that designation for the same reason(s). Buyers should use any brief grading codes or descriptors as guides for the preliminary selection of prints. Since print dealers and auction houses rely on repeat business from their clients, they are very willing to respond to inquiries that seek additional information about their offerings.

2098. The Four seasons of Life: Middle Age.

2128. Franklin's Experiment, June 1752.

2201. Fruits of the Seasons.

2412. Gold Mining in California.

2417. The Golden Morning.

The potential buyer should, therefore, obtain a detailed condition report to satisfy himself or herself that the print is acceptable. Of course, there *is no* substitute for a firsthand, unframed, two-sided examination! Print dealers who provide mail-order sales almost invariably provide a five-day, return-for-refund examination period to ensure client satisfaction. Such is not the case with major auction houses. Their acceptance of your mail bid constitutes a sale, just as if you were in attendance and bidding.

The condition or grade of a print coupled with its popularity (the demand for it), its availability or scarcity, and the quality of the impression are the key factors of value and, consequently, price. For N. Currier and Currier & Ives prints, prices seem to be governed first by popularity and scarcity; on a secondary level are state of preservation and quality of impression and coloration. Regarding impression quality and coloration, the firms produced relatively consistent images. Occasionally, a particular impression will be observed to be noticeably stronger or weaker and therefore command a premium or require a lower value appraisal. Condition is a more significant factor as value and grade are directly proportional. The difference in value between prints that have the same image, title, and folio size, but which are dissimilar with regard to condition is often quite dramatic. In 1978, for example, in sales nine and one-half months apart, Sotheby Parke Bernet, Inc., cataloged two coveted Currier & Ives prints, both titled *The Lightning Express Trains / "Leaving the Junction"* (both C3535). They were described as follows: "Hand colored, several repaired tears, surface scratches and water stains, lower publication line, after F.F. Palmer, 1863,...28 × 18⅛." And, "Hand colored, bright impression, slight discoloration after F.F. Palmer, 1863,...27⅞ × 18⅛."

Sotheby's estimated prices for these prints were $2,000 to $2,500 and $2,800 to $3,400 respectively. The knockdown prices strongly suggest that, estimated prices notwithstanding, even the worth of important pieces is determined by their quality and condition. The print that was not so well preserved sold for $1,600. The superior (note "bright impression," a significant component of value) and better preserved specimen realized $6,200, or almost four times more. Such occurrences are not unique; in fact, they are typical.

2448. A Good Send-off, Go!

In the succeeding paragraphs, fundamental grading parameters are presented for each grade classification or term. Comments have been added.

Poor. Alternatively "fair." Unfortunately, N. Currier and Currier & Ives prints are too often encountered in this state. Certainly a majority of prints receiving this designation must be considered non-collectible. Colin Simkin, commenting in the "Foreward" to the 1970 edition of *Currier & Ives Prints, An Illustrated Checklist,* states: "Prints with worm holes, punctures or large tears should be avoided unless the value is such that it would warrant the expense of expert repairs."

Rarity should also be considered. Exceptions are made for rare, highly prized, or historically significant issues. Suffice it to note that a print labeled "poor" has either been thoroughly mistreated or neglected to the extent that the print, and specifically the image, has suffered catastrophic injury.

Major defects are often found in combination, although any one, individually, would usually require the rating "poor." These defects include prominent or pervasive staining, noticeable paper abrasions or losses or severe tears in the image (plate), cropping of margins, heavy creases, excessive color fading, age toning (darkening) of the paper, and poor restorations. Prints in "poor" condition are often sold "as is," with no recourse available to the purchaser. Substantial, costly, expert restoration may not guarantee a satisfactory, aesthetic result. *Caveat emptor.*

Good. Typically, the assignment of "good" is given to prints having one, but not more than two perceptible but not prominent defects. These defects may affect both the image and/or the margins. A "good" print may exhibit defects such as a modest-size abrasion in the plate or a combination of small ones. Small, pin-size holes in the image are acceptable for this grade provided they are few in number and are reparable. The trimming of a subtitle or line of verse is permitted here. However, the title line and any significant subtitle(s) must be intact.

Defects that diminish the overall aesthetic appeal of the image are recognized in this classification. To the extent that they are not major defects, they may include: noticeable or distracting age toning (resulting from acids inherent in the paper in combination with environmental light and humidity); water staining; discernible loss of color intensity due to harsh cleaning or exposure to light; and, foxing or mildew staining. Marginal losses due to trimming are a significant characteristic of a "good" print. Generally, minimum marginal widths necessary for inclusion in this classification are ⅜ inch

2540. *Grand Young Trotting Stallion Axtell.*

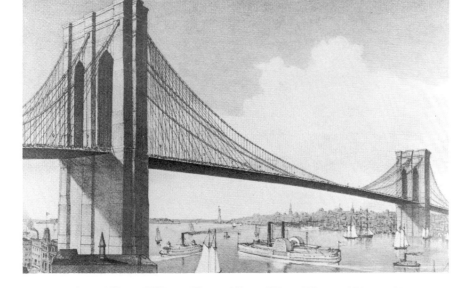

2594. *The Great East River Suspension Bridge.*

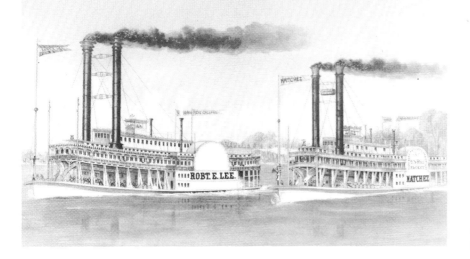

2644. *The Great Race on the Mississippi.*

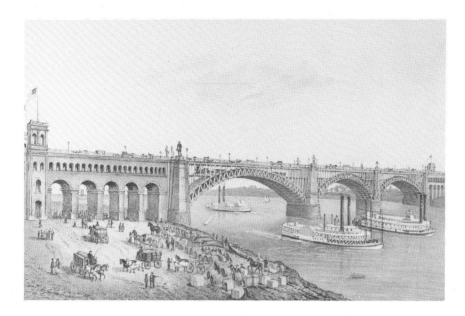

2648. The Great St. Louis Bridge.

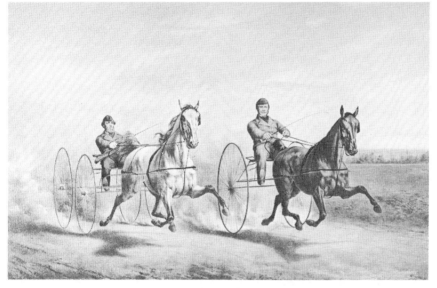

2800. Hero and Flora Temple.

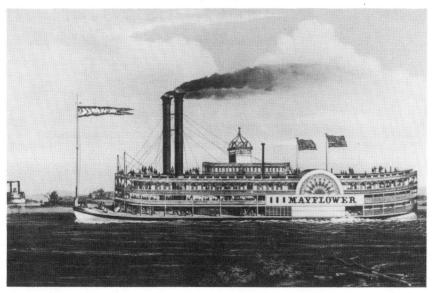

2813. High Pressure Steamboat Mayflower.

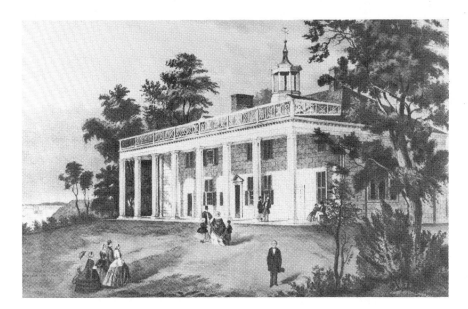

2874. *The Home of Washington /*
Mount Vernon, Va.

for small folio N. Currier and Currier & Ives prints, ½ inch for medium, and ¾ inch for the large folio prints. Tears also influence print grades. Two or three marginal tears that extend near the plate line or image edge would not disqualify a print from the "good" class. However, tears that pass through the title line or tears that extend into the image are serious defects. To maintain this classification, allowances for plate tears should not exceed ½ inch for small folios, 1 inch for medium, and 2 inches for large folios.

Very Good. This is the grading term appearing with the greatest frequency. It represents a print that, all factors considered, is typical of the Currier & Ives group surviving to the present. "Very good" is the standard or paradigm. Its characteristics are the criteria by which a print is judged acceptable. The plate of a "very good" print will be free from all but the most imperceptible defect. There will be no stains, tears, or abrasions here. Colors will be reasonably bright and fresh. The print will not be mounted or backed.

Marginal width and condition are also integral factors in the designation "very good." Width is determined by perpendicular measurement from the image edge or plate mark (line) to the edge of the sheet at the closest point of removal due to loss or trimming. Thus, a margin tested at three points as 5/16 inch, ⅞ inch, and ¾ inch would be judged to be 5/16 inch wide. To qualify for this grade all margins should measure no less than ¾ inch for small folios, 1 inch for medium, and 1 1/2 inches for large. For bottom margins, these measurements would be in addition to the title plus any subtitle lines. Minor allowances are sometimes made for bottom margins falling short of the measurements listed above. Margin breaks are permitted provided they do not approach the image — no closer than about ½ inch. Minor, light marginal discoloration is permissible.

Vignettes are images possessing no delimited boundary or plateline. These images tone gradually into the surrounding ground or unprinted areas of the sheet. Vignettes may have no appreciable background drawing and, therefore, determination of marginal width is not possible. In this event, knowledge of sheet size is important. Advertising copy from the Currier & Ives firm indicates, for example, that the sheet size of small folio prints was 13½ × 17¾ inches. Given these dimensions, a fair standard for the sheet size of a vignetted, small folio print is 10 × 14 inches. Personal tastes should dictate, however.

3002. Hunting, Fishing, and Forest Scenes.

It is very important to remember two points. First, marginal trimming imparts a defect to the print. Margin trimming in nineteenth century America was a common practice. The percentage of N. Currier and Currier & Ives prints having "full," unreduced margins was slightly less than 1.4 percent of the total population (24,210) of cataloger and offeror descriptions that comprise the data base for this book. Second, never trim or permit trimming of print margins for *any* reason. Do not reduce them to fit a frame or produce a uniform width.

Remember, the margin is an integral part of the aesthetic and intrinsic worth of any print. Simkin notes, "Prints with margins trimmed to the illustration are almost worthless." Similarly, in their work *The World of Currier and Ives,* King and Davis write: "Wide margins are very important to a collector. Due to trimming , a print that has 'ample margins' has a rarity value all its own."

This is an appropriate place to discuss restorations and their impact on grade, and consequently, valuation. It is certainly possible for a print to be upgraded as a result of a successful, professional restoration. Removal of surface soiling, local cleaning of modest staining, and repair of marginal tears not entering the plate or image can usually raise the grade of a print from "good" to the level of "very good." It is unlikely, however, that a print in "poor" condition — one having unquestionably serious defect(s) — can successfully be elevated to "good." Although the defect may be masked or ameliorated to present a more pleasing aesthetic result (and, on occasion, an increase in value) the defect remains an inherent vice that should be listed in any description. Moreover, restorative treatment of any type, even local cleaning, should also be included especially if the restoration is not reversible. The buyer is entitled to receive as complete a history of his or her print as the seller can provide.

Fine. Alternatively, "very fine." A superior specimen infrequently found. The impression must be sharp and fresh. The plate must be defect free. The colors must be vivid and skillfully applied. Margins must be wide — approaching 2 inches for small and medium folios and 3 inches for large folio prints. Allowances are made only for the slightest tear at the margin's edge and for soft, even time toning. A print in "fine" condition is a premium item. Less than 3 percent of the prints in this study represented this grade.

3004. Hunting on the Plains.

3069. In the Harbor.

3079. Independence Hall, Philadelphia 1776.

3112. The Ingleside Winter.

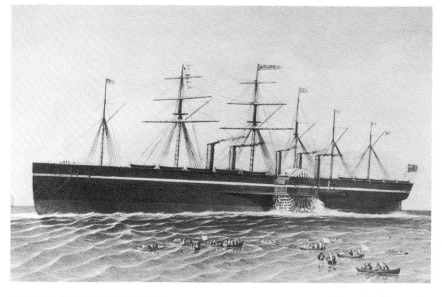

3130. The Great Iron Steam Ship "Great Eastern."

3327. The Katz-Kills in Winter / Bastion Falls.

3430. The Landing of Columbus Octr. 11, 1492.

Mint. Also, "pristine." In those extraordinary circumstances where paper and printing material and storage environment and time are united to perfection a print may deserve this designation. A "mint" state print is 100 percent original, defect free (including full margins), and perfectly preserved. "Mint" is not so much a reporting of condition as it is a statement of how successfully the print has been preserved in surviving to the present day. In his monograph entitled "Currier & Ives: Quality Guidelines for Collectors," Robert Searjeant recommends:

> If you are a relatively new collector — or even an old timer — if you wish to build your collection into a hundred or more prints in only "mint" or "pristine" condition, my advice is — forget it!!!...The vast majority of "mint" or "pristine" prints have been carefully scavenged and plucked over the years...[and] are resting quietly on the walls of our museums, galleries and in large private collections.

Mr. Searjeant is correct. Of the print offerings studied in preparation for this book, eighty-nine were described as "mint." This figure is less than four-tenths of 1 percent.

In summary, one point is worth learning. Grading is subjective. The assignment of a grade and, consequently, a dollar value is a matter of opinion. Hopefully, the grader is a person who is knowledgeable regarding print grading guidelines, thorough in his or her examination of the print, and an unbiased decision-maker. Sooner or later even the most meticulous grader will miss some defect or distraction and overstate the grade and value. It is incumbent on the collector/buyer to educate himself or herself as to those general grading standards in current use. Buyers should satisfy themselves as to both condition and price. This can be accomplished in part by reading. Primarily, however, judging the quality of a print is a skill acquired by having frequent contact with prints in the marketplace. Observing and asking questions equals learning.

4

Matting and Framing Works of Art on Paper

The objective in matting works of art on paper is to provide them with an envelope of protection and support. When housed in a mat, prints can be stored and handled with a much lower incidence of deterioration and injury. Observing additional conservation guidelines will allow safe framing for display.

Six points must be observed in displaying prints: (1) only acid-free mat board may be employed; (2) no synthetic, chemical adhesive may be used to attach the print to its mat board support; (3) the glazing material may not contact the print's surface; (4) the frame must be sealed to prevent dust, biological agents, insects, and pollutants from gaining access to the work; (5) the print's environment should remain as constant as possible with regard to temperature and humidity; (6) the lighting source must be as free from ultraviolet radiation as possible.

The standard mat used at the Library of Congress is constructed from two pieces of acid-free, four-ply mat board. The two boards — the mount board and the window board — are cut to the same size and hinged on a long edge with a 1 inch wide, non-acidic, gummed cloth tape such as linen tape. (Smith, M.A., p.1) The window cut from the window board should be an opening of sufficient area such that no part of the image, plate line, titles (and subtitles) or publisher line is covered when the print is hung in the mat. For prints with margins, an aesthetically pleasing marginal width should be exposed. This exposure generally ranges between ¼ and ½ inch.

3433. *Landing of the Pilgrims at Plymouth.*

52

3480. The Levee - New Orleans.

3540. Lily Lake / Near St. John, N.B.

3823. The Low Pressure Steamboat "Isaac Newton."

3829. The Lucky Escape.

4126. Mill River Scenery.

4144. The "Minute-Men" of the Revolution.

4394. *Natural Bridge* / In the "Blue Ridge" Region.

Cutting the opening in the window board requires more patience than skill. The equipmental needs are few and inexpensive. They include a hand-held mat cutter, utility knife, metal straightedge, large work bench, a 4 × 5 foot piece of sheetrock (dry wall), and a ruler graduated in 1/16 inches. Although mat cutting instruments having price tags exceeding $750 are available, little additional precision is really gained by using them for making straight cuts as opposed to a $15 hand held cutter. Their advantage results from considerable time saving, which may or may not be important, depending on the number of mats the individual needs to prepare.

The initial matting step is to cut the mount board and window board to the same size using a utility knife. Height and width measurements are taken from the print image (plus title lines), and an amount is added to allow for marginal exposure. The width of the "window" is then deducted from the overall width of the window board, with the result divided in half to yield the width of the window board's margins. Typically, this width will range between 2 and 6 inches. It will also be repeated as the measurement of the top margin. For aesthetic effect, the bottom margin of the window board is cut slightly wider, depending on the size and character of the print or its intended frame.

The sheetrock is laid over the working surface, serving as a clean (and disposable) protective covering. Next, the window board is placed face-down on the sheetrock and the calculated margin areas are marked in pencil. The window is cut from the back. There are two advantages: First, the pencil lines that indicate the perimeter of the window are easily erased after cutting; and, second, the slight overcutting at the corner edges will not be visible from the front view. The straightedge is then positioned beside the opening marks, and the mat cutter is slowly drawn along the edge of this guide. Most cutters can be adjusted to give window edges that are 90-degree straight edges or 45-degree beveled edges. To produce a clean cut, each side of the window should be cut through with a single stroke. After the cuts have been made, the window is removed and the exposed edges are buffed lightly with a fine grade sandpaper or bone fodder to prevent damage to the artwork by the fresh, sharp window edges. The window board and the mount board can now be hinged together using the gummed cloth tape previously mentioned.

4416. New England Coast Scene.

Hinges are used to attach the print to the mount board. This provides very critical support for the artwork. The most effective and safest hinges are made from Japanese papers such as Kitakata, Sekishu, and Mulberry. These hinging papers are considered the safest and most effective because their long fibers are both durable and flexible and provide excellent support. Japanese papers should not be trimmed to hinging size with sharp instruments. Instead, the paper must be folded, burnished along the fold, opened, refolded, and burnished again. A very small brush is then used to apply a light bead of water down the length of the fold. The sheet is opened and gently separated along the dampened line. This method of tearing leaves long edge fibers. The hinge's edges are thus soft and will not cause injury to the print. Feathered edges also help provide a better bond between the hinge and the print.

To maximize the safety of the print, careful consideration and good judgment must govern decisions about the hinges. The paper must be examined and its condition evaluated, since the number of hinges and their size are determined by the paper's size, weight, and mechanical strength. If the sheet size does not exceed about 14 inches, two 1 × ¾ inch hinges should be sufficient. Larger prints will require three or perhaps even four hinges measuring 1½ × ¾ inches. The weight of the hinge should never exceed that of the sheet or the sheet's mechanical strength if its condition has deteriorated. The reason here is related to the protection of the artwork. In the event of careless handling or stress, the hinge will tear rather than the print. Hinges torn from Sekishu or Mulberry paper are used for thick or heavy prints. Kitakata paper would be used to support lighter weight print sheets or prints whose condition is delicate.

Hinges are always affixed to the top of the print sheet. The outside hinges are positioned approximately ½ inch from the ends of the top of the sheet. An exception is made if a corner has been damaged and subsequently repaired — the hinge should not cover the repair. The interior hinge in a three-hinge group is centered, while the two mid-area hinges of a group of four are given uniform spacing.

The best hinge is the pendant hinge. This type hinge is also known as the T-hinge, hinged tab, or T-hanger. It is constructed with two pieces of the hinging paper placed perpendicular to each other in the shape of the letter "T". The pendant (stem) is attached to the artwork itself by the long edge. Approximately ¼ to ⅜ inch of the pendant should be overlapped by the top edge of the sheet. The sheet is laid with the image side down on a flat surface covered with a clean, acid-free paper or tissue. The pH neutral adhesive is

4457. *Niagara Falls* / From Goat Island.

4536. *Off a Lee Shore.*

4719. *Partridge Shooting.*

4754. Perry's Victory on Lake Erie.

4785. The Pioneer Cabin of the Yo-Semite Valley.

4959. The Progress of the Century.

5042. A Race on the Mississippi.

thinly and evenly applied by brush only to the area of the pendant that contacts the sheet. Excessive application of paste will saturate the hinge and perhaps cause wrinkling of the sheet at the point of contact. The pendant is then blotted with a piece of cotton to absorb any excess moisture. To insure good contact, the pendant is covered with a thin sheet of polyester or nylon web that is overlaid with a piece of blotting paper and lightly weighted. The webbing prevents the hinge and blotter from adhering to each other during the drying period (usually twenty to thirty minutes).

After the pendant halves of the T-hinge have been positioned, the print sheet is turned image-side up in preparation for its attachment to the mount board. Carefully place the print on the mount board, close the window board and adjust the sheet until the print is correctly positioned beneath the window. Lightweight, metal print clips may be used to hold the print in position. The hinging process will be completed by affixing a crosspiece tab over each pendant. The crosspiece is larger than the pendant by perhaps 50 percent. Since this piece will not be in contact with the sheet, its size is not so critical as long as it is sufficiently large to lend complete support. Adhesive is brushed on more thickly than before but, again, not to the point of saturation. The crosspiece is then centered perpendicularly across the pendant about 1/16 to ⅛ inch away from the top edge of the sheet. Again, the polyester web, blotter, and (somewhat heavier) weight are applied to establish a sound bond between the crosstab and the mount board.

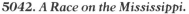

STANDARD MAT

After an appropriate drying period the matted and hinged artwork is ready for inspection. The crosspiece tabs should be checked to be certain they are secure. The spacing between each tab and the sheet should also be re-examined since this small space permits the hinge to flex when the print is raised for examination of the reverse, or verso. If everything is in order the print is ready for either storage or framing.

Considering hinging adhesives, *none* of the commercially available, synthetic adhesives or pressure-sensitive tapes should be used when attaching the print to the mount board. Simply, they are unequivocally unacceptable as hinging substances. These include "Scotch" or cellophane tapes, masking tape, white glues, animal glue, spray adhesives, heat sealing tissues, contact cements, and moisture-activated gummed paper tapes. Such products should not be used for two reasons. First, they do not provide the feature of reversibility, which is the paramount consideration of the conservator when framing to conservation standards or performing general restorative activities involving works of art on paper. Even after short-term contact, this group of adhesive fasteners can only be safely removed by a conservation specialist.

5422. *Scenery of the Upper Missis-sippi.*

The problem, of course, is to prevent losses where the surface is lifted as the adhesive agent is removed. Second, the chemical components of these adhesives and glues are fugitive. In a normal environment, chemical degradation begins after a very short time. As chemical separation occurs the released chemicals are absorbed by the fibers of the paper. This results in local staining that is usually irreversible. Even so-called acid-free tapes should be avoided, safety claims notwithstanding. These products have not received complete testing under real environmental conditions for aging characteristics and long-term reversibility.

Traditionally, the adhesives preferred by conservators are wheat or rice starch pastes. They are the safest adhesives because they provide a secure, acid-free reversible bond. Moreover, they can accept chemical additives that leave them unattractive to insects and vermin. The short-comings of the starch pastes are the amount of time required to prepare them, the lack of control over this "cooking" process, and their relatively short shelf-lives due to spoiling. Today, modified dextrine adhesives having a neutral pH and water-activated reversibility are proper substitutes for the starch pastes. Methyl cellulose is another neutral pH adhesive that is resoluble in water. Prepared from powder that is dissolved in water, it produces a paste that should only be used in applications where its substantial water content can be tolerated. In paste form, methyl cellulose has an infinite shelf-life.

One other caveat merits mention. Prints should never be "mounted," "backed," or "laid-down;" that is, they should never be attached directly to the mount board unless preservation dictates such measures. Prints are too often affixed to mount boards by the application of adhesive to the reverse. Mounting a print by securing just the four corners to the backing material is almost as detrimental to the print as overall mounting. Prints must have room to "breathe." They must have room to react to changes in temperature and humidity. Since paper is hygroscopic, it will expand or contract in response to atmospheric changes. So, too, will the (paper) mount board. The problem is that the two paper materials will not expand and contract at the same rate. The asynchronous responses of the two papers will be stressful to the fibers of the artwork, especially if the atmospheric fluctuations are dramatic. This is the reason prints are hinged and not mounted.

It is imperative that a glazing material be used in framing works of art on paper. Window glass or Plexiglas is used to protect the work from dust, pollution, and ultraviolet radiation. The selection of one of these glazing materials depends primarily on two factors — size of the frame chosen for the artwork and conservation requirements. Both materials have positive and negative attributes.

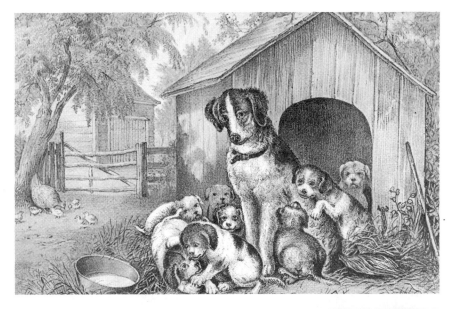

5486. *"She Had So Many Children She Didn't Know What To Do."*

5551. *"Sleepy Hollow" Church* / Near Tarrytown, N.Y.

5715. *Staten Island and the Narrows* / From Ft. Hamilton.

61

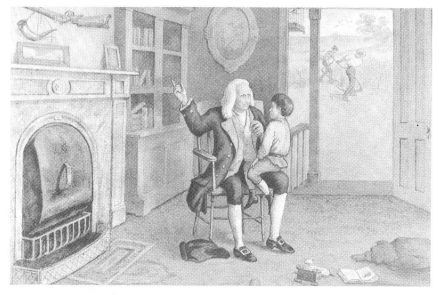

5835. *The Story of the Revolution.*

5839. *Strawberries.*

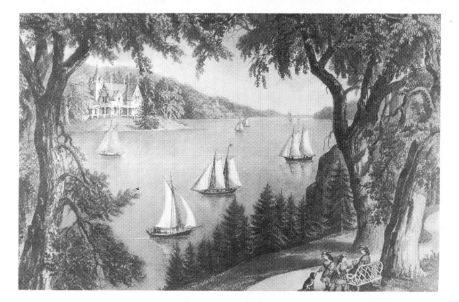

5847. *A Suburban Retreat.*

5856. Summer Flowers.

Plexiglas is an acrylic plastic that is capable of filtering out the most damaging component of light — ultraviolet radiation. Two varieties of Plexiglas are appropriate as glazing material. Plexiglas UF1 is clear in color and filters approximately 75 percent of ultraviolet radiation. Unfortunately, UF1 has a tendency to yellow with age — it is often warranted for five years against this event. Plexiglas UF3 filters about 92 percent of ultraviolet radiation. It has a more stable nature but does have a noticeable yellow tint that will distort the viewer's perception of print coloration. When compared to glass, Plexiglas has comparative extremes. Plexiglas is virtually unbreakable, lightweight, and a superior thermal insulator. On the negative extreme, it is remarkably easily scratched and it exhibits static electrical properties that make it highly dust attractive. The cost of Plexiglas UF3 is also an extreme and runs about four times that of ordinary glass. Plexiglas UF1 has about the same cost as single-strength glass.

Single-strength glass may be used in glazing applications not exceeding about 2½ × 3½ feet in area. Beyond this size, double-strength glass or Plexiglas should be seriously considered since they are less apt to suffer breakage. The problem with moving to a double-strength glass is increased weight. This is because the thickness of glass must be increased as surface dimensions increase in order to maintain appropriate tensile strength. Naturally, the principle drawback to using glass is its inflexibility. Glass does filter ultraviolet radiation but not to the extent of Plexiglas UF3. Finally, in all situations involving prints or other artworks (such as those done with pastels, chalk, or charcoal) with delicate or friable (easily crumbled) surfaces, glass should be used as the glazing. As noted, Plexiglas has an affinity for building static electrical charges on its surfaces. Such a charge could attract materials away from the surface of the artwork causing irreversible damage.

Non-glare or reflection-proof glass is also available as a glazing material. When these products were first introduced it was required that the artwork be placed in contact with the "glass" to produce the desired non-reflective effect. In some instances this requirement is still applicable today. It is vitally important for the well-being of any print that it should *never* contact the glazing material especially if glass is used. Appearance aside, the function of the window half of a mat is to keep the print surface away from the glass. Because it reacts to atmospheric conditions, radical changes in temperature (and humidity) could cause moisture to condense on the inside of the glass.

5866. Summer in the Woods.

In this situation a print that has contact with the glass could easily absorb the moisture. The consequences are water staining, mold growth (and the subsequent staining called foxing), and adhesion of the print surface to that of the glass, which often results in losses to the print when the two are later separated. Since the properties of non-glare are consistent with those of regular glass, and because it is not perfectly transparent, thereby distorting the appearance of the artwork to a small extent, non-glare glass is less suitable as a glazing material. Additionally, its cost is substantially greater than ordinary glass.

Improper framing is undoubtedly responsible for imparting more damage to works of art on paper than is any other source. Consider all the old pictures you have ever bought that were still housed in their original period frames. You could probably count on one hand the number that were sufficiently well framed that the work remained both unaltered and undamaged. The frame not only serves as a display unit, it must also provide a stable, dust-free, protective environment. First, the frame must be sturdy. Second, it must present a barrier to those agents that will harm its contents. Plexiglas may be used to shield the print from ultraviolet radiation in those situations where the light source is high in ultraviolet content. Prints displayed in an environment characterized by a substantial volume of airborne pollutants or extended periods of high humidity should probably be "sealed" into their frame. This operation can be accomplished by laying a continuous strip of Double-Coated No. 415 Polyester Tape along the rabbet, or support shelf, of the frame and pressing the glazing material against it. To finish the enclosure of the work, a sheet of three mil Mylar (an inert, neutral pH, flexible polyester plastic) can be extended over the entire reverse surface of the frame and secured with the No. 415 tape.

Many framing applications will simply consist of: (1) placing the frame face-down on a protective surface; (2) laying the (cleaned) glazing material on the rabbet followed by the matted artwork; (3) inserting a backing board of four-ply, 100 percent rag content behind the mat to provide additional support and protection; (4) securing this package with glazier's push points — glazing points that can be driven easily into the sidewall of the frame rabbet using a screwdriver or putty knife (use one every 2 to 3 inches); and (5) enclosing the frame with a one-ply, 100 percent acid-free paper barrier secured to the entire reverse area of the frame along the outermost perimeter with a neutral pH adhesive.

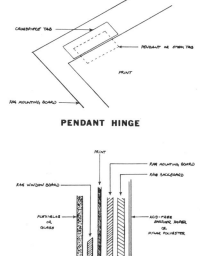

PENDANT HINGE

FRAMING ARRANGEMENT

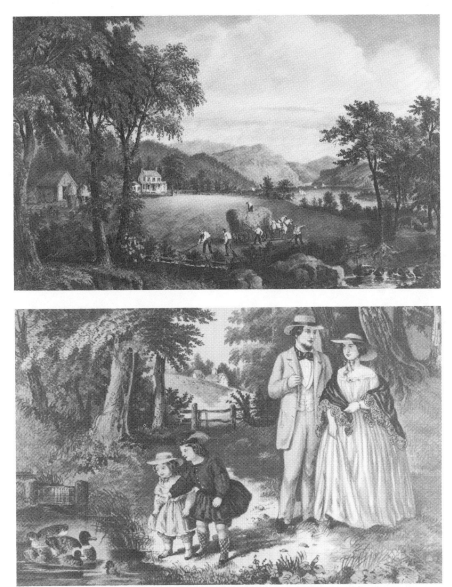

5868. *A Summer Landscape* /
Haymaking.

5874. *A Summer Ramble.*

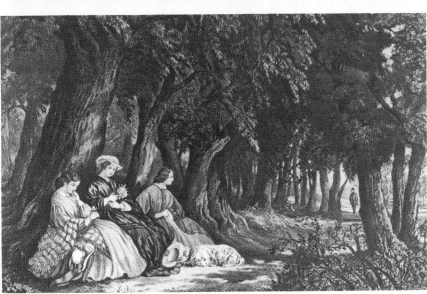

5896. *The Sunset Tree.*

5900. The Surprise.

If both matting and framing are to be accomplished by a framing service, do not fail to specify that you require 100 percent conservation materials, including 100 percent rag mat papers. If your framer is not completely knowledgeable on this subject (and many are not) find another. Under no circumstances should the framer be authorized to alter the print sheet in any manner, particularly to the extent of making repairs (unless he or she is a qualified paper conservator) or trimming the margins. Inappropriate framing techniques that cause injury to prints are avoidable. Avoiding them is the responsibility of the collector/owner.

Matting and framing should be reviewed as soon as a print enters your collection. If the matting materials are not consistent with current conservation standards, they must be replaced. If the character or stability of the print is suspect or if it has obvious injuries, it should be given to a competent conservator for restorative treatment.

After reframing and display, it is important to keep three points clearly in mind. No framing should be considered permanent — frames should be opened and their contents examined every three to five years to ensure that no deteriorative processes are occurring behind the window. Second, prints survive longer if they are given periodic rests away from light. Three months on display followed by three months in darkness is preferred, although perhaps not desirable. However, some effort should be made to rotate the collection away from light so that none of the prints suffer continuous exposure:

> Rotation of prints serves more than a practical purpose. The print connoisseur collects not for the sake of mere acquisition, nor to demonstrate his devotion to art, but because of his endless fascination with the myriad expressions which the printmaking media makes possible. Constant viewing of the same work often neutralizes appreciation. By changing his exhibitions, the collector can be stimulated by the new and relax with the old. (Schonberg, p.7)

Finally, prints must never be displayed in areas that are near sources of heat or dampness or which are brightly illuminated, especially by direct sunlight. The impact of any of these elements alone would be catastrophic.

5

Lithographic Technique: Creating a Lithograph

Few writings that discuss lithography deal at length with the physical and chemical processes required to produce a lithograph. Considering that the combined output of the firms of N. Currier and Currier & Ives exceeded 7,450 prints or an average of two to three new prints each week for sixty-four years (1834-1898), the author was curious about the energies and resources necessary for creating a lithograph. With the enthusiastic encouragement of Professor Lloyd Menard, University of South Dakota School of Fine Arts, the author enrolled in the University's fifteen-week, introductory course to lithographic printmaking. The experience was most exciting and gratifying. Both elementary and sophisticated techniques for creating images on stone were demonstrated. Many of these were devised by Senefelder and remain fundamentally unchanged since his era. The following paragraphs straightforwardly detail the method for creating a "litho."

The great majority of lithographic stones extant today are Kellheim stones from the Solnhofen, Bavaria, quarries. They were quarried during the nineteenth century and the first decades of this century. Because they are fine-grained, virtually free from impurities, and yield remarkably consistent results at each stage of the lithographic process, Kellheim stone has always been considered superior in quality to all other lithographic limestone.

Lithographic stones were produced in sizes that ranged from approximately 4″ × 6″ × 2″ to 36″ × 60″ × 5″. Just as folio size influences the value of Currier & Ives prints, a stone's size contributes to its value. The primary component of value, however, is the physical quality of the stone, which is

5906. *Surrender of Lord Cornwallis at Yorktown, Va.*

5943. Tacony and Mac.

5968. A Taste for Fine Art.

6167. Trotters on the Snow.

6227. *The Trout Brook.*

indicated by its color. Three general color classifications are recognized. The most desirable color is a medium gray, followed by pale gray and light yellow. The darker stones are more dense and sharply grained, and, consequently, the artist is able to produce a greater range of tonal variations within the image. In addition, they are better able to withstand the action of the acids used to process the drawn image and the pressure of the press when printing. Gray stones were also less plentiful. These combined factors caused lithographers to place premium values on the Kellheim gray stones. It is therefore probable that the Currier & Ives firm employed the softer and coarser yellow stones, sacrificing tonal range in favor of cost.

The lithographic process is begun by selecting a level-surfaced stone of uniform thickness. The first operation is grinding, or graining, the stone. The objectives are to remove any previous image or surface dirt and to impart a microscopic coarseness, or "surface tooth," to the stone. The initial step is to flow water across the stone and liberally, yet evenly, cover its surface with coarse, No. 100 Carborundum grit. Carborundum is a product resembling metal filings. It is the most common graining abrasive in contemporary lithography. Traditionally, sand, quartz particulates, emery, and pumice were the materials used as graining abrasives. In *Currier and Ives' America,* Colin Simkin writes: "The stones for small folio and relatively unimportant prints were rubbed with fine sand; for the large folio and better subjects they were rubbed again with pumice. The purpose of this was not to polish them but to give them a minutely roughened surface with a 'tooth' to which the grease crayon would adhere much as chalk does to a slate."

The grinding is accomplished using either another stone or a levigator. Stone-to-stone grinding is the traditional method and results in the simultaneous preparation of two drawing surfaces. The first (bottom) stone is placed on a secure table or drawing platform. Its surface is liberally wetted with water; excess water is removed by hand wiping. The No. 100 Carborundum grit is sprinkled evenly over the surface until nearly complete and even coverage is obtained. The face of the second stone is wetted; the stone is inverted and carefully laid on the bottom stone, thus sandwiching the Carborundum between them. The artist places one hand at a corner of the upper stone and the other in the corner diagonally opposite. The grinding action consists of slowly and rhythmically drawing the upper stone back and forth across the stationary bottom stone by (repeating) a one-half rotation in the clockwise

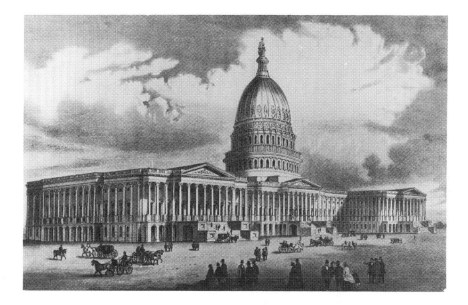

6294. United States Capitol /
Washington, D.C.

direction and then executing a similar rotation counter-clockwise. After a few minutes the grit loses its cutting edge. The stones are separated and flushed with water. Fresh abrasive is then applied and the grinding is repeated. This sequence continues for perhaps three or four repetitions or until clean surfaces have been achieved.

After the surfaces are satisfactorily clean, the medium grade of Carborundum, No. 180, is used to reduce surface coarseness. The procedure is the same — wetting, dusting, grinding, flushing, inspecting — and is repeated two or three times. Fine-grained No. 220 Carborundum follows. Two or three applications and grindings of this grit will provide a surface texture best suited to receive the drawing.

The alternative to preparing a stone via stone-to-stone grinding employs a levigator. The levigator consists of a precisely machined, stainless steel disk fitted with a vertically extended, cylindrical handle. This handle is positioned off-center, approximately 2 inches from the rim. Levigators are usually 10 inches in diameter by 1 inch thick, or 12 by 1¼ inches, and weigh between ten and twenty pounds. Within the handle of the levigator, ball bearings are housed. They permit the weighted disk to spin or rotate when the handle is cranked in a circular motion. Again, water and grit are applied to the surface being ground. The artist carefully mounts the levigator near a corner of the stone and begins rotating it. As the rotation is continued, he or she drives the device across the stone in an overlapping pattern from left to right and then top to bottom. When the surface has the appropriate texture, the stone is rinsed very thoroughly and permitted to dry completely. It is now ready to accept the drawing. According to Cliffe (p.10): "Lithography is a process capable of great refinement and subtlety...it is capable of rendering large and powerful images, of delicate drawing, of a wide and exciting range of textures — the possibilities are virtually unlimited."

The materials commonly used to create the drawing or image are lithographic crayons, pencils, and tusche. Crayons are ¼ inch square by 2 inch long sticks of fats (grease), black pigment, and binder. Pencils are simply paper-wrapped, ⅛ inch cylinders of crayon material. This form provides the artist greater tonal control in drawing technique than the traditional crayon. Both crayon and pencil can be delicately applied to produce finely divided image tones. Tusche is available in two forms — as a liquid ink with a very high fat content or as a water- or solvent-soluble paste. Liquid tusche may be applied by a number of techniques including pen, brush, and direct pouring.

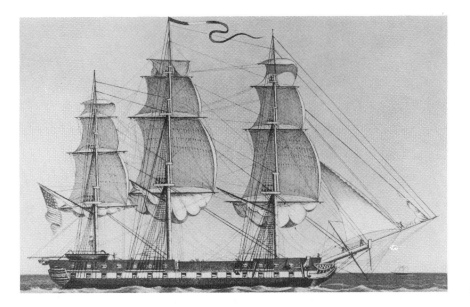

6304. *U.S. Frigate Constitution.*

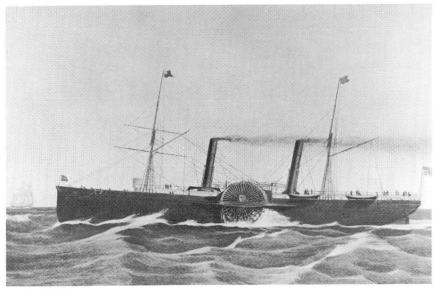

6312. *U.S. Mail Steamship "Adriatic."*

6365. *The Velocipede.*

6395. *View of Harper's Ferry, Va.*

6434. *View on Hudson River /*
From Ruggle's House, Newburgh.

6440. *View on the Delaware /*
"Water Gap" in the Distance.

6451. *View on the Rondout.*

Liquid tusche in ink form is used to create linear designs or solid black areas. The soluble, paste tusches are usually used as washes that can be flowed or brushed on to create abstract effects.

The artist may approach the stone in one of three ways: He or she may develop an image directly on the stone, trace an outline of the image on the stone, or transfer an original drawing to it. The transfer system was devised by Senefelder. Simply, the artist draws the image on paper (special transfer papers are available) using lithographic crayon or pencil. The image side of the sheet is then placed on the clean surface of a prepared stone, and the stone is passed beneath the pressure bar of the lithographic press. While the transfer process is a more convenient and, perhaps, more efficient method for producing a drawing on stone, its drawback is that alterations of tonal values occur regularly. The tonality of the image may either be coarsened by the transfer, or tonal passages may be lost if all of the design is not successfully transferred to the stone.

Artists with great confidence in their drawing skills may elect to draw directly on the stone. Alternatively, the tracing method can be employed. Using a hard pencil and firm pressure, the artist traces the outline of an original drawing (or creates an original drawing) on a sheet of unglazed tracing paper. The reverse of the paper will exhibit a faint, raised impression of the tracing. Next, red oxide powder is rubbed across this surface with a soft cloth until complete coverage is achieved. The tracing paper is righted, carefully centered on a prepared stone, and secured at the corners with small pieces of masking tape. The pencil lines are retraced using firm strokes. The oxide powder is imparted to the stone, providing an outline for drawing and shading.

An enlargement of a cross-sectional view of a lithographic stone would reveal a closely ordered succession of sharp and irregular, mountainlike peaks and valleys. When the crayon or pencil contacts the surface, pigmented fat (grease) is captured by the peaks. "In taking full advantage of the drawing surface afforded by the stone, it must be borne in mind that all tones in a lithograph are composed of small black dots [of grease]....Their shape, size and number, in a given area, control the character of the form in which they occur." (Wengenroth, p.18.)

Lithographic tones are developed by a building-up of the molecules of fat contained in the crayon or pencil drawing materials. Crayons and pencils are available in eight and five states of hardness, respectively. The softer drawing instruments have high percentages of fats and low percentages of binders and hardeners such as shellac or mastic. Successively higher numbered crayons or

6522. *Washington Crossing The Delaware.*

pencils have proportionally less fats and more hardeners. The artist works from hard to soft. Generally, he or she creates or builds tone by delicately shading an area with a relatively hard (low fat content) crayon or pencil. The area is deftly reworked until the desired tone is developed. If the tone is not sufficiently dark, the artist reworks the area with a succession of softer crayons or pencils. In effect, the larger the local dots of grease captured by the "peaks," the darker the printed tone of that area will be.

Many days, or just a few minutes, may be devoted to creating the image on stone. Since lithographic stones are very sensitive to the molecules of fat contained in the drawing materials, the development of the image must be carefully executed. Only very minor adjustments are possible. Stray marks or an inappropriate design can be corrected by locally scraping or honing the stone's surface. Such operations injure the surface to the extent that successful reworking of a scraped area is impossible. If corrections or changes are extensive, it is usually best to abandon the image, regrind the stone and begin anew.

The completed image can be a gratifying achievement. Unfortunately, there is a challenging sequence of chemical processes that must be negotiated before the stone's image can become a printed one.

> The aim of processing is to separate chemically the image and nonimage areas of the drawing so that they will receive or reject ink consistently. When processing begins the image areas consist of passages drawn with greasy lithographic crayon or tusche. Through chemical processing the fatty-acid particles contained in the drawing are liberated, permitting them to combine with the stone itself. The greasy areas are now ink-attractive and form the printing image. Simultaneously, the undrawn or nonimage areas are so treated that they will receive water and repel grease. (Antreasian, p.55)

Processing the stone is effected by the application of an "etching solution." (This term is a misnomer since the stone is not subjected to a corrosive, acidic action that "bites" or reduces the surface.) The etching solution has two components. They consist of one or more acids distributed in liquid gum arabic. The acids are the agents that unite the fats from the crayons or pencils and the stone's surface. The gum arabic desensitizes the nonimage areas by penetrating every minute pore of the stone and forming a mask, or stencil, which will receive a film of water that protects these areas from the greasy ink used in printing.

Processing begins by dusting the image, first with rosin and then with powdered talc. These substances are acid resistant. They help protect the image from the corrosive action of the nitric, phosphoric, and tannic acids that may be employed to unite the image and the stone. Dusting simply

6541. Washington, from the President's House.

6609. A Well-Bred Setter.

6675. Wild Horses at Play on the American Prairies.

6677. Wild Turkey Shooting.

6699. Wm. Penn's Treaty with the Indians.

6742. Winter Morning in the Country.

requires that sufficient rosin be sprinkled to generally cover the image. A soft brush is used to distribute the rosin to achieve 100 percent coverage and, therefore, penetration into the pores. The excess rosin is brushed from the stone and the talc, or French chalk, dusting proceeds in the same manner.

The application of the acid and gum solution is the critical operation in processing the stone. The artist must first evaluate the tonal values in the drawing. If they vary over a broad range, it is best to prepare two or more etching solutions, or one for each value. The basic constituents of an etching solution, gum arabic and nitric acid, are mixed in varying proportions to accommodate the drawing. Heavily drawn passages have more fat content and, consequently, produce the darker print tones; they require "hotter" or more acidic etching solutions to successfully liberate the fats from the drawing into the stone. Depending on the color of the stone, heavy deposits of drawing material necessitate approximately twelve to eighteen drops of nitric acid per ounce of gum arabic; medium drawing requires between eight and sixteen drops, while delicate drawing may require from zero to six drops of the acid.

Experience will dictate the acidic strength of the etch. However, due care must be taken to not apply too strong an etch to a given stone and drawing. Since the grain of the stone is susceptible to the corrosive action of the acid, an etch that is too "hot" could cause loss of tonal quality. This would occur when the surface "peaks," which have captured the fatty drawing materials, are actually bitten away by the action of the acid. The fats that had been released into them would similarly disintegrate and the tone would be lost.

The various etching solutions are liberally applied to their intended tonal passages using clean brushes. Application proceeds until the entire stone is covered. The stone is not disturbed for ten minutes. During this period two actions occur simultaneously. The nitric acid first separates the fatty acids (grease) from the black pigment and binding agents in the drawing materials. It then causes a chemical union between these fats and the stone. This union is secure, insoluble, and attractive to printing ink. The gum arabic desensitizes the nonimage areas of the stone by building a thin continuous film, or stencil, across the nonimage areas. This gum stencil is water-attractive. After the action of the etch is complete, it is reduced to a light, even coat by carefully wiping with a slightly dampened sponge. Rolled cheesecloth is used to buff the gum to a thin, even, dry stencil.

The next step can be somewhat disconcerting to the beginning student, inspite of pre-process explanation. This step is called the "washout." Its purpose is to remove the now unnecessary components of the drawing materials left as the residue of the etching process. This will prevent their interference in the printing process. Recall that the drawing crayons or pencils contain not only fats but also hardeners (binders) and pigment (since the essential fats are virtually colorless). A turpentine-like solvent, lithotine, is flowed across the entire stone to saturate the image. A soft cloth is used to gently massage the drawn areas, releasing the binders and pigment from the surface. Since the fats have penetrated the structure of the stone and the gum stencil is insoluble in lithotine, they are not affected by the washout. The dried stone presents only the faintest image of the artist's work; with the pigment washed out, only the almost colorless grease remains.

The apparent loss of one's hard work is, however, only temporary. Asphaltum, a tarlike residue obtained from petroleum refining, is diluted with lithotine to a viscosity like that of low-weight motor oil. A few ounces are rubbed gently into the stone. The gum stencil protects the nonimage areas, while the greasy drawing comprising the image greedily absorbs the asphaltum. This important operation succeeds in establishing an ink base for printing. After drying, the asphaltum is water-washed from the stone; that is, water removes the asphaltum from the undrawn areas. The asphaltum-laden image is not affected by this washing since it is greasy by nature.

After the stone is dried, it is ready for the initial roll-up, or inking. The purpose of the roll-up is to ink the image to "full strength;" that is, to raise it to the tonal intensity of the artist's original on-stone image. The stone is kept damp with an almost imperceptible film of water. The gum stencil will receive and hold the water, thereby protecting the nonimage areas from the greasy printing ink. A stiff ink having the viscosity of paste shoe polish is spread in a 1″ × 12″ bead on an inking slab. A leather-covered, rolling pin-type inking roller is used to spread the ink out onto the slab. As the ink is spread, the roller becomes "charged" with an even layer of ink. The artist or printer returns to deposit a very thin layer of ink on the image by slowly and with moderate pressure passing the roller across the stone. The stone is then wiped with a lightly wetted sponge to refreshen the evaporating water film so that it can continue to protect the nonimage areas. The roller is recharged with ink and passed over the stone again. The roll-up continues with alternating applications of ink and water until the image is fully charged with ink. Only when the image is determined to be at full strength is the stone set aside to dry.

When the stone is completely dry, perhaps after sitting undisturbed overnight, it is ready to receive a second etch. This etch is referred to as the stabilizing etch because it reinforces both the design and the gum stencil to a printing-ready state. The procedure is the same as that of the first etch, except the etching solutions have their acid content reduced by about one-half. The second etch completes the process of preparing the stone for printing.

The printing process is begun by readying the hand-operated lithographic press. In principle, this press employs sliding pressure to transfer ink from the charged image to the paper. The inked stone with mounted printing paper is passed beneath the pressure-bearing scraper bar and a contact transfer is effected.

Simply, the lithographic press consists of a press bed and scraper. The press bed is a movable, horizontal platform on which the stone is centered for printing. The scraper is a stationary structure that spans the width of the press in such a manner that the press bed can pass beneath it much like a river beneath a bridge. A height-adjustable, press-wide beam is housed in the structure. Into the underside of the beam, or scraper box, a 1″ × 4″ bar of wood, the scraper bar, can be inserted. The scraper bar is locked into the beam so that the 1-inch edge is slightly exposed. The exposed edge is fashioned with a leather strap.

LITHOGRAPHIC PRESS

First, the stone is centered on the press bed. Through a system of gears and a hand crank, the bed is driven beneath the scraper until the stone's leading 1 inch is directly beneath the scraper bar. A ¼-inch thick, rectangular sheet of fiberglass called a tympan is placed over the stone, and the scraper box is lowered until the scraper bar contacts the tympan. A pressure lever on the scraper increases the contact pressure between the scraper bar and the tympan-covered stone. The scraper box is now locked into place, and a mark is placed on the press bed to indicate the distance the bed must travel to position the leading edge of the stone safely beneath the scraper bar. The pressure lever is released, and the bed is advanced until the trailing edge of the stone is beneath the scraper bar. This point is similarly marked, and the bed is backed out from beneath the scraper.

At this point the amount of pressure that will cause the transfer of ink to the printing paper has been adjusted. The extent of the stone has been marked on the press bed. If this were not done, the printer might inadvertently drive the stone out from under the scraper, whereupon the downward pressure of the bar might cause the stone to break or become otherwise seriously damaged. A specially formulated lithographic grease with the consistency of petroleum jelly is now used to lubricate the leather covering of the scraper bar and the tympan sheet. The tympan will protect the stone and printing paper and facilitate their passage under the pressurizing scraper bar.

6747. Winter Sports - Pickerel Fishing.

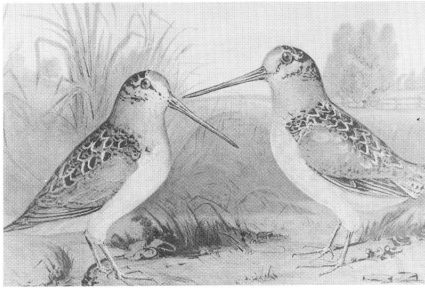

6771. Woodcock / Scolopax Minor.

6802. The Yacht "Henrietta" of N.Y. 205 Tons.

6839. Young Blood in an Old Body.

864. Caught on the Fly.

2856. Home from the Brook.

The artist next measures and tears the printing paper selected to receive the image. Registration, or positioning marks, are scratched into the stone's surface so that the image will have the same relative position for each successive printing. At this point, the proofing and edition printing can begin.

Recall that the stone was left with a fully inked and stabilized image as a result of the roll-up following the second etch. The initial printing operation requires the re-establishment of an ink-ready base for the image. This necessitates a washout of the roll-up ink with the lithotine solvent and a subsequent application of asphaltum in the same manner as before. After the asphaltum is washed from the nonimage areas, the artist or printer returns to the inking slab, recharges the inking roller, and begins to develop the image to printable strength. Water wipings and ink applications are again performed. The alternating spongings that deposit a thin film of water on the stone are most important. Water, which is kept from being absorbed by the porous stone as a result of the gum stencil, is the ink-rejecting agent that prevents the grease-laden ink from sticking to the nonimage areas. If the stone is accidentally permitted to dry, subsequent passes of an ink-charged roller would deposit ink over both the image and (now unprotected) nonimage areas, thereby ruining the artist's work.

When the image is "up to strength," the printing paper is carefully positioned on the stone in accordance with the registration marks. The tympan is placed over the stone, and the press bed is advanced to the mark indicating the leading edge of the stone. The scraper box is now lowered, and the pressure lever is drawn down to effect a very firm contact between the scraper bar and the tympan. The gears of the press are engaged, and the bed is driven forward, stopping at the mark indicating the end of the stone. The first proof has been pulled. The press bed is backed out and the tympan is removed, exposing the print, which is carefully pealed from the stone. The stone is immediately refreshened with water. The artist inspects the result and sets the print aside to dry completely. To produce additional prints, the steps of wetting, recharging, and pulling are repeated. On completion of the last print, the stone is fully recharged with ink and covered with a protective film of gum arabic that is buffed dry. The stone can be set aside until more prints are desired.

6

Best Fifty Prints: A Consensus

The year was 1932. "The jury was made up of twelve discriminating collectors whose studies and wide experience made them eminently qualified for the task," (Conningham, p.xvii). The idea belonged to Harry S. Newman of the Old Print Shop, New York. The task was to determine which large folio lithographs published under the imprints of N. Currier and Currier & Ives comprised the "Best Fifty" group. Individual lists submitted by these select jurors itemized their nominees for this group. The results were tabulated. *Husking,* after Eastman Johnson, led a list that truly presented a panorama of both the oeuvre of the firms and the American scene in the second half of the nineteenth century.

During January and February, 1933, the *New York Sun* published an illustration of each of the "Best Fifty" large folio prints. Later that year, Newman published *Best Fifty Currier & Ives Prints, Large Folio Size.* This book contained reproductions of each print selected with additional description. The "Best Fifty" large folio prints met with such enormous success that the jury was reconvened, and a year later Newman published a book presenting the "Best Fifty" small folio prints (including four that are medium folio size).

Best Fifty Large Folio Prints

No.	Title	Con'ham No.
1	*Husking*	3008
2	*American Forest Scene* / Maple Sugaring	157
3	*Central Park, Winter* / The Skating Pond	954
4	*Home to Thanksgiving*	2882
5	*Life of a Hunter* / A Tight Fix	3522
6	*Life on the Prairie* / The "Buffalo Hunt"	3527
7	*"Lightning Express" Trains* / "Leaving the Junction"	3535
8	*Peytona and Fashion* / In their great match...	4763
9	*Rocky Mountains, The* / Emigrants Crossing the Plains	5196
10	*Trolling for Blue Fish*	6158
11	*Whale Fishery, The* / The Sperm Whale in a Flurry	6627
12	*Winter in the Country* / The Old Grist Mill	6738
13	*American Farm Scenes* / No. 4 (Winter)	136
14	*American National Game of Baseball, The*	180

Best Fifty Small Folio Prints

7

Value Guide to Currier & Ives Prints

1	**AARON CLARK**	S	225
2	**ABBEY, THE**	VS	50
3	**ABBEY OF CLARE GALWAY, THE**	S	40
4	**ABBEY OF THE HOLY CROSS, THE**	S	40
5	**ABBOTTSFORD (sic)** / The Seat of Sir Walter Scott	M	115
6-9	**ABIGAIL**	S	50
10	**ABORIGINAL / PORTFOLIO, THE**	S	85
11	**ABRAHAM LINCOLN**	L	200
12	**ABRAHAM LINCOLN** / Assassinated April 14th, 1865	M	175
13	**ABRAHAM LINCOLN** / Sixteenth President of the U. S.	S	175
14	**ABRAHAM LINCOLN** / Sixteenth President of the U. S.	S	90
15	**ABRAHAM LINCOLN** / Sixteenth President of the U. S.	S	85
16	**ABRAHAM LINCOLN** / Sixteenth President of the U. S.	S	85
17	**ABRAHAM LINCOLN** / Sixteenth President of the U. S.	S	90
18	**ABRAHAM LINCOLN** / Sixteenth President of the U. S.	S	85
19	**ABRAHAM LINCOLN** / Sixteenth President of the U. S.	S	85
20	**ABRAHAM LINCOLN** / Sixteenth President of the U. S.	S	225
21	**ABRAHAM LINCOLN** / Sixteenth President of the U. S.	S	90
22	**ABRAHAM LINCOLN** / Sixteenth President of the U. S.	S	90
23	**ABRAHAM LINCOLN** / The Martyr President	L	200
24	**ABRAHAM LINCOLN** / The Martyr President (Koehler publ)	L	175
25	**ABRAHAM LINCOLN** / The Martyr President	M	145
26	**ABRAHAM LINCOLN** / The Nation's Martyr	S	95
27	**ABRAHAM LINCOLN** / The Nation's Martyr	S	95
28	**ABRAHAM LINCOLN** / The Nation's Martyr	L	200
29	**ABRAHAM'S DREAM!** / "Coming events cast...shadows..."	S	100
30	**ACADEMY WALTZ**	S	85
31	**ACCEPTED, THE**	S	50
32	**ACCOMMODATION TRAIN, THE**	S	170
33	**ACROSS THE CONTINENT** / "Westward the Course of Empire"	L	10700
34	**ACTRESS, THE**	S	55
35	**ADA**	S	50
36	**ADAM AND EVE DRIVEN OUT OF PARADISE**	S	75
37	**ADAM AND EVE DRIVEN OUT OF PARADISE**	S	75
38	**ADAM AND EVE IN THE GARDEN OF EDEN**	S	80
39	**ADAM NAMING THE CREATURES**	S	75
40	**ADAMS EXPRESS CO., THE**	L	6500
41	**ADELAIDE**	S	45
42	**ADELAIDE**	S	45
43-48	**ADELINE**	S	45
49	**ADIEU AT FONTAIN-BLEAU**	L	175
50	**ADMIRAL FARRAGUT'S FLEET ENGAGING THE REBEL BATTERIES**	S	265
51	**ADMIRAL PORTER'S FLEET RUNNING THE REBEL BLOCKADE**	S	275
52	**AESTHETIC CRAZE, THE**	S	200
53	**AFFAIR OF HONOR, AN** — The Critical Moment	S	180
54	**AFFAIR OF HONOR, AN** — A Stray Shot	S	180
55	**AFRICA**	S	65
56	**AFRICA**	S	60
57	**AFRICAN JUNGLE, THE** / (Puzzle print)	S	300

58	AFTER MARRIAGE / Experience	L	125
59	AFTER THE BATH	S	60
60	AGE OF BRASS, THE / ...triumphs of Women's rights	S	240
61	AGE OF IRON, THE / Man as he expects to be	S	240
62	AGNES	S	55
63	AGNES	S	55
64	AGNES	S	60
65	A. GOLDSMITH'S B.G. DRIVER, BY VOLUNTEER	S	265
66	AGRICULTURAL HALL / Grand United States Centennial...	S	100
67	AGRICULTURAL SOCIETY, THE / Awarded this Diploma	M	125
68	AHEAD OF THE WORLD / Great Amer. Four Track Railroad	L	15000
69	AIN'T I SOME	S	165
70	AIN'T THEY CUNNING?	S	65
71	ALABAMA STATE MARCH, THE	S	75
72	ALARM, THE	S	275
73	ALEXANDER	S	90
74	ALICE	S	55
75	ALICE	S	55
76	ALICE	S	55
77	ALL BROKE UP	S	200
78	"ALL HAIL THE POWER OF CHRIST'S NAME"	S	25
79	ALL NICE AND HOT	S	135
80	ALL PRIMED	S	75
81	ALL RIGHT!	S	100
82	ALL SO TIRED	S	55
83	ALL THE WORLD IS SCHEMING	S	60
84	ALL WRONG	S	100
85	ALMIRA	S	50
86	ALMIRA	S	60
87	ALNWICK CASTLE, SCOTLAND	M	110
88	ALONZO AND CORA / Destruction of the Temple...	S	95
89	AMANDA	S	55
90	AMANDA	S	55
91	AMANDA	S	55
92	AMATEUR MUSCLE IN THE SHELL	M	250
93	AMATEUR MUSCLE IN THE SHELL	S	185
94	AMATEUR MUSCLE IN THE SHELL	VS	65
95	AMBUSCADE, THE	M	1250
96	AMELIA	S	55
97	AMELIA	S	65
98	AMELIA	S	60
99	AMELIA	S	65
100	AMELIA	S	65
101	AMELIA	S	55
102	AMERICA	S	65
103	AMERICA	S	65
104	AMERICA	S	75
105	AMERICAN AUTUMN FRUITS	S	145
106	AMERICAN AUTUMN FRUITS	L	750
107	AMERICAN BEAUTY, THE	S	45
108	AMERICAN BROOK TROUT	S	300
109	AMERICAN BUFFALOES	S	300
110	AMERICAN CHAMPION, THE / Yacht "Puritan"	S	300
111	AMERICAN CHOICE FRUITS	L	665
112	AMERICAN CHOICE FRUITS	L	665
113	AMERICAN CLIPPER SHIP, AN / Off Sandy Hook...	S	825
114	AMERICAN CLIPPER SHIP *BREWER* 4TH SHIP, THE	S	1700
115	AMERICAN CLIPPER SHIP *WITCH OF THE WAVE*, THE	S	950
116	AMERICAN CLUB HUNT / Halt on the Scent	S	190
117	AMERICAN CLUB HUNT / Taking a Header	S	190
118	AMERICAN COAST SCENE / Desert Rock Light House	S	285
119	AMERICAN COAST SCENE / Desert Rock Light House	L	1975
120	AMERICAN COTTAGE NO. 1	VS	115
121	AMERICAN COUNTRY LIFE / May Morning	L	900
122	AMERICAN COUNTRY LIFE / October Afternoon	L	1000
123	AMERICAN COUNTRY LIFE / Pleasures of Winter	L	1600
124	AMERICAN COUNTRY LIFE / Summer's Evening	L	900
125	AMERICAN DEAD GAME	L	850
126	AMERICAN ECLIPSE	S	225
127	AMERICAN ECLIPSE / The Celebrated Race Horse...	S	225
128	AMERICAN EXPRESS TRAIN	S	1035
129	AMERICAN "EXPRESS" TRAIN	L	8200
130	AMERICAN EXPRESS TRAIN	L	8500
131	AMERICAN FARM LIFE	M	450
132	AMERICAN FARM SCENE, AN / In the Olden Time	S	200
133	AMERICAN FARM SCENES / No. 3 (Autumn)	L	1650
134	AMERICAN FARM SCENES / No. 1 (Spring)	L	1800
135	AMERICAN FARM SCENES / No. 2 (Summer)	L	1650
136	AMERICAN FARM SCENES / No. 4 (Winter)	L	2825
137	AMERICAN FARM, WINTER see c3438	VS	—
138	AMERICAN FARM YARD— EVENING	L	950

139	**AMERICAN FARM YARD— MORNING**	L	875
140	**AMERICAN FEATHERED GAME** / Mallard and Canvas Back Ducks	M	425
141	**AMERICAN FEATHERED GAME** / Mallard and Canvas Back Ducks	M	450
142	**AMERICAN FEATHERED GAME** / Partridges	M	425
143	**AMERICAN FEATHERED GAME** / Partridges	M	425
144	**AMERICAN FEATHERED GAME** / Wood Duck and Golden Eye	M	400
145	**AMERICAN FEATHERED GAME** / Wood Duck and Golden Eye	M	400
146	**AMERICAN FEATHERED GAME** / Woodcock and Snipe	M	420
147	**AMERICAN FEATHERED GAME** / Woodcock and Snipe	M	420
148	**AMERICAN FIELD SPORTS** / "A Chance for Both Barrels"	L	2100
149	**AMERICAN FIELD SPORTS** / "Flush'd"	L	2400
150	**AMERICAN FIELD SPORTS** / "On a Point"	L	2250
151	**AMERICAN FIELD SPORTS** / "Retrieving"	L	2250
152	**AMERICAN FIREMAN, THE** / Always Ready	M	925
153	**AMERICAN FIREMAN, THE** / Facing the Enemy	M	1000
154	**AMERICAN FIREMAN, THE** / Prompt to the Rescue	M	925
155	**AMERICAN FIREMAN, THE** / Rushing to the Conflict	M	950
156	**AMERICAN FOREST GAME**	L	900
157	**AMERICAN FOREST SCENE** / Maple Sugaring	L	6000
158	**AMERICAN FRONTIER LIFE** / "The Hunter's Strategem"	L	3600
159	**AMERICAN FRONTIER LIFE** / On the War Path	L	3775
160	**AMERICAN FRUIT PIECE**	S	150
161	**AMERICAN FRUIT PIECE**	L	1650
162	**AMERICAN FRUITS**	S	135
163	**AMERICAN GAME**	L	850
164	**AMERICAN GAME FISH**	L	765
165	**AMERICAN GIRL** / By Amos' Cassius M. Clay, Jr....	S	235
166	**AMERICAN GIRL** / Record 2:16½	S	250
167	**AMERICAN GIRL AND LADY THORN** / In their great match	L	1250
168	**AMERICAN HOMESTEAD — AUTUMN**	S	385
169	**AMERICAN HOMESTEAD — AUTUMN**	S	500
170	**AMERICAN HOMESTEAD — SPRING**	S	325
171	**AMERICAN HOMESTEAD — SUMMER**	S	345
172	**AMERICAN HOMESTEAD — WINTER**	S	665
173	**AMERICAN HUNTING SCENES** / "An Early Start"	L	3200
174	**AMERICAN HUNTING SCENES** / "A Good Chance"	L	3200
175	**AMERICAN JOCKEY CLUB RACES, JEROME PARK**	L	1995
176	**AMERICAN LANDSCAPE** / Early Morning	L	725
177	**AMERICAN LANDSCAPE** / Sacandaga Creek	VS	70
178	**AMERICAN LANDSCAPES** (4 views on one sheet)	S	160
179	**AMERICAN MOUNTAIN SCENERY**	M	450
180	**AMERICAN NATIONAL GAME OF BASEBALL, THE**	L	10750
181	**AMERICAN PATRIOT'S DREAM** / The Night before the battle	M	185
182	**AMERICAN PRIVATEER "GENERAL ARMSTRONG"**...	S	550
183	**AMERICAN PRIZE FRUIT**	L	1475
184	**AMERICAN PRIZE FRUIT** / #736	S	145
185	**AMERICAN RAILROAD SCENE** / Lightning Express Trains...	L	9000
186	**AMERICAN RAILROAD SCENE** / Tickets to all points West	L	8550
187	**AMERICAN RAILROAD SCENE** / Snowbound	S	1850
188	**AMERICAN RAILROAD SCENE** / Snowbound	S	1850
189	**AMERICAN RAILWAY SCENE, AT HORNELLSVILLE, ERIE R.R.**	L	7950
190	**AMERICAN RIVER SCENERY** / View on the Androscoggin	M	465
191	**AMERICAN SCENERY** / Palenville, N.Y.	S	145
192	**AMERICAN SHIP RESCUING THE OFFICERS AND CREW**...	M	535
193	**AMERICAN SLOOP YACHT MAYFLOWER**	L	675
194	**AMERICAN SLOOP YACHT "VOLUNTEER"**	L	800
195	**AMERICAN SPECKLED BROOK TROUT**	L	975
196	**AMERICAN STEAM BOATS ON THE HUDSON**	L	1775

351	BALLYNAHINCH / Ireland	S	80
352	BALTIMORE BAKERY / Thomas Richie & Co	M	190
353	BALTIMORE CLIPPER / Laying to	S	1225
354	BALTIMORE IN 1880	S	345
355	BALTIMORE ORIOLE	VS	75
356	BANKS OF DOON, THE / Burn's Monument	M	120
357	BAPTISM OF CHRIST	S	25
358	BAPTISM OF JESUS CHRIST	S	25
359	BAPTISM OF JESUS CHRIST	S	25
360	BAPTISM OF JESUS CHRIST	L	45
361	BAPTISM OF POCAHONTAS, THE	S	70
362	BAPTISMAL CERTIFICATE	S	40
363	BARBER, THE	S	140
364	BARD, THE / By Longfellow, dam Bradamante...	S	255
365	BARE CHANCE, A	S	175
366	BARE CHANCE, A	VS	80
367	BAREFACED CHEEK	S	200
368	BAREFOOT BOY, THE	S	110
369	BAREFOOT BOY, THE	S	110
370	BAREFOOT GIRL, THE	S	95
371	BARK "THEOXENA", THE / 3rd Ship...Austrian...Line	L	2400
372	BARON'S CASTLE, THE	S	75
373	BARSQUALDI'S STATUE / Liberty Frightening the World	S	225
374	BASE HIT, A	S	325
375	BASS FISHING / At Macomb's Dam, Harlem River, N.Y.	L	1475
376	BASS FISHING	S	525
377	BATTERY, NEW YORK, THE / By Moonlight	S	450
378	BATTLE AT BUNKER'S HILL / Fought June 17th, 1775	S	250
379	BATTLE AT BUNKER'S HILL / Fought June 17th, 1775	S	250
380	BATTLE AT CEDAR MOUNTAIN, AUG. 9TH, 1862, THE	S	170
381	BATTLE AT CEDAR MOUNTAIN, AUG. 9TH, 1862, THE	S	170
382	BATTLE OF FIVE FORKS, VA. / April 1st, 1865, THE	S	160
383	BATTLE OF MISSIONARY RIDGE, GA., THE	S	150
384	BATTLE OF ANTIETAM, MD., SEPT. 17th, 1862, THE	S	160
385	BATTLE OF BATON ROUGE, LA., AUG. 4th, 1862, THE	S	200
386	BATTLE OF BENTONVILLE, N.C., THE / March 19th, 1865	S	150
387	BATTLE OF BOONVILLE—THE GREAT MISSOURI "LYON" HUNT	M	200
388	BATTLE OF BUNKER'S HILL / Fought June 17th, 1775	S	250
389	BATTLE OF BUENA VISTA / Fought Feby. 23rd, 1847	S	115
390	BATTLE OF BUENA VISTA / Fought Feby. 23rd, 1847	S	140
391	BATTLE OF BULL RUN, VA., JULY 21st, 1861	S	185
392	BATTLE OF CEDAR CREEK, VA., OCT. 19th, 1864, THE	S	160
393	BATTLE OF CERRO GORDO, APRIL 18th, 1847	S	140
394	BATTLE OF CHAMPION HILLS, MISS., MAY 16th, 1863, THE	S	155
395	BATTLE OF CHANCELLORSVILLE, VA., MAY 3rd, 1863	S	165
396	BATTLE OF CHATTANOOGA, TENN., NOVR. 24-25th, 1863	S	170
397	BATTLE OF CHICKAMAUGA, GEO, THE	S	170
398	BATTLE OF CHURUBUSCO	S	125
399	BATTLE OF CLONTARF, A.D. 1014, THE / Ireland	S	60
400	BATTLE OF COAL HARBOR, VA., JUNE 1st, 1864	S	160
401	BATTLE OF CORINTH, MISS., OCT. 4th, 1862	S	145
402	BATTLE OF FAIR OAKS, VA., MAY 31st, 1862, THE	S	205
403	BATTLE OF FAIR OAKS, VA., MAY 31st, 1862, THE	L	700
404	BATTLE OF FORT DOUGLAS (Arkansas)	S	150
405	BATTLE OF FREDRICKSBURG, VA., DECR. 13th, 1862	S	160
406	BATTLE OF GETTYSBURG, PA., JULY 3rd, 1863, THE	L	750
407	BATTLE OF GETTYSBURG, PA., JULY 3rd, 1863, THE	S	185
408	BATTLE OF JONESBORO, GEORGIA, SEPT. 1st, 1864, THE	S	175
409	BATTLE OF LEXINGTON, KY., 1861, THE	S	160
410	BATTLE OF MALVERN HILL, VA., JULY 1st, 1862, THE	S	160
411	BATTLE OF MEXICO, THE	S	145
412	BATTLE OF MILL SPRING, KY., JAN. 19th, 1862	S	170
413	BATTLE OF MILL SPRING, KY., JAN. 19th, 1862	S	160
414	BATTLE OF MONTEREY	S	135
415	BATTLE OF MURFREESBORO, TENN., DEC. 31st, 1862	L	695

416	BATTLE OF NEW ORLEANS FOUGHT JANY. 8th, 1815, THE	S	145
417	BATTLE OF NEW ORLEANS FOUGHT JANY. 8th, 1815, THE	S	145
418	BATTLE OF NEW ORLEANS FOUGHT JANY. 8th, 1815, THE	S	145
419	BATTLE OF NEWBURN, N.C., MARCH 14th, 1862	S	150
420	BATTLE OF PEA RIDGE, ARKANSAS, MARCH 8th, 1862	S	160
421	BATTLE OF PEA RIDGE, ARKANSAS, MARCH 8th, 1962, THE	L	650
422	BATTLE OF PETERSBURG, VA., APRIL 2nd, 1865, THE	S	160
423	BATTLE OF PITTSBURGH, TENN., APRIL 7th, 1862, THE	S	150
424	BATTLE OF PITTSBURGH, TENN., APRIL 7th, 1862, THE	S	150
425	BATTLE OF PITTSBURGH, TENN., APRIL 7th, 1862, THE	L	725
426	BATTLE OF RESACA DE LA PALMA, MAY 9th, 1846	S	115
427	BATTLE OF SACREMENTO, THE / Fought Feb. 28th, 1847	S	135
428	BATTLE OF SACREMENTO, THE / Fought Feb. 28th, 1847	S	135
429	BATTLE OF SHARPSBURG, MD., SEPT. 16th, 1862, THE	S	160
430	BATTLE OF SPOTTSYLVANIA, VA., MAY 12th, 1864, THE	S	175
431	BATTLE OF THE BOYNE / July 1st, 1690	S	40
432	BATTLE OF THE GIANTS / Buffalo Bulls...	S	1200
433	BATTLE OF THE KINGS	L	1425
434	BATTLE OF THE KINGS	L	1425
435	BATTLE OF THE WILDERNESS, VA., MAY 5th & 6th, 1864	L	675
436	BATTLE OF THE WILDERNESS, VA., MAY 5th & 6th, 1864	S	160
437	BATTLE OF WATERLOO, JUNE 18th, 1815	S	120
438	BATTLE OF WILLIAMSBURG, VA., MAY 5th, 1862	S	160
439	BATTLE OF WILLIAMSBURG, VA., MAY 5th, 1862, THE	L	700
440	BAY GELDING ALLEY, BY VOLUNTEER / Record 2:19	S	380
441	BAY GELDING FRANK BY PATHFINDER 2nd	S	275
442	BAY OF ANNAPOLIS, THE / Nova Scotia	S	150
443	BAY STALLION HAMBRINO, BY EDWARD EVERETT	S	310
444	BE NOT WISE IN THINE OWN EYES	S	35
445	BEACH SNIPE SHOOTING	M	1600
446	BEAR HUNTING / Close Quarters (little "Tight Fix")	S	720
447	BEAR HUNTING / Close Quarters	S	400
448	BEATRICE CENCI	S	35
449	BEAU AWAKE	S	50
450	BEAUTIES OF THE BILLIARDS, THE / "A Carom..."	L	500
451	BEAUTIES OF THE BALLET	S	55
452	BEAUTIFUL BLONDE	M	70
453	BEAUTIFUL BRUNETTE	S	65
454	BEAUTIFUL DREAMER	S	60
455	BEAUTIFUL EMPRESS, THE	S	40
456	BEAUTIFUL PAIR, A	S	85
457	BEAUTIFUL PERSIAN, THE / #112	S	65
458	BEAUTIFUL PERSIAN, THE	S	65
459	BEAUTIFUL QUADROON, THE	S	40
460	BEAUTY ASLEEP	S	60
461	BEAUTY AWAKE	S	60
462	BEAUTY OF NEW ENGLAND	S	50
463	BEAUTY OF THE ATLANTIC	S	55
464	BEAUTY OF THE ATLANTIC	S	60
465	BEAUTY OF THE MISSISSIPPI	S	50
466	BEAUTY OF THE NORTH, THE	L	75
467	BEAUTY OF THE NORTH WEST	M	65
468	BEAUTY OF THE PACIFIC, THE	S	50
469	BEAUTY OF THE RHINE	S	45
470	BEAUTY OF THE SOUTH, THE	S	60
471	BEAUTY OF THE SOUTH, THE	L	75
472	BEAUTY OF THE SOUTH WEST	S	50
473	BEAUTY OF VIRGINIA	S	50
474	BED TIME	S	45
475	BEFORE MARRIAGE / Anticipation	L	125
476	BEG SIR!	S	50
477	BEGGING A BITE	S	60
478	BEGGING A CRUST	S	70
479	BEHOLD! HOW BRIGHTLY BREAKS THE MORNING	S	60
480	BELGIAN ROYAL & U.S. MAIL STEAMER / Westernland	S	200
481	BELGIAN ROYAL & U.S. MAIL STEAMER / Noordland	S	200
482	BELIEVER'S VISION, THE	M	30
483	BELIEVER'S VISION, THE	S	25
484	BELL RINGERS, THE	S	70
485	BELLA / By Rysdyk's Hambletonian...	S	295
486	BELLE HAMLIN	S	285
487	BELLE HAMLIN AND JUSTINA DRIVEN BY J.C. HAMLIN	S	285
488	BELLE OF CHICAGO, THE	S	55

489	BELLE OF NEW YORK, THE	S	60
490	BELLE OF NEW YORK, THE / #446	S	70
490A	BELLE OF SARATOGA, THE	M	70
491	BELLE OF THE EAST / #466	S	65
492	BELLE OF THE EAST	M	75
493	BELLE OF THE SEA	S	50
494	BELLE OF THE WEST, THE	S	65
495	BELLE OF THE WINTER, THE	M	350
496	BELL-Y PUNCH, THE / The conductor...collects a fare	S	200
497	BELTED WILL'S TOWER— NAWORTH, IRELAND	S	35
498	BENDING HER BEAU	S	165
499	BENJAMIN FRANKLIN / The Statesman and Philosopher	S	375
500	BENJA. FRANKLIN	S	125
501	BESSIE	S	45
502	BEST HORSE, THE	S	90
503	BEST IN THE MARKET, THE	S	75
504	BEST IN THE MARKET, THE	S	75
505	BEST LIKENESS, THE	M	130
506	BEST SCHOLAR, THE	S	55
507	BEST TIME ON RECORD, THREE HEATS...	S	375
508	BETHESDA FOUNDATION / Central Park, N.Y.	S	165
509	BETROTHED, THE	S	55
510	BETROTHED, THE / #506	S	55
511	BETWEEN TWO FIRES	S	210
512	BETWEEN TWO FIRES	VS	100
513	BEWILDERED HUNTER, THE / "Puzzle Picture"	S	325
514	BEWILDERED HUNTER, THE / "Puzzle Picture"	S	325
515	B.F. PROCTOR	S	45
516	B.F. PROCTOR	S	45
517	BIBLE AND TEMPERANCE, THE	S	120
518	BIBLE AND TEMPERANCE, THE	S	120
519	BIBLE AND TEMPERANCE, THE	S	120
520	BIBLE AND TEMPERANCE, THE	S	120
521	BIG THING ON ICE, A	M	285
522	BILLIARDS—"A DOUBLE CAROM"	S	250
523	BILLIARDS—"FROZE TOGETHER"	S	250
524	BILLIARDS—"PLAYED OUT"	S	250
525	BILLY EDWARDS / Light Weight Champion of the World	M	285
526	BIRD TO BET ON, THE	S	75
527	BIRDIE AND PET	VS	110
528	BIRD'S EYE VIEW OF / Mount Vernon	M	315

529	BIRD'S EYE VIEW OF PHILADELPHIA	S	275
530	BIRD'S EYE VIEW OF THE CENTENNIAL EXHIBITION BUILDINGS	S	225
531	BIRD'S EYE VIEW OF THE CITY OF NEW YORK	VS	135
532	BIRD'S EYE VIEW OF THE PAUPER LUNATIC ASYLUM	S	115
533	BIRD'S NEST, THE	S	45
534	BIRTH OF OUR SAVIOR, THE	S	25
535	BIRTH OF OUR SAVIOR, THE	S	25
536	BIRTHPLACE OF GENL. FRANKLIN PIERCE / Hillsboro, N.H.	S	150
537	BIRTHPLACE OF HENRY CLAY / Hanover County, Virginia	S	150
538	BIRTHPLACE OF SHAKESPEARE, THE / Stratford on Avon	M	150
539	BIRTHPLACE OF WASHINGTON, THE / At Bridge's Creek...	S	290
540	BITE ALL AROUND, A	S	80
541	BITE ALL AROUND, A	VS	70
542	BITING LIVELY!	S	250
543	BLACK BASS SPEARING, / On the Restigouche, N.B.	M	1400
544	BISHOP ALLEN OF THE AFRICAN CHURCH	S	20
545	BLACK BLONDE, THE	S	40
546	BLACK CLOUD / By Ashland Chief, dam by Capt. Walker	S	265
547	BLACK DUCK SHOOTING	S	220
548	BLACK DUCK SHOOTING	VS	105
549	BLACK EYED BEAUTY, THE	S	45
550	BLACK EYED SUSAN	S	65
551	BLACK EYED SUSAN / #102	S	175
552	BLACK EYED SUSAN	S	50
553	BLACK EYED SUSAN	S	50
554	BLACK GELDING FRANK, BY PATHFINDER 2nd, THE	S	275
555	BLACK HAWK / Union Course, L.I., Tuesday, Sept. 25	M	1025
556	BLACK HAWK AND JENNY LIND / Union Course, L.I....	L	1190
557	BLACK ROCK CASTLE / Cork River, Ireland	S	55
558	BLACK PERSIAN, THE	S	50
559	BLACK SQUALL, A	S	205
560	BLACKBERRY DELL	M	275
561	BLACKFISH NIBBLE, A. / Hush! I Feel him!—Golly!	S	235
562	BLACKWELLS ISLAND, EAST RIVER / Eighty Sixth St.	M	730
563	BLACKWOOD, JR. / Black Stallion by Blackwood...	S	255

564	BLARNEY CASTLE / County Cork	S	65
565	BLESSED SHEPARDESS, THE	S	25
566	BLESSED SHEPARDESS, THE	S	25
567	BLESSED VIRGIN MARY	S	25
568	BLESSING OF A WIFE, THE	S	80
569	BLESSING OF LIBERTY, THE	S	75
570	BLOCKADE ON THE "CONNECTICUT PLAN," THE	S	150
571	BLOOD WILL TELL	S	190
572	BLOOD WILL TELL	VS	85
573	BLOOMER COSTUME, THE	S	165
574	BLOOMER COSTUME, THE / #645	S	185
575	BLOWER / King of the Road	S	250
576	BLUE EYED BEAUTY	S	55
577	BLUE EYED MARY	S	50
578	BLUE FISHING	S	450
579	BLUE MONDAY	S	150
580	BOATSWAIN, THE	S	95
581	BODINE / The Trotting Whirlwind of the West	S	365
582	BODY OF GEN. ROBERT E. LEE LYING IN STATE, THE	S	75
583	BODY OF HIS HOLINESS POPE PIUS IX	S	25
584	BODY OF THE MARTYR PRESIDENT, ABRAHAM LINCOLN	S	85
585	BODY OF THE MOST REV. ARCHBISHOP HUGHES...	S	25
586	BODY OF THE MOST REVD ARCHBISHOP HUGHES...	S	25
587	BOLTED!	S	185
588	BOLTED!	VS	85
589	BOMBARDMENT AND CAPTURE OF FORT FISHER, N.C.	S	290
590	BOMBARDMENT AND CAPTURE OF FORT HENRY, TENN.	S	245
591	BOMBARDMENT AND CAPTURE OF FORT HINDMAN, ARK.	S	200
592	BOMBARDMENT AND CAPTURE OF FREDERICKSBURG, VA.	S	180
593	BOMBARDMENT AND CAPTURE OF ISLAND "NUMBER TEN"	L	725
594	BOMBARDMENT AND CAPTURE OF THE FORTS AT HATTERAS INLET	S	250
595	BOMBARDMENT OF FORT PULASKI COCKSPUR ISLAND, GEO...	S	175
596	BOMBARDMENT OF FORT SUMTER, CHARLESTOWN HARBOR	S	210
597	BOMBARDMENT OF FORT SUMTER, CHARLESTOWN HARBOR	S	210
598	BOMBARDMENT OF ISLAND "NUMBER TEN" IN THE MISSISSIPPI RIVER	S	255
599	BOMBARDMENT OF SEBASTOPOL	S	135
600	BOMBARDMENT OF TRIPOLI / August 1804	S	300
601	BOMBARDMENT OF VERA CRUZ / March 25th, 1847	S	170
602	BOMBARDMENT OF VERA CRUZ / March 25th, 1847	S	150
603	BONEFACED CHEEK	S	70
604	BONESETTER / By the Brook's Horse...	S	295
605	BONESETTER RECORD 2:19	VS	65
606	"BONNIE" YOUNG CHIEFTAIN, THE	M	90
607	BONNINGTON LINN	VS	85
608	BOOMERANG, A	S	160
609	BOQUET OF FRUIT, A	S	75
610	BOQUET, THE	S	75
611	BOQUET OF ROSES	S	75
612	BOSS HORSE, THE — Driven by the King Pin	S	200
613	BOSS OF THE MARKET, THE	S	160
614	BOSS OF THE RING, THE	S	185
615	BOSS OF THE ROAD, THE	S	225
616	BOSS OF THE ROAD, THE	VS	70
617	BOSS OF THE ROAD, THE	S	225
618	BOSS OF THE ROAD, THE	L	365
619	BOSS OF THE TRACK, THE	S	225
620	BOSS ROOSTER, DE	S	205
621	BOSS STATE CARRIER, THE	S	125
622	BOSS TEAM, THE / Deadwood and Swiggler	S	200
623	BOSTON HARBOR / The Rocky Point of Boston	S	235
624	BOTHWELL BRIDGE ON THE CLYDE	M	110
625	BOTHWELL CASTLE ON THE CLYDE	M	110
626	BOTHWELL CASTLE ON THE CLYDE see c607	VS	—
627	BOUND DOWN THE RIVER	S	425
628	BOUND TO HEAR BEECHER	S	120
629	BOUND TO HEAR BEECHER	VS	80
630	BOUND TO SHINE!! / Or a Brush on the Road	S	230
631	BOUND TO SHINE	S	175
632	BOUND TO SHINE	VS	80
633	BOUND TO SMASH!! / Or caught by the Wool	S	230

634	BOUQUET, THE	S	80
635	BOUQUET OF FRUIT	S	85
636	BOUQUET OF ROSES, THE	S	85
637	BOUQUET OF THE VASE, THE	S	80
638	BOWER OF BEAUTY	S	50
639	BOWER OF ROSES, THE	L	210
640	BOY AND DOG	S	75
641	BOY OF THE PERIOD, STIRRING UP THE ANIMALS, THE	S	125
642	BOYNE WATER, THE	S	80
643	BOZ D. LAWRENCE	S	45
644	BRACE OF MEADOW LARKS, A	S	90
645	BRACK DOG WINS, DE	S	175
646	BRANCH AND THE VINE	S	50
647	BRANCH CANNOT BEAR FRUIT, THE	S	60
648	BRANDING SLAVES / On the coast of Africa...	S	225
649	BRANDY SMASH!	S	160
650	BRAVE BOY OF THE WAXHAWS, THE / Andrew Jackson...	S	195
651	BRAVE WIFE	S	85
652	"BREAKING IN" / A Black Imposition	S	175
653	"BREAKING OUT" / A Lively Scrimmage	S	175
654	BREAKING THAT "BACKBONE"	M	200
655	BRER THULDY'S STATUE / Liberty frightenin de World	S	225
656	BRIAN BORUE / At the Battle of Clontarf	S	35
657	BRIC-A-BRAC-MANIA, THE	S	65
658	BRIDAL BOUQUET, THE	S	100
659	"BRIDAL VEIL" FALL / YoSemite Valley, California	S	260
660	BRIDAL WREATH, THE	S	70
661	BRIDE, THE	S	50
662	BRIDE, THE	S	50
663	BRIDE, THE	L	50
664	BRIDE & BRIDEGROOM, THE	S	50
665	BRIDE OF LAMMERMOOR, THE	S	40
666	BRIDE OF THE WHITE HOUSE, THE	S	75
667	BRIDESMAID, THE	S	60
668	BRIDESMAID, THE	L	100
669	BRIDGE, THE	VS	95
670	BRIDGE AT THE OUTLET, THE / Lake Memphremagog	S	150
671	BRIDGET	S	50
672	BRIDGET	S	55
673	BRIG	S	475
674	BRIG. GEN. FRANZ SIGEL	S	70
675	BRIG. GEN. IRWIN McDOWELL	S	70
676	BRIG. GEN. LOUIS BLENKER	S	70
677	BRIG. GENERAL NATHL. LYON	S	80
678	BRIG. GENERAL W. T. SHERMAN, U.S.A.	S	75
679	BRIG. GENL. AMBROSE E. BURNSIDE	S	75
680	BRIG. GENL. MICHAEL CORCORAN	S	90
681	BRIG. GENL. MICHAEL CORCORAN	S	90
682	BRIG. GENL. NATHL. LYON, UNITED STATES ARMY	S	75
683	BRIG. GENL. ROBERT ANDERSON	S	75
684	BRIG. GENL. THOMAS FRANCIS MEAGHER	S	85
685	BRIG. GENL. WM. SPRAGUE, U.S.A.	S	65
686	BRIG. GENL. W. S. ROSECRANS	S	70
687	BRIG VISION, CAPT. DONOVAN	S	230
688	BRIGAND, THE	S	100
689	BRIGHAM YOUNG	M	100
690	BRILLIANT CHARGE OF CAPT. MAY, THE	S	115
691	BRILLIANT CHARGE OF CAPT. MAY, THE	S	115
692	BRILLIANT NAVAL VICTORY ON THE MISSISSIPPI RIVER	S	270
693	BRING UP YOUR HORSES	L	1265
694	BROADWAY BELLE, A	S	50
695	BROADWAY FASHIONS, NEW YORK	L	225
696	BROADWAY FASHIONS, NEW YORK	L	225
697	BROADWAY, NEW YORK / From the Western Union Building	L	3300
698	BROADWAY, NEW YORK / South from the Park	S	400
699	BROADWAY, NEW YORK SOUTH FROM THE PARK	S	400
700	BRONZE STATUE OF ANDREW JACKSON, WASHINGTON D.C.	S	95
701	BROOK, THE	S	110
702	BROOK, SUMMER, THE	S	135
703	BROOK TROUT FISHING / "An Anxious Moment"	L	2950
704	BROOK TROUT FISHING	S	525
705	BROOK TROUT—JUST CAUGHT	M	355
706	BROTHER AND SISTER	S	60
707	BROTHER AND SISTER	S	60
708	BROTHER AND SISTER	S	60
709	BROTHER AND SISTER	S	60
710	BRUSH FOR THE LEAD, A / New York "Flyers" on the snow	L	2250

711	BRUSH FOR THE HOMESTRETCH, THE	L	1175
712	BRUSH ON THE ROAD, A / Best 2 in 3	S	250
713	BRUSH ON THE ROAD, A / Mile heats, best 2 in 3	M	350
714	BRUSH ON THE ROAD, A / Mile Heats, Best 2 in 3	S	245
715	BRUSH ON THE ROAD, A / Mile Heats, Best 2 in 3	S	245
716	"BRUSH" ON THE SNOW, A	M	950
717	BRUSH WITH WEBSTER CARTS, A	L	1250
718	"BUCK" TAKING THE "POT"	S	150
719	"BUDD" OF THE DRIVING PARK, THE	M	140
720	BUDS OF PROMISE	S	65
721	BUFFALO & CHICAGO / Steam Packet Empire State	S	315
722	BUFFALO BULL, CHASING BACK	M	1000
723	BUFFALO CHASE, THE / "Singling Out"	M	1100
724	BUFFALO DANCE, THE / "To make the Buffaloes come"	M	1000
725	BUFFALO HUNT ON SNOW SHOES	M	1100
726	BUFFALO HUNT, THE / Surrounding the Herd	M	1200
727	BUFFALO HUNT ON THE BANKS OF THE UPPER MISSOURI	M	1150
728	BUFFALO HUNT UNDER THE WHITE WOLF SKIN	M	1150
729	BULL DOZED!!	S	185
730	BULL DOZED!!	VS	75
731	BULL-DOZED	S	185
732	BULLY TEAM, THE / Scaldine and Early Nose	S	275
733	BURIAL OF CHRIST, THE	S	25
734	BURIAL OF CHRIST, THE	S	25
735	BURIAL OF DESOTO	S	45
736	BURIAL OF THE BIRD, THE	S	40
737	BURNING GLASS, THE	M	250
738	BURNING OF CHICAGO, THE	S	475
739	BURNING OF THE CITY HALL, NEW YORK	S	425
740	BURNING OF THE CLIPPER SHIP "GOLDEN LIGHT"	S	550
741	BURNING OF THE HENRY CLAY NEAR YONKERS	S	285
742	BURNING OF THE INMAN LINE STEAMSHIP CITY OF MONTREAL	S	235
743	BURNING OF THE NEW YORK CRYSTAL PALACE	L	1325
744	BURNING OF THE NEW YORK CRYSTAL PALACE	S	300
745	BURNING OF THE OCEAN MONARCH OF BOSTON...	S	265
746	BURNING OF THE PALACE STEAMER ROBERT E. LEE	S	275
747	BURNING OF THE SPLENDID STEAMER "ERIE"...	S	275
748	BURNING OF THE STEAMSHIP AUSTRIA, SEPT., 1858	S	250
749	BURNING OF THE STEAMSHIP "GOLDEN GATE"	S	330
750	BURNING OF THE STEAMSHIP "GOLDEN GATE"	S	330
751	BURNING OF THE STEAMSHIP NARAGANSETT	S	225
752	BURNING OF THE THRONE, THE / Paris, 25th Feb. 1848	S	60
753	BURNING OF THE U.S. SHIP OF THE LINE PENNSYLVANIA	S	300
754	BURNING OF WARWICK CASTLE, DEC. 3rd, 1871	S	70
755	BUSTIN' A PICNIC	S	225
756	"BUSTING THE POOL"	S	215
757	BUSTIN THE RECORD / "Time Knocked Out"	S	240
758	BUTT OF THE JOKERS, THE	S	185
759	BUTTERMILK FALLS	VS	95
760	BY THE SEASHORE	M	125
761	BYRON AND MARIANNA	S	65
762	BYRON IN THE HIGHLANDS	S	65
763	BYRON'S FIRST LOVE	S	65
764	CAIRN'S QUICK STEP	S	75
765	CAKE WALK, DE / For Beauty, Grace and Style...	S	170
766	CALIFORNIA BEAUTY, THE	S	75
767	CALIFORNIA GOLD	S	500
768	CALIFORNIA SCENERY / Seal Rocks — Point Lobos	S	225
769	CALIFORNIA WONDER OCCIDENT OWNED BY GOV. L. STANFORD	S	210
770	CALIFORNIA WONDER OCCIDENT OWNED BY GOV. L. STANFORD	S	210
771	CALIFORNIA WONDER, THE / Hinda Rose	S	190
772	CALIFORNIAN SEEKING THE ELEPHANT	S	100
773	CAMPING IN THE WOODS / "A Good Time Coming"	L	3550
774	CAMPING IN THE WOODS / "Laying Off"	L	3550
775	CAMPING OUT / "A Life in the Woods for Me"	S	200
776	CAMPING OUT—LIFE IN THE WOODS	M	500
777	CAMPING OUT / "Some of the right sort"	L	3200
778	CAN YOU KEEP A SECRET?	S	55

872	CEDARS OF LEBANON, THE	S	35
873	CELA WINDER	S	45
874	CELEBRATED BOSTON TEAM MILL BOY AND BLONDIE...	L	1125
875	CELEBRATED CLIPPER BARK GRAPESHOT...	S	280
876	CELEBRATED CLIPPER SHIP "DREADNOUGHT", THE	S	475
877	CELEBRATED CLIPPER SHIP "DREADNOUGHT" / Off Tuskar Light	S	550
878	CELEBRATED ETHIOPIAN MELODIES, THE	S	40
879	CELEBRATED FIGHTING PIG "PAPE," THE	M	400
880	CELEBRATED "FOUR IN HAND" STALLION TEAM, THE	L	1725
881	CELEBRATED "FOUR IN HAND" STALLION TEAM, THE	L	1750
882	CELEBRATED HORSE "BLOWER" KING OF THE ROAD, THE	S	275
883	CELEBRATED HORSE "DEXTER," - "The King of the Turf"	L	1800
884	CELEBRATED HORSE "DEXTER," - "The King of the World"	L	1800
885	CELEBRATED HORSE GEORGE M. PATCHEN...	L	1450
886	CELEBRATED TROTTING HORSE "JOHN STEWART"	L	1275
887	CELEBRATED HORSE LEXINGTON (5 yrs. old) BY "BOSTON"...	L	3100
888	CELEBRATED HORSE "LEXINGTON" (5 yrs. old) BY "BOSTON"...	L	1800
889	CELEBRATED KOOK FAMILY, THE	S	100
890	CELEBRATED MARE FLORA TEMPLE - "The Queen of the Turf"	L	1575
891	CELEBRATED MARE FLORA TEMPLE - "The Queen of the Turf"	L	1575
892	CELEBRATED MARE FLORA TEMPLE - "The Queen of the Turf"	L	1575
893	CELEBRATED PACING MARE "POCAHONTAS"...	L	1390
894	CELEBRATED "PLOUGH HORSE" CAPTAIN LEWIS	S	260
895	CELEBRATED / SPRING-FLOWER POLKA, THE	S	60
896	CELEBRATED STALLION TRIO / Wamba / Bud Crooke...	L	1200
897	CELEBRATED STALLIONS "GEORGE WILKES"/"COMM. VANDERBILT"	M	850
898	CELEBRATED TERRIER DOG MAJOR...	L	285
899	CELEBRATED TROTTER JAY EYE SEE DRIVEN BY E.D. BLITHER	L	1200
900	CELEBRATED TROTTER MOOSE, BY THE WASHBURN HORSE	S	315
901	CELEBRATED TROTTING HORSE "CAMORS" BY GEN. KNOX...	S	315
902	CELEBRATED TROTTING HORSE GLOSTER, BY VOLUNTEER...	S	300
903	CELEBRATED TROTTING HORSE HENRY, DRIVEN BY J. MURPHY	S	350
904	CELEBRATED TROTTING HORSE HENRY, DRIVEN BY J. MURPHY	S	350
905	CELEBRATED TROTTING HORSE HOPEFUL...	L	1075
906	CELEBRATED TROTTING HORSE HOPEFUL...	L	1075
907	CELEBRATED TROTTING HORSE "JOHN STEWART"...	L	1200
908	CELEBRATED TROTTING HORSE "JOHN STEWART"...	L	1250
909	CELEBRATED TROTTING HORSE JUDGE FULLERTON...	L	1200
910	CELEBRATED TROTTING HORSE "PROSPERO"...	S	225
911	CELEBRATED TROTTING HORSE TRUSTEE...	L	1650
912	CELEBRATED TROTTING MARE "DAISY DALE"...	S	255
913	CELEBRATED TROTTING MARE FLORA TEMPLE...	S	340
914	CELEBRATED TROTTING MARE GOLDSMITH MAID...	S	325
915	CELEBRATED TROTTING MARE GOLDSMITH MAID...	S	325
916	CELEBRATED TROTTING MARE HATTIE WOODWARD...	L	1000
917	CELEBRATED TROTTING MARE HUNTRESS...	S	335
918	CELEBRATED TROTTING MARE LADY THORN...	L	1400
919	CELEBRATED TROTTING MARE LADY THORN...	L	1400

920	CELEBRATED TROTTING MARE LUCILLE GOLDDUST...	S	365
921	CELEBRATED TROTTING MARE LUCY PASSING THE JUDGES' STAND	L	1125
922	CELEBRATED TROTTING MARE LULA OWNED BY MR. J. HARKER	S	325
923	CELEBRATED TROTTING MARE LULA...	S	265
924	CELEBRATED TROTTING MARE "WIDOW McCHREE"...	L	1000
925	CELEBRATED TROTTING MARES MAUDE S. AND ALDINE...	L	1300
926	CELEBRATED TROTTING STALLION ALEXANDER...	L	1200
926A	CELEBRATED TROTTING STALLION COL. UPTON, WILL, THE	L	935
927	CELEBRATED TROTTING STALLION ETHAN ALLEN...	S	260
928	CELEBRATED TROTTING STALLION "FRANCE'S ALEXANDER"...	S	260
929	CELEBRATED TROTTING STALLION "FRANCE'S ALEXANDER"...	L	1035
930	CELEBRATED TROTTING STALLION GEORGE WILKES...	M	700
931	CELEBRATED TROTTING STALLION GEORGE WILKES...	S	300
932	CELEBRATED TROTTING STALLION GEORGE WILKES...	L	1450
933	CELEBRATED TROTTING STALLION JAY GOULD	S	300
934	CELEBRATED TROTTING STALLION PATRON BY PANCOAST	S	235
935	CELEBRATED TROTTING STALLION SMUGGLER...	L	1250
936	CELEBRATED TROTTING STALLION SMUGGLER...	L	1150
937	CELEBRATED TROTTING STALLION / "Woodford Mambrino"	S	325
938	CELEBRATED TROTTING STALLIONS E. ALLEN & G. PATCHEN	L	1800
939	CELEBRATED TROTTING STALLIONS YOUNG WOFUL & ABDALLAH CHIEF	L	1575
940	CELEBRATED TROTTING TEAM EDWARD AND SWIVELLER	L	1075
941	CELEBRATED WINNING HORSES AND JOCKEYS...AMER. TURF	L	1000
942	CELEBRATED WINNING HORSES AND JOCKEYS...AMER. TURF	L	1000
943	CELEBRATED WINNING HORSES AND JOCKEYS...AMER. TURF	L	1000
944	CELEBRATED YACHT "AMERICA," THE	S	550
945	CELEBRATED YACHTS, THE / Coronet and Dauntless	M	450
946	CENTENNIAL BOCK BIER / The Best can be had here	M	175
947	CENTENNIAL EXHIBITION BUILDINGS, PHILADELPHIA	S	150
948	CENTRAL PARK IN WINTER	S	1600
949	CENTRAL PARK — THE BRIDGE	S	335
950	CENTRAL PARK, N.Y. / The Bridge	S	275
951	CENTRAL PARK, THE DRIVE	M	425
952	CENTRAL PARK, THE LAKE	M	435
953	CENTRAL PARK, WINTER / The Skating Carnival	S	1375
954	CENTRAL PARK, WINTER / The Skating Pond	L	5200
955	CENTRE HARBOR / Lake Winnipiseogee, N.H.	L	400
956	CENTREVILLE AND BLACK DOUGLAS / Centreville Course	L	1125
957	CERITO IN THE SYLPHIDE	S	70
958	CERTIFICATE OF BAPTISM	S	30
959	CERTIFICATE OF BAPTISM	S	20
960	CERTIFICATE OF HONOR / Awarded to... (both sizes)	VS-S	65
961	CERTIFICATE OF MARRIAGE	S	50
962	CH. MAURICE de TALLYRAND	VS	100
963	CHAMPION IN DANGER, THE	S	175
964	CHAMPION IN LUCK, THE	S	175
965	CHAMPION IRISH SETTER ROVER, BY BEAUTY...	S	75
966	CHAMPION PACER DIRECT, BY DIRECTOR / Record 2:06	S	245
967	CHAMPION PACER DIRECT, BY DIRECTOR / Record 2:05 ½	L	1095
968	CHAMPION PACER JOHNSTON, BY BASHAW GOLDDUST, THE	L	1265
969	CHAMPION PACER MASCOT, RECORD 2:04	S	250
970	CHAMPION PACER MASCOT, RECORD 2:04	L	950
971	CHAMPION RACE, A	L	1000
972	CHAMPION RACE, A	L	1000
973	CHAMPION ROWIST, THE PRIDE OF THE CLUB, THE	M	340

1044	CHOICE SEGARS AND FINE TOBACCO	S	95
1045	CHRIST AND THE ANGELS	S	25
1046	CHRIST AND THE WOMAN OF SAMARIA AT JACOBS WELL	S	25
1047	CHRIST AND THE WOMAN OF SAMARIA AT JACOBS WELL	S	25
1048	CHRIST AT THE WELL	S	25
1049	CHRIST AT THE WELL / "Whosoever shall drink..."	S	25
1050	CHRIST AT THE WELL	S	25
1051	CHRIST BEARING HIS CROSS	S	30
1052	CHRIST BEARING HIS CROSS	S	30
1053	CHRIST BEFORE PILATE	S	30
1054	CHRIST BEFORE PILATE	S	30
1055	CHRIST BEFORE PILATE	S	30
1056	CHRIST BLESSING LITTLE CHILDREN	S	25
1057	CHRIST BLESSING LITTLE CHILDREN	S	25
1058	CHRIST BLESSING LITTLE CHILDREN	S	25
1059	CHRIST BLESSING THE CHILDREN	S	25
1060	CHRIST HEALING THE SICK	S	25
1061	CHRIST IN THE GARDEN	S	25
1062	CHRIST IN THE GARDEN OF OLIVES	S	25
1063	CHRIST IS OUR LIGHT / Our Star of Redemption	S	25
1064	CHRIST IS OUR LIGHT — OUR STAR OF REDEMPTION	S	25
1065	CHRIST RESTORETH THE BLIND	S	25
1066	CHRIST RESTORETH THE BLIND	S	25
1067	CHRIST RESTORETH THE BLIND	S	25
1068	CHRIST STILLING THE TEMPEST	S	25
1069	CHRIST THE CONSOLER	S	25
1070	CHRIST WALKING ON THE SEA	S	30
1071	CHRIST WALKING ON THE SEA	S	30
1072	CHRIST WASHING HIS DISCIPLES' FEET	S	25
1073	CHRIST WEEPING OVER JERUSALEM	S	25
1074	CHRIST WEEPING OVER JERUSALEM	S	25
1075	CHRIST'S ENTRY INTO JERUSALEM	S	25
1076	CHRIST'S SERMON ON THE MOUNT	M	25
1077	CHRIST'S SERMON ON THE MOUNT	S	25
1078	CHRISTENING, THE	S	30
1079	CHRISTIAN'S HOPE, THE	S	20
1080	CHRISTIAN'S REFUGE, THE	M	35
1081	CHRISTMAS SNOW	VS	300
1082	CHRISTOPHER COLUMBUS / Discoverer of America, 1492	L	150
1083	CHRISTUS CONSOLATOR / Come unto Me,...	S	20
1084	CHRISTUS CONSOLATUS / Come unto Me,...	S	20
1085	CITY HALL AND COUNTY COURTHOUSE, NEWARK, N.J.	S	400
1086	CITY HALL, NEW YORK	S	265
1087	CITY HALL, NEW YORK	S	265
1088	CITY HALL AND VICINITY, NEW YORK CITY	S	375
1089	CITY HOTEL / Broadway, New York	L	950
1090	CITY OF BALTIMORE, THE	L	1000
1091	CITY OF BOSTON, THE	L	1050
1092	CITY OF BROOKLYN	L	900
1093	CITY OF BROOKLYN / This certifies that...	S	100
1094	CITY OF CHICAGO, THE	L	1100
1095	CITY OF CHICAGO, THE	L	1625
1096	"CITY OF CHICAGO" (Steamship)	L	785
1097	CITY OF JUNGO	S	50
1098	CITY OF MEXICO — VISTA DE MEXICO	S	130
1099	CITY OF NEW ORLEANS, THE	L	1750
1100	CITY OF NEW ORLEANS / Levee, St. Charles Hotel,...	S	600
1101	CITY OF NEW YORK	S	625
1102	CITY OF NEW YORK	L	1500
1103	CITY OF NEW YORK	L	1500
1104	CITY OF NEW YORK, THE	L	1150
1105	CITY OF NEW YORK, THE	L	1150
1106	CITY OF NEW YORK, THE	L	1050
1107	CITY OF NEW YORK, THE	L	1800
1108	CITY OF NEW YORK, THE	L	975
1109	CITY OF NEW YORK, THE	L	975
1110	CITY OF NEW YORK, THE	L	975
1111	CITY OF NEW YORK AND ENVIRONS	S	400
1112	CITY OF NEW YORK / From Jersey City	S	475
1113	CITY OF NEW YORK, THE / showing the Buildings...	L	865
1114	CITY OF NEW YORK, THE / Showing the Building of...	L	800
1115	"CITY OF PEKING," PACIFIC MAIL STEAMSHIP CO.	S	175
1116	CITY OF PHILADELPHIA, THE	L	1000
1117	CITY OF ST. LOUIS, THE	L	1100
1118	CITY OF SAN FRANCISCO	S	300
1119	CITY OF SAN FRANCISCO, THE	L	1200

No.	Title	Size	Price
1120	THE CITY OF SAN FRANCISCO SKETCHED AND DRAWN BY C.R. PARSONS	L	1450
1121	CITY OF VERA CRUZ, — VISTA DE VERA CRUZ	S	75
1122	CITY OF WASHINGTON, THE	L	1000
1123	CITY OF WASHINGTON, THE	L	1000
1124	CLAM BOY — ON HIS MUSCLE	S	100
1125	CLARA	S	55
1126	CLARA	S	65
1127	CLARA	S	55
1128	CLARISSA / Copyright Sarony and Major	S	75
1129	"CLEAN SWEEP, A"	S	215
1130	CLEAR GRIT	S	80
1131	"CLEARING, A" / On the American Frontier	S	260
1132	CLEARING, THE	S	170
1133	CLEVELAND FAMILY, THE	S	50
1134	CLEVELAND FAMILY, THE	L	115
1135	CLEVELAND SMILE, THE	S	75
1136	CLIFTON HALL, BRISTOL COL., PA.	M	125
1137	CLINGSTONE — RECORD 2:14	VS	65
1138	CLINGSTONE / By Rysdyk's dam Gretchen...	S	275
1139	CLIPPER SHIP "ADELAIDE"	L	5500
1140	CLIPPER SHIP "COMET" OF NEW YORK	L	2850
1141	"CLIPPER SHIP CONTEST"	L	2775
1142	CLIPPER SHIP "COSMOS," THE	M	1500
1143	CLIPPER SHIP "DREADNOUGHT"	L	3800
1144	CLIPPER SHIP DREADNOUGHT — OFF TUSKAR LIGHT	L	3800
1145	CLIPPER SHIP "FLYING CLOUD"	L	2950
1146	CLIPPER SHIP "GREAT REPUBLIC"	L	3150
1147	CLIPPER SHIP "GREAT REPUBLIC"	L	2225
1148	CLIPPER SHIP "GREAT REPUBLIC"	S	325
1149	CLIPPER SHIP "GREAT REPUBLIC"	S	325
1150	CLIPPER SHIP "GREAT REPUBLIC"	S	325
1151	CLIPPER SHIP "GREAT REPUBLIC"	S	325
1152	CLIPPER SHIP "GREAT REPUBLIC"	S	325
1153	CLIPPER SHIP "HURRICANE"	L	7000
1154	CLIPPER SHIP IN A HURRICANE, A	M	1450
1155	CLIPPER SHIP IN A HURRICANE, A	S	525
1156	CLIPPER SHIP IN A HURRICANE, A	S	525
1157	CLIPPER SHIP IN A SNOW SQUALL, A	S	550
1158	CLIPPER SHIP "LIGHTNING"	L	5650
1159	CLIPPER SHIP "NIGHTINGALE" / Getting under weigh...	L	8200
1160	CLIPPER SHIP "OCEAN EXPRESS" / Outward bound...	L	3300
1161	CLIPPER SHIP OFF CAPE HORN, A	S	500
1162	CLIPPER SHIP OFF THE PORT	S	550
1163	CLIPPER SHIP "QUEEN OF CLIPPERS"	S	450
1164	CLIPPER SHIP "RACER"	L	5500
1165	CLIPPER SHIP "RED JACKET" / In the ice off Cape Horn	L	6000
1166	CLIPPER SHIP "RED JACKET" / In the ice off Cape Horn	S	600
1167	CLIPPER SHIP "SOVEREIGN OF THE SEAS"	L	5475
1168	CLIPPER SHIP "SWEEPSTAKES"	L	5000
1169	CLIPPER SHIP "THREE BROTHERS," 2972 TONS	L	1650
1170	CLIPPER SHIP "THREE BROTHERS" / ..."Vanderbilt"	S	350
1171	CLIPPER SHIP "YOUNG AMERICA"	L	5000
1172	CLIPPER SHIPS HOMEWARD BOUND	S	450
1173	CLIPPER YACHT "AMERICA," THE	M	850
1174	CLIPPER YACHT "AMERICA," THE	M	735
1175	CLIPPER YACHT "AMERICA," THE	M	735
1176	CLIPPER YACHT "AMERICA," THE / Of New York...	S	735
1177	CLOSE CALCULATION, A	S	95
1178	CLOSE FINISH, A	S	240
1179	"CLOSE HEAT, A" / Judge Fullerton, Gazelle & Huntress	L	1300
1180	CLOSE LAP ON THE RUN IN, A	L	900
1181	CLOSE QUARTERS	L	700
1182	COACHING—FOUR IN HAND / A Swell turn out	M	600
1183	COCK-A-DOODLE-DO	S	75
1184	COCK OF THE WALK, THE	S	175
1185	COD FISHING—OFF NEWFOUNDLAND	S	800
1186	COL. E.L. SNOW	S	50
1187	COL. EDWARD D. BAKER / U.S. Senator from Oregon	S	40
1188	COL. ELMER E. ELLSWORTH	S	70
1189	COL. ELMER E. ELLSWORTH	S	70

1255	CORNED BEEF	S	165
1256	CORNELIA	S	50
1257	CORNELIA	S	50
1258	CORNWALLIS IS TAKEN!	S	400
1259	CORRECT LIKENESS OF H. ROCKWELL'S HORSE ALEXANDER	M	500
1260	CORRECT LIKENESS OF MR. H. ROCKWELL'S HORSE ALEXANDER	S	225
1261	CORSAIRS ISLE, THE	M	110
1262	CORTELYOU MANSION—OLD MANSION HOUSE, GOWANUS ROAD	S	150
1263	COTTAGE BY THE CLIFF, THE	S	145
1264	COTTAGE BY THE WAYSIDE, THE	S	135
1265	COTTAGE DOORYARD— EVENING, THE	M	300
1266	COTTAGE LIFE—SPRING	M	205
1267	COTTAGE LIFE—SUMMER	S	185
1268	COTTAGE LIFE—SUMMER	M	205
1269	COTTAGES, THE see C669	VS	—
1270	COTTER'S SATURDAY NIGHT, THE	S	100
1271	COTTON PLANTATION ON THE MISSISSIPPI, A	L	720
1272	COURAGEOUS CONDUCT OF A YOUNG GIRL	S	110
1273	COURSE OF TRUE LOVE, THE	S	80
1274	COURTSHIP / The Happy Hour	S	65
1275	COUSINS, THE	S	45
1276	COVE OF CORK, THE	S	80
1277	COZZEN'S DOCK, WEST POINT / Hudson River	M	440
1278	CRACK SHOT, A	S	125
1279	CRACK SHOT, A	VS	55
1280	CRACK SHOTS, IN POSITION, THE	S	165
1281	"CRACK" SLOOP IN A RACE TO WINDWARD / Yacht Gracie	L	1300
1282	"CRACK TEAM" AT A SMASHING GAIT, A	L	900
1283	CRACK TROTTER, A — "COMING AROUND"	S	275
1284	CRACK TROTTER, A — "A LITTLE OFF"	S	275
1285	"CRACK TROTTER, A" — BETWEEN THE HEATS	VS	75
1286	"CRACK TROTTER" — BETWEEN THE HEATS	M	385
1287	"CRACK TROTTER" IN THE HARNESS OF THE PERIOD, A	VS	75
1288	"CRACK TROTTER" IN THE HARNESS OF THE PERIOD, A	M	350
1289	CRACOVIENNE, THE / Danced by Madlle. Elssler	S	60
1290	CRACOVIENNE, THE / Danced by Madlle. Elssler	S	60
1291	CRADLE OF LIBERTY, THE	S	150
1292	CRAPS—A BUSTED GAME	S	250
1293	CRAPS—A CLOSE CALL	S	250
1294	CRAYON STUDIES / #464	S	120
1295	CRAYON STUDIES / #472	S	245
1296	CRAYON STUDIES / #473	S	150
1297	CRAYON STUDIES / Old Mansion House, Gowanus Road	S	185
1298	CRAYON STUDIES / Summer Noon	S	135
1299	CRAYON STUDIES / View on Fulton Avenue, Brooklyn	S	185
1300	CREAM OF LOVE, THE	S	75
1301	CREATING A SENSATION / The "Bully Boy on a Bicycle"	S	250
1302	CROMWELL'S BRIDGE / Glengariff, Ireland	S	55
1303	CROSS AND ANCHOR OF ROSES	S	40
1304	CROSS AND CROWN OF FLOWERS	S	35
1305	CROSS AND THE CROWN, THE	M	30
1306	CROSS MATCHED RACE, A	M	615
1307	"CROSS MATCHED" TEAM, A	S	185
1308	CROSSED BY A "MILK TRAIN"	S	200
1309	CROSSED BY A "MILK TRAIN"	S	200
1310	CROW / Quadrilles, The	S	75
1311	"CROWD" THAT "SCOOPED" THE POOLS, THE	VS	65
1312	"CROWD" THAT "SCOOPED" THE POOLS, THE	S	310
1313	CROWING MATCH, A	VS	65
1314	CROWN OF THORNS, THE / Ecce Homo	S	25
1315	CROW'S NEST / North River	S	135
1316	"CROXIE" / by Clark Chief	S	225
1317	CRUCIFIXION, THE	S	25
1318	CRUCIFIXION, THE	S	25
1319	CRUCIFIXION, THE	S	25
1320	CRUCIFIXION, THE	S	25
1321	CRUCIFIXION, THE	M	50
1322	CRUCIFIXION, THE	S	30
1323	CRUCIFIXION, THE / La Crucifixion	M	60
1324	CRUISER "NEW YORK," THE	S	270
1325	CRYSTAL PALACE, THE / The Magnificent Buildings...	S	165
1326	CRYSTAL PALACE, THE / The Magnificent Buildings...	S	165
1327	CUMBERLAND VALLEY / From Bridgeport Heights...	L	550
1328	CUP THAT CHEERS, A	S	100
1329	CUNARD STEAMSHIP "SERVIA"	S	225

1459	DAY BEFORE MARRIAGE, THE	S	50
1460	DAY BEFORE MARRIAGE, THE	S	50
1461	DAY BEFORE MARRIAGE, THE / The Bride's Jewels	S	75
1462	DAY BEFORE THE WEDDING, THE	S	50
1463	DAY OF REST, THE	M	125
1464	DEACON'S MARE, THE	VS	75
1465	DEACON'S MARE, THE / Getting the Word Go!	S	235
1466	DEAD BEAT, A	S	120
1467	DEAD BROKE	S	125
1468	DEAD GAME / Quail	S	170
1469	DEAD GAME / Woodcock & Partridge	S	170
1470	"DEAREST SPOT ON EARTH TO ME, THE"	S	175
1471	DEATH BED OF THE MARTYR PRESIDENT, ABRAHAM LINCOLN	M	125
1472	DEATH OF THE HON. ANDREW JOHNSON	S	50
1473	DEATH OF CALVIN, THE	S	20
1474	DEATH OF CHARLES SUMNER, THE	S	60
1475	DEATH OF COL. EDWARD D. BAKER	S	55
1476	DEATH OF COL. ELLSWORTH	S	90
1477	DEATH OF COL. JOHN J. HARDIN	S	55
1478	DEATH OF COL. PIERCE M. BUTLER	S	50
1479	DEATH OF DANIEL O'CONNELL	S	30
1480	DEATH OF GENL. ANDREW JACKSON	S	80
1481	DEATH OF GENERAL GRANT, THE	S	70
1482	DEATH OF GENERAL JAMES A. GARFIELD	S	80
1483	DEATH OF GENERAL LYON	S	125
1484	DEATH OF GENERAL ROBERT E. LEE	S	75
1485	DEATH OF GENL. Z. TAYLOR	S	65
1486	DEATH OF HARRISON, APRIL 4, A.D. 1841	S	70
1487	DEATH OF HARRISON, APRIL 4, A.D. 1841	S	70
1488	DEATH OF HONL. HENRY CLAY	S	65
1489	DEATH OF HONL. HENRY CLAY	S	65
1490	DEATH OF JOHN QUINCY ADAMS	S	50
1491	DEATH OF LIEUT. COL. HENRY CLAY, JR.	S	130
1492	DEATH OF LIEUT. COL. HENRY CLAY, JR.	S	130

1493	DEATH OF MAJ. GENL. JAMES B. M'PHERSON	S	70
1494	DEATH OF MAJOR RINGGOLD	S	85
1495	DEATH OF MAJOR RINGGOLD	S	85
1496	DEATH OF MINNEHAHA, THE	L	200
1497	DEATH OF MONTGOMERY	S	75
1498	DEATH OF NAPOLEON	S	70
1499	DEATH OF POPE PIUS IXth.	S	40
1500	DEATH OF PRESIDENT LINCOLN / At Washington...	S	70
1501	DEATH OF PRESIDENT LINCOLN / At Washington...	S	70
1502	DEATH OF PRESIDENT LINCOLN	M	125
1503	DEATH OF ST. JOSEPH	S	25
1504	DEATH OF ST. JOSEPH	S	25
1505	DEATH OF ST. PATRICK, THE APOSTLE OF IRELAND	S	25
1506	DEATH OF "STONEWALL" JACKSON	S	75
1507-1510	DEATH OF TECUMSEH	S	100
1511	DEATH OF TECUMSEH	S	125
1512	DEATH OF THE BLESSED VIRGIN	S	25
1513	DEATH OF THE JUST, THE	S	25
1514	DEATH OF THE SINNER, THE	S	25
1515	DEATH OF WARREN AT THE BATTLE OF BUNKER HILL	S	80
1516-1521	DEATH OF WASHINGTON, DEC. 14, A.D. 1799	S	90
1522	DEATH OF WASHINGTON, DECEMBER 14, A.D. 1799	M	125
1523	DEATH SHOT, THE	S	210
1524-1528	DECLARATION, THE	S	60
1529	DECLARATION, THE	S	65
1530	DECLARATION COMMITTEE, THE	S	200
1531	DECLARATION OF INDEPENDENCE, THE	S	135
1532	DECLARATION OF INDEPENDENCE, THE	S	135
1533	DECLARATION OF INDEPENDENCE, THE	S	135
1534	DECORATION OF THE CASKET OF GEN. LEE...	S	60
1535	DEER AND FAWN	S	200
1536	DEER HUNTING BY TORCHLIGHT	M	375
1537	DEER HUNTING ON THE SUSQUEHANNA	M	375
1538	DEER IN THE WOODS	S	225
1539	DEER SHOOTING / In the Northern Woods	S	425
1540	DEFENCE OF THE FLAG, THE	S	75
1541	DEFIANCE!	S	150

1542	DELAYING A START	S	325
1543	DELIA	S	50
1544	DELICIOUS COFFEE!	S	65
1545	DELICIOUS FRUIT	VS	60
1546	DELICIOUS FRUIT	S	75
1547	DELICIOUS FRUIT	M	145
1548	DELICIOUS FRUIT	M	145
1549	DELICIOUS ICE CREAM	S	70
1550	DEMOCRACY IN SEARCH OF A CANDIDATE, THE	M	125
1551	DEMOCRATIC PLATFORM, THE	M	185
1552	DEMOCRATIC REFORMERS IN SEARCH OF A HEAD	S	140
1553	DEPARTED WORTH	S	45
1554	DEPTHS OF DESPAIR, THE	S	75
1555	DER HUGERN VON VATERLAND	S	25
1556-1559	DESCENT FROM THE CROSS, THE	S	30
1560	DESIGN FOR A MODEL SCHOOL HOUSE	S	70
1561	DESIGN FOR ASTOR'S HOTEL...	S	125
1562	DESIGN FOR ASTOR'S HOTEL, N.Y.	S	125
1563	DESIGN FOR PADDLE WHEEL STEAMER...	M	165
1564	DESIGN MADE FOR ASTOR'S HOTEL	S	100
1565	DESPERATE FINISH, A	S	160
1566	DESPERATE FINISH, A	L	850
1567	DESPERATE PEACE MAN, A	S	70
1568	DESSERT OF FRUIT, A	S	110
1569	DESSERT OF FRUIT, A	L	350
1570	DESTRUCTION OF JERUSALEM BY THE ROMANS	L	145
1571	DESTRUCTION OF TEA AT BOSTON HARBOR, THE	S	725
1572	DESTRUCTION OF THE REBEL MONSTER "MERRIMAC"...	S	335
1573	DESTRUCTION OF THE REBEL RAM "ARKANSAS"	S	325
1574	DEVIL'S GLEN, THE / Killarney, Ireland	S	65
1575	DEWDROP / By Falsetto, dam by Explosion	S	230
1576	DE WITT CLINTON	VS	100
1577	"DEXTER" / By Rysdyk's Hambletonian...	S	300
1578	DEXTER, ETHAN ALLEN, AND MATE	S	350
1578A	DEXTER, ETHAN ALLEN, AND MATE	S	350
1579	DEXTEROUS WHIP, A	S	100
1580	DICK SWIVELLER / By Walkill Chief...	S	335
1581	DIE FAMILIE DES KAISER'S VON DEUTSCHLAND	S	40
1582	DIRECT, DRIVEN BY GEO. STARR / Record 2:05 ½	S	195
1583	DIRECTOR	VS	65
1584	DISCHARGING THE PILOT	L	3350
1585	DISCOVERY OF THE MISSISSIPPI, THE	S	150
1586	DISLOYAL BRITISH "SUBJECT," A	S	100
1587	DISPUTED HEAT, A / Claiming a Foul	L	1400
1588	DISPUTED PRIZE, THE	S	80
1589	DISTANCED!!	S	210
1590	DISTANT RELATIONS	S	95
1591	DISTINGUISHED MILITIA GENL. DURING AN ACTION, A	S	45
1592	DIS-UNITED STATES / or the Southern Confederacy	S	225
1593	DO YOU LOVE BUTTER?	S	60
1594	"DODGE" THAT WON'T WORK, A	S	120
1595	DODGER — CARTER H. HARRISON AGAINST THE BOODLERS	S	85
1596	DOLLY VARDEN	S	55
1597	DOMESTIC BLISS / The First Born	S	50
1598	DOMESTIC BLOCKADE, THE	L	300
1599	DOMINO	S	60
1600	DON JUAN / Plate 1 # 145	S	65
1601	DON JUAN / Plate 2 # 146	S	65
1602	DON JUAN AND LAMBRO	S	70
1603	DON JUAN SEPARATED FROM HAIDEE	S	55
1604	DONE GONE BUSTED!	S	195
1605	DON'T HURT MY BABY	S	75
1606	DON'T SAY NAY	S	65
1607	DON'T YOU WANT ANOTHER BABY?	S	85
1608	DON'T YOU WISH YOU MIGHT GET IT?	S	75
1609	DOREMUS, SUYDAMS AND NIXON, IMPORTERS AND JOBBERS OF DRY GOODS	M	125
1610	DOTTY DIMPLE	S	60
1611	DOUBLE-BARRELLED BREECH LOADER	S	185
1612	DOVE, THE	S	55
1613	DOVE'S REFUGE, THE	S	55
1614	DOWN, CHARGE!	S	385
1615	DR. FRIEDR. HECKER	S	25
1616	DR. WILLIAM VALENTINE	M	150
1617	DRAW POKER—GETTING 'EM LIVELY	S	210

1716	ELOPEMENT, THE	S	80
1717	EMBLEM OF HOPE, THE	S	45
1718	EMBLEM OF SALVATION, THE	S	35
1719	EMBRACING AN OPPORTUNITY	S	50
1720	EMELINE	S	55
1721	EMELINE	S	55
1722	EMELINE	S	55
1723	EMILY	S	45
1724	EMILY	S	55
1725	EMILY / #52	S	75
1726-			
1730	EMMA	S	55
1731	EMMET'S BETROTHED	S	35
1732	EMPORER, THE	S	50
1733	EMPORER OF NORFOLK / By Norfolk...	S	180
1734	EMPRESS, THE	S	50
1735	EMPRESS EUGENIE	S	50
1736	EMPRESS EUGIENE AND QUEEN VICTORIA	S	40
1737	EMPRESS JOSEPHINE	S	50
1738	EMPTY CRADLE, THE	S	45
1739	ENCHANTED CAVE, THE	L	115
1740	ENCHANTED ISLES	S	70
1741	END OF LONG BRANCH, THE	S	150
1742	ENGLISH BEAUTY, THE	S	50
1743	ENGLISH SNIPE	S	150
1744	ENGLISH SNIPE	S	165
1745	ENGLISH WINTER SCENE, AN	S	315
1746	ENGLISH YACHT OFF SANDY HOOK, AN	S	275
1747	ENOCH ARDEN—THE HOUR OF TRIAL	L	450
1748	ENOCH ARDEN—THE HOUR OF TRIAL	S	150
1749	ENOCH ARDEN—THE LONELY ISLE	L	475
1750	ENOS T. THROOP	VS	25
1751	ENTRANCE TO THE HIGHLANDS / Hudson River...	L	800
1752	ENTRANCE TO THE HOLY SEPULCHRE, JERUSALEM	S	25
1753	ERIN GO BRAH / The Great International Rifle Match	M	200
1754	ESCAPE OF THE SERGEANT CHAMPE, THE	S	185
1755	ESTHER	S	50
1756	ESTHER	S	50
1757	ETHAN ALLEN AND MATE AND DEXTER	L	1550
1758	ETHAN ALLEN & MATE AND LANTERN & MATE	L	1450
1759	ETHAN ALLEN & MATE AND LANTERN & MATE	L	1450
1760	ETHAN ALLEN AND MATE TO WAGON	S	400
1761	ETTA	S	45
1762	"EUCHERED"	S	95
1763	EUGENIE / Empress Regent of France	S	40
1764	EUROPA	M	90
1765	EUROPE	S	45
1766	EUROPE	S	60
1767	EUROPEAN BOWLING ALLEY, THE	S	125
1768	EUROPEAN WAR DANCE, THE	S	275
1769	EVACUATION OF RICHMOND, VA.	S	175
1770	EVANGELINE	S	65
1771	EVANGELINE	L	170
1772	EVENING OF LOVE, THE	S	40
1773	EVENING PRAYER, THE	S	55
1774	EVENING PRAYER, THE	S	35
1775	EVENING PRAYER, THE	S	35
1776	EVENING STAR, THE	S	40
1777	EVENING STAR, THE	S	40
1778	EVENING STAR, THE	S	40
1779	EVENING STAR, THE	S	50
1780	EVENTIDE—OCTOBER / The Village Inn	L	1075
1781	EVENTIDE—THE CURFEW	S	145
1782	EVERYBODY'S FRIEND	M	200
1783	EVERY THING COMING DOWN	S	165
1784	EVERYTHING LOVELY	S	95
1785	EXCITING FINISH, AN	S	200
1786	EXCITING FINISH, AN	L	900
1787	EXPRESS STEAMSHIP "AUGUSTA VICTORIA"...	S	175
1788	EXPRESS STEAMSHIP "COLUMBIA", THE	S	175
1789	EXPRESS STEAMSHIP "FURST BISMARK"...	S	175
1790	EXPRESS TRAIN, THE	S	2000
1791	EXPRESS TRAIN, THE	L	7650
1792	EXPRESS TRAIN, THE	S	1200
1793	EXPRESS TRAIN, THE	S	1000
1794	EXPRESS TRAIN, THE / #127	S	1275
1795	EXPULSION OF ADAM AND EVE	S	120
1796	EXQUISITE, THE / The "Pet of the Ladies."	M	85
1797	EXTRA COOL LAGER BEER	S	100
1798	EXTRAORDINARY EXPRESS ACROSS THE ATLANTIC	S	350
1799	FAIR BEAUTEOUS QUEEN	S	50
1800	FAIR EQUESTRIAN	L	165
1801	FAIR EQUESTRIAN, THE	S	350
1802	"FAIR FIELD AND NO FAVOR, A"	L	1000
1803	"FAIR MOON, TO THEE I SING"	S	90
1804	"FAIR MOON, TO THEE I SING"	VS	50
1805	FAIR PATRICIAN, THE	S	45
1806	FAIR PATRICIAN, THE	M	70
1807	FAIR PURITAN, THE	S	45
1808	FAIR START, A	S	195

1808A	FAIR START, A	M	225
1809	FAIREST FLOWER SO PALELY DROOPING	S	60
1810	FAIREST OF THE FAIR	S	65
1811	FAIRIES HOME, THE	L	125
1812	FAIRIES HOME, THE	M	100
1813	FAIRMOUNT WATER WORKS / From the Canal...	M	400
1814	FAIRY GROTTO	L	130
1815	FAIRY GROTTO, THE	S	80
1816	FAIRY ISLE, THE	S	65
1817	FAIRY TALES	S	50
1818	FAITH, HOPE AND CHARITY	S	30
1819	FALL AND WINTER FASHIONS FOR 1837 & 8....	L	550
1820	FALL FROM GRACE, A	S	325
1821	FALL OF RICHMOND, VIRGINIA, THE	L	675
1822	FALL OF RICHMOND, VIRGINIA, THE	S	190
1823	FALL OF RICHMOND, VA., THE	S	190
1824	FALLING SPRINGS, VA.	S	175
1825	FALL OF SEBASTOPOL, THE	S	75
1826	FALLS "DES CHATES" / Ottawa River, Canada	S	175
1827	FALLS OF NIAGARA / From Clifton House	S	300
1828	FALLS OF NIAGARA, THE / "From the Canada Side"	L	2000
1829	FALLS OF NIAGARA, THE / "From the Canada Side"	L	2130
1830	FALLS OF THE OTTAWA RIVER / Canada	S	200
1831	FALLS OF TIVOLI, ITALY	S	50
1832	FALSETTO / By Enquirer dam Farfaletta	S	320
1833	FAMILIEN REGISTER	S	20
1834	FAMILIEN REGISTER	S	20
1835	FAMILY DEVOTION / Reading the Scriptures	S	35
1836	FAMILY DEVOTION	S	35
1837	FAMILY GARLAND	S	35
1838	FAMILY GARLAND	S	35
1839	FAMILY OF LOUIS KOSSUTH	S	40
1840	FAMILY PETS, THE	S	60
1841	FAMILY PHOTOGRAPH REGISTER	S	45
1842	FAMILY PHOTOGRAPH REGISTER, THE	M	55
1843	FAMILY PHOTOGRAPH TREE, THE	S	75
1844	FAMILY RECORD	S	30
1845-			
1847	FAMILY REGISTER	S	40
1848	FAMILY REGISTER	S	65
1849-			
1853	FAMILY REGISTER	S	40
1854	FAMILY REGISTER	S	25
1855	FAMILY REGISTER	S	25
1856	FAMILY REGISTER (A)	S	30
1857	FAMILY REGISTER (C)	S	40
1858	FAMILY REGISTER / For Colored People	S	40
1859	FAMILY REGISTER	M	60
1860	FAMOUS DOUBLE TROTTING TEAM, THE	L	1040
1861	FAMOUS TROTTER MAJOLICA, BY BONNER'S "STARTLE"	L	1100
1862	FAMOUS TROTTER POLICE GAZETTE, FORMERLY EMMA B.	L	1050
1863	FAMOUS TROTTING GELDING GUY BY KENTUCKY PRINCE	S	275
1864	FAMOUS TROTTING MARE GOLDSMITH MAID, RECORD 2:14	S	350
1865	FANCIED SECURITY, OR THE RATS ON A BENDER	S	285
1866	FANNIE	S	55
1867	FANNIE	S	55
1868-			
1871	FANNY	S	55
1872	FANNY ELSSLER IN THE SHADOW DANCE	S	65
1873	FANNY ELSSLER / In the Favorite Dance	S	60
1874	FAREWELL, THE	S	75
1875	FAREWELL, THE	M	75
1876	FAREWELL A'WHILE MY NATIVE ISLE	S	45
1877	FARM AND FIRESIDE	M	185
1878	FARM LIFE IN SUMMER / The Cooling Stream	L	675
1879	FARM YARD / No. 1 # 717	S	125
1880	FARM YARD, THE	S	275
1881	FARM-YARD IN WINTER, THE	L	3660
1882	FARM YARD PETS	S	55
1883	FARM YARD PETS	S	55
1884	FARM YARD — WINTER	S	350
1885	FARMER GARFIELD / Cutting a swath...	S	145
1886	FARMER'S DAUGHTER, THE	S	65
1887	FARMER'S FRIENDS, THE	S	75
1888	FARMER'S FRIENDS, THE	S	155
1889	FARMER'S HOME — AUTUMN, THE	L	1300
1890	FARMER'S HOME — HARVEST, THE	L	1450
1891	FARMER'S HOME — SUMMER, THE	L	1300
1892	FARMER'S HOME — WINTER, THE	L	3075
1893	FARMER'S HOUSE / With plans for basement,...	S	70
1894	FARMER'S PRIDE, THE	S	85
1895	FARMER'S SON, THE	S	65

1974	FIRST LOVE	S	65
1975	FIRST MEETING OF WASHINGTON AND LAFAYETTE, THE	S	200
1976	FIRST PANTS, THE	M	100
1977	FIRST PARTING, THE	S	50
1978	FIRST PARTY, THE	S	85
1979	FIRST PLAYMATE, THE	S	55
1980	FIRST PRAYER, THE	S	30
1981	FIRST PRAYER, THE	M	30
1982	FIRST PREMIUM GRAPES / A Royal Cluster	M	275
1983	FIRST PREMIUM MUSCAT GRAPES / A Royal Cluster	M	275
1984	FIRST PREMIUM POULTRY	S	120
1985	FIRST PRESIDENT OF THE MORMONS	S	100
1986	FIRST PRESIDENTS / of the Church of Jesus Christ	S	160
1987	FIRST RIDE, THE	S	80
1988	FIRST RIDE, THE	S	80
1989	FIRST SCHOLAR, THE	S	55
1990	FIRST SMOKE, THE / All Right	S	225
1991	FIRST SMOKE, THE / All Wrong	S	225
1992	FIRST SNOW, THE	S	350
1993	FIRST STEP, THE	S	60
1994	FIRST STEP, THE	S	55
1995	FIRST STEP, THE / "Come to Mama"	S	60
1996	FIRST STEP, THE / "Come to Mama"	M	135
1997	FIRST TOILET, THE	S	65
1998	FIRST TROT OF THE SEASON, THE	L	2175
1999	FIRST VIOLET, THE	S	50
2000	FIRST UNDER THE WIRE	S	285
2001	FISH OUT OF WATER, A	M	180
2002	FISHERMAN'S COT, THE	VS	165
2003	FISHERMAN'S DOG, THE	S	60
2004	FLAG OF OUR UNION, THE	M	90
2005	FLEETY GOLDDUST / By Old Golddust,...	S	350
2006	FLEETY GOLDDUST, RECORD 2:10 ½	S	350
2007	FLIGHT INTO EGYPT	S	35
2008	FLIGHT OF ELIZA, THE	S	40
2009	FLIGHT OF THE MEXICAN ARMY	S	125
2010	FLIGHT OF THE MEXICAN ARMY	S	125
2011	FLIGHT OF THE STAKEHOLDER	S	190
2012	FLOATING DOWN TO MARKET	S	325
2013	FLORA	S	55
2014	FLORA	VS	40
2015	FLORA TEMPLE ... / In a match with Highland Maid	L	1400
2016	"FLORA TEMPLE" AND "HIGHLAND MAID"	L	1400
2017	FLORA TEMPLE AND LANCET / In their great match...	L	1500
2018	FLORA TEMPLE AND LANCET / In their great match...	L	1500
2019	FLORA TEMPLE AND PRINCESS / The Competitors...	L	1400
2020	FLORA TEMPLE AND PRINCESS / In their great match...	L	1450
2021	FLORAL BEAUTIES	S	125
2022	FLORAL BOUQUET	S	115
2023	FLORAL CROSS	S	45
2024	FLORAL GEMS	S	100
2025	FLORAL GIFT	S	100
2026	FLORAL GIFT	VS	65
2027	FLORAL GROUP	S	75
2028	FLORAL OFFERING	S	100
2029	FLORAL TREASURE	VS	65
2030	FLORAL TRIBUTE	S	100
2031	FLORA'S BOUQUET	S	75
2032	FLORA'S GIFT	VS	75
2033	FLORA'S TREASURE	VS	60
2034	FLORA'S TREASURES	S	85
2035	FLORENCE	S	60
2036	FLORIDA / By Rysdyk's Hambletonian...	L	1265
2037	FLORIDA COAST	S	220
2038	FLOWER BASKET, A	S	80
2039	FLOWER BASKET, A	S	90
2040	FLOWER BASKET, THE	S	90
2041	FLOWER DANCE, THE / By the Vienna Children	S	105
2042	FLOWER GIRL, THE	S	70
2043	FLOWER OF THE HAREM, THE	S	50
2044	FLOWER PIECE / A choice Bouquet	S	95
2045	FLOWER STAND, THE	S	85
2046	FLOWER-STREWN GRAVE, THE	S	35
2047	FLOWER VASE, THE	S	130
2048	FLOWER VASE, THE	S	125
2049	FLOWER VASE, THE	S	115
2050	FLOWER VASE, THE	S	115
2051	FLOWER VASE, THE	S	125
2052	FLOWER VASE, THE	M	285
2053	FLOWER VASE, THE	L	275
2054	FLOWER VASE, THE	S	95
2055	FLOWER VASE, THE	S	95
2056	FLOWERS	S	100
2057	FLOWERS	S	125
2058	FLOWERS	S	90
2059	FLOWERS	M	95
2060	FLOWERS	S	110
2061	FLOWERS NO. 1	S	100
2062	FLOWERS NO. 1	S	120

2063	FLOWERS NO. 1	S	100
2064	FLOWERS NO. 1	S	100
2065	FLOWERS NO. 2	S	120
2066	FLOWERS NO. 2	S	125
2067	FLOWERS — ROSES AND BLUEBELLS	S	125
2068	FLOWERS — ROSES AND BLUEBELLS	M	155
2069	FLOWERS / Roses and Buds	S	95
2070	FLOWERS / Roses and Buds	S	95
2071	FLUSHING A WOODCOCK	S	240
2072	FLY FISHING	S	225
2073	FLYING DUTCHMAN C. MARLOW AND VOLTIGEUR N. FLATMAN	L	1285
2074-2077	FOLIAGE	VS	135
2078	FOLLY OF THE SECESSION, THE	S	125
2079	FONT AT EASTER, THE	S	50
2080	FONT AT EASTER, THE	S	50
2081	FORDING THE RIVER	M	335
2082	FORDING THE RIVER	S	100
2083	FORDS OF THE JORDAN, THE	S	40
2084	FOREST SCENE ON THE LEHIGH	M	500
2085	FOREST SCENE, SUMMER	S	175
2086	FOREST SCENE, SUMMER	S	175
2087	FORK OVER WHAT YOU OWE	S	175
2088	FORT PICKENS / Pensacola Harbor, Florida	S	200
2089	FORT SUMTER / Charleston Harbor, S.C.	S	225
2090	FOUL TIP, A	S	345
2091	"FOUR-IN-HAND"	L	1800
2092	"FOUR-IN-HAND"	L	1800
2093	"FOUR-IN-HAND"	L	1800
2094	FOUR MASTED STEAMSHIP "EGYPT" OF THE NATIONAL LINE	S	250
2095	FOUR OARED SHELL RACE, A	L	3500
2096	FOUR SEASONS OF LIFE, CHILDHOOD, THE	L	1000
2097	FOUR SEASONS OF LIFE, MIDDLE AGE, THE	L	1150
2098	FOUR SEASONS OF LIFE, THE MIDDLE AGE	L	1000
2099	FOUR SEASONS OF LIFE. OLD AGE, THE	L	1200
2100	FOUR SEASONS OF LIFE. YOUTH, THE	L	1200
2101	FOURTH OF JULY	S	110
2102	FOURTH OF JULY / Young America Celebrating	L	325
2103	FOX CHASE / Gone Away, No. 2	S	300
2104	FOX CHASE / In Full Cry, No. 3	S	300
2105	FOX CHASE / The Death, No. 4	S	300
2106	FOX CHASE / Throwing Off, No. 1	S	300
2107	FOX HOUNDS	S	300
2108	FOX-HUNTER, THE	S	300
2109	FOX-HUNTER, THE	S	300
2110	FOX HUNTING, FULL CRY	M	800
2111	FOX HUNTING, THE DEATH	M	800
2112	FOX HUNTING, THE FIND	M	800
2113	FOX HUNTING, THE MEET	M	800
2114	FOX WITHOUT A TAIL — OR THE SOUTHERN CONFEDERACY	S	150
2115	FOXHALL / By King Alphonso, Dam Jamaica,...	L	1000
2116	FOXHALL / Mr. Jas. R. Keene's bay colt...	S	290
2117	FOXHALL — WINNER OF THE GRAND PRIZE OF PARIS 1881	VS	75
2118	FOX'S OLD BOWERY THEATRE	M	400
2119	FRAGRANT AND FAIR	S	145
2120	FRAGRANT CUP, A	M	100
2121	FRANCES	S	60
2122	FRANCIS R. SHUNK / Governor of Pennsylvania	S	45
2123	FRANKIE AND TIP	S	50
2124	FRANKLIN	S	75
2125	FRANKLIN	M	100
2126	FRANKLIN PIERCE / Democratic Candidate...	S	90
2127	FRANKLIN PIERCE / Fourteenth President...	S	90
2128	FRANKLIN'S EXPERIMENT, JUNE 1752	S	575
2129	FRAUD AGAINST TRUTH	S	95
2130	FREDERICK DOUGLASS / The Colored Champion of Freedom	S	50
2131	FREE FOR ALL	M	325
2132	FREE LUNCH, A	M	250
2133	FREE SOIL BANNER	S	165
2134	FREE TRADE AND PROTECTION	M	215
2135	FREEDMEN'S BUREAU, THE	S	200
2136	FREEDOM TO IRELAND	M	55
2137	FREEDOM TO THE SLAVES	S	285
2138	FREELAND / By Longfellow, Dam Belle Night,...	S	285
2139	FRENCH REVOLUTION, THE / Burning the Royal Carriages	S	155
2140	FRENCH REVOLUTION, THE / Scene in the Throne-room	S	155
2141	FRESH BOUQUET, A	S	125
2142	FRESH COOL / LAGER BEER	S	125
2143	FRIEND CLEVELAND	S	100
2144	FRIEND IN NEED, A	S	55
2145	FRIENDS OF FLOWERS	S	50
2146	FRIENDSHIP, LOVE, AND TRUTH	S	50

2147	FRIGHTENED BROOD, THE	S	70
2148	FRIGHTENED BROOD, THE	S	70
2149	FROLICSOME KITS	S	90
2150	FROLICKSOME KITS	VS	65
2151	FROLICKSOME PETS	S	100
2152	FROM SHORE TO SHORE	S	45
2153	FRONTIER LAKE, THE	S	190
2154	FRONTIER SETTLEMENT, A	M	400
2155	FROZEN UP	S	875
2156	FRUIT	M	150
2157	FRUIT	S	75
2158	FRUIT	S	75
2159	FRUIT, THE, NO.1	S	90
2160	FRUIT AND FLOWER PIECE	M	270
2161	FRUIT AND FLOWER PIECE	S	90
2162	FRUIT AND FLOWER PIECE	S	90
2163	FRUIT AND FLOWERS	S	85
2164	FRUIT AND FLOWERS. NO. 1	S	90
2165	FRUIT AND FLOWERS. NO. 2	S	90
2166	FRUIT AND FLOWERS	S	90
2167	FRUIT AND FLOWERS	S	90
2168	FRUIT AND FLOWERS	S	90
2169	FRUIT AND FLOWERS	S	90
2170	FRUIT AND FLOWERS IN SUMMER	S	80
2171	FRUIT AND FLOWERS OF AUTUMN	M	215
2172	FRUIT AND FLOWERS OF AUTUMN	M	225
2173	FRUIT GIRL, THE	S	50
2174	FRUIT GIRL, THE	S	50
2175	FRUIT GIRL, THE	S	50
2176	FRUIT PIECE, THE	S	95
2177	FRUIT PIECE, THE	M	200
2178	FRUIT PIECE, THE	M	280
2179	FRUIT PIECE	S	95
2180	FRUIT PIECE	S	95
2181	FRUIT PIECE	VS	60
2182	FRUIT PIECE / Summer Gift	S	155
2183	FRUIT PIECE / Autumn Gift	S	155
2184	FRUIT VASE	S	95
2185	FRUIT VASE	S	95
2186	FRUIT VASE	S	95
2187	FRUIT VASE	S	95
2188	FRUITS AND FLOWERS	S	90
2189	FRUITS, AUTUMN VARIETIES	S	105
2190	FRUITS, SUMMER VARIETIES	S	105
2191	FRUITS AND FLOWERS OF SUMMER	M	255
2192	FRUITS OF INTEMPERANCE, THE	S	210
2193	FRUITS OF INTEMPERANCE, THE	S	210
2194	FRUITS OF TEMPERANCE, THE	S	175
2195	FRUITS OF TEMPERANCE, THE	S	175
2196	FRUITS OF THE GARDEN	S	90
2197	FRUITS OF THE GOLDEN LAND	S	100
2198	FRUITS OF THE SEASON	S	90
2199	FRUITS OF THE SEASON	S	90
2200	FRUITS OF THE SEASON — AUTUMN	S	100
2201	FRUITS OF THE SEASONS	S	125
2202	FRUITS OF THE SEASONS	S	125
2203	FRUITS OF THE TROPICS	S	95
2204	"FULL HAND, A"	S	65
2205	FUNERAL OF DANIEL O'CONNELL, THE	S	40
2206	FUNERAL OF PRESIDENT LINCOLN, NEW YORK...	S	300
2207	"FUST BLOOD, DE"	S	225
2208	"FUST KNOCK-DOWN, DE"	S	225
2209	FUTURITY RACE AT SHEEPSHEAD BAY, THE	L	1850
2210	GALLANT CHARGE OF THE FIFTY-FOURTH MASSACHUSETTS...	S	150
2211	GALLANT CHARGE OF THE KENTUCKY CAVALRY...	S	140
2212	GALLANT CHARGE OF THE KENTUCKIANS...	S	140
2213	GALLANT CHARGE OF THE "SIXTY-NINTH"	S	150
2214	GAME COCK, THE — EL GALLO DE PELEA / Full Feather	S	200
2215	GAME COCK, THE — EL GALLO DE PELEA / Trimmed	S	200
2216	GAME COCK, THE	S	200
2217	GAME DOG, A	S	175
2218	GAME OF THE ARROW / Archery of the Mandan Indians.	M	1200
2219	GAP OF DUNLOE, THE / Ireland	S	85
2220	GARDEN OF GETHSEMANE, THE	S	25
2221	GARDEN, ORCHARD AND VINE	M	725
2222	GARFIELD FAMILY, THE	S	60
2223	GARNET POOL, THE / White Mountains	M	350
2224	GARRETT DAVIS / By Glencoe, Dam by Sir Leslie	L	1650
2225	GATE OF BELEN / Mexico...	S	40
2226	GAY DECEIVER, THE	M	125
2227	GEBURTS UND TAUFSCHEIN	S	25
2228	GEMS OF THE ATLANTIC, THE	S	450
2229	GEMS OF THE PACIFIC, THE	S	450
2230	GEMS OF AMERICAN SCENERY	S	245
2231	GENERAL AMPUDIA TREATING FOR THE CAPITULATION...	S	130
2232	GENERAL AND MRS. WASHINGTON	S	100

2233 GENERAL ANDREW JACKSON / The Hero, the Sage,...	S	95
2234 GENERAL ANDREW JACKSON / The Hero, the Sage,...	S	95
2235 GEN. ANDREW JACKSON / The Hero of New Orleans	S	105
2236 GEN. ANDREW JACKSON / The Hero of New Orleans	S	105
2237 GEN. ANDREW JACKSON / The Hero of New Orleans	S	105
2238 GENERAL ANDREW JACKSON / At New Orleans	S	95
2239 GENERAL ANDREW JACKSON / Born 15th March, 1767...	S	95
2240 GENL. ANDREW JACKSON / "The Union...preserved"	S	95
2241 GEN. BEM, THE HUNGARIAN HERO	S	35
2242 GEN. BENJ. F. BUTLER / Greenback Labor Candidate...	S	45
2243 GENERAL BUTLER AND DEXTER / In their great match...	L	1310
2244 GENERAL BUTLER AND DEXTER / Match for $2000,...	S	595
2245 GEN. CHESTER A. ARTHUR / Republican Candidate...	M	100
2246 GEN. CHESTER A. ARTHUR / Twenty-first President...	M	100
2247 GEN. D.E. TWIGGS / At...Chapuletepec	S	70
2248 GENL. DEMBINSKY / The Polish Champion of Liberty	S	35
2249 GENL. E. CAVAIGNAC	S	35
2250 GENERAL FRANCIS MARION, OF SOUTH CAROLINA...	S	375
2251 GENL. FRANK P. BLAIR, JR.	S	50
2252 GENL. FRANKLIN PIERCE	L	100
2253 GENL. FRANKLIN PIERCE / Fourteenth President...	S	85
2254 GENL. FRANZ SIGEL	S	50
2255 GENL. FRANZ SIGEL / At the battle of Pea Ridge, Ark.	S	85
2256 GENL. G.T. BEAUREGARD	S	60
2257 GENERAL GARIBALDI / The Hero of Italy	S	35
2258 GENERAL GARIBALDI / The Hero of Italy	S	35
2259 GENL. GEO. B. McCLELLAN AND STAFF	S	95
2260 GENL. GEO. B. McCLELLAN AND STAFF / before Yorktown	S	100
2261 GEN. GEORGE WASHINGTON / The Father of his Country	S	100
2262 GEN. GEORGE WASHINGTON / The Father of his Country	S	100
2263 GEN. GEORGE WASHINGTON / The Father of his Country	S	100
2264 GENERAL GEORGE WASHINGTON / The Father...	S	100
2265 GENL. GEORGE WASHINGTON / The Father of his Country	M	200
2266 GENL. GEORGE WASHINGTON / The Father of his Country	S	100
2267 GENL. GEORGE WASHINGTON MORRISON NUTT	S	125
2268 GENL. GORGEY / The Hungarian Patriot	S	35
2269 GENERAL GRANT	S	75
2270 GENERAL GRANT	L	200
2271 GENERAL GRANT, U.S.	L	200
2272 GENERAL GRANT / In his library, writing his memoirs	L	200
2273 GENERAL GRANT AND FAMILY	S	65
2274 GENERAL GRANT AT THE TOMB OF ABRAHAM LINCOLN	S	85
2275 GENERAL HELMUTH VON MOLTKE VON PREUSSEN	S	40
2276-2279 GENERAL ISRAEL PUTNAM / The Iron Son of '76...	S	150
2280 GEN. JAMES A. GARFIELD / Twentieth President...	S	65
2281 GENERAL JAMES A. GARFIELD / Twentieth President...	M	75
2282 GENL. JAMES IRVIN / Whig Candidate...	S	50
2283 GEN. JOHN C. BRECKENRIDGE	S	60
2284 GENL. JOHN E. WOOL / At the battle of Buena Vista	S	70
2285 GEN. JOSEPH E. JOHNSTON	S	75
2286 GENERAL LAFAYETTE / Companion-in-Arms of Washington	S	90
2287 GENERAL LAFAYETTE / Companion-in-Arms of Washington	S	90
2288 GENL. LEWIS CASS / Of Michigan	S	50
2289 GENL. MEAGHER AT THE BATTLE OF FAIR OAKS, VA.	S	140
2290 GENERAL PHILIP KEARNEY	S	130
2291 GENERAL ROBERT E. LEE	S	75
2292 GEN. ROBERT E. LEE AT THE GRAVE OF "STONEWALL" JACKSON	S	110
2293 GENERAL SCOTT'S VICTORIOUS ENTRY...CITY OF MEXICO	S	125
2294 GENERAL SHIELDS AT THE BATTLE OF WINCHESTER, VA., 1862	S	140
2295 GENERAL STONEMAN'S GREAT CAVALRY RAID, MAY 1863	S	150

2296	GENERAL TAYLOR AND STAFF	S	95
2297	GENL. TAYLOR AT THE BATTLE OF PALO ALTO	S	125
2298	GENL. TAYLOR AT THE BATTLE OF PALO ALTO	S	125
2299	GENL. TAYLOR AT THE BATTLE OF RESACA DE LA PALMA	S	125
2300	GENL. TAYLOR AT THE BATTLE OF RESACA DE LA PALMA	S	125
2301	GENL. THOMAS FRANCIS MEAGHER AT...FREDERICKSBURG	S	145
2302	GENERAL TOM THUMB	S	120
2303	GENERAL TOM THUMB / Born in 1832...	S	120
2304	GENERAL TOM THUMB / Born in 1832...	S	120
2305	GENERAL TOM THUMB / The smallest man alive	S	135
2306	GENERAL TOM THUMB / Standing by...	S	135
2307	GENL. TOM THUMB & WIFE, COM. NUTT & MINNIE WARREN	S	160
2308	GENL. TOM THUMB AS HOP O' MY THUMB	S	100
2309	GENL. TOM THUMB'S MARRIAGE AT GRACE CHURCH, N.Y.	S	100
2310	GENERAL TRANSATLANTIC COMPANY'S STEAMER NORMANDIE	S	225
2311	GENERAL TROCHU / Gouverneur de Paris...	S	25
2312	GEN. U.S. GRANT	S	75
2313	GEN. U.S. GRANT	S	75
2314	GEN. U.S. GRANT	S	75
2315	GENERAL U.S. GRANT / General-in-Chief...	S	75
2316	GEN. U.S. GRANT / The Nation's Choice...	S	75
2317	GENERAL U.S. GRANT / President of the U.S.	S	75
2318	GENERAL U.S. GRANT	S	70
2319	GENERAL VIEW OF THE CITY OF TORONTO, N.C.	M	150
2320	GENL. VON STEINMETZ / Von Preussen	S	30
2321	GENL. WILLIAM F. PACKER / Governor of Pennsylvania	S	35
2322	GENERAL WILLIAM H. HARRISON / Hero of Tippecanoe	S	135
2323	GENERAL WILLIAM H. HARRISON / Hero of Tippecanoe	S	135
2324	GEN. WILLIAM H. HARRISON / Battle of Tippecanoe	S	135
2325	GEN. WILLIAM H. HARRISON / Battle of Tippecanoe	S	135
2326	GENL. WILLIAM J. WORTH	S	50
2327	GENL. WILLIAM T. SHERMAN / U.S. Army	S	65
2328	GEN. WINFIELD S. HANCOCK / Democratic Candidate...	S	65
2329	GEN. Z. TAYLOR / The Hero of the Rio Grande	S	95
2330	GEN. Z. TAYLOR / "Rough and Ready"	S	95
2331	GENERAL Z. TAYLOR / "Rough and Ready"	S	95
2332	GENTEEL STEPPER, A	VS	50
2333	GENTEEL STEPPER, A	VS	50
2334	GENUINE HAVANA, A	S	55
2335	GEORGE	S	50
2336	GEORGE AND LUCY	S	60
2337	GEORGE AND MARTHA WASHINGTON	S	75
2338	GEORGE B. McCLELLAN	M	75
2339	GEORGE CLINTON	VS	35
2340	GEORGE M. DALLAS	S	75
2341	GEORGE M. DALLAS / The People's Candidate...	S	85
2342	GEORGE M. DALLAS / The People's Candidate...	S	85
2343	GEORGE M. DALLAS / Vice-President of the U.S.	S	110
2344	GEORGE M. PATCHEN, BROWN DICK AND MILLER'S DAMSEL	L	1725
2345	GEORGE W. WILLIAMS	S	30
2346	GEORGE WASHINGTON	M	115
2347	GO. WASHINGTON	M	115
2348	GO. WASHINGTON	M	115
2349	GO. WASHINGTON	S	90
2350	GO. WASHINGTON	S	90
2351	GEORGE WASHINGTON	S	95
2352-2355	GEORGE WASHINGTON / First President	S	100
2356	GEORGE WASHINGTON AND HIS FAMILY	L	275
2357	GEORGIANA	S	50
2358	GEORGIANA	S	50
2359	GEORGIE / Quite tired	S	45
2360	GEORGIE / Quite tired	S	45
2361	GERMAN BEAUTY	S	45
2362	GERTRUDE	S	45
2363	GETTING A BOOST	S	250
2364	GETTING A FOOT	S	200
2365	GETTING A HOIST / A Bad Case of Heaves	S	220
2366	GETTING A HOIST	VS	150
2367	GETTING DOWN	S	75
2368	GETTING IN	S	75

No.	Title		Size	Price
2369	**GETTING OUT**		S	75
2370	**GETTING UP**		S	75
2371	**GHOST, THE** / A new spectral illusion...		S	165
2372	**GIANT'S CAUSEWAY, THE** / County Antrim — Ireland		S	60
2373	**GIFT OF AUTUMN, A**		S	135
2374	**GIPSIE'S CAMP, THE**		M	125
2375	**GIRARD AVENUE BRIDGE** / Fairmount Park, Philadelphia		S	180
2376	**GIRL I LOVE, THE**		S	60
2377	**GIRL OF MY HEART, THE**		S	60
2378	**GIRL OF THE PERIOD, THE**		S	85
2379	**"GIVE ME LIBERTY, OR GIVE ME DEATH!"**		S	275
2380	**GIVE US THIS DAY** / OUR DAILY BREAD		S	25
2381	**GIVE US THIS DAY OUR DAILY BREAD**		S	25
2382	**GIVING HIM TAFFY**		S	60
2383	**GLEN AT NEWPORT, THE**		S	225
2384	**GLENGARIFF INN,** / Ireland		S	55
2385	**GLIMPSE OF THE HOMESTEAD, A**		M	370
2386	**GLIMPSE OF THE HOMESTEAD, A**		M	370
2387	**GLIMPSE OF THE HOMESTEAD, A**		M	325
2388	**GLORIOUS CHARGE OF HANCOCK'S DIVISION...**		S	165
2389	**GO AS YOU PLEASE**		S	70
2390	**GO IN AND WIN**		S	185
2391	**GOD BLESS FATHER AND MOTHER**		S	60
2392	**GOD BLESS OUR HOME**		S	125
2393	**GOD BLESS OUR SCHOOL**		S	145
2394	**GOD BLESS THEE AND KEEP THEE**		S	25
2395	**"GOD IS LOVE"**		S	25
2396	**GOD SAVE MY FATHER'S LIFE**		S	30
2397	**GOD SPAKE ALL THESE WORDS**		S	25
2398	**GOING AGAINST THE STREAM**		M	80
2399	**GOING FOR A SHINE**		S	190
2400	**GOING FOR HIM**		S	85
2401	**GOING FOR THE MONEY**		L	1200
2402	**GOING IT BLIND** / "Give me a good pair of wheels..."		S	150
2403	**GOING TO PASTURE** / Early Morning		S	165
2404	**GOING TO THE FRONT!**		S	175
2405	**GOING TO THE FRONT**		S	175
2406	**GOING TO THE FRONT**		VS	65
2407	**GOING TO THE MILL**		S	130
2408	**GOING TO THE MILL**		M	225
2409	**GOING TO THE TROT** / A Good day and Good Track		L	1600
2410	**GOING WITH THE STREAM**		M	80
2411	**GOLD DUST**		S	275
2412	**GOLD MINING IN CALIFORNIA**		S	800
2413	**GOLD SEEKERS, THE**		S	550
2414	**GOLDEN FRUITS OF CALIFORNIA**		L	725
2415	**GOLDEN MORNING, A**		M	200
2416	**GOLDEN MORNING, THE**		M	200
2417	**GOLDEN MORNING, THE**		S	200
2418	**GOLDSMITH MAID, 2:14**		S	275
2419	**GOLDSMITH MAID** / Record 2:14		S	300
2420	**GOLDSMITH MAID AND AMERICAN GIRL**		L	1350
2421	**GOLDSMITH MAID AND JUDGE FULLERTON**		S	500
2422	**GOLDSMITH MAID AND LUCY**		S	300
2423	**Duplicates c65**		—	—
2424	**GOOD CHANCE, A**		L	3250
2425	**GOOD DAY'S SPORT, A** / Homeward Bound		L	4000
2426	**GOOD ENOUGH!**		S	55
2427	**GOOD EVENING**		S	70
2428	**GOOD LITTLE FIDO AND NAUGHTY KITTIE**		S	85
2429	**GOOD FOR A COLD**		S	60
2430	**GOOD FOR NOTHING**		M	100
2431	**GOOD FRIENDS, THE**		S	50
2432	**GOOD HUSBAND, THE**		S	200
2433	**GOOD LITTLE BROTHER**		S	75
2434	**GOOD LITTLE GIRL**		S	65
2435	**GOOD LITTLE SISTERS**		S	75
2436	**GOOD LUCK TO YE**		VS	60
2437	**GOOD MAN AT THE HOUR OF DEATH**		S	80
2438	**GOOD MORNING**		S	50
2439	**GOOD MORNING! LITTLE FAVORITE!**		S	50
2440	**GOOD NATURED MAN, THE**		S	45
2441	**GOOD NIGHT! LITTLE PLAYFELLOW**		S	65
2442	**"GOOD OLD DOGGIE"**		M	110
2443	**GOOD OLD ROVER AND KITTIE**		S	85
2444	**GOOD RACE, WELL WON, A**		L	1100
2445	**GOOD SAMARITAN, THE**		S	35
2446	**GOOD SAMARITAN, THE**		S	35
2447	**GOOD SEND OFF, GO!**		L	1250
2448	**GOOD SEND OFF, GO!** / Goldsmith Maid...Henry		L	1250
2449	**GOOD SHEPHERD, THE**		S	45
2450	**GOOD SHEPHERDESS, THE**		S	45
2451	**GOOD TIMES ON THE OLD PLANTATION**		S	450
2452	**GOSPEL ORDINANCE**		S	25
2453	**GOT 'EM BOTH!**		S	225
2454	**GOT 'EM BOTH!**		L	500
2455	**"GOT THE DROP ON HIM"**		S	250
2456	**GOVERNMENT GUARDS — CONN.** / 1st Company		S	100

2457	GOV. GROVER CLEVELAND / 22nd President...	M	85
2458	GOVERNMENT HOUSE	L	550
2459	GOVERNOR RUTHERFORD B. HAYES	S	65
2460	GOV. SAMUEL J. TILDEN / Of New York	S	60
2461	GOVERNOR SPRAGUE / Black Trotting Stallion,...	S	250
2462	GOV. THOMAS A. HENDRICKS / Of Indiana	S	50
2463	GOVERNOR WADE HAMPTON	S	50
2464	GRACE DARLING	S	150
2465	GRACE, MERCY AND PEACE	S	30
2466	GRACES OF THE BICYCLE, THE	S	100
2467	GRACES OF THE BICYCLE, THE	VS	60
2468	GRACIE	S	50
2469	GRAF VON BISMARK / Preussicher Premier Minister	S	35
2470	GRAND BANNER OF THE RADICAL DEMOCRACY / for 1864	S	175
2471	GRAND BIRD'S EYE VIEW OF THE EAST RIVER...BRIDGE	L	1500
2472	GRAND BIRD'S EYE VIEW OF THE...COLUMBIAN EXHIBITION	L	675
2473	GRAND CALIFORNIA FILLY, SUNOL...	S	325
2474	GRAND CALIFORNIA FILLY, THE / Wildflower	S	325
2475	GRAND CALIFORNIA TROTTING MARE SUNOL	L	1250
2476	GRAND CENTENNIAL SMOKE, A / History in Vapor	M	300
2477	GRAND CENTENNIAL WEDDING, THE	M	250
2478	GRAND DEMOCRATIC FREE SOIL BANNER	S	175
2479	GRAND DISPLAY OF FIREWORKS AND ILLUMINATIONS, THE	S	350
2480	GRAND DISPLAY OF FIREWORKS AND ILLUMINATIONS, THE	M	450
2481	GRAND DRIVE, CENTRAL PARK, N.Y., THE	L	2500
2482	GRAND FIGHT FOR THE CHAMPION'S BELT...	S	150
2483	GRAND FOOTBALL MATCH— DARKTOWN AGAINST BLACKVILLE / A KICK OFF	S	225
2484	GRAND FOOTBALL MATCH— DARKTOWN AGAINST BLACKVILLE	S	225
2485	GRAND FUNERAL PROCESSION IN MEMORY OF GEN. JACKSON	S	75
2486	GRAND FUNERAL PROCESSION OF THE VICTIMS REVOLUTION	S	35
2487	GRAND HORSE ST. JULIEN, THE "KING OF TROTTERS," THE	S	320
2488	GRAND HORSE ST. JULIEN, THE "KING OF TROTTERS," THE	S	320
2489	GRAND NATIONAL AMERICAN BANNER / Millard Fillmore...	S	250
2490	GRAND NATIONAL DEMOCRATIC BANNER / Polk The young Hickory	S	225
2491	GRAND NATIONAL DEMOCRATIC BANNER / Polk the young Hickory	S	225
2492	GRAND NATIONAL DEMOCRATIC BANNER / Lewis Cass	S	200
2493	GRAND NATIONAL DEMOCRATIC BANNER / Franklin Pierce	S	200
2494	GRAND NATIONAL DEMOCRATIC BANNER / Press Onward	S	200
2495	GRAND NATIONAL DEMOCRATIC BANNER / James Buchanan	S	200
2496	GRAND NATIONAL DEMOCRATIC BANNER FOR 1860	S	200
2497	GRAND NATIONAL DEMOCRATIC BANNER / Peace! Union! and Victory!	S	205
2498	GRAND NATIONAL DEMOCRATIC BANNER	S	200
2499	GRAND NATIONAL DEMOCRATIC BANNER / 1880	L	265
2500	GRAND NATIONAL DEMOCRATIC BANNER / Home Rule and Honest Money	S	200
2501	GRAND NATIONAL / Liberal Republican banner for 1872	S	210
2502	GRAND NATIONAL REPUBLICAN BANNER / Free Labor...	S	245
2503	GRAND NATIONAL REPUBLICAN BANNER FOR 1872	S	200

2504	GRAND NATIONAL REPUBLICAN BANNER / Liberty & Union	S	200
2505	GRAND NATIONAL REPUBLICAN BANNER / 1880	S	200
2506	GRAND NATIONAL REPUBLICAN BANNER / 1880	L	275
2507	GRAND NATIONAL TEMPERANCE BANNER	S	160
2508	GRAND NATIONAL TEMPERANCE BANNER	S	160
2509	GRAND NATIONAL UNION BANNER FOR 1860	S	220
2510	GRAND NATIONAL UNION BANNER FOR 1864	S	220
2511	GRAND NATIONAL WHIG BANNER / Onward	S	195
2512	GRAND NATIONAL WHIG BANNER / Onward	S	195
2513	GRAND NATIONAL WHIG BANNER / Zachary Taylor...	S	220
2514	GRAND NATIONAL WHIG BANNER / Press Onward	S	220
2515	GRAND NATIONAL, WHIG BANNER	S	185
2516	GRAND NEW STEAMBOAT PILGRIM, THE LARGEST IN THE WORLD	L	1000
2517	GRAND PACER FLYING JIB, RECORD 2:04, THE	S	250
2518	GRAND PACER MASCOT BY DECEIVER / Record 2:04	L	705
2519	GRAND PACER RICHBALL, RECORD 2:12 ½, THE	S	250
2520	GRAND PATENT INDIA—RUBBER AIR LINE...TO CALIFORNIA	M	400
2521	GRAND RACER KINGSTON, BY SPENDTHRIFT, THE	L	1140
2522	GRAND RECEPTION OF KOSSUTH	S	75
2523	GRAND SALOON OF THE PALACE STEAMER DREW	L	1000
2524	GRAND STALLION ALLERTON, BY JAY BIRD, THE	S	240
2525	GRAND STALLION MAXY COBB, BY HAPPY MEDIUM, THE	S	250
2526	GRAND STALLION MAXY COBB, BY HAPPY MEDIUM, THE	S	250
2527	GRAND THROUGH ROUTE BETWEEN NORTH AND SOUTH	S	550
2528	GRAND TROTTER CLINGSTONE...	L	1050
2529	GRAND TROTTER "CLINGSTONE" BY RYSDYK'S DAM...	S	285
2530	GRAND TROTTER EDWIN THORNE...	L	950
2531	GRAND TROTTING QUEEN NANCY HANKS...	L	1175
2532	GRAND TROTTING STALLION AXTEL...	L	975
2533	GRAND TROTTING STALLION BONESETTER...	S	250
2534	GRAND TROTTING STALLION BONESETTER...	S	250
2535	GRAND TROTTING STALLION ST. JULIEN...	L	1225
2536	GRAND UNITED ORDER OF ODD-FELLLOWS / Chart	S	80
2537	GRAND UNITED STATES CENTENNIAL EXHIBITION 1876	S	160
2538	GRAND YOUNG TROTTER JAY EYE SEE, THE / Record 2:10	S	290
2539	GRAND YOUNG TROTTING MARE NANCY HANKS...	S	300
2540	GRAND YOUNG TROTTING STALLION "AXTELL"...	S	275
2541	GRANDEST PALACE DRAWING ROOM STEAMERS IN THE WORLD	L	1000
2542	GRANDFATHER'S ADVICE / "Honor thy Father and Mother"	S	50
2543	GRANDMA'S "SPECS"	S	60
2544	GRANDMA'S "SPECS" / #272	S	60
2545	GRANDMA'S TREASURES	S	55
2546	GRANDMOTHER'S PRESENT, THE	S	60
2547	GRANDPA'S "SPECS"	S	60
2548	"GRANDPA'S SPECS"	S	60
2549	GRANDPA'S CANE	M	80
2550	GRANDPAPA'S CANE	S	70
2551	GRANDPAPA'S CANE	S	70
2552	GRANDPAPA'S RIDE	M	85
2553	GRANT AND HIS GENERALS	M	170
2554	GRANT & LEE MEETING NEAR APPOMATTOX COURTHOUSE, VA.	S	150
2555	GRANT AT HOME	S	45
2556	GRANT AT HOME	L	95
2557	GRANT IN PEACE	S	45
2558	GRASS HOPPPER STRUT, THE	S	125
2559	GRAVE OF STONEWALL JACKSON, THE	S	70
2560	GRAY EAGLE	L	875
2561	GRAY GELDING JACK BY PILOT MEDIUM	S	240

2562	GRAY'S ELEGY — IN A COUNTRY CHURCHYARD	L	300
2563	GRAZING FARM, THE	L	500
2564	GREAT AMERICAN BUCK HUNT OF 1856, THE	M	250
2565	GREAT AMERICAN TANNER, THE	S	200
2566	GREAT BARTHOLDI STATUE, THE	VS	80
2567	GREAT BARTHOLDI STATUE, THE	VS	80
2568	GREAT BARTHOLDI STATUE, THE	VS	80
2569	GREAT BARTHOLDI STATUE, THE	S	325
2570	GREAT BARTHOLDI STATUE, THE	L	1000
2571	GREAT BARTHOLDI STATUE, THE	L	1000
2572	GREAT BARTHOLDI STATUE, THE	L	1000
2573	GREAT BARTHOLDI STATUE, THE	M	600
2574	GREAT BARTHOLDI STATUE, THE	M	600
2574A	GREAT BARTHOLDI STATUE, THE	L	1000
2575	GREAT BARTHOLDI STATUE, THE	L	1000
2576	GREAT BARTHOLDI STATUE, THE	M	850
2577	GREAT BATTLE OF MURFREESBORO, TENN...	S	160
2578	GREAT BLACK SEA LION, THE	S	215
2579	GREAT COMMAND, THE	M	60
2580	GREAT CONFLAGRATION AT PITTSBURGH, PA...	S	625
2581	GREAT CONFLAGRATION AT PITTSBURGH, PA...	S	625
2582	GREAT DOUBLE TEAM TROT, A	L	950
2583	GREAT DOUBLE TEAM TROT / Darkness & Jessie Wales	L	1150
2584	GREAT EAST RIVER BRIDGE, THE	S	350
2585	GREAT EAST RIVER BRIDGE, THE	S	350
2586	GREAT EAST RIVER SUSPENSION BRIDGE / No. 1	VS	85
2587	GREAT EAST RIVER SUSPENSION BRIDGE / No. 2	VS	85
2588	GREAT EAST RIVER SUSPENSION BRIDGE / No. 3	VS	85
2589	GREAT EAST RIVER SUSPENSION BRIDGE, THE	VS	85
2590	GREAT EAST RIVER SUSPENSION BRIDGE, THE	VS	85
2591	GREAT EAST RIVER SUSPENSION BRIDGE, THE	VS	85
2592	GREAT EAST RIVER SUSPENSION BRIDGE, THE	L	1000
2593	GREAT EAST RIVER SUSPENSION BRIDGE, THE	L	1000
2594	GREAT EAST RIVER SUSPENSION BRIDGE, THE	S	350
2595	GREAT EAST RIVER SUSPENSION BRIDGE, THE	S	400
2596	GREAT EAST RIVER SUSPENSION BRIDGE, THE	L	1000
2597	GREAT EAST RIVER SUSPENSION BRIDGE, THE	L	1000
2598	GREAT EAST RIVER SUSPENSION BRIDGE, THE	VS	100
2599	GREAT EAST RIVER SUSPENSION BRIDGE, THE	L	1000
2600	GREAT EAST RIVER SUSPENSION BRIDGE, THE	L	1000
2601	GREAT EAST RIVER SUSPENSION BRIDGE, THE	L	1350
2602	GREAT EAST RIVER SUSPENSION BRIDGE, THE	L	1000
2603	GREAT EASTERN / The Mammoth Trotting Gelding...	S	275
2604	"GREAT EASTERN," THE / 22,500 Tons	M	250
2605	"GREAT EASTERN," THE / 22,500 Tons	S	200
2606	"GREAT EASTERN" / The Iron Steamship "Leviathan"...	L	975
2607	GREAT EXHIBITION OF 1851, THE	M	300
2608	GREAT EXHIBITION OF 1860, THE / Greeley...	M	225
2609	GREAT FAIR ON A GRAND SCALE, A	M	375
2610	GREAT FIELD IN A GREAT RUSH, A	L	1000
2611	GREAT FIGHT AT CHARLESTON, S.C. ...	S	275
2612	GREAT FIGHT BETWEEN THE "MERRIMAC" & "MONITOR"...	S	400
2613	GREAT FIGHT FOR THE CHAMPIONSHIP, THE	S	350
2614	GREAT FIRE AT BOSTON, THE	S	325
2615	GREAT FIRE AT CHICAGO, OCTR. 8th, 1871, THE	L	6000
2616	GREAT FIRE AT ST. JOHN, N.B., JUNE 20th, 1877, THE	S	195
2617	GREAT FIRE AT ST. LOUIS, MO.	S	400
2618	GREAT FIRE OF 1835, THE / "The Fire"...	L	1200
2619	GREAT FIRE OF 1835, THE / "The Ruins"	L	1000

2620	GREAT FIVE MILE ROWING MATCH FOR $4000	L	4000
2621	GREAT FOOTRACE FOR THE PRESIDENTIAL PURSE...	M	250
2622	GREAT HORSES IN A GREAT RACE	L	1215
2623	GREAT INTERNATIONAL BOAT RACE, AUG. 27th, 1869	S	1350
2624	GREAT INTERNATIONAL UNIVERSITY BOAT RACE, THE	L	3600
2625	GREAT INTERNATIONAL YACHT RACE...	L	2200
2626	GREAT INTERNATIONAL YACHT RACE...	S	350
2627	GREAT MATCH AT BALTIMORE, THE	M	250
2628	GREAT MATCH RACE (A DEAD HEAT)...	M	500
2629	GREAT MISSISSIPPI STEAMBOAT RACE, THE	S	500
2630	GREAT MISSISSIPPI STEAMBOAT RACE, THE	S	500
2631	GREAT MISSISSIPPI STEAMBOAT RACE, THE	S	500
2632	GREAT NAVAL BLOCKADE OF ROUND ISLAND, THE	M	325
2633	GREAT NAVAL VICTORY IN MOBILE BAY...	S	275
2634	GREAT OCEAN YACHT RACE, THE	L	2050
2635	GREAT OYSTER EATING MATCH...	S	190
2636	GREAT OYSTER EATING MATCH...	S	190
2637	GREAT PACER JOHNSTON...	S	250
2638	GREAT PACER SORREL DAN...	S	240
2639	GREAT POLE MARES BELLE HAMLIN AND "JUSTINA"...	S	300
2640	GREAT PONTOON DRAWBRIDGE, THE	S	350
2641	GREAT PRESIDENTIAL SWEEPSTAKES OF 1856, THE	M	300
2642	GREAT RACE AT BALTIMORE, OCT. 24th, 1877, THE	S	425
2643	GREAT RACE FOR WESTERN STAKES 1870, THE	S	300
2644	GREAT RACE ON THE MISSISSIPPI, THE	L	3850
2645	GREAT RACING CRACK HINDOO, BY VIRGIL...	S	300
2646	GREAT REPUBLICAN REFORM PARTY, THE	S	175
2647	GREAT RIOT AT THE ASTOR PALACE OPERA HOUSE, NEW YORK	S	400
2648	GREAT ST. LOUIS BRIDGE, THE / Across the Mississippi	S	575
2649	GREAT SALT LAKE, UTAH	S	150
2650	GREAT "SCULLERS RACE" ON THE ST. LAWRENCE, THE	S	1150
2651	GREAT SIRE OF TROTTERS, ELECTIONEER...	S	280
2652	GREAT THROUGH ROUTE BETWEEN THE / NORTH AND SOUTH	L	950
2653	GREAT VICTORY IN THE SHENENDOAH VALLEY, VA. Sept. 19th, 1864	S	160
2654	GREAT WALK — COME IN AS YOU CAN / The Finish	S	165
2655	GREAT WALK — GO AS YOU PLEASE / The Start	S	165
2656	GREAT WALK — COME IN AS YOU CAN, THE	VS	55
2657	GREAT WALK — GO AS YOU PLEASE, THE	VS	55
2658	GREAT WEST, THE	S	825
2659	GRECIAN BEND, THE	S	150
2660	GREY EAGLE / DRIVEN BY HIRAM WOODRUFF, ESQ.	L	925
2661	GREY EDDY / Centreville Course, L.I. ...	L	1275
2662	GREY MARE EMMA B BY BAYARD / Record 2:22 ½	S	235
2663	GREY MARE LUCY, THE PACING QUEEN, THE	S	275
2664	GREY MARE POLICE GAZETTE, FORMERLY EMMA B.	S	235
2665	GREY TROTTING WONDER HOPEFUL / Record 2:14 ¾	S	250
2666	GROTTOES OF THE SEA, THE	S	75
2667	GROTTOES OF THE SEA, THE	S	70
2668	GROUP OF FRUIT	S	100
2669	GROUP OF FLOWERS	S	110
2670	GROUP OF LILIES	S	100
2671	GROUP OF LILIES	S	100
2672	GROUP OF LILIES	S	100
2673	GROVER CLEVELAND / President of the U.S.	S	90
2674	GROWLING MATCH, A	S	70
2675- 2678	GUARDIAN ANGEL, THE	S	50
2679	GUION LINE STEAMSHIP "ARIZONA"...	S	300
2680	GULICK GUARD / Firemen with Pleasure...	M	145
2681	GUNBOAT CANDIDATE / At the Battle of Malvern Hill	S	155
2682	GUNBOAT CANDIDATE / At the Battle of Malvern Hill	S	155
2683	GUSTAV STRUVE	S	35
2684	GUY BY KENTUCKY PRINCE / Record 2:10 ¾	S	225
2685	HADLEY FALLS / Massachusetts	M	375

2686	HAGUE STREET EXPLOSION	S	760
2687	HAIDEE	S	50
2688	HAIDEE	S	50
2689	HAIL MARY, MOTHER OF GOD	S	25
2690	HAIR TONIC EXPLOSION, A	S	175
2691	HALLS OF JUSTICE, NEW YORK	S	175
2692	HALLS OF JUSTICE, NEW YORK	S	175
2693	HALLS OF JUSTICE, NEW YORK	S	175
2694	HALT BY THE WAYSIDE, A	S	185
2695	HAMBLETONIAN	S	315
2696	HAMBRINO / Bay Stallion by Edward Everett...	S	250
2697	HAMBURG — AMERICAN LINE MAIL STEAMER / Frisia	S	200
2698	HANDSOME MAN, THE	S	65
2699	HAND-WRITING ON THE WALL, THE	S	55
2700	HANNAH	S	65
2701	HANNAH	S	65
2702	HANNAH	S	65
2703	HANNIS / Record 2:17 ¼	S	265
2704	HANNIS	S	265
2705	HANOVER / By Hindoo Bourbon Belle...	S	240
2706	HAPPY FACES / A Ballad	S	60
2707	HAPPY FAMILY, A	S	50
2708	HAPPY FAMILY, A	S	75
2709	HAPPY FAMILY, THE	S	150
2710	HAPPY FAMILY, THE	S	150
2711	HAPPY FAMILY, THE	S	150
2712	HAPPY FAMILY, THE / Ruffed Grouse and Young	L	12500
2713	HAPPY HOME, THE	S	75
2714	HAPPY HOUR, THE	S	75
2715	HAPPY LAND	S	60
2716	HAPPY LITTLE CHICKS	S	180
2717	HAPPY LITTLE PUPS	S	55
2718	HAPPY MOTHER, THE	S	50
2719	HAPPY MOTHER	M	75
2720	HAPPY MOTHER, THE	S	385
2721	HAPPY NEW YEAR	S	200
2722	HAPPY NEW YEAR	S	150
2723	HAPPY NEW YEAR	S	150
2724	HARBOR FOR THE NIGHT, A	S	230
2725	HARBOR OF NEW YORK, THE	S	640
2726	HARBOR OF NEW YORK, THE	S	640
2727	HARD ROAD TO TRAVEL, A	S	235
2728	HARD ROAD TO TRAVEL	S	200
2729	HARRIET	S	55
2730	HARRIET	S	65
2731	HARRIET	S	55
2732	HARRIET	S	70
2733	HARRISBURG AND THE SUSQUEHANNA	M	850
2734	HARRY BASSETT / By "Lexington"...	S	395
2735	HARRY BASSETT AND LONGFELLOW	L	1600
2736	HARRY BASSETT AND LONGFELLOW / At Saratoga...	S	450
2737	HARRY BLUFF	S	50
2738	HARRY WILKES / By George Wilkes...	L	1000
2739	HARRY WILKES	VS	75
2740	HARVARD COLLEGE, CAMBRIDGE, MASS.	S	1215
2741	HARVEST	S	180
2742	HARVEST	S	180
2743	HARVEST DANCE, THE	S	75
2744	HARVEST DANCE, THE	S	75
2745	HARVEST FIELD, THE	M	300
2746	HARVEST MOON, THE	M	425
2747	HARVEST QUEEN, THE	S	60
2748	HARVESTER, THE	M	85
2749	HARVESTING	S	230
2750	HARVESTING / The Last Load	S	230
2751	HAT THAT MAKES THE MAN	S	90
2752	HAT THAT MAKES THE MAN, THE	S	125
2753	HAT THAT MAKES THE MAN, THE	VS	65
2754	HATTIE	S	60
2755	HATTIE WOODWARD / Record 2:15 ½	VS	100
2756	HAUNTED CASTLE	S	75
2757	HAUNTS OF THE WILD SWAN, THE	S	245
2758	HAVANA / View from the Lower Batteries	S	150
2759	HAVE A PEACH	S	65
2760	HAYING-TIME — THE FIRST LOAD	L	1650
2761	HAYING-TIME — THE LAST LOAD	L	1650
2762	HE IS SAVED	S	45
2763	HE LOVES ME!	S	50
2764	HEAD AND HEAD AT THE WINNING POST	L	525
2765	HEAD AND HEAD FINISH, A	M	500
2766	HEAD AND HEAD FINISH, A	L	1000
2767	HEAD AND HEAD FINISH, A	L	1000
2768	HEADS OF THE DEMOCRACY	S	120
2769	HEALTH TO THE KING AND BISMARK	S	125
2770	HEART OF DIVINE LOVE	S	25
2771	HEART OF JESUS	S	25
2772	HEART OF THE WILDERNESS, THE	M	315
2773	"HEATHEN CHINEE.," THE	S	250
2774	HEBE	VS	30
2775	HEIGHT OF IMPUDENCE, THE	S	100
2776	HEIR TO THE THRONE, AN	M	275

2777	HELEN	S	60
2778	HELEN	S	60
2779	HENRIETTA	S	60
2780	HENRY	S	60
2781	HENRY / Record 2:20 ½	S	235
2782	HENRY BIBB / Lord deliver me from slavery	S	265
2783	HENRY CLAY	L	95
2784	HENRY CLAY / Justice to Harry of the West	S	140
2785	HENRY CLAY / Nominated for Eleventh President...	S	95
2786-			
2793	HENRY CLAY / Of Kentucky	S	100
2794	HENRY CLAY / Painted and Engraved by A.H. Richie	S	100
2795	HENRY CLAY / The Farmer of Ashland	S	115
2796	HENRY CLAY / The Nation's Choice for eleventh president	S	100
2797	HENRY CLAY / The Nation's Choice for eleventh president	S	100
2798	HENRY WILKES	S	235
2799	HERCULES OF THE NATION SLAYING THE GREAT DRAGON SECESSION	S	225
2800	HERO AND FLORA TEMPLE	L	1650
2801	HEROES OF "76" MARCHING TO THE FIGHT	S	250
2802	HEROINE OF MONMOUTH, THE / Molly Pitcher...	S	240
2803	HEROINE OF THE LIGHTHOUSE, THE	S	80
2804	HEWITT'S QUICK STEP	S	75
2805	HIAWATHA'S DEPARTURE	L	375
2806	HIAWATHA'S WEDDING	S	200
2807	HIAWATHA'S WEDDING	L	375
2808	HIAWATHA'S WOOING	S	200
2809	HIAWATHA'S WOOING	L	375
2810	HIGH BRIDGE AT HARLEM, N.Y., THE	S	435
2811	HIGH BRIDGE AT HARLEM, N.Y., THE	S	195
2812	HIGH OLD SMOKE, A	S	190
2813	HIGH PRESSURE STEAMBOAT MAYFLOWER...	L	2675
2814	HIGH SPEED STEAM YACHT STILETTO, ...	S	350
2815	HIGH TONED	VS	75
2816	HIGH TONED	VS	75
2817	HIGH TONED	VS	75
2818	HIGH TONED	S	75
2819	"HIGH WATER" IN THE MISSISSIPPI	L	3100
2820	HIGHLAND BEAUTY, THE	S	40
2821	HIGHLAND BOY, THE	S	40
2822	HIGHLAND GIRL, THE	S	40
2823	HIGHLAND FLING	S	110
2824	HIGHLAND FLING, THE / A Bonny Shot for a Canny Scot	M	200
2825	HIGHLAND LOVERS, THE	S	45
2826	HIGHLAND MARY	S	40
2827	HIGHLAND WATERFALL	VS	60
2828	HIGHLANDER / By Glencoe, dam Castanet...	L	1400
2829	HIGHLANDER'S RETURN, THE	M	125
2830	HILLSIDE PASTURES — CATTLE	M	200
2831	HILLSIDE PASTURES — SHEEP	M	200
2832	HILLSIDE, THE see c859	VS	—
2833	HINDOO, WINNER OF THE KENTUCKY DERBY, 1881	VS	125
2834	HIS EMINENCE / Cardinal McCloskey	M	30
2835	HIS MOTHER-IN-LAW	S	250
2836	HOLD THE FORT	S	60
2837	HOLD YOUR HORSE, BOSSY?	S	175
2838	HOLIDAYS IN THE COUNTRY / Troublesome Flies	L	725
2839	HOLY BIBLE, THE	S	25
2840	HOLY CATHOLIC FAITH, THE	S	25
2841	HOLY COMMUNION, THE	S	25
2842	HOLY CROSS, THE	S	25
2843	HOLY CROSS ABBEY ON THE SUIR	S	25
2844	HOLY EUCHARIST, THE	S	25
2845	HOLY EUCHARIST, THE	S	25
2846	HOLY FACE, THE	S	25
2847	HOLY FAMILY	S	25
2848	HOLY FAMILY	S	25
2849	HOLY FAMILY	S	25
2850	HOLY FAMILY	S	25
2851	HOLY SACRAMENT OF THE ALTAR	S	25
2852	HOLY SEPULCHRE, THE	S	25
2853	HOLY VIRGIN / Pray for Us	S	25
2854	HOLY WELL, THE	S	25
2855	HOME AND FRIENDS	S	65
2856	HOME FROM THE BROOK / The Lucky Fisherman	L	2400
2857	HOME FROM THE WAR	S	120
2858	HOME FROM THE WAR / The Soldier's Return	S	120
2859	HOME FROM THE WOODS / The Successful Sportsman	L	2650
2860	HOME IN THE COUNTRY, A	M	550
2861	HOME IN THE WILDERNESS, A	S	685
2862	HOME IN THE WOODS, A	S	250
2863	HOME OF EVANGELINE, THE	L	415
2864	HOME OF FLORENCE NIGHTENGALE, THE	M	115
2865	HOME OF THE DEER, THE / Morning in the Adirondacks	L	4500
2866	HOME OF THE DEER, THE	M	350
2867	HOME OF THE DEER, THE	M	350
2868	HOME OF THE SEAL	S	170

2869	HOME OF THE SOUL, THE	S	25
2870	HOME OF WASHINGTON, MOUNT VERNON, THE	M	300
2871	HOME OF WASHINGTON, THE / Mount Vernon, Va.	S	150
2872	HOME OF WASHINGTON, THE / Mount Vernon, Va.	M	240
2873	HOME OF WASHINGTON, MOUNT VERNON, VA.	L	400
2874	HOME OF WASHINGTON, THE / Mount Vernon, Va.	M	240
2875	HOME ON "SICK LEAVE"	S	100
2876	HOME ON THE MISSISSIPPI, A	S	410
2877	HOME SWEET HOME	L	425
2878	HOME, SWEET HOME	S	150
2879	HOME SWEET HOME	S	175
2880	HOME SWEET HOME	M	150
2881	HOME SWEET HOME	S	150
2882	HOME TO THANKSGIVING	L	12000
2883	HOME TREASURES	S	60
2884	HOMEWARD BOUND	S	450
2885	HOMEWARD BOUND	S	450
2886	HOMEWARD BOUND	S	450
2887	HONEST ABE TAKING THEM ON THE HALF SHELL	M	300
2888	HONOR THE LORD	S	35
2889	HONOR THE LORD / With Thy Substance	S	35
2890	HON. ABRAHAM LINCOLN / Of Illinois	L	600
2891	HON. ABRAHAM LINCOLN / "Our Next President"	S	275
2892	HON. ABRAHAM LINCOLN / "Our Next President"	S	200
2893	HON. ABRAHAM LINCOLN / "Our President"	S	150
2894	HON. ABRAHAM LINCOLN / Republican Candidate...	M	600
2895	HON. ABRAHAM LINCOLN / Republican Candidate...	S	225
2896	HON. ABRAHAM LINCOLN / Sixteenth President...	M	200
2897	HON. CHARLES GAVIN DUFFY / The Irish Patriot	S	40
2898	HON. DANIEL WEBSTER	S	185
2899	HON. EDWARD EVERETT OF MASSACHUSETTS	M	100
2900	HON. HANNIBAL HAMLIN / "Our Next Vice President"	S	75
2901	HON. HANNIBAL HAMLIN	S	75
2902	HON. HANNIBAL HAMLIN	M	100
2903	HON. HERSCHEL V. JOHNSON	S	75
2904	HON. HORACE GREELEY / Our Next President	S	100
2905	HON. HORATIO SEYMOUR	S	85
2906	HON. HORATIO SEYMOUR	M	100
2907	HON. JAMES G. BLAINE	L	160
2908	HON. JAS. G. BLAINE / The Great American Statesman	S	100
2909	HON. JEFFERSON DAVIS	S	150
2910	HON. JOHN A. LOGAN	S	75
2911	HON. JOHN BELL / Of Tennessee	M	100
2912	HON. JOHN BELL / Of Tennessee	L	100
2913	HON. JOHN BELL / "Our Next President"	S	80
2914	HON. JOHN C. BRECKENRIDGE	S	80
2915	HON. JOHN C. BRECKENRIDGE	M	95
2916	HON. JOHN C. BRECKENRIDGE / Of Kentucky	L	125
2917	HON. JOHN CILLEY	L	100
2918	HON. JOSEPH LANE	S	60
2919	HON. SCHUYLER COLFAX	S	60
2920	HON. STEPHEN A. DOUGLAS	S	80
2921	HON. STEPHEN A. DOUGLAS	L	125
2922	HON. STEPHEN A. DOUGLAS OF ILLINOIS	S	80
2923	HON. STEPHEN A. DOUGLAS / Of Illinois	L	125
2924	HON. STEPHEN A. DOUGLAS / U.S. Senator from Illinois	S	80
2925	HON. WM. A. WHEELER / Of New York	S	60
2926	HON. WILLIAM H. ENGLISH	M	125
2927	HONOUR!	S	100
2928	HOOKED!	S	300
2929	HOPEFUL / Grey gelding by Godfrey's Patchen...	S	275
2930	HOPEFUL / Grey gelding by Godfrey's Patchen...	L	1375
2931	HOPEFUL / Grey gelding,...	S	275
2932	HOPEFUL / Grey gelding,...	S	275
2933	HOPEFUL / By Godfrey's Patchen,...	L	1200
2934	HOPEFUL / Record 2:16 ½ to wagon	VS	75
2935	HOPEFUL DRIVER, A / You Can Bet Your Life On Me	S	150
2936	HORACE GREELEY	M	100
2937	HORACE GREELEY / Our Next President	M	100
2938	HORSE CAR SPORTS GOING TO A CHICKEN SHOW / All Flush	S	250
2939	HORSE CAR SPORT ON THE BACK TRACK / Dead Broke	S	250
2940	HORSE FAIR, THE	S	225
2941	HORSE FOR THE MONEY, THE	S	290
2942	HORSE SHED STAKES, FREE FOR ALL, THE	S	225
2943	HORSE SHED STAKES, THE	VS	70
2944	HORSE THAT DIED ON THE MAN'S HANDS, THE	S	215
2945	HORSE THAT TOOK THE POLE, THE	M	325
2946	HORSE-MAN OF THE PERIOD, THE	M	1000
2947	HORSE-MAN OF THE PERIOD, THE	M	300

2948	HORSES AT THE FORD	L	800
2949	HORSES IN A THUNDERSTORM	S	185
2950	HORTICULTURAL HALL	S	160
2951	HOT RACE FROM THE START, A	L	1175
2952	HOT RACE TO THE WIRE, A	S	250
2953	HOT RACE TO THE WIRE, A	S	385
2954	HOUR OF VICTORY, THE / "Zouaves remember Ellsworth"	M	115
2955	HOUSE IN ROXBURY, MASS., THE	S	150
2956	HOUSE, KENNEL AND FIELD	L	125
2957	HOUSEHOLD PETS	S	60
2958	HOUSEHOLD PETS / #493	S	60
2959	HOUSEHOLD PETS / #334	S	60
2960	HOUSEHOLD TREASURES / #493	S	70
2961	HOUSEHOLD TREASURES	S	70
2962	HOVE TO FOR A PILOT	L	6500
2963	HOW PRETTY!	S	50
2964	HOW SWEET!	S	50
2965	HOWLING SWELL, A / On the War Path	S	200
2966	HOWLING SWELL, A / With his scalp in danger	S	200
2967	HOWTH CASTLE / Ireland	S	40
2968	H—OXFORD'S, YOU KNOW	S	75
2969	H R H ALBERT / Prince of Wales	S	40
2970	H R H PRINCESS LOUISE	S	35
2971	HUDSON AT PEEKSKIL, THE	S	255
2972	HUDSON, FROM WEST POINT, THE / Grounds of USMA	M	650
2973	HUDSON HIGHLANDS, THE / From the Peekskill...	L	975
2974	HUDSON HIGHLANDS, THE / From the Peekskill...	L	1500
2975	HUDSON HIGHLANDS, THE	S	225
2976	HUDSON HIGHLANDS, THE / Near Newburg, N.Y.	S	210
2977	HUDSON NEAR COLDSPRING, THE	S	185
2978	HUDSON RIVER — CROW'S NEST	S	265
2979	HUDSON RIVER — CROW'S NEST	S	265
2980	HUDSON RIVER STEAMBOAT "BRISTOL"	S	400
2981	HUDSON RIVER STEAMBOAT "ST. JOHN"	L	1950
2982	HUES OF AUTUMN, THE / On Racquet River	S	235
2983	HUG ME CLOSER, GEORGE!	S	350
2984	HUMMING TROT, A	M	375
2985	HUNDRED LEAF ROSE	S	75
2986	HUNDRED LEAF ROSE	S	75
2987	HUNDRED LEAF ROSE	S	75
2988	HUNDRED LEAF ROSE	S	75
2989	"HUNG UP" -- WITH THE STARCH OUT	S	225
2990	"HUNG UP" -- WITH THE STARCH OUT	VS	65
2991	HUNGRY LITTLE KITTENS	S	90
2992	HUNTER'S DOG, THE	S	375
2993	HUNTER'S SHANTY, THE / In the Adirondacks	L	1550
2994	HUNTER'S SHANTY, THE	VS	80
2995	HUNTING CASUALTIES / A turn of speed over the Flats	S	350
2996	HUNTING CASUALTIES / A Strange Country	S	350
2997	HUNTING CASUALTIES / Dispatched to Headquarters	S	350
2998	HUNTING CASUALTIES, UP TO SIXTEEN STONE	S	350
2999	HUNTING CASUALTIES / A rare sort for the Downs	S	350
3000	HUNTING CASUALTIES / A Mutual Determination	S	350
3001	HUNTING, FISHING AND FOREST SCENES / Good Luck all around	L	1800
3002	HUNTING, FISHING AND FOREST SCENES / Shantying...	L	1800
3003	HUNTING IN THE NORTHERN WOODS	S	400
3004	HUNTING ON THE PLAINS	S	800
3005	HUNTING ON THE SUSQUEHANNA	M	375
3006	HURRY UP THE CAKES	S	125
3007	HUSH! I'VE A NIBBLE	S	300
3008	HUSKING	L	4100
3009	H.W. BEECHER	M	85
3010	HYDE PARK, HUDSON RIVER	S	165
3011	HYDE PARK / On the Hudson River	S	320
3012	HYDROGRAPHIC MAP	M	225
3013	HYDROGRAPHIC MAP SHOWING THE DISTRIBUTION OF RAIN...	L	325
3014	I AM AS DRY AS A FISH	S	195
3015	I CANNA BID HIM GANG, MITHER	S	75
3016	I SEE YOU	S	55
3017	I TOLD YOU SO	S	60
3018	I TOLD YOU SO	M	175
3019	I WILL NOT ASK TO PRESS THAT CHEEK	S	150
3020	I WILL NOT ASK TO PRESS THAT CHEEK	VS	65
3021	ICE-BOAT RACE ON THE HUDSON	S	2000
3022	ICE COLD SODA WATER	S	80
3023	ICE CREAM RACKET, AN — FREEZING IN	S	190
3024	ICE CREAM RACKET, AN — THAWING OUT	S	190

3025	ICED LEMONADE / COOL AND REFRESHING	M	85
3026	IDLEWILD — ON THE HUDSON	S	200
3027	ILLUMINATED CARDS / FOR SCHOOLS	S	100
3028	ILLUMINATED CARDS / FOR SCHOOLS	S	100
3029	IMMACULATE CONCEPTION, THE	S	25
3030	IMPEACHMENT OF DAME BUTLER, FESSENDEN...	S	70
3031	IMPENDING CATASTROPHE, AN	S	90
3032	IMPENDING CATASTROPHE, AN	S	90
3033	IMPENDING CRISIS, THE, OR CAUGHT IN THE ACT	M	225
3034	IMPERIAL BEAUTY, THE	S	55
3035	IMPERIAL GERMAN MAIL STEAMER ALLER	S	185
3036	IMPERIAL GERMAN MAIL STEAMER ELBE	S	185
3037	IMPERIAL GERMAN MAIL STEAMER FULDA	S	185
3038	IMPERIAL GERMAN MAIL STEAMER HAVEL, THE	S	185
3039	IMPERIAL GERMAN MAIL STEAMER TRAVE, THE	S	185
3040	IMPERIAL GERMAN MAIL STEAMER WERRA, THE	S	185
3041	IMPORTED MESSENGER	S	300
3042	IMPORTED MESSENGER / The great fountainhead...	S	310
3043	IMPOSING THE CARDINAL'S BERETTA	S	25
3044	IN A TIGHT PLACE / getting squeezed	M	175
3045	IN AND OUT OF CONDITION	S	175
3046	IN AND OUT OF CONDITION	L	225
3047	IN AND OUT OF CONDITION	VS	55
3048	IN FULL BLOOM	S	50
3049	IN FULL DRESS	S	50
3050	IN GOD IS OUR TRUST	S	50
3051	IN MEMORIAM	S	40
3052-3058	IN MEMORY OF	S	40
3059-3061	IN MEMORY OF	S	50
3062	IN MEMORY OF	M	60
3063	IN MEMORY OF	S	40
3064	IN / MEMORY / OF	S	75
3065-3068	IN MEMORY OF	S	50
3069	IN THE HARBOR	S	375
3070	IN THE INDIAN PASS / Adirondacks	S	200
3071	IN THE MOUNTAINS	S	155
3072	IN THE MOUNTAINS	M	185
3073	IN THE NORTHEN WILDS / Trapping Beaver	S	375
3074	IN THE SPRING TIME	S	85
3075	IN THE WOODS	S	145
3076	IN THE WOODS	S	145
3077	INAUGURATION OF WASHINGTON, THE	S	175
3078	INCREASE IN FAMILY, AN	M	100
3079	INDEPENDENCE HALL 1776 PHILADELPHIA	S	315
3080	INDEPENDENT GOLD HUNTER ON HIS WAY TO CALIFORNIA	S	295
3081	INDIAN BALL PLAYERS	M	1000
3082	INDIAN BEAR DANCE, THE	M	1250
3083	INDIAN BEAUTY, THE	S	60
3084	INDIAN BUFFALO HUNT / "Close Quarters"	M	1150
3085	INDIAN BUFFALO HUNT / On the "Prairie Bluffs"	M	1150
3086	INDIAN FALLS / New York	S	145
3087	INDIAN FAMILY	S	90
3088	INDIAN FAMILY, THE	S	90
3089	INDIAN HUNTER	S	250
3090	INDIAN HUNTER, THE	S	250
3091	INDIAN LAKE — SUNSET	L	740
3092	INDIAN PASS, THE / Rocky Mountains	M	765
3093	INDIAN SUMMER / Squam Lake, N.H.	M	450
3094	INDIAN TOWN / River St. John, N.B.	S	210
3095	INDIAN WARRIOR, THE	S	150
3096	INDIANS ATTACKING THE GRIZZLY BEAR	M	1250
3097	INFANCY OF JESUS	S	20
3098	INFANCY OF THE VIRGIN	S	20
3099	INFANT BROOD, THE	S	375
3100	INFANT BROOD, THE	S	375
3101	INFANT JESUS PREACHING IN THE TEMPLE	S	25
3102	INFANT ST. JOHN, THE	S	20
3103	INFANT ST. JOHN, THE / #84	S	25
3104	INFANT ST. JOHN, THE / El Chiquito Sn. Juan	S	25
3105	INFANT SAVIOUR, THE	S	25
3106	INFANT SAVIOUR, THE / El Salvator del Mundo	S	25
3107	INFANT SAVIOUR & ST. JOHN	S	25
3108	INFANT SAVIOUR AND ST. JOHN	S	25
3109	INFANT SAVIOUR WITH MARY AND JOSEPH	S	30
3110	INFANT TOILET	S	65
3111	INFANTRY MANOEUVRES BY THE DARKTOWN VOLUNTEERS	S	200
3112	INGLESIDE WINTER, THE	S	400

3113	**INITIATION CEREMONIES OF THE DARKTOWN LODGE**	S	225
3114	**INITIATION CEREMONIES OF THE DARKTOWN LODGE**	S	225
3115	**INNISFALLEN** / Ireland	M	85
3116	**INNOCENCE**	S	40
3117	**INNOCENCE**	L	50
3118	**INTERIOR OF FORT SUMTER** / During the Bombardment	S	205
3119	**INTO MISCHIEF**	S	75
3120	**INTO MISCHIEF**	M	110
3121	**INTO MISCHIEF**	L	145
3122	**INUNDATION, THE**	S	90
3123	**INUNDATION, THE**	S	90
3124	**INVITING DISH, AN**	S	85
3125	**INVITING GIFT, AN**	S	75
3126	**IRA D. SANKEY** / The Evangelist of Song	S	40
3127	**IRISH BEAUTY, THE**	S	50
3128	**IRON R. M. STEAMSHIP "PERSIA" — CUNARD LINE**	S	250
3129	**IRON STEAM SHIP GREAT BRITAIN, THE**	S	350
3130	**IRON STEAM SHIP "GREAT EASTERN," 22,500 TONS, THE**	L	1500
3131	**IROQUOIS** / By Imp Leamington...	L	900
3132	**IROQUOIS — WINNER OF THE DERBY**	VS	75
3133	**IROQUOIS WINNING THE DERBY**	S	450
3134	**IRREPRESSIBLE CONFLICT, THE**	M	230
3135	**ISABELLA**	S	65
3136	**ISABELLA**	S	65
3137	**ISABELLA**	S	65
3138	**ISABELLA**	S	50
3139	**ITALIAN LANDSCAPE**	S	80
3140	**IVANHOE** / Interview of the Templar and Rebecca	S	50
3141	**IVY BRIDGE, THE**	S	140
3142	**IVY CLAD RUINS, THE**	S	140
3143	**IVY CLAD RUINS, THE**	M	225
3144	**IVY CLAD RUINS, THE**	M	150
3145	**JACK ROSSITER** / Saratoga Course 2:28 — 1849	L	1485
3146	**JACK ROSSITER** / Union Course, L.I. ...	L	1485
3147	**JAMES**	S	80
3148	**JAMES A. GARFIELD**	S	50
3149	**JAMES BUCHANAN** / Democratic Candidate...	S	100
3150	**JAMES BUCHANAN** / Democratic Candidate...	L	150
3151	**JAMES BUCHANAN** / Fifteenth President...	S	100
3152	**JAMES BUCHANAN** / Fifteenth President...	S	100
3153	**JAMES HAMMILL AND WALTER BROWN IN THEIR** / ...Match	L	3250
3154	**JAMES G. BIRNEY**	S	95
3155	**JAMES G. BIRNEY** / Nominated by the Liberty Party...	S	95
3156	**JAMES J. CORBETT — CHAMPION HEAVYWEIGHT**	M	400
3157	**JAMES K. POLK** / #29	S	85
3158	**JAMES K. POLK** / Eleventh President...	S	100
3159-3163	**JAMES K. POLK** / Eleventh President...	S	85
3164	**JAMES K. POLK** / Nominated for - Eleventh President	S	100
3165	**JAMES K. POLK** / President Elect of the United States	S	85
3166	**JAMES K. POLK** / The People's Candidate...	S	85
3167	**JAMES K. POLK** / The People's Choice...	S	85
3168	**JAMES K. POLK** / Union Course, L.I. ...	M	600
3169	**JAMES L. HEWITT & CO.** / Music Publishers	S	300
3170	**JAMES L. HEWITT & CO.**	S	75
3171	**JAMES MADISON** / Fourth President of the U.S.	S	125
3172	**JAMES MONROE** / Fifth President of the U.S.	S	120
3173	**JAMES MYERS** / Samuel Lewis — Chas. C. Merchant	S	250
3174	**JAMES STEPHENS**	S	35
3175-3181	**JANE**	S	50
3182	**JAY EYE SEE** / By Dictator	S	300
3183	**JAY EYE SEE** / Record 2:01	L	950
3184	**JAY EYE SEE** / Record 2:01	L	1000
3185	**JAY EYE SEE** / The Phenomenal Trotting Gelding	L	1000
3186	**JAY EYE SEE, 2:10**	VS	75
3187	**JAY EYE SORE, DE GREAT WORLD BEATER**	S	220
3188	**JEANETTE**	S	55
3189	**JEANETTE**	S	55
3190	**JEANIE**	S	60
3191	**JEFF D. HUNG ON A "SOUR APPLE TREE"...**	S	175
3192	**JEFF DAVIS ON HIS OWN PLATFORM**	S	175
3193	**JEFFERSON DAVIS**	S	140
3194	**JEFF'S LAST SHIFT**	S	185
3195	**JEM MACE**	M	250
3196	**JENNIE**	S	50
3197	**JENNIE CRAMER**	S	70
3198	**JENNY LIND**	S	125

3267	**JOHN HANCOCK'S DEFIANCE**	S	190
3268	**JOHN J. DWYER, CHAMPION OF AMERICA**	M	315
3269	**JOHN JAY**	VS	30
3270	**JOHN L. SULLIVAN** / Champion Pugilist of the World	M	360
3271	**JOHN MILTON**	M	40
3272	**JOHN MITCHELL** / The First Martyr of Ireland	S	50
3273	**JOHN MITCHELL**	S	50
3274	**JOHN MITCHELL**	S	50
3275	**JOHN MORRISSEY**	M	350
3276	**JOHN QUINCY ADAMS** / Sixth President of the U.S.	S	115
3277	**JOHN QUINCY ADAMS** / Sixth President of the U.S.	S	125
3278	**JOHN QUINCY ADAMS**	S	85
3279	**JOHN R. GENTRY** / Record 2:00 ½	S	240
3280	**JOHN STRAUS! JOHN STRAUS!** /"The Girls are all Mad"	S	60
3281	**JOHN TYLER** / Tenth President of the U.S.	S	110
3282	**JOHN WESLEY**	S	35
3283	**JOHN WESLEY PREACHING ON HIS FATHER'S GRAVE**	S	45
3284	**JOHNNY AND LILY**	S	65
3285	**JOHNSON'S HOTEL, KEPT ON THE EUROPEAN PLAN**	M	650
3286	**JOHNSTON, PACER — RECORD 2:06 ¼**	VS	65
3287	**JOLLY DOG, A**	S	150
3288	**JOLLY HUNTERS, THE**	S	165
3289	**JOLLY JUMPER, A**	S	175
3290	**JOLLY SMOKER, THE**	S	200
3291	**JOLLY SMOKER, THE**	L	240
3292	**JOLLY SMOKER, THE**	VS	75
3293	**JOLLY SMOKER, THE**	VS	75
3294	**JOLLY SMOKER, THE**	VS	75
3295	**JOLLY YOUNG DUCKS**	M	185
3296	**JOSEPH C. YATES**	VS	30
3297	**JOSEPH GRIMALDI**	VS	25
3298-			
3302	**JOSEPHINE**	S	55
3303	**JOSIE**	S	50
3304	**JUDGE FULLERTON** / As he appeared in harness...	S	350
3305	**JULIA**	S	50
3306	**JULIA**	S	60
3307	**JULIA**	S	60
3308-			
3311	**JULIA**	S	50
3312	**JULIA** / "I should like to be treated like a dog"	S	75
3313	**JULIET**	S	50
3314	**JULIETTE**	S	45
3315	**JUNE**	S	50
3316	**JUNO**	VS	30
3317	**JUNO** / A celebrated setter	S	95
3318	**JUNO**	S	125
3319	**JUNO**	S	125
3320	**JUST CAUGHT** / Trout and Pickerel	S	185
3321	**JUST MARRIED**	S	50
3322	**JUST MY STYLE**	S	45
3323	**KAISER WILHELM DER GROSSE** / North German Lloyd Line	S	175
3324	**KATE**	M	75
3325	**KATE**	S	50
3326	**KATE**	S	50
3327	**KATZ-KILLS IN WINTER, THE** /Bastion Falls	S	240
3328	**KENILWORTH CASTLE**	L	150
3329	**KILKENNY CASTLE** / Ireland	S	85
3330	**KILLERIES, THE**	S	75
3331	**KILLENEY HILL** / Dublin	S	55
3332	**KIND, KIND AND GENTLE IS SHE**	S	45
3333	**KING OF THE FOREST, THE**	S	225
3334	**KING OF THE HOUSE**	S	125
3335	**KING OF THE HOUSE, THE**	S	125
3336	**KING OF THE ROAD, THE** / Dexter...	L	1300
3337	**KING OF THE TURF "DEXTER" DRIVEN BY BUD DOBLE**	S	300
3338	**KING OF THE ROAD, THE** / Dexter	S	300
3339	**KING OF THE TURF ST. JULIEN...**	L	1300
3340-			
3343	**KING WILLIAM III** / Crossing the Boyne	S	20
3344	**KING WILLIAM III** / Prince of Orange	S	20
3345	**KING WILLIAM OF ORANGE**	S	20
3346	**KINGSTON** / By Spendthrift	S	250
3347	**KISS IN THE DARK, A**	S	350
3347A			
	KISS ME QUICK	S	90
3348	**KISS ME QUICK**	S	90
3349	**KISS ME QUICK** / "Children: This is the third time..."	S	365
3350	**KITCH-EE-I-AA-BA — OR THE BIG BUCK**	S	100
3351	**KITTIES AMONG THE CLOVER**	S	95
3352	**KITTIES AMONG THE ROSES**	S	95
3353	**KITTIES' BREAKFAST**	L	170
3354	**KITTIE'S LESSON**	S	90
3355	**KITTIES ON A FROLIC** / The New Hat	S	90
3356	**KITTIES ON A FROLIC** / The New Hat	S	90
3357	**KITTY**	VS	30
3358	**KITTY**	S	75

3359 **KITTY AND POLLY** / Dividing the Spoils	M	150
3360 **KITTY AND ROVER**	S	90
3361 **KITTY IN CLOVER**	S	85
3362 **KITTY'S DINNER**	S	90
3363 **KNITTING LESSON, THE**	M	515
3364 **KNOCKED INTO A COCKED HAT**	M	195
3365 **KONIG WILHELM VON PREUSSEN IN DER SCHLACT VON SEDAN**	S	30
3366 **KOSSUTH** / Hungary's Champion & America's Guest	S	35
3367 **KREMLIN** / Record 2:07 ¾	S	240
3368 **LA ALEMADA DE MEXICO — THE PUBLIC PARK OF MEXICO**	S	95
3369 **LA CIGARITA**	VS	85
3370 **LA GITANA**	S	40
3371 **LA MUZURKA**	S	65
3372 **LA REINE DES ANGES**	S	25
3373 **LADDER OF FORTUNE, THE**	S	200
3374 **LADIES BOQUET, THE**	S	90
3375 **LADIES BOQUET, THE**	S	90
3376 **LADIES BOUQUET, THE**	S	90
3377 **LADIES LOYAL UNION LEAGUE, THE**	S	60
3378 **LADY AND MOOR**	S	45
3379 **LADY EMMA, GEORGE WILKES, AND GENERAL BUTLER**	L	1365
3380 **LADY FULTON** / Winner of the great match...	S	400
3381 **LADY MAUD** / Bay Mare by General Knox...	S	275
3382 **LADY MOSCOW** / Union Course, L.I....	L	1100
3383 **LADY MOSCOW, ROCKET, AND BROWN DICK**	L	1250
3384 **LADY OF THE LAKE**	S	50
3385 **LADY OF THE LAKE**	S	60
3386 **LADY OF THE LAKE**	S	50
3387 **LADY SUFFOLK** / 1 Mile in 2:26	M	1100
3388 **LADY SUFFOLK** / Centerville Course, L.I.	L	1500
3389 **LADY SUFFOLK. RECORD 2:26**	L	1250
3390 **LADY SUFFOLK AND LADY MOSCOW**	L	1250
3391 **LADY SUTTON** / Centerville Trotting Course, L.I.	L	1000
3392 **LADY SUTTON**	S	400
3393 **LADY THORN** / By Mambrino Chief...	S	285
3394 **LADY THORN AND MOUNTAIN BOY** / In their great match...	L	1175
3395 **LADY THORN AND MOUNTAIN BOY** / Trotting for a Purse...	L	1175
3396 **LADY WASHINGTON**	L	75
3397 **LADY WASHINGTON**	S	40
3398 **LADY WASHINGTON**	M	75
3399 **LADY WOODRUFF, MILLER'S DAMSEL, GEN. DARCY & STELLA**	L	1950
3400 **LADY'S BOUQUET, THE**	S	95
3401 **LADY'S BOUQUET, THE**	S	90
3402 **LAFAYETTE**	S	55
3403 **LAFAYETTE AT** / the Tomb of Washington	S	75
3404 **LAFAYETTE LAKE** / Near Tallahassee, Florida	S	175
3405 **LAKE AND FOREST SCENERY**	M	370
3406 **LAKE GEORGE** / Black Mountain	S	185
3407 **LAKE GEORGE, N.Y.**	S	160
3408 **LAKE GEORGE** / White Mountains	S	160
3409 **LAKE IN THE WOODS, THE**	S	150
3410 **LAKE LUGANO, ITALY**	S	45
3411 **LAKE LUGANO, ITALY**	L	70
3412 **LAKE MEMPHREMAGOG** / Owl's Head	S	155
3413 **LAKE MOHONK**	S	145
3414 **LAKE OF THE DISMAL SWAMP, THE**	L	195
3415 **LAKE OF THE DISMAL SWAMP, THE**	S	135
3416 **LAKE THUN — NEAR THE ALPS**	VS	25
3417 **LAKE THUN — NEAR THE ALPS**	S	35
3418 **LAKE WINNEPOSOGIS, MANITOBA, CANADA**	S	150
3419 **LAKE WINNIPISEOGEE** / From Center Harbor, N.H.	L	600
3420 **LAKE WINNIPISEOGEE see c3439**	VS	—
3421 **LAKES OF KILLARNEY, THE**	S	65
3422 **LAKES OF KILLARNEY, THE**	L	225
3423 **LAKESIDE HOME**	M	325
3424 **LAMB AND THE LINNET, THE**	S	35
3425 **LANCASHIRE BELL RINGERS, THE**	S	110
3426 **LANDING A TROUT**	S	210
3427 **LANDING IN THE WOODS, A**	S	95
3428 **LANDING OF COLUMBUS**	S	115
3429 **LANDING OF COLUMBUS, THE** / At San Salvador	S	115
3430 **LANDING OF COLUMBUS, OCTR. 11TH, 1492**	S	115
3431 **LANDING OF COLUMBUS, OCTR. 11TH, 1492**	S	115
3432 **LANDING OF THE AMERICAN FORCES UNDER GENL. SCOTT**	S	190

3433 LANDING OF THE PILGRIMS AT PLYMOUTH	S	215
3434 LANDING OF THE PILGRIMS AT PLYMOUTH	S	215
3435 LANDING OF THE PILGRIMS AT PLYMOUTH, MASS., DEC. 22	S	335
3436 LANDSCAPE AND CATTLE	M	215
3437 LANDSCAPE AND RUINS	M	150
3438 LANDSCAPE CARDS / Moonlight and Winter Effects...	S	400
3439 LANDSCAPE CARDS / Sylvan Lake...	S	400
3440 LANDSCAPE, FRUIT AND FLOWERS	L	1900
3441 LANDSCAPE—MORNING	L	275
3442 LANERCOST PRIORY / England	M	115
3443 LAPPED ON THE LAST QUARTER	S	285
3444 LAST DITCH OF CHIVALRY, THE...	M	155
3445 "LAST DITCH" OF THE DEMOCRATIC PARTY	M	175
3446 LAST GUN OF THE ARCTIC, THE / Stewart Holland	M	225
3447 LAST HIT IN THE GAME, THE	S	245
3448 LAST LEADERS OF HUNGARY, THE	S	25
3449 LAST SHAKE, THE	S	90
3450 LAST SHOT, THE	L	4325
3451 LAST SUPPER, THE / Verily I say...	M	55
3452- 3456 LAST SUPPER, THE	S	35
3457 LAST WAR-WHOOP, THE	L	4150
3458 LAST WAR WHOOP, THE	L	4150
3459 LAUGH NO. 1, THE / The Butt of the Jokers	S	175
3460 LAUGH NO. 2, THE / The Point of the Joke	S	175
3461 LAURA	S	70
3462 LAURA	S	50
3463 LAWN TENNIS AT DARKTOWN / A Scientific Player	S	235
3464 LAWN TENNIS AT DARKTOWN / A Scientific Stroke	S	235
3465 "LAYING BACK"—STIFF FOR A BRUSH	S	180
3466 "LAYING BACK"—STIFF FOR A BRUSH	VS	65
3467 LE MARECHAL MACMAHON / Grand Commandant	S	25
3468 LE PETIT ST. JEAN / The Infant St. John	S	25
3469 LE PETIT ST. JEAN	S	25
3470 LE SAUVEUR DU MONDE—EL SALVADOR DEL MUNDO	S	25
3471 LEADERS, THE / Jay Eye See 2:10...	L	675
3472 LEARN SOMETHING SO THAT YOU CAN DO SOMETHING...	S	100
3473 LEARNING TO RIDE	S	65
3474 LEE AT THE GRAVE OF STONEWALL JACKSON	S	75
3475 LEND ME YOUR WATCH!	S	200
3476 LEONORA	S	50
3477 LES MEMBRES DE GOUVERMENT PROVISOIRE...	S	35
3478 LET NOT MERCY AND TRUTH FORSAKE THEE	S	60
3479 LETTING THE CAT OUT OF THE BAG	M	210
3480 LEVEE—NEW ORLEANS, THE	L	3600
3481 LEWIS CASS / Democratic Candidate	S	85
3482 LEWIS CASS / Democratic Candidate	S	85
3483 LEXINGTON / The great Monarch of the Turf...	S	425
3484 LEXINGTON OF 1861, THE	S	200
3485 LIBERTY	S	55
3486 LIBERTY	S	55
3487 LIBERTY FRIGHTENING THE WORLD	VS	90
3488 LIEUT. GEN. N. B. FORREST	S	50
3489 LIEUT. GENERAL ULYSSES S. GRANT AT...VICKSBURG	S	70
3490 LIEUT. GENL. ULYSSES S. GRANT	S	55
3491 LIEUT. GENL. ULYSSES S. GRANT	S	55
3492 LIEUT. GENL. ULYSSES S. GRANT	S	55
3493 LIEUT. GENL. WILLIAM T. SHERMAN	S	60
3494 LIEUT. GEN. WINFIELD SCOTT	L	75
3495 LIEUT. GEN. WINFIELD SCOTT	S	50
3496 LIEUT. GEN. WINFIELD SCOTT	S	55
3497 LIEUT. GEN. WINFIELD SCOTT	M	75
3498 LIFE AND AGE OF MAN, THE	S	140
3499 LIFE & AGE OF MAN, THE	S	140
3500 LIFE & AGE OF MAN, THE	S	150
3501 LIFE & AGE OF WOMAN, THE	S	130
3502 LIFE AND AGE OF WOMAN, THE	S	130
3503 LIFE AND DEATH	S	125
3504 LIFE IN NEW YORK—CUFFY DANCING FOR EELS	S	175
3505 LIFE IN NEW YORK / The Breadth of Fashion—5th Avenue	S	300
3506 LIFE IN NEW YORK / That's So!	S	230
3507 LIFE IN THE CAMP— PREPARING FOR SUPPER	L	800
3508 LIFE IN THE COUNTRY— EVENING	M	365

3509	LIFE IN THE COUNTRY— MORNING	M	365
3510	LIFE IN THE COUNTRY— MORNING	S	215
3511	LIFE IN THE COUNTRY / Out for a Day's Shooting	L	4400
3512	LIFE IN THE COUNTRY / "The Morning Ride"	L	4150
3513	LIFE IN THE WOODS— "RETURNING TO CAMP"	L	2850
3514	LIFE IN THE WOODS— "STARTING OUT"	L	2875
3515	LIFE OF A FIREMAN, THE / The Fire	L	1935
3516	LIFE OF A FIREMAN, THE / The Metropolitan System	L	4300
3517	LIFE OF A FIREMAN, THE / The new era. Steam & Muscle	L	1900
3518	LIFE OF A FIREMAN, THE / The Night Alarm	L	2065
3519	LIFE OF A FIREMAN, THE / The Race	L	1975
3520	LIFE OF A FIREMAN, THE / The Ruins	L	1865
3521	LIFE OF A HUNTER, THE / Catching a Tartar	L	4900
3522	LIFE OF A HUNTER / A Tight Fix	L	20000
3523	LIFE OF A SPORTSMAN, THE / Camping in the Woods	S	390
3524	LIFE OF A SPORTSMAN, THE / Coming into Camp	S	415
3525	LIFE OF A SPORTSMAN, THE / Going Out	S	400
3526	LIFE OF A TRAPPER, THE / A Sudden Halt	L	7000
3527	LIFE ON THE PRAIRIE / The "Buffalo Hunt"	L	6800
3528	LIFE ON THE PRAIRIE / The Trapper's Defence...	L	5925
3529	LIGHT AND SHADOW	M	125
3530	LIGHT ARTILLERY	M	250
3531	LIGHT OF THE DWELLING, THE	S	60
3532	LIGHTHOUSE POINT	VS	40
3533	LIGHTNING EXPRESS, THE	S	1150
3534	LIGHTNING EXPRESS, THE	S	1225
3535	"LIGHTNING EXPRESS" TRAINS / "Leaving the Junction"	L	8850
3536	LIGHTNING EXPRESS TRAINS LEAVING THE JUNCTION, THE	S	1500
3537	LILLIPUTIAN KING / 28 inches high	S	100
3538	LILLY	VS	25
3539	LILY AND HER KITTY	S	90
3540	LILY LAKE / Near St. John, N.B.	S	120
3541	LIME KILN CLUB, DE	S	225
3542	"LIMITED EXPRESS" / "Five seconds for refreshments."	S	225
3543	LINCOLN	M	200
3544	LINCOLN AT HOME	S	75
3545	LINCOLN AT HOME	L	175
3546	LINCOLN FAMILY, THE	S	60
3547	LINCOLN FAMILY, THE	S	60
3548	LINCOLN STATUE, THE	S	95
3549	LINCOLN "THREE IN ONE PICTURE"	S	450
3550	LINCOLN "THREE IN ONE PICTURE"	S	450
3551	LINE SHOT, A — THE AIM	S	190
3552	LINE SHOT, A — THE RECOIL	S	190
3553	LION AND THE LAMB, THE	S	65
3554	LION HUNTER, THE	S	65
3555	LIONS OF THE DERBY, THE	S	235
3556	LIONS OF THE DERBY, THE / Iroquois and Archer	S	235
3557	LISMORE CASTLE / County Waterford	S	60
3558	LITERARY DEBATE IN THE DARKTOWN CLUB / The Question Settled	S	215
3559	LITERARY DEBATE IN THE DARKTOWN CLUB / Settling...	S	215
3560	LITTLE ALMS-GIVER, THE	S	65
3561	LITTLE ANNA	S	50
3562	LITTLE ANNIE	S	55
3563	LITTLE ANNIE / and her Kittie	S	75
3564	LITTLE ANNIE AND HER KITTIES	S	80
3565	LITTLE ARTHUR / By Glencoe...	L	1390
3566	LITTLE ASTRONOMER, THE	S	65
3567	LITTLE BAREFOOT	S	80
3568	LITTLE BASHFUL	S	50
3569	LITTLE BEAR, THE	S	50
3570	LITTLE BEAU, THE	S	50
3571	LITTLE BEAUTY, THE	S	45
3572	LITTLE BEAUTY	M	90
3573	LITTLE BEGGAR, THE	S	40
3574	LITTLE BELLE	S	50
3575	LITTLE BLOSSOM	S	60
3576	LITTLE BLUEBELL	S	50
3577	LITTLE BO-PEEP	S	65
3578	LITTLE BOUNTIFUL	S	75
3579	LITTLE BOUQUET	S	50
3580	LITTLE BOUQUETS	S	115
3581	LITTLE BOY BLUE	S	65
3582	LITTLE BROTHER	S	55
3583	LITTLE BROTHER	S	55
3584	LITTLE BROTHER	S	60
3585	LITTLE BROTHER AND I	S	55
3586	LITTLE BROTHER AND SISTER	S	50
3587	LITTLE BROTHER AND SISTER	S	70

3588	LITTLE BROTHER AND SISTER	S	70
3589	LITTLE BROTHERS	S	70
3590	LITTLE BROTHERS	S	70
3591	LITTLE BRUNETTE	M	60
3592	LITTLE BUSY BEE	S	65
3593	LITTLE BUTTERFLY	S	60
3594	LITTLE CAROLINE	S	55
3595	LITTLE CARRIE	S	50
3596	LITTLE CAVALIER, THE	S	55
3597	LITTLE CHARLIE	S	55
3598	LITTLE CHARLIE AND HIS HORSE	S	65
3599	LITTLE CHARLIE / "The Prize Boy"	S	65
3600	LITTLE CHERUBS, THE	S	35
3601	LITTLE CHIEFTAIN	S	55
3602	LITTLE CHILDREN—LOVE ONE ANOTHER	S	50
3603	LITTLE COLORED PET	S	50
3604	LITTLE DAISY	M	50
3605	LITTLE DOLLY	S	45
3606	LITTLE DOT	S	45
3607	LITTLE DRESSMAKER, THE	S	60
3608	LITTLE DRUMMER BOY, THE	S	70
3609	LITTLE EMMA	S	125
3610	LITTLE EMMIE	S	55
3611	LITTLE EMMIE	S	55
3612	LITTLE EMPORER, THE	S	25
3613	LITTLE ELLA	S	75
3614	LITTLE ELLEN	S	50
3615	LITTLE EVA	S	50
3616	LITTLE FAIRY	S	50
3617	LITTLE FANNIE	S	60
3618	LITTLE FANNY	S	50
3619	LITTLE FAVORITE, THE	S	60
3620	LITTLE FAVORITE, THE	S	60
3621	LITTLE FAVORITE, THE	S	55
3622	LITTLE FIREMAN, THE	L	145
3623	LITTLE FLORA	S	55
3624	LITTLE FLORA	S	55
3625	LITTLE FLOWER GATHERER	S	50
3626	LITTLE FLOWER GIRL, THE / #589	S	75
3627	LITTLE FLOWER GIRL, THE	S	50
3628	LITTLE FLOWER GIRL	S	50
3629	LITTLE FOLKS IN THE COUNTRY	S	60
3630	LITTLE FREDDIE	S	50
3631	LITTLE FRUIT BEARER	S	60
3632	LITTLE FRUIT GIRL, THE / #590	S	75
3633	LITTLE FRUIT GIRL	S	75
3634	LITTLE GAME OF BAGATELLE BETWEEN OLD ABE...	S	145
3635	LITTLE GEORGIE	S	50
3636	LITTLE GROGGY, A	S	200
3637	LITTLE HARRY / #617	S	55
3638	LITTLE HARRY	S	60
3639	LITTLE HERO	S	55
3640	LITTLE "HIGH STRUNG," A	S	225
3641	LITTLE HIGHLANDER, THE	S	50
3642	LITTLE JAMIE	S	50
3643	LITTLE JANE	S	60
3644	LITTLE JANE / #615	S	60
3645	LITTLE JANICE	S	50
3646	LITTLE JENNIE	S	60
3647	LITTLE JOHNNIE AND BESSIE	S	60
3648	LITTLE JOHNNIE	S	60
3649	LITTLE JULIA	S	70
3650	LITTLE KATE	S	50
3651	LITTLE KATE	S	50
3652	LITTLE KATIE	S	50
3653	LITTLE KITTIE AND HER KITS	S	80
3654	LITTLE KITTIES AMONG THE ROSES	S	85
3655	LITTLE KITTY	S	90
3656	LITTLE LILY	S	50
3657	LITTLE LIZZIE	S	65
3658	LITTLE LIZZY	S	65
3659	LITTLE LULU / So Sleepy	S	75
3660	LITTLE MAGGIE	S	55
3661	LITTLE MAMIE	S	60
3662	LITTLE MAMMA, THE	S	60
3663	LITTLE MANLY	S	55
3664	LITTLE MARTHA / #320	S	60
3665	LITTLE MARTHA / #320	S	60
3666	LITTLE MARTHA	S	60
3667	LITTLE MARY	S	70
3668	LITTLE MARY	S	70
3669	LITTLE MARY AND HER LAMB	S	65
3670	LITTLE MARY AND THE LAMB	S	75
3671	LITTLE MAY BLOSSOM	S	45
3672	LITTLE MAY BLOSSOM	S	45
3673	LITTLE MAY QUEEN	S	60
3674	LITTLE MAY QUEEN	S	60
3675	LITTLE MECHANIC, THE	S	70
3676	LITTLE MERRY BOY	S	50
3677	LITTLE MINNIE	S	55
3678	LITTLE MINNIE / "Taking Tea"	S	55
3679	"LITTLE MORE GRAPE CAPT. BRAGG," A	S	150
3680	"LITTLE MORE GRAPE CAPT. BRAGG," A / #474	S	150
3681	LITTLE MOTHER, THE	S	85
3682	LITTLE MOURNER	S	40
3683	LITTLE NELLIE	S	60
3684	LITTLE NELLY	S	60
3685	LITTLE ORPHAN GIRL, THE	S	45
3686	LITTLE PETS, THE	S	90
3687	LITTLE PILGRIMS, THE	S	60
3688	LITTLE PLAYFELLOW, THE	S	65
3689	LITTLE PLAYMATES, THE	S	50
3690	LITTLE POTATO BUGS	S	50
3691	LITTLE PROTECTOR, THE	S	45
3692	LITTLE PROTECTOR, THE	S	45

3693	LITTLE PRUDY	S	50
3694	LITTLE RECRUIT, THE	M	95
3695	LITTLE RED RIDING HOOD	L	145
3696	LITTLE RED RIDING HOOD	S	90
3697	LITTLE ROSEBUD	S	45
3698	LITTLE SAINT JOHN BAPTIST	S	25
3699	LITTLE SARAH	S	70
3700	LITTLE SARAH	S	80
3701	LITTLE SARAH	S	80
3702	LITTLE SARAH	S	70
3703	LITTLE SCHOLAR, THE	S	55
3704	LITTLE "76"	S	75
3705	LITTLE SHORE BIRD	S	70
3706	LITTLE SISTER	S	55
3707	LITTLE SISTER	S	60
3708	LITTLE SISTER / #587	S	60
3709	LITTLE SISTER	S	55
3710	LITTLE SISTERS	S	70
3711	LITTLE SISTERS	S	70
3712	LITTLE SISTER'S FIRST STEP	S	65
3713	LITTLE SISTER'S FIRST STEP	S	65
3714	LITTLE SISTERS RIDE	S	75
3715	LITTLE SISTERS, THE	S	70
3716	LITTLE SISTERS, THE	M	75
3717	LITTLE SISTERS, THE	M	75
3718	LITTLE SLEEPY	S	60
3719	LITTLE SNOWBIRD	S	220
3720	LITTLE STUDENTS, THE	S	55
3721	LITTLE SUNBEAM	S	60
3722	LITTLE SUNSHINE	S	60
3723	LITTLE SWEETHEART	S	50
3724	LITTLE TEA PARTY, THE	S	70
3725	LITTLE TEACHER, THE	S	60
3726	LITTLE THOUGHTFUL	S	45
3727	LITTLE VIOLET	S	50
3728	LITTLE VOLUNTEER, THE	S	95
3729	LITTLE VOLUNTEERS, THE	S	65
3730	LITTLE WANDERER, THE	S	100
3731	LITTLE WHITE DOGGIES / Into Mischief	S	105
3732	LITTLE WHITE KITTIES / Eating Cake	S	100
3733	LITTLE WHITE KITTIES / Fishing	S	105
3734	LITTLE WHITE KITTIES / Into Mischief	S	100
3735	LITTLE WHITE KITTIES / Playing Ball	S	100
3736	LITTLE WILDFLOWER	S	60
3737	LITTLE WILLIAM AND MARY	S	45
3738	LITTLE WILLIE	S	70
3739	LITTLE YACHTSMAN, THE	S	115
3740	LITTLE ZOUAVE, THE / "Up boys, and at them"	S	55
3741	LIVING CHINESE FAMILY, THE	S	75
3742	LIVINGSTON GUARDS QUICK STEP	S	65

3743	LIZZIE	S	50
3744	LLEWELLYN — THE GREAT	S	25
3745	LOADING COTTON	S	535
3746	LOBSTER SAUCE	S	50
3747	LOBSTER SAUCE	M	70
3748	LOG CABIN OR TIPPECANOE WALTZ	S	70
3749	LOLA MONTEZ	S	85
3750	LOLA MONTEZ AS MARIQUITA	S	85
3751	LOLA MONTEZ, BELLE OF THE WEST	S	85
3752	LONDON FROM KEW GARDENS	S	75
3753	LONDONDERRY, IRELAND	S	40
3754	LONDONDERRY / Ireland	L	100
3755	LONDONDERRY / On the River Foyle, Ireland	S	40
3756	LONG ISLAND SOUND	M	640
3757	LONG LIVE THE REPUBLIC	M	120
3758	LONGFELLOW	S	60
3759	LONGFELLOW / By Lexington, dam Nantura	S	325
3760	LOOK AT MAMA / #229	S	45
3761	LOOK AT MAMA	S	45
3762	LOOK AT MAMMA	S	45
3763	LOOK AT PAPA	S	45
3764	LOOK AT PAPA	S	45
3765	LOOK AT PAPA	S	45
3766	LOOK AT PAPA	S	45
3767	LOOKING DOWN THE YO-SEMITE	S	305
3768	LOOKING IN	S	95
3769	LOOKING OUT	S	75
3770	LOOKING UNTO JESUS	S	25
3771	LOOKOUT MOUNTAIN, TENNESSEE / ...Chattanooga Rail Road	L	5250
3771A	LORD BE WITH YOU, THE	S	50
3772	LORD BE WITH YOU, THE	S	110
3773	LORD BE WITH YOU, THE	S	85
3774	LORD'S PRAYER, THE	S	30
3775	LORD'S PRAYER, THE	S	30
3776	LORD'S PRAYER, THE	S	30
3777	LORD BYRON	S	45
3778	LORD'S SUPPER, THE	S	30
3779	LOSS OF THE STEAMBOAT SWALLOW	S	325
3780	LOSS OF THE STEAMER "CIMBRIA"	S	235
3781	LOSS OF THE U.S.M. STEAM SHIP ARCTIC	S	225
3782	LOST	S	75
3783	LOST CAUSE, THE	S	75
3784	LOST IN THE SNOW / Dogs of St. Bernard	S	140
3785	LOTTIE	S	60
3786	LOUE SOIT A JAMAIS J.C. DANS LE TRES SAINT SACREMENT DE L'AUTEL	S	20

3787	LOUIS KOSSUTH / General in Chief...	S	40
3788	LOUIS KOSSUTH AND HIS STAFF	S	40
3789	LOUIS NAPOLEON BONAPARTE	S	80
3790-3794	LOUISA	S	50
3795	LOUISA V. PARKER AS EVA IN "UNCLE TOM'S CABIN"	S	100
3796	LOVE IS THE LIGHTEST	S	70
3797	LOVE IS THE LIGHTEST	S	70
3798	LOVE LETTER, THE	S	50
3799	LOVE LETTER, THE	S	50
3800	LOVE LIFE AT WINDSOR CASTLE	S	30
3801	LOVE'S LIGHT / Makes Home Bright	S	75
3802	LOVE ONE ANOTHER	S	75
3803	LOVE THE OLD DOG, TOO	S	80
3804	LOVELY CALM, A	S	205
3805	LOVERS, THE	S	50
3806	LOVERS, THE	S	60
3807	LOVER'S ADIEU, THE	S	85
3808	LOVER'S ADIEU, THE	S	50
3809	LOVER'S LEAP	S	80
3810	LOVER'S QUARREL, THE	S	70
3811	LOVER'S QUARREL, THE	S	70
3812	LOVER'S QUARREL, THE	S	70
3813	LOVER'S RECONCILIATION, THE	S	65
3814	LOVER'S RECONCILIATION, THE	S	65
3815	LOVER'S RECONCILIATION, THE	S	65
3816	LOVER'S RECONCILIATION, THE	S	65
3817	LOVER'S RETURN, THE	S	70
3818	LOVER'S RETURN, THE	S	70
3819	LOVER'S WALK, THE	S	60
3820	LOVER'S WALK, THE	S	60
3821	LOVE'S LIGHT / Makes Home Bright	S	75
3822	LOVE'S MESSENGER	S	55
3823	LOW PRESSURE STEAMBOAT "ISAAC NEWTON," THE	L	3335
3824	LOW WATER IN THE MISSISSIPPI	L	3100
3825	LOWER LAKE OF KILLARNEY, THE	S	95
3826	LOYAL UNION LEAGUE CERTIFICATE	S	75
3827	LUCILLE / By Exchequer - Record 2:21	S	275
3828	LUCILLE GOLDDUST / Driven by Chas. S. Green	S	295
3829	LUCKY ESCAPE, THE	M	270
3830	LUCRETIA	S	55
3831	LUCRETIA	S	95
3832	LUCRETIA R. GARFIELD	S	50
3833	LUCY	S	65
3834	LUCY	S	65
3835	LUCY	S	65
3836	LUCY / By Geo. M. Patchen	S	250
3837	LUCY RECORD 2:15 DRIVEN BY SAM KEYES	S	250
3838	LUDVIG KOSSUTH / The Hungarian Leader	S	40
3839	LUGGELAW / County Wicklaw-Ireland	S	65
3840	LUKE BLACKBURN / By Bonnie Scotland, Dam Nevada	S	270
3841	LUKE BLACKBURN	VS	80
3842	LULA / Bay Mare, by Alexander's Norman	L	925
3843	LULA / Record 2:15 Driven by Chas. S. Green	S	240
3844	LUSCIOUS PEACHES	S	105
3845	LUXURY OF TOBACCO, THE	S	250
3846	LYDIA	S	75
3847	"MAC" / June 28th, 1853. In a match with "Tacony"...	L	1725
3848	MAC AND ZACHARY TAYLOR	L	1800
3849	MAC-CUT-MISH-E-CA-CU-CAC / or Black Hawk	S	175
3850	MACHINERY HALL / Grand U.S. Centennial Exhibition, 1876	S	150
3851	MADAME CELESTE AS "MIAMI"	S	95
3852	MADE. VESTRIS	S	40
3853	MADISON, THE CAPITOL OF WISCONSIN	S	320
3854	MADLE TAGLIONI AS LA BAYADERE	S	75
3855	MADLLE AUGUSTA IN LA BAYADERE	S	65
3856	MADLLE AUGUSTA IN LA BAYADERE	S	65
3857	MADLLE CELESTE / As The Wild Arab Boy	S	80
3858	MADLLE FANNY ELSSLER IN "LA TARANTULE"	S	65
3859	MADLLE FANNY ELSSLER IN THE CRACOVIENNE	S	65
3860	MADLLE TAGLIONI AS LA BAYADERE	S	75
3861	MADONNA DI SAN SISTO	S	25
3862	MADONNA OF THE SHAWL	S	25
3863	MAGADINO, LAKE MAGGIORE / Canton Tessin, Switzerland	L	85
3864	MAGGIE	S	45
3865	MAGIC CURE, THE	S	175
3866	MAGIC GROTTOES see c3438	VS	—
3867	MAGIC GROTTOES	S	65
3868	MAGIC GROTTOES, THE	M	95
3869	MAGIC LAKE see c3438	VS	—

3870	MAGIC LAKE	M	110
3871	MAGIC LAKE, THE	M	110
3872	MAGNIFICENT BUILDING FOR THE WORLD'S FAIR OF 1851	S	150
3873	MAGNIFICENT NEW STEAMER "PRISCILLA"..., THE	S	245
3874	MAGNIFICENT NEW STEAMER "PURITAN"..., THE	M	340
3875	MAGNIFICENT NEW STEAMER "PURITAN"..., THE	S	250
3876	MAGNIFICENT NEW STEAMSHIP "CITY OF ROME"...	S	275
3877	MAGNIFICENT O'CONNELL FUNERAL CAR, THE	S	60
3878	MAGNIFICENT STEAMSHIP "BRITANNIC"... WHITE STAR LINE	S	260
3879	MAGNIFICENT STEAMSHIP "CITY OF NEW YORK"	S	325
3880	MAGNIFICENT STEAMSHIP "CITY OF PARIS," THE	S	275
3881	MAGNIFICENT STEAMSHIP "CITY OF ROME" 8415 TONS...	S	275
3882	MAGNIFICENT STEAMSHIP "GERMANIC"... WHITE STAR LINE	S	250
3883	MAGNIFICENT STEAMSHIP "MAJESTIC"... WHITE STAR LINE	S	250
3884	MAGNIFICENT STEAMSHIP "NEW YORK"... AMERICAN LINE	S	300
3885	MAGNIFICENT STEAMSHIP "PARIS" OF THE AMERICAN LINE	S	275
3886	MAGNIFICENT STEAMSHIP "ST. LOUIS"... AMERICAN LINE	S	235
3887	MAGNIFICENT STEAMSHIPS, THE / Egypt and Spain	L	100
3888	MAIDEN ROCK / Mississippi River	S	390
3889	MAIDEN ROCK / Mississippi River	S	425
3890	MAIDEN'S PRAYER, THE	S	35
3891	MAIDEN'S ROCK / Mississippi River	S	390
3892	MAIN BUILDING / Grand U.S. Centennial Exhibition, 1876	S	205
3893	MAIN OF THE COCKS, A	M	200
3894	MAINE GIANTESS, THE / Miss Silva Hardy...	S	155
3895	MAJ. GEN. FRANZ SIGEL / The hero of the West	S	80
3896	MAJ. GEN. JOHN C. FREMONT / U.S. Army	S	65
3897	MAJ. GEN. PHILIP H. SHERIDAN / U.S. Army	S	75
3898	MAJ. GEN. PHILIP H. SHERIDAN / Rallying his troops...	S	115
3899	MAJOLICA / Owned by Nathan Straus...	L	850
3900	MAJOLICA—RECORD 2:15	VS	65
3901	MAJR. GENL. AMBROSE E. BURNSIDE / Commander in Chief	S	95
3902	MAJR. GENL. AMBROSE E. BURNSIDE / Fredericksburg, Va.	S	95
3903	MAJ. GEN. BENJ. F. BUTLER / Of Massachusetts	S	70
3904	MAJR. GENL. FRANZ SIGEL / The Hero of the West	S	80
3905	MAJR. GENL. GEORGE B. McCLELLAN / At...Antietam, Md. Sept. 17th, 1862	S	115
3906	MAJR. GENL. GEO. B. McCLELLAN / General-in-Chief	S	75
3907	MAJR. GENL. GEORGE B. McCLELLAN / The people's choice	S	95
3908	MAJR. GENL. GEORGE B. McCLELLAN / U.S. Army	S	75
3909	MAJR. GENL. GEORGE G. McCLELLAN / U.S. Army	S	75
3910	MAJR. GENL. GEORGE G. McCLELLAN / U.S. Army	S	75
3911	MAJR. GENL. GEORGE G. MEADE / At...Gettysburg...	S	135
3912	MAJR. GENL. GEORGE G. MEADE / Commander-in-Chief...	S	75
3913	MAJOR GENL. HENRY W. HALLECK / General-in-Chief...	M	120
3914	MAJOR GENL. HENRY W. HALLECK	S	95
3915	MAJOR GENL. HENRY W. HALLECK, U.S.A.	S	60
3916	MAJ. GENL. JOHN C. FREMONT / U.S. Army	S	90
3917	MAJOR GENL. JOHN E. WOOL / U.S. Army	M	75
3918	MAJOR GENL. JOHN E. WOOL	S	60
3919	MAJR. GENL. JOHN POPE	S	60
3920	MAJOR GENERAL JOHN POPE	S	60
3921	MAJOR GENL. JOSEPH HOOKER	S	110
3922	MAJOR GENL. JOSEPH HOOKER / Commander-in-Chief...	S	110
3923	MAJOR GENL. JOSEPH HOOKER / (Fighting Joe)...	S	150
3924	MAJR. GENL. NATHL. BANKS	S	85
3925	MAJ. GEN. PHILIP H. SHERIDAN / Rallying his troops...	S	115

3926	MAJ. GEN. PHILIP H. SHERIDAN / U.S. Army	S	75
3927	MAJR. GENL. Q. A. GILMORE	S	65
3928	MAJ. GENL. U.S. GRANT / At the siege of Vicksburg...	S	75
3929	MAJOR GENL. WILLIAM S. ROSECRANS / At...Murfreesboro	S	100
3930	MAJOR GENERAL WILLIAM S. ROSECRANS	S	65
3931	MAJOR GEN. WILLIAM T. SHERMAN / ...Victorious March	S	125
3932	MAJR. GENL. WILLIAM T. SHERMAN	S	80
3933	MAJOR GENL. WINFIELD SCOTT / At Vera Cruz...	S	90
3934	MAJOR GENL. WINFIELD SCOTT	L	100
3935	MAJOR GENERAL WINFIELD SCOTT / General-in-Chief	S	75
3936	MAJOR GENERAL WINFIELD SCOTT / General-in-Chief	S	85
3937	MAJ. GENL. WINFIELD HANCOCK / At...Spottsylvania Court House	S	85
3938	MAJOR GENL. Z. TAYLOR BEFORE MONTEREY	S	95
3939	MAJOR GENERAL ZACHARY TAYLOR / "Rough and Ready"	S	95
3940	MAJOR ROBERT ANDERSON / The Hero of Fort Sumter	S	90
3941	MAJOR SAMUEL RINGGOLD / (Of the Flying Artillery)...	S	70
3942	MA-KO-ME-TA OR BEAR'S OIL /A Monomonic Chief	S	65
3943	MAMA'S DARLING	L	125
3944	MAMA'S DARLINGS	S	65
3945	MAMA'S JEWEL	S	45
3946	MAMA'S PET	S	50
3947	MAMA'S PET	S	55
3948	MAMA'S PETS	S	55
3949	MAMA'S ROSEBUD	M	75
3950	MAMBRINO	S	275
3951	MAMBRINO / The Sire of Imported Messenger	S	300
3952	MANBRINO PILOT, DAISY BURNS, AND ROSAMOND	L	1025
3953	MAMMA'S DARLINGS	S	60
3954	MAMMA'S PET	S	60
3955	MAMMA'S PETS	S	75
3956	MAMMA'S TREASURE	M	75
3957	MAMMOTH IRON STEAMSHIP "GREAT EASTERN," THE	S	275
3958	MAMMOTH IRON STEAMSHIP "GREAT EASTERN," THE	S	275
3959	MAMMOTH IRON STEAMSHIP "GREAT EASTERN"	S	275
3960	MAMMOTH IRON STEAMSHIP "LEVIATHAN" / 22,500 TONS	S	275
3961	MAN OF WORDS — THE MAN OF DEEDS WHICH DO YOU THINK...	S	165
3962	MAN OF WORDS, THE — The Man of Deeds	S	165
3963	MAN THAT GAVE BARNUM HIS TURN, THE	S	150
3964	MAN THAT KEPT THE BRIDGE, THE	S	170
3965	MAN THAT KNOWS A HORSE, THE	M	275
3966	MAN WHO DRIVES TO WIN, THE	S	175
3967	MANAGING A CANDIDATE	M	175
3968	MANIFESTATION OF THE SACRED HEART	S	25
3969	MANSION OF THE OLDEN TIME, A	S	155
3970	MAP OF CENTREVILLE / County Seat of St. Joseph County	L	245
3971	MAP OF MT. VERNON	S	265
3972	MAP OF PROPERTY AT / JAMAICA, L.I.	L	650
3973	MAP OF THE PROPERTY / Chelsea New York	M	200
3974	MAP OF THE / WESTERN LAND DISTRICT WISCONSIN	L	400
3975	MAPLE SUGARING / Early Spring in the Northern Woods	S	1075
3976	MARCH AWAY! MARCH AWAY! BUCKLER AND BONNET BLUE!	S	80
3977	MARCUS MORTON / Governor of Massachusetts	S	50
3978- 3982	MARGARET	S	60
3983	MARGUERITE	S	50
3984- 3990	MARIA	S	60
3991	MARIA	S	50
3992	MARIA	S	60
3993	MARINE BARK "CATALPA"	S	600
3994	MARINE BARK "THE AMAZON"	S	600
3995	MARION'S BRIGADE CROSSING THE PEDEE RIVER, S.C. 1788	S	400
3996	MARRIAGE, THE	S	55
3997	MARRIAGE, THE	S	55
3998	MARRIAGE, THE	S	55
3999	MARRIAGE CERTIFICATE / "Whom God Hath joined..."	S	60
4000	MARRIAGE CERTIFICATE / "Whom God hath joined..."	S	60
4001	MARRIAGE CERTIFICATE	S	50
4002	MARRIAGE CERTIFICATE	S	50

4003	MARRIAGE CERTIFICATE	S	80
4004	MARRIAGE CERTIFICATE	S	50
4005	MARRIAGE CERTIFICATE	S	50
4006	MARRIAGE CERTIFICATE	S	50
4007	MARRIAGE CERTIFICATE	S	70
4008	MARRIAGE EVENING, THE	S	75
4009	MARRIAGE EVENING	S	60
4010	MARRIAGE MORNING, THE	S	75
4011	MARRIAGE MORNING	S	75
4012	MARRIAGE OF QUEEN VICTORIA TO PRINCE ALBERT	S	45
4013	MARRIAGE OF THE FREE SOIL AND LIBERTY PARTIES	S	250
4014	MARRIAGE VOW, THE	S	60
4015	MARRIAGE VOW, THE	S	60
4016	MARRIED	S	60
4017-			
4020	MARTHA	S	60
4021	MARTHA	S	45
4022	MARTHA WASHINGTON	S	55
4023	MARTHA WASHINGTON	S	75
4024	MARTHA WASHINGTON	S	55
4025	MARTHA WASHINGTON	VS	95
4026	MARTHA WASHINGTON	S	55
4027	MARTHA WASHINGTON	M	75
4028	MARTIN VAN BUREN	VS	50
4029	MARTIN VAN BUREN / The Champion of Democracy	S	110
4030	MARTIN VAN BUREN / The Champion of Democracy	S	110
4031	MARTIN VAN BUREN / Eighth President...	S	110
4032	MARTIN VAN BUREN / Eighth President...	S	110
4033	MARTIN VAN BUREN / Eighth President...	M	135
4034	MARTIN VAN BUREN / Eighth President...	S	110
4035	MARTIN VAN BUREN / Free Soil Candidate for 12th President	S	125
4036	MARY	S	75
4037	MARY	S	75
4038	MARY	S	65
4039	MARY	S	55
4040-			
4043	MARY	S	65
4044-			
4046	MARY	S	55
4047	MARY	M	75
4048	MARY	S	50
4049	MARY AND HER LITTLE LAMB	M	100
4050	MARY ANN	S	70
4051	MARY ANN	S	80
4052	MARY ANN	S	70
4053	MARY ELIZABETH	S	70
4054	MARY ELIZABETH	S	65
4055	MARY JANE	S	65
4056	MARY JANE	S	65
4057	MARY JANE	S	75
4058	MARY, QUEEN OF SCOTS	S	45
4059	MARY, QUEEN OF SCOTS	S	45
4060	MARY, QUEEN OF SCOTS	S	45
4061	MARY, QUEEN OF SCOTS LEAVING FRANCE	S	65
4062	MARY'S LITTLE LAMB	S	75
4063	MASHERS, THE	S	170
4064	MASONIC CHART, THE	S	125
4065	MASSACHUSETTS	M	325
4066	MASTER R.W. OSBORN / The Lilliputian King	S	115
4067	MATCH AGAINST TIME, A	S	275
4068	MATER DOLOROSA	S	25
4069	MATER DOLOROSA	S	25
4070	MATERNAL AFFECTION	S	60
4071	MATERNAL AFFECTION	S	60
4072	MATERNAL AFFECTION	S	60
4073	MATERNAL HAPPINESS	S	60
4074	MATERNAL PIETY	S	55
4075	MATILDA	S	60
4076	MATILDA	S	60
4077	MATILDA	S	75
4078	MATILDA	S	55
4079	MATING — IN THE WOODS / "Ruffed Grouse"	S	415
4080	MATTIE	S	50
4081	MATTIE HUNTER, RECORD 2:12 ½	S	250
4082	MATTIE HUNTER, PACER — RECORD 2:15	VS	60
4083	MATTIE HUNTER / The sorrel beauty...Pacing Quartette	S	250
4084	MAUD MULLER	L	100
4085	MAUD S. RECORD 2:09 ¾	S	325
4086	MAUD S. AND ST. JULIEN	S	350
4087	MAXY COBB / Record 2:13 ¼	VS	75
4088	MAY QUEEN / By Alexander's Norman....	S	245
4089	MAY QUEEN, THE	S	55
4090	MAY QUEEN, THE	S	55
4091	MAYFLOWER SALUTED BY THE FLEET	L	850
4092	MAZEPPA PL. 1	S	60
4093	MAZEPPA PL. 2	S	60
4094	MAZEPPA PL. 3	S	60
4095	MAZEPPA PL. 4	S	60
4096	M'DONOUGH'S VICTORY ON LAKE CHAMPLAIN	S	375
4097	MEADOW IN SPRINGTIME, THE / The Twin Lambs	L	225
4098	MEADOW, SPRINGTIME, THE	L	225
4099	MEADOWSIDE COTTAGE	M	350
4100	MEDALLA MILAGROSA — MIRACULOUS MEDAL	S	35
4101	MEETING OF THE WATERS, THE / In the Vale of Avoca...	S	70

4102	MEETING OF THE WATERS, THE / In the Vale of Avoca...	L	200
4103	MELROSE ABBEY	S	80
4104	MELROSE ABBEY	S	80
4105	MELROSE ABBEY	M	150
4106	MERCHANT'S EXCHANGE, NEW YORK / Wall Street	S	650
4107	MERRY CHRISTMAS	S	75
4108	MERRY CHRISTMAS	S	75
4109	MERRY CHRISTMAS	S	200
4110	MERRY, MERRY MAIDEN AND THE TAR, THE	S	150
4111	MEXICAN FANDANGO	S	65
4112	MEXICAN GUERRILLEROS / Mexico in 1848	S	125
4113	MEXICANS EVACUATING VERA CRUZ, THE	S	135
4114	MIDDLESEX PAUPER LUNATIC ASYLUM LONDON ENGLAND	M	75
4115	MIDNIGHT / By Peacemaker, by Rysdyk's Hambletonian	S	340
4116	MIDNIGHT RACE ON THE MISSISSIPPI, A	L	3900
4117	MIDNIGHT RACE ON THE MISSISSIPPI	S	490
4118	MIDSUMMER-NIGHT'S DREAM, A	L	125
4119	MILIGROSA IMAGEN	S	20
4120	MILITARY COLLEGE OF CHAPULTEPEC, THE	S	120
4121	MILITARY RING, THE	S	160
4122	MILL BOY AND BLONDINE	S	250
4123	MILL COVE LAKE / Near Po'keepsie-on-the-Hudson	S	300
4124	MILL DAM AT "SLEEPY HOLLOW", THE	L	1000
4125	MILL IN THE HIGHLANDS	M	285
4126	MILL RIVER SCENERY	L	350
4127	MILL-STREAM, THE	M	350
4128	MILLARD FILLMORE / Thirteenth President of the U.S.	S	385
4129	MILLARD FILLMORE / Thirteenth President of the U.S.	L	485
4130	MILLARD FILLMORE / Thirteenth President of the U.S.	S	325
4131	MILLARD FILLMORE / Whig Candidate for Vice-President	S	400
4132	MILLER'S HOME, THE	M	375
4133	MIND YOUR LESSON, FIDO	S	75
4134	MINER, STEVENS & CO.	L	1000
4135	MINIATURE LANDSCAPES	M	210
4136	MINIATURE LANDSCAPES NO. 1	S	200
4137	MINIATURE SHIP "RED, WHITE, AND BLUE"	S	225
4138	MININATURE SHIP "RED, WHITE, AND BLUE," THE	S	225
4139	MINK TRAPPING / "Prime"	L	8250
4140	MINNEHAHA / Laughing Water	S	165
4141	MINNEHAHA FALLS / Minnesota	M	295
4142	MINNE	VS	30
4143	MINNE	S	50
4144	"MINUTE-MEN" OF THE REVOLUTION, THE	S	290
4145	MIRACULOUS MEDAL	S	25
4146	MIRACULOUS IMAGE OF ST. FRANCIS XAVIER	S	20
4147	MISCHIEF AND MUSIC	S	75
4148	MISCHIEVOUS LITTLE DOGGIE	S	85
4149	MISCHIEVOUS LITTLE KITTIE	S	95
4150	MISCHIEVOUS LITTLE KITTIES	S	90
4151	MISERIES OF A BACHELOR, THE	S	225
4152	MISS ELIZABETH REID — THE LILLIPUTIAN QUEEN	S	100
4153	MISS ELIZABETH REID — MISS HANNAH CROUSE	S	100
4154	MISS JANE CAMPBELL / The Great Connecticut Giantess	S	100
4155	MISS MARTHA JONES / The Lilliputian Queen	S	100
4156	MISS S. PHILLIPS / The Distinguished Vocalist	S	85
4157	MISS SUSAN BARTON / The Mammoth Lady	S	100
4158	MISS WOODFORD / By Billet, dam Fancy Jane...	S	260
4159	MISSIONARY STONE CHAPEL AT WHEELOCH, CHOCTAW NATION	S	95
4160	MISSISSIPPI IN TIME OF PEACE, THE	L	1000
4161	MISSISSIPPI IN TIME OF WAR, THE	L	925
4162	MIXED AT THE FINISH	S	300
4163	MODEL ARTISTS AS THE THREE GRACES...	S	75
4164	MODERN COLLEGE SCULL, A / Graduating with all honors	M	225
4165	MODERN COLOSSUS, THE	M	225
4166	MOLLIE McCARTHY	VS	60
4167	MOLLIE McCARTHY / The Racing Queen of the Pacific Slope	S	275
4168	MOMENTOUS QUESTION, THE /"Ah, Billy, my beauty..."	S	250
4169	MOMENTOUS QUESTION, THE /Is my face good for a drink?	S	250
4170	MOMENTOUS QUESTION, THE	S	175
4171	MONROE CHIEF / Record 2:18 ¼	VS	65
4172	MONUMENT	S	95
4173	MOONLIGHT	VS	50
4174	MOONLIGHT	M	85

4175	MOONLIGHT IN FAIRYLAND	S	90
4176	MOONLIGHT IN THE TROPICS	S	115
4177	MOONLIGHT ON LAKE CATALPA, VA.	M	195
4178	MOONLIGHT ON LONG ISLAND SOUND	S	335
4179	MOONLIGHT ON THE LAKE	M	200
4180	MOONLIGHT ON THE MISSISSIPPI	S	325
4181	MOONLIGHT PROMENADE, THE	S	65
4182	MOONLIGHT PROMENADE	S	65
4183	MOONLIGHT / The Castle	S	75
4184	MOONLIGHT — THE RUINS	S	70
4185	MOOSE AND WOLVES	S	550
4186	MOOSEHEAD LAKE	S	180
4187	MORE FREE THAN WELCOME	S	175
4188	MORE FRIGHTENED THAN HURT	S	95
4189	MORE FRIGHTENED THAN HURT	S	200
4190	MORE PLUCKY THAN PRUDENT	S	245
4191	MORE THAN WELCOME	S	65
4192	MORGAN LEWIS	S	70
4193	MORGAN LEWIS	VS	55
4194	MORNING	S	75
4195	MORNING GLORIES	S	75
4196	MORNING IN THE WOODS	L	2200
4197	MORNING IN THE WOODS	L	2200
4198	MORNING OF LIFE, THE	S	60
4199	MORNING OF LIFE, THE	S	60
4200	MORNING OF LOVE, THE	S	60
4201	MORNING PRAYER, THE	S	45
4202	MORNING PRAYER, THE	S	35
4203	MORNING PRAYER, THE	L	50
4204	MORNING PRAYER, THE	M	50
4205	MORNING PRAYER, THE	L	35
4206	MORNING PRAYER, THE / "Defend us from all evil..."	S	35
4207	MORNING RECREATION, THE	S	50
4208	MORNING RIDE, THE	S	100
4209	MORNING RIDE, THE	S	100
4210	MORNING ROSE, THE	S	50
4211	MORNING ROSE, THE	S	50
4212	MORNING ROSES	S	50
4213	MORNING STAR, THE	S	55
4214	MORNING STAR, THE	S	55
4215	MORNING STAR	S	55
4216	MOSES AND THE DECALOGUE	S	30
4217	MOSS ROSE, THE	S	95
4218	MOSS ROSE, THE	S	95
4219	MOSS ROSE, THE	S	95
4220	MOSS ROSES AND BUDS	S	90
4221	MOSS ROSES AND BUDS	S	90
4222	MOST HOLY CATHOLIC FAITH, THE	S	25
4223	MOST HOLY SACRIFICE, THE	S	25
4224	MOST REV. JOHN HUGHES, D.D., THE	M	30
4225	MOST REV. JOHN HUGHES, D.D., THE	S	30
4226	MOST REV. JOHN McCLOSKEY, D.D., THE	S	30
4227	MOST REVEREND M.J. SPALDING, D.D., THE	S	20
4228	MOTHER AND CHILD	S	60
4229	MOTHERLESS, THE	S	50
4230	MOTHERLESS, THE	S	50
4231	MOTHER'S BLESSING, THE	M	125
4232	MOTHER'S DREAM, THE	S	50
4233	MOTHER'S DREAM, THE	M	125
4234	MOTHER'S JOY	S	50
4235	MOTHER'S JOY	S	50
4236	MOTHER'S JOY	S	50
4237	MOTHER'S PET	S	75
4238	MOTHER'S TREASURE, A	S	40
4239	MOTHER'S WING	M	150
4240	MT. HOLYOKE FEMALE SEMINARY, SOUTH HADLEY, MASS.	S	325
4241	MOUNT VESUVIUS, ITALY	S	65
4242	MOUNT WASHINGTON AND THE WHITE MOUNTAINS	L	950
4243	MOUNTAIN PASS, THE / Sierra Nevada	L	1000
4244	MOUNTAIN RAMBLE, A	S	135
4245	MOUNTAIN SPRING, THE / West Point, near Cozzen's Dock	M	565
4246	MOUNTAIN STREAM, THE	M	325
4247	MOUNTAINEER'S HOME, THE	M	330
4248	MOUNTAINEER'S RETURN, THE	S	45
4249	MR. AUGUST BELMONT'S / Potomac...and Masher...	L	1450
4250	MR. BONNER'S HORSE JOE ELLIOT, DRIVEN BY J. BOWEN	L	1750
4251	MR. FRANK WORK'S CELEBRATED TEAM/Edward and Swiveller	S	400
4252	MR. J. PROCTOR / in his Great Original Character	S	140
4253	MR. JAS. R. KEENE'S BAY COLT, 3YRS., FOXHALL...	S	260
4254	MR. PLACIDE / In the Character of Frederick 2nd...	S	80
4255	MR. PIERRE LORILLARD'S BR. COLT, 3 YRS., IROQUOIS...	S	280
4256	MR. WM. H. VANDERBILT DRIVING HIS MAGNIFICENT TEAM	S	300
4257	MR. WM. H. VANDERBILT'S CELEBRATED ROAD TEAM	S	275

4258 MR. WM. H. VANDERBILT'S CELEBRATED TEAM	L	1525
4259 MR. WM. H. VANDERBILT'S CELEBRATED ROAD TEAM	S	325
4260 MRS. FISH AND THE MISSES FOX / The orignial Mediums...	S	175
4261 MRS. GEORGE JONES, THE TRAGIC ACTRESS	S	75
4262 MRS. J.K. POLK	S	60
4263 MRS. LUCRETIA R. GARFIELD	M	50
4264 MRS. LUCY L. BLISS / Authoress of "Rock of Ages"...	S	50
4265 MUCKROSS ABBEY, KILLARNEY	S	35
4266 MUD S., DE GREAT RECORD BUSTER	S	260
4267 MULE TEAM ON A DOWN GRADE, A	S	225
4268 MULE TEAM ON AN UP GRADE, A	S	225
4269 MURDER OF MISS JANE McCREA, A.D. 1777	S	140
4270 MUSIC	S	190
4271 MUSIC / Chestnut Mare, by Middletown...	L	725
4272 MUSIC HATH CHARMS!	S	85
4273 MUSTANG TEAM, THE	M	225
4274 MY ABSENT LOVE	S	50
4275 MY BOYHOOD HOME	S	165
4276 MY BOYHOOD'S HOME	S	165
4277 MY BROTHER	S	60
4278 MY CHARMING GIRL	S	55
4279 MY CHILD	S	75
4280 MY CHILD! MY CHILD!	S	50
4281 MY CHOICE	S	45
4282 MY CHOICE	M	50
4283 MY COTTAGE HOME	L	500
4284 MY COTTAGE HOME see c3438	VS	—
4285 MY DARLING BOY	S	60
4286 MY DARLING GIRL	S	55
4287 MY DARLING GIRL	S	60
4288 MY DARLING GIRL / Kiss Me Quick	S	60
4289 MY DEAR LITTLE PET	S	75
4290 MY FAVORITE HORSE	S	75
4291 MY FAVORITE PONY	S	75
4292 MY FATHER LAND	S	40
4293 MY FAVORITE	S	50
4294 MY FAVORITE	S	50
4295 MY FIRST FRIEND	S	60
4296 MY FIRST LOVE	S	50
4297 MY FIRST PLAYMATE	S	50
4298 MY FIRST PLAYMATE	S	60
4299 MY FRIEND AND I	S	50
4300 MY GENTLE DOVE	S	75
4301 MY GENTLE LOVE	S	50
4302 MY HEART'S DESIRE	S	50
4303 MY HEART'S TREASURE	S	50

4304 MY HERO	S	60
4305 MY HIGHLAND BOY	S	50
4306 MY HIGHLAND BOY	S	50
4307 MY HIGHLAND GIRL	S	50
4308 MY HIGHLAND GIRL	S	50
4309 MY HIGHLAND GIRL	S	50
4310 MY INTENDED	S	50
4311 MY KITTY AND CANARY	S	70
4312 "MY LIPS SHALL PRAISE THEE"	S	45
4313 MY LITTLE DRUMMER BOY	S	50
4314 MY LITTLE FAVORITE	S	60
4315 MY LITTLE FAVORITE	M	60
4316 MY LITTLE FAVORITE	M	70
4317 MY LITTLE FRIEND	S	50
4318 MY LITTLE PET	S	50
4319-		
4325 MY LITTLE PLAYFELLOW	S	60
4326 MY LITTLE WHITE BUNNIES	S	70
4327 MY LITTLE WHITE BUNNIES	S	70
4328 MY LITTLE WHITE KITTENS	S	95
4329 MY LITTLE WHITE KITTIE / After the Goldfish	S	95
4330 MY LITTLE WHITE KITTIE / Fishing	S	95
4331 MY LITTLE WHITE KITTIE / Its First Mouse	S	95
4332 MY LITTLE WHITE KITTIES / Into Mischief	S	105
4333 MY LITTLE WHITE KITTIES / Learning their A B C's	S	105
4334 MY LITTLE WHITE KITTIES / Playing Ball	S	110
4335 MY LITTLE WHITE KITTIES / Playing Ball	S	110
4336 MY LITTLE WHITE KITTIES / Playing Dominoes	S	115
4337 MY LITTLE WHITE KITTIES	S	95
4338 MY LITTLE WHITE KITTIES / Taking the Cake	S	95
4339 MY LITTLE WHITE KITTIES / Taking the Cake	S	100
4340 MY LITTLE WHITE KITTIES / Their First Mouse	S	95
4341 MY LITTLE WHITE KITTIES / Their First Mouse	S	95
4342 MY LONG TAIL BLUE	S	75
4343 MY LOVE AND I	S	70
4344 MY OWN MAMA	S	50
4345 MY OWN SWEET PET	S	50
4346 MY OWN TRUE LOVE	S	45
4347 MY PET BIRD	S	65
4348 MY PET BIRD	M	90
4349 MY PICTURE	L	95
4350 MY PONY AND DOG	S	105
4351 MY PONY & DOG	S	85
4352 MY PRETTY IRISH GIRL	S	60
4353 MY SISTER	S	45

4354	MY SWEETHEART	S	50
4355	MY SWEETHEART	L	70
4356	MY THREE WHITE KITTENS	S	95
4357	MY THREE WHITE KITTIES / Learning their A B C's	S	110
4358	NANCY	S	65
4359	NANCY	S	65
4360	NANCY HANKS	S	300
4361	NAPOLEON	M	100
4362	NAPOLEON	S	65
4363	NAPOLEON AT ST. HELENA	S	80
4364	NAPOLEON AT ST. HELENA	S	100
4365	NAPOLEON AT WATERLOO	S	125
4366	NAPOLEON BONAPARTE / Emperor of France	M	85
4367	NAPOLEON CROSSING THE ALPS	S	80
4368	NAPOLEON CROSSING THE ALPS	S	100
4369	NAPOLEON, EMPEROR OF FRANCE	S	90
4370	NAPOLEON / In the highest degree of his prosperity	S	90
4370A	NAPOLEON / The Hero of 100 Battles	S	95
4371	NAPOLEON / The Hero of 100 Battles	S	95
4372	NAPOLEON'S STRATEGY, OR KING WILLIAM OUT-GENERALED	S	100
4373	NAPOLEON EUGENE LOUIS	S	40
4374	NAPOLEON II - DUKE OF REICHSTADT	S	40
4375	NAPOLEON III	S	35
4376	NARRAGANSETT STEAMSHIP CO'S STEAMER "BRISTOL"...	S	315
4377	NARRAGANSETT STEAMSHIP CO'S STEAMER "PROVIDENCE"...	S	315
4378	NARROW WAY, THE	S	85
4379	NARROWS, THE / From Fort Hamilton	S	300
4380	NARROWS, FROM STATEN ISLAND, THE	S	275
4381	NARROWS, NEW YORK BAY, THE / From Staten Island	S	270
4382	NARROWS, NEW YORK BAY, FROM STATEN ISLAND	S	270
4383	NAT LANGHAM / Champion of the Middle Weights	M	325
4384	NATIONAL CADETS 9th REGT. NEW YORK STATE ARTILLERY	S	75
4385	NATIONAL DEMOCRATIC BANNER FOR 1860	S	175
4386	NATIONAL DEMOCRATIC BANNER, 1860	S	185
4387	NATIONAL DEMOCRATIC BANNER OF VICTORY, 1868	S	175
4388	NATIONAL GAME, THE / Three "Outs" and one "Run"	M	265
4389	NATIONAL UNION REPUBLICAN BANNER, 1860	S	200
4390	NATIONAL UNION REPUBLICAN BANNER, 1868	S	200
4391	NATIONAL WASHINGTON MONUMENT	S	230
4392	NATIONAL WASHINGTON MOUNMENT, THE	L	325
4393	NATURAL AND THE SPIRITUAL MAN, THE	S	25
4394	NATURAL BRIDGE / In the "Blue Ridge" region,...	S	210
4395	"NAUGHTY CAT!"	S	95
4396	NAVAL BOMBARDMENT OF VERA CRUZ	S	160
4397	NAVAL HEROES OF THE UNITED STATES / #1	S	435
4398	NAVAL HEROES OF THE UNITED STATES / #2	S	435
4399	NAVAL HEROES OF THE UNITED STATES / #3	S	435
4400	NAVAL HEROES OF THE UNITED STATES / #4 (no known copy)	S	—
4401	NAZARETH OF GALILEE	S	35
4402	NEARER MY GOD TO THEE	S	70
4403	NEAREST WAY IN SUMMER TIME, THE	M	325
4404	NEARING THE FINISH LINE / The American Sloop "Volunteer"	L	850
4405	NECK AND NECK TO THE WIRE / Jay Eye See...Maud S...	L	750
4406	NECKER	S	60
4407	NELLIE	S	75
4408	NELSON	S	240
4409	NETTIE / By Rysdyk's Hambletonian...	S	300
4410	NETTIE — RECORD 2:18	S	300
4411	NEW BROOD, THE	S	75
4412	NEW CACHUCHA, THE	S	20
4413	NEW "CONFEDERATE CRUISER," THE	S	225
4414	NEW ENGLAND BEAUTY, A	S	60
4415	NEW ENGLAND COAST SCENE, OFF BOSTON LIGHT	S	290
4416	NEW ENGLAND COAST SCENE	S	330
4417	NEW ENGLAND HOME, A	S	180
4418	NEW ENGLAND HOMESTEAD, A	S	160
4419	NEW ENGLAND SCENERY	L	1850
4420	NEW ENGLAND WINTER SCENE	L	4850
4421	NEW EXCURSION STEAMER, THE / Columbia	L	900

4422	**NEW FASHIONED GIRL, THE**	S	85
4423	**NEW FOUNTAIN OF DEMOCRACY, THE**	S	225
4424	**NEW HAT MAN, THE**	S	100
4425	**NEW JERSEY FOX HUNT, A /** "Taking a Breath"	S	265
4426	**NEW JERSEY FOX HUNT, A /** "A Smoking Run"	S	265
4427	**NEW PALACE STEAMER PILGRIM, OF THE FALL RIVER LINE**	M	325
4428	**NEW ST. PATRICK'S CATHEDRAL, THE**	S	140
4429	**NEW STEAMSHIP "ETRURIA," THE**	S	200
4430	**NEW STEAMSHIP "PAVONIA," THE**	S	200
4431	**NEW STEAMSHIP "UMBRIA," OF THE CUNARD LINE, THE**	S	200
4432	**NEW SUSPENSION BRIDGE — NIAGARA FALLS, THE**	S	335
4433	**NEW YORK AND BROOKLYN**	L	1300
4434	**NEW YORK AND BROOKLYN /** With Jersey City...	L	1300
4435	**NEW YORK BAY /** From Bay Ridge, L.I.	M	1775
4436	**NEW YORK BAY, FROM BAY RIDGE /** Long Island	S	275
4437	**NEW YORK BAY /** From the Telegraph Station	S	325
4438	**NEW YORK BEAUTY, THE**	S	55
4439	**NEW YORK CLIPPER SHIP "CHALLENGE"**	S	575
4440	**NEW YORK CRYSTAL PALACE FOR THE EXHIBITION...**	L	500
4441	**NEW YORK CRYSTAL PALACE**	S	225
4442	**NEW YORK CRYSTAL PALACE**	S	225
4443	**NEW YORK FERRY BOAT**	S	500
4444	**NEW YORK FERRY BOAT**	S	360
4445	**NEW YORK FIREMAN'S MONUMENT**	M	125
4446	**NEW YORK FROM WEEHAWKEN**	S	400
4447	**NEW YORK LIGHT GUARDS QUICK STEP**	S	110
4448	**NEW YORK, LOOKING NORTH FROM THE BATTERY**	S	350
4449	**NEW YORK /** Pilot's Monument	M	125
4450	**NEW YORK YACHT CLUB REGATTA, THE**	L	2700
4451	**NEWFOUNDLAND DOG**	S	75
4452	**NEWFOUNDLAND DOG**	S	75
4453	**NEWPORT BEACH**	S	465
4454	**NIAGARA BY MOONLIGHT**	M	255
4455	**NIAGARA FALLS**	S	150
4456	**NIAGARA FALLS**	M	275
4457	**NIAGARA FALLS /** From Goat Island	M	255
4458	**NIAGARA FALLS /** From Goat Island	M	255
4459	**NIAGARA FALLS FROM GOAT ISLAND**	S	160
4460	**NIAGARA FALLS /** From Table Rock	S	175
4461	**NIAGARA FALLS /** From the Canada Side	S	160
4462	**NICE AND TEMPTING OYSTERS**	S	90
4463	**NICE FAMILY PARTY, A**	M	185
4464	**NIGGER IN THE WOODPILE, THE**	M	250
4465	**NIGH TO BETHANY**	S	30
4466	**NIGH TO BETHANY**	S	30
4467	**NIGHT**	S	40
4468	**NIGHT AFTER THE BATTLE /** Burying the Dead	S	120
4469	**NIGHT AFTER THE BATTLE, THE /** Burying the Dead	S	120
4470	**NIGHT AFTER THE BATTLE, THE**	S	120
4471	**NIGHT BEFORE THE BATTLE /** The Patriot's Dream	M	150
4472	**NIGHT BY THE CAMP-FIRE**	M	340
4473	**NIGHT EXPRESS, THE /** The Start	S	1675
4474	**NIGHT ON THE HUDSON, A /** "Through at Daylight"	L	2300
4475	**NIGHT SCENE AT A JUNCTION**	L	8500
4476	**NIGHT SCENE AT AN AMERICAN RAILWAY JUNCTION**	L	8500
4477	**NIGHT SCENE AT AN AMERICAN RAILWAY JUNCTION**	L	8500
4478	**NIGHTMARE IN THE SLEEPING CAR, A**	S	285
4479	**NILLS TOWER, NAWORTH**	S	45
4480	**NINETY AND NINE, THE**	S	35
4481	**NIP AND TUCK!**	S	205
4482	**"NIP AND TUCK" RACE, A**	M	300
4483	**NIPPED IN THE ICE**	S	600
4484	**NO MA'AM, I DIDN'T COME TO SHOOT BIRDS**	VS	70
4485	**NO MA'AM, I DON'T CARE TO SHOOT BIRDS**	S	180
4486	**NO, NO FIDO**	VS	75
4487	**"NO ONE TO LOVE ME"**	S	90
4488	**NO ROSE WITHOUT A THORN**	S	110
4489	**NO SLATE HERE**	S	165
4490	**NO TICK HERE**	S	125
4491	**NO TIME HERE — PLAYED OUT**	S	175
4492	**NO YOU DON'T**	S	95
4493	**NO YOU DON'T**	S	95
4494	**NOAH'S ARK**	S	300

4495	NOAH'S ARK	S	155
4496	NOAH'S ARK	S	155
4497	NOAH'S ARK	S	155
4498	NOAH'S ARK	S	155
4499	NOBBY TANDEM, A	VS	60
4500	NOISY PETS	S	70
4501	NOONTIDE A SHADY SPOT	S	140
4502	NORTH AMERICAN INDIANS	M	850
4503	NORTH RIVER FERRY BOAT	S	175
4504	NORTH SEA WHALE FISHERY	S	800
4505	NORTH SIDE VIEW OF THE NORTH CHINCHA ISLAND	S	70
4506	NORTHERN BEAUTY, THE	S	50
4507	NORTHERN SCENERY see c2230	VS	—
4508	NOSE OUT OF JOINT, THE	S	55
4509	NOSE OUT OF JOINT, THE / Buds of Promise	S	55
4510	NOSEGAY, THE	S	90
4511	NOSEGAY, THE	S	90
4512	NOSEGAY, THE	S	90
4513	NOT CAUGHT / There is many a slip between...cup...lip	M	190
4514	NOT CAUGHT YET	S	195
4515	NOTCH HOUSE, WHITE MOUNTAINS, THE / New Hampshire	S	180
4516	NOTHING VENTURED NOTHING HAVE	S	65
4517	NOTICE TO SMOKERS AND CHEWERS	S	95
4518	NOTICE TO SMOKERS / AND CHEWERS	S	250
4519	NOVA SCOTIA SCENERY	M	300
4520	NOW AND THEN	M	200
4521	NUESTRA SENORA DE GUADALUPE — OUR LADY OF GUADALUPE	S	25
4522	"O DAT WATERMELLON"	S	235
4523	O! THERE'S A MOUSIE!	S	85
4524	OBDURATE MULE, AN / Going back on the Parson	S	195
4525	OBSERVATIONS ON THE CURE OF STRABISMUS	VS	60
4526	OCCIDENT / (Formerly "Wonder") brown gelding...	L	1600
4527	OCCIDENT / By St. Clair — Record 2:16 ¾	S	325
4528	OCEAN STEAMER IN A HEAVY GALE, AN	S	335
4529	OCTOBER LANDSCAPE	M	560
4530	ODD FELLOW / Friendship, Love and Truth	S	60
4531	ODD FELLOWS	S	60
4532	ODD FELLOWS	S	60
4533	ODD FELLOWS CHART	S	85
4534	ODD FELLOWS CHART / For colored people	S	115
4535	"ODD TRICK, THE"	S	100
4536	OFF A LEE SHORE	S	400
4537	OFF FOR THE WAR	S	115
4538	OFF FOR THE WAR	S	115
4539	OFF FOR THE WAR / The Soldier's Adieu	S	120
4540	OFF HIS NUT	S	250
4541	OFF ON THE FIRST SCORE	M	735
4542	OFF ON THE FIRST SCORE	M	735
4543	OFF THE COAST IN A SNOWSTORM	S	650
4544	OFF THE PORT	S	765
4545	OH! HOW FINE	S	75
4546	OH! HOW NICE	S	75
4547	OH SWEETLY WE WILL SING LOVE	S	60
4548	OLD BARN FLOOR, THE	L	2125
4549	OLD BLANFORD CHURCH / Petersburg, Virginia	S	150
4550	OLD BRIDGE, THE	S	95
4551	OLD BULL DOG ON THE RIGHT TRACK, THE	M	275
4552	OLD CASTLE, THE	S	90
4553	OLD CREDIT PLAYED OUT	S	175
4554	OLD DARBY AND JOAN	S	60
4555	OLD FARM GATE, THE	L	625
4556	OLD FARM HOUSE WILLIAMSBURG, L.I.	S	250
4557	OLD FARM HOUSE, THE	S	680
4558	OLD FEUDAL CASTLE, THE	S	85
4559	OLD FORD BRIDGE, THE	S	160
4560	OLD GENERAL READY FOR A "MOVEMENT", THE	M	150
4561	OLD HOMESTEAD, THE	M	315
4562	OLD HOMESTEAD, THE	M	315
4563	OLD HOMESTEAD IN WINTER, THE	L	5750
4564	OLD IRONSIDES	S	125
4565	OLD KENTUCKY HOME, DE	S	100
4566	OLD LADY WHO LIVED IN A SHOE, THE	S	125
4567	OLD MANSE, THE	S	205
4568	OLD MANSION HOUSE, GOWANUS ROAD	S	200
4569	OLD MARE THE BEST HORSE, THE	L	945
4570	OLD MASSA'S GRAVE	S	50
4571	OLD MILL — IN SUMMER, THE	S	135
4572	OLD MILL-DAM, THE / At Sleepy Hollow	S	225
4573	OLD NEPTUNE, THE GREAT BLACK SEA LION	S	125
4574	OLD NORMAN CASTLE, THE	S	75
4575	OLD NORMAN CASTLE, THE	L	150
4576	OLD OAKEN BUCKET, THE	L	1080
4577	OLD OAKEN BUCKET, THE	S	165
4578	OLD PLANTATION HOME, THE	S	400

4579	OLD RUINED CASTLE, THE	S	85
4580	OLD RUINS, THE	S	90
4581	OLD RUINS, THE	S	85
4582	OLD SAW MILL, L.I.	S	200
4583	OLD SLEDGE / High-Low-Jack-Game	S	200
4584	OLD STONE HOUSE, L.I. 1699, THE	S	200
4585	OLD SUIT AND THE NEW, THE	S	65
4586	OLD SUIT AND THE NEW, THE	VS	85
4587	OLD TENNANT PARSONAGE, THE / on Monmouth Battlefield	M	400
4588	OLD WAY, THE / The New Way	S	150
4589	OLD VIRGINNY	S	80
4590	OLD WEIR BRIDGE, THE / Lakes of Killarney	M	75
4591	OLD WINDMILL, THE	M	275
4592	ON A POINT	M	585
4593	ON A STRONG SCENT!	S	180
4594	ON BOARD THE GREAT WESTERN STEAM SHIP...	S	85
4595	ON THE HALF SHELL	S	190
4596	1876 — ON GUARD / Unceasing vigilance...	S	125
4597	ON HIS STYLE	S	250
4598	ON THE COAST OF CALIFORNIA	S	200
4599	ON THE DOWNS, AT EPSOM	S	90
4600	ON THE HOMESTRETCH	S	250
4601	ON THE HUDSON	S	225
4602	ON THE HUDSON	S	225
4603	ON THE JUNIATA	M	250
4604	ON THE LAKE	S	185
4605	ON THE MISSISSIPPI	S	450
4606	ON THE MISSISSIPPI	S	450
4607	ON THE MISSISSIPPI / Loading Cotton	S	550
4608	ON THE OWAGO	S	140
4609	ON THE ST. LAWRENCE / Indian Encampment	S	220
4610	ON THE SEINE	VS	75
4611	ONCONVANIENCE OF SINGLE LIFE, THE	S	235
4612	ONE FLAG — ONE COUNTRY — ZWEI LAGER	S	85
4613	"ONE FOR HIS NOB"	S	100
4614	ONE FOR HIS PET	S	50
4615	ONE OF THE HEAVYWEIGHTS	S	60
4616	ONLY DAUGHTER, THE	S	50
4617	ONLY DAUGHTER, THE	S	50
4618	ONLY DAUGHTER, THE / Pet of the Family	S	50
4619	ONLY LIVING GIRAFFES IN AMERICA	S	90
4620	ONLY SON, THE	S	50
4621	ONLY SON, THE	S	50
4622	OPERATIC QUADRILLES	S	65
4623	ORANGEMENS CHART. O.B.L.	S	45
4624	OREGON	S	325
4625	ORIENTAL LANDSCAPE	L	150
4626	ORIGIN OF THE SPECIES, THE	S	100
4627	ORIGINAL "GENERAL TOM THUMB" AS HE APPEARED...	S	125
4628	ORMONDE / Ridden by Fred Archer	S	310
4629	ORNAMENTAL CARDS	S	65
4630	OSAGE WARRIOR / Iroquois. Pawnee Woman	M	850
4631	OSCAR J. DUNN, LIEUT. GOVR. OF LOUISIANA	S	40
4632	OSTEND DOCTRINE, THE	S	170
4633	O'SULLIVAN'S CASCADE / Lake of Killarney	S	70
4634	OTHELLO...TROTTING STALLION...	M	360
4635	"OULD TIMES" AT DONNYBROOK FAIR	S	125
4636	OUR BOAT SETS LIGHTLY ON THE WAVE	S	125
4637	"OUR CABINET"	L	85
4638	OUR FATHER / WHO ART IN HEAVEN	S	50
4639	OUR FATHER / WHO ART IN HEAVEN	M	40
4640	OUR LADY OF GUADALUPE	S	25
4641	OUR LADY OF KNOCK	S	40
4642	OUR LADY OF LOURDES	S	25
4643	OUR LADY OF MERCY	S	30
4644	OUR LADY OF MOUNT CARMEL	S	25
4645	OUR LADY OF MOUNT CARMEL	S	25
4646	OUR LADY OF REFUGE	S	25
4647	OUR LADY OF THE LIGHT	S	25
4648	OUR LADY OF THE ROSARY	S	30
4649	OUR LADY OF THE SEVEN SORROWS	S	25
4650	OUR PASTURE	S	100
4651	OUR PASTURE	S	100
4652	OUR PETS / Fast Asleep	S	65
4653	OUR PETS / Wide Awake	S	65
4654	OUR REDEEMER	S	25
4655	OUR SAVIOR / The Agony in Gethsemane	S	25
4656	OUR SAVIOR AT PRAYER	S	25
4657	OUR SAVIOR / El Senor	S	25
4658	OUR VICTORIOUS FLEET IN CUBAN WATERS	L	935
4659	OUR VILLAGE HOME	VS	35
4660	OUT FOR A DAY'S SHOOTING / Off For the Woods	L	4400
4661	OUTLET OF NIAGARA RIVER, THE	S	180
4662	OUTLET OF THE NIAGARA RIVER, THE / Lake Ontario...	S	180
4663	OUTWARD BOUND	S	520

4664	OUTWARD BOUND	S	1450
4665	OUTWARD BOUND	S	520
4666	OUTWARD BOUND	S	520
4667	OUTWARD BOUND	S	40
4668	OVER THE GARDEN WALL	M	95
4669	OYSTER PADDY	S	95
4670	OYSTER SUPPER, AN / "We Won't Get Home Until Morning"	S	115
4671	OYSTERS IN THE LATEST STYLE	S	95
4672	PACIFIC COAST STEAMSHIP CO.'S STEAMER / ...California	L	2850
4673	PACIFIC MAIL STEAMSHIP..."GREAT REPUBLIC"	S	265
4674	PACING A FAST HEAT	M	550
4675	PACING A FAST HEAT	M	550
4676	PACING CHAMPIONS ON THEIR METTLE	S	325
4677	PACING FOR A GOOD PURSE	L	1195
4678	PACING FOR A GRAND PURSE	L	1195
4679	PACING HORSE "BILLY BOYCE" OF ST. LOUIS	L	1150
4680	PACING IN THE LATEST STYLE	L	1000
4681	PACING KING, HAL POINTER, BY BROWN HAL,...	S	300
4682	PACING KING ROBERT J. RECORD 2:01 ½	S	285
4683	PACING KING ROBERT J. RECORD 2:01 ½	L	1270
4684	PACING KING ROBERT J. IN HIS RACE WITH JOE PATCHEN	S	285
4685	PACING WONDER LITTLE BROWN JUG, OF CHICAGO, ILLS.	S	340
4686	PACING WONDER SLEEPY TOM, THE BLIND HORSE, THE	S	350
4687	PACING WONDER SLEEPY TOM, THE BLIND HORSE, THE	S	300
4688	PADDLE WHEEL STEAMSHIP "MASSACHUSETTS", THE	L	675
4689	PADDY AND THE PIGS	M	100
4690	PADDY MURPHY'S "JANTIN CAR"	S	145
4691	PADDY RYAN / "The Trojan Giant"	M	275
4692	PAGE, THE	S	50
4693	PAIR OF NUTCRACKERS, THE	S	125
4694	PAP, SOUP, AND CHOWDER	S	300
4695	PAPAL BENEDICTION, THE	S	30
4696	PAPA'S COMING	S	60
4697	PAPA'S DARLINGS	S	60
4698	PAPA'S DARLINGS	S	60
4699	PAPA'S NEW HAT	S	50
4700	PAPA'S PET	S	90
4701	PARLEY, A / Prepared for an Emergency	L	7500
4702	PAROLE / Browm Gelding by Imp. Leamington...	S	335
4703	PAROLE / Browm Gelding by Imp. Leamington...	S	335
4704	PAROLE / Browm Gelding by Imp. Leamington...	L	1540
4705	PAROLE	VS	100
4706	PARSON'S COLT, THE / Hears a trotter behind him...	S	315
4707	PARSON'S COLT, THE	L	975
4708	PARSON'S COLT, THE	VS	80
4709	PART OF THE BATTLE OF SHILOH	S	150
4710	PARTHENON OF ATHENS	M	150
4711	PARTING, THE / or the Sailors Wife	S	75
4712	PARTING HOUR, THE	S	45
4713	PARTING HOUR, THE	S	45
4714	PARTRIDGE SHOOTING	M	2125
4715	PARTRIDGE SHOOTING	S	500
4716	PARTRIDGE SHOOTING	S	385
4717	PARTRIDGE SHOOTING	M	2125
4718	PARTRIDGE SHOOTING	S	300
4719	PARTRIDGE SHOOTING	S	385
4720	PAST AND FUTURE	L	125
4721	PASTURE IN SUMMER, THE	L	655
4722	PASTURE — NOONTIDE	M	250
4723	PATH THROUGH THE FIELDS, THE	S	115
4724	PATH THROUGH THE WOODS, THE	S	150
4725	PATRIOT OF 1776, A / Defending His Homestead	S	205
4726	PATTERN IN CONNEMARA	S	60
4727	PAUL & VIRGINIA / Lost in the Wood...	S	75
4728	PAUL AND VIRGINIA'S DEPARTURE FOR FRANCE	S	75
4729	PAULINE	S	65
4730	PAULINE	S	65
4731	PAWLE	S	65
4732	PEACE	S	80
4733	PEACE AND PLENTY	M	175
4734	PEACE BE TO THIS HOME	S	75
4735	PEACEFUL LAKE, THE	S	95
4736	PEACEFUL RIVER, THE	S	140
4737	PEACHES AND GRAPES / First Prize	S	110
4738	PEEK-A-BOO!	S	70
4739	PEERLESS BEAUTY, THE	S	65
4740	PEERLESS GOLDSMITH MAID, DRIVEN BY BUDD DOBLE, THE	S	315
4741	PEERLESS GOLDSMITH MAID, DRIVEN BY BUDD DOBLE, THE	S	315

4742 PELLHAM / July 2nd, 1849, trotted one mile...	L	700
4743 PENITENT MULE. THE PARSON ON DECK, THE	S	220
4744 PENNSYLVANIA HALL, BRISTOL COLLEGE see c1136	M	—
4745 PENNSYLVANIA RAILROAD SCENERY	S	550
4746 PEOPLE IN THE TUILERIES, THE	S	130
4747 PEOPLE'S EVENING LINE	VS	90
4748 PEOPLE'S LINE. HUDSON RIVER	L	1350
4749 PERCHERON STALLION DUC DE CHARTRES...	L	575
4750 PERFECT BLISS	M	150
4751 PERFECT BLISS	S	100
4752 PERFECT BLISS	VS	70
4753 PERMANENT FAIR GOUNNDS OF THE / QUEENS COUNTY...	L	500
4754 PERRY'S VICTORY ON LAKE ERIE	S	590
4755 PERSIAN BEAUTY	S	60
4756 PET OF THE FAMILY, THE	S	60
4757 PET OF THE FAMILY / on Christmas morning	S	70
4758 PET OF THE FANCY	S	125
4759 PET OF THE FANCY	S	125
4760 PET OF THE FANCY	VS	60
4761 PET OF THE LADIES, THE	S	125
4762 PETS IN SPRINGTIME	S	75
4763 PEYTONA AND FASHION / In their great match...$20,000	L	11000
4764 PHALLAS / by Dictator - Record 2:15 ½	S	290
4765 PHALLAS—DRIVEN BY E.D. BLITHERS—RECORD 2:15 ½	L	650
4766 PHALLAS — RECORD 2:13 ¾	VS	55
4767 PHEBE	S	55
4768 PHEBE	S	75
4769 PHENOMENAL TROTTING GELDING JAY EYE SEE BY DICTATOR	L	750
4770 PHILOSOPHER IN ECSTASY, A / "By George! I've got it!!"	S	180
4771 PHILOSOPHY OF TOBACCO, THE	S	100
4772 PHOEBE	S	50
4773 PHOTOGRAPH MARRIAGE CERTIFICATE	S	55
4774 PIC-NIC PARTY, THE	M	700
4775 PIC-NIC PARTY, THE	L	885
4776 PICADOR	M	155
4777 PICKEREL	S	190
4778 PICTURESQUE LANDSCAPES	S	150
4779 PIEDMONT / By Almond, dam by Mambrino Chief	S	265
4780 PIGEON SHOOTING / "Playing the Decoy"	L	2550
4781 PILGRIM'S PROGRESS, THE	S	75
4782 PILOT BOAT IN A STORM	S	410
4783 PILOT BOAT IN A STORM	S	410
4784 PINCH TAKEN, THE	S	115
4785 PIONEER CABIN OF THE YO-SE-MITE VALLEY, THE	S	325
4786 PIONEER'S HOME, THE / On the Western Frontier	L	1975
4787 PLACID LAKE / Adirondacks	S	180
4788 PLACID LAKE / Adirondacks	S	165
4789 PLAN OF GILBERT'S BALANCE FLOATING DRY DOCK	L	300
4790 PLAN OF NEW HAVEN, CONN.	L	400
4791 PLAN OF SCHOOL HOUSE	S	70
4792 PLAN OF THE CITY OF NEW YORK, A	L	600
4793 PLATNER & SMITH — LEE, MASS.	S	100
4794 PLAYED OUT	S	175
4795 PLAYFUL	M	125
4796 PLAYFUL FAMILY, THE	S	90
4797 PLAYFUL FAMILY, THE	S	80
4798 PLAYFUL PETS, THE	S	75
4799 PLAYFUL PETS, THE	S	75
4800 PLAYING DOMINOES	S	75
4801 PLAYMATES, THE	S	65
4802 PLAYMATES, THE	S	65
4803 PLAYMATES, THE	S	75
4804 PLEASE GIVE ME A LIGHT, SIR	S	100
4805 PLEASE GIVE ME A LIGHT SIR	VS	70
4806 PLEASURE	S	190
4807 PLEASURE / A Freemonter Before the Election	S	200
4808 PLEASURES OF THE COUNTRY, THE / Sweet Home	M	255
4809 PLEASURES OF THE COUNTRY / Winter	S	425
4810 PLUCK / One of the Right Sort	M	110
4811 PO-CAN-TECO, THE / From Irving Park see c759	VS	—
4812 POCAHONTAS BOY (1790) RECORD 2:31	L	1100
4813 POCAHONTAS SAVING THE LIFE OF CAPT'N JOHN SMITH	S	125
4814 POINT OF THE JOKE, THE	S	190
4815 POINTER, THE	S	40
4816 POINTERS	S	150
4817 POINTING A BEVY	L	700
4818 POLISHED OFF / Golly — He's Licked	S	225
4819 POLITICAL ARENA, THE	S	90
4820 POLITICAL "BLONDINS" CROSSING SALT RIVER	M	250
4821 POLITICAL DEBATE IN THE DARKTOWN CLUB, A	S	225

4822	POLITICAL DEBATE IN THE DARKTOWN CLUB, A	S	225
4823	POLITICAL GYMNASIUM, THE	M	225
4824	POLITICAL "SIAMESE" TWINS, THE	M	225
4825	POLKA, THE / Pl. 1	S	55
4826	POLKA, THE / Pl. 2	S	55
4827	POLKA, THE / Pl. 3	S	55
4828	POLKA, THE / Pl. 4	S	55
4829	POLLY AND KITTY / Roses Have Thorns	M	150
4830	POMONA'S TREASURES	S	65
4831	POMPON ROSE, THE	VS	150
4832	POND IN THE WOODS, THE	M	215
4833	PONTO	S	50
4834	PONY TEAM, THE	S	65
4835	PONY WAGON, THE	S	65
4836	POOL, THE see c2002	S	—
4837	POOL OF SILOAM, THE	S	40
4838	POOR DOLLY	S	45
4839	POOR TRUST IS DEAD / Bad Pay Killed Him	S	200
4840	POPE LEO XIII	S	25
4841	POPE PIUS IX	S	25
4842	POPE PIUS IX	S	25
4843	POPE PIUS IX / Anno Domine 1846	S	30
4844	POPE PIUS IX / Bestowing the Papal benediction...	S	30
4845	POPE PIUS IXth, LYING IN STATE	S	25
4846	POPPING THE QUESTION	S	75
4847	PORT OF NEW YORK, THE	L	1900
4848	PORT OF NEW YORK, THE	L	1900
4849	PORT OF NEW YORK, THE	L	1250
4850	PORTRAIT OF A GIRL	S	55
4851	PORTUGUESE MARINER'S SONG, THE	S	125
4852	POSITIVE PROCESS FROM A NEGATIVE RESULT, A	S	250
4853	POST OFFICE, THE / New York	S	800
4854	POT LUCK	S	80
4855	POULTRY SHOW ON A BUST, A	S	235
4856	POULTRY SHOW ON THE ROAD, A	S	235
4857	POULTRY YARD, THE	M	175
4858	POWER OF MUSIC, THE	S	125
4859	PRAIRIE FIRES OF THE GREAT WEST	S	880
4860	PRAIRIE HENS	S	265
4861	PRAIRIE HUNTER, THE / "One rubbed out"	L	3600
4862	PRAIRIE ON FIRE	S	300
4863	PRAIRIE WOLVES ATTACKING A BUFFALO BULL	M	1100
4864	PRAISE THE LORD / O MY SOUL	S	35
4865	PRAY "GOD BLESS PAPA AND MAMA"	S	40
4866	PRAY "GOD BLESS PAPA AND MAMA"	S	40
4867	PREMIUM FRUIT	S	165
4868	PREMIUM POULTRY	S	120
4869	PREPARING FOR CONGRESS	S	275
4870	PREPARING FOR MARKET	L	2700
4871	PREPARING FOR MARKET	L	2700
4872	PREPARING FOR MARKET	L	2700
4873	PRESIDENT CLEVELAND AND HIS CABINET	S	100
4874	PRESIDENT CLEVELAND AND HIS CABINET	L	190
4875	PRESIDENT CLEVELAND AND HIS CABINET	L	190
4876	PRESIDENT HARRISON AND HIS CABINET	S	100
4877	PRESIDENT HARRISON AND HIS CABINET	L	175
4878	PRESIDENT HAYES AND HIS CABINET	S	125
4879	PRESIDENT LINCOLN AND HIS CABINET	S	150
4880	PRESIDENT LINCOLN AND SECRETARY SEWARD SIGNING...	S	150
4881	PRESIDENT LINCOLN AT GENL. GRANT'S HEADQUARTERS	M	150
4882	PRESIDENT LINCOLN AT HOME / Reading the Scriptures...	S	75
4883	PRESIDENT LINCOLN AT HOME / Reading the Scriptures...	S	75
4884	PRESIDENTIAL FISHING PARTY OF 1848, THE	S	225
4885	PRESIDENTIAL RECEPTION IN 1789, A	S	140
4886- 4902	PRESIDENTS OF THE UNITED STATES, THE	S	120
4903	PRESIDENTS, THE / Of the United States, 1789 to 1861	S	130
4904	PRESIDENTS, THE / Of the United States, 1789 to 1869	S	140
4905	PRESS GANG, THE	S	95
4906	PRETTY AMERICAN, THE	S	70
4907	PRETTY DOLLY	S	55
4908	PRETTY POLL	S	45
4909	PRETTY STORY, THE see c527	S	—
4910	PRIDE OF AMERICA, THE	S	65
4911	PRIDE OF AMERICA, THE	S	150
4912	PRIDE OF KENTUCKY, THE	S	60
4913	PRIDE OF KILDARE, THE	S	60
4914	PRIDE OF THE GARDEN, THE	S	125
4915	PRIDE OF THE SOUTH, THE	S	60
4916	PRIDE OF THE WEST, THE	S	60
4917	PRIDE OF THE WEST, THE	S	70
4918	PRIDE OF THE WEST, THE	S	60
4919	PRIMARY DRAWING STUDIES	S	120

4920	PRIME TOBACCO / Tobacco Jack	S	125
4921-			
4924	PRINCE ALBERT	S	40
4925	PRINCE AND LANTERN / In their great match for $10,000	L	1445
4926	PRINCE AND PRINCESS OF WALES, THE	S	45
4927	PRINCE OF THE BLOOD, A	L	160
4928	PRINCE OF WALES AND FAMILY	S	45
4929	PRINCE OF WALES, THE	S	45
4930	PRINCE OF WALES AND FAMILY, THE	S	45
4931	PRINCE OF WALES AT THE TOMB OF WASHINGTON, OCT. 1860	S	75
4932	PRINCE WILKES RECORD 2:14 ¾...	S	290
4933	PRINCESS ROYAL OF ENGLAND	S	50
4934	PRIZE "BLACK HAMBURG" GRAPES	M	275
4935	PRIZE BOY, THE	L	175
4936	PRIZE BOY, THE	L	175
4937	PRIZE FAT CATTLE	S	75
4938	PRIZE FIGHTER, THE	M	115
4939	PRIZE GRAPES	M	275
4940	PRIZE HERD, A	L	300
4941	PRIZE JERSEY LITCHFIELD BULL	S	75
4942	PRIZE JERSEY "NIOBE"	S	75
4943	PRIZE SETTER, A	S	170
4944	PRIZE TROTTER, A	S	350
4945	PRIZE TROTTER, A / Clear the Track!...	S	400
4946	PROCTOR KNOTT / By Luke Blackburn...	S	250
4947	PRODIGAL SON IN MISERY, THE	S	30
4948	PRODIGAL SON RECEIVING HIS PATRIMONY, THE	S	30
4949	PRODIGAL SON RETURNS TO HIS FATHER, THE	S	30
4950	PRODIGAL SON WASTING HIS SUBSTANCE, THE	S	30
4951	PROFIT AND LOSS	S	225
4952	PROGRESS OF INTEMPERANCE, THE	S	200
4953	PROGRESS OF INTEMPERANCE, THE / The invitation...	S	200
4954	PROGRESS OF INTEMPERANCE, THE / Sick and Repentant	S	200
4955	PROGRESS OF INTEMPERANCE, THE / The Relapse	S	200
4956	PROGRESS OF INTEMPERANCE, THE / The Ruined Family	S	200
4957	PROGRESS OF INTEMPERANCE, THE / The Expectant Wife	S	200
4958	PROGRESS OF INTEMPERANCE, THE / The Robber	S	200
4959	PROGRESS OF THE CENTURY, THE	S	590
4960	PROGRESSIVE DEMOCRACY— PROSPECT OF A SMASH UP	M	275
4961	PROMISING FAMILY, A / Black and Tan	S	85
4962	PROPAGATION SOCIETY, THE	VS	80
4963	PROPOSAL, THE	S	65
4964	PROTECTED STEEL CRUISER PHILADELPHIA U.S. NAVY	M	300
4965	PROTEINE / By Blackwood...	S	265
4966	PROVIDENCE AND STONINGTON...STEAMER / Rhode Island	S	325
4967	PROVIDENCE AND STONINGTON...STEAMER / Rhode Island	L	1050
4968	PROVIDENCE AND STONINGTON...STEAMER MASSACHUSETTS	L	1050
4969	PROVIDENCE AND STONINGTON STEAMSHIP CO'S STEAMERS...	L	1050
4970	PROVISIONS DOWN / Oh! Oh! Oh!	S	350
4971	PUPPIES NURSERY, THE	S	70
4972	PUPPY	S	50
4973	PURITAN AND GENESTA ON THE HOME STRETCH, THE	L	1400
4974	PURSUIT, THE	L	4250
4975	PURSUIT, THE	S	80
4976	PURSUIT OF THE MEXICANS BY THE U.S. DRAGOONS	S	150
4977	PUSS IN BOOTS	S	100
4978	PUSSY'S RETURN	S	95
4979	PUT UP JOB, A	S	325
4980	PUTTING ON HIS AIRS	S	120
4981	PUZZLE / For a Winter's Evening	S	400
4982	PUZZLE FOR A WINTER'S EVENING	S	300
4983	PUZZLE PICTURE—OLD SWISS MILL	S	310
4984	PUZZLED FOX, THE	S	325
4985	PUZZLED FOX, THE / Find the horse, lamb...	S	325
4986	QUADRILLES / from Auber's Celebrated Opera	S	75
4987	QUADRILLES / from Auber's Celebrated Opera	S	75

4988	QUAIL / or Virginia Partridge	S	285
4989	QUAIL SHOOTING	L	2875
4990	QUAIL SHOOTING	S	475
4991	QUAILS	S	225
4992	QUAILS	S	250
4993	QUARREL, THE	S	75
4994	QUEEN OF ANGELS	S	25
4995	QUEEN OF ANGELS, THE	S	25
4996	QUEEN OF BEAUTY	S	50
4997	QUEEN OF BEAUTY, THE	S	50
4998	QUEEN OF BEAUTY, THE	S	50
4999	QUEEN OF CATTLE, THE	M	75
5000	QUEEN OF CATTLE, THE— THE CHAMPION STEER	L	125
5001	QUEEN OF HEARTS	L	100
5002	QUEEN OF LOVE, THE	S	45
5003	QUEEN OF LOVE AND BEAUTY	S	50
5004	QUEEN OF LOVE AND BEAUTY	S	50
5005	QUEEN OF AMAZONS ATTACKED BY A LION	S	45
5006	QUEEN OF THE ANGELS, THE	S	25
5007	QUEEN OF THE BALL, THE	S	45
5008	QUEEN OF THE BLONDES	S	50
5009	QUEEN OF THE BRUNETTES	S	55
5010	QUEEN OF THE FLOWERS	S	50
5011	QUEEN OF THE GARDEN	S	85
5012	QUEEN OF THE HOUSE	S	125
5013	QUEEN OF THE SOUTH	S	50
5014	QUEEN OF THE SOUTH, THE	S	50
5015	QUEEN OF THE TURF "LADY THORN"...	S	350
5016	QUEEN OF THE TURF "MAUDE S."...	L	1800
5017	QUEEN OF THE WEST, THE	S	55
5018	QUEEN OF THE WOODS	M	70
5019	QUEEN OF THE WOODS, THE	M	70
5020-			
5025	QUEEN VICTORIA	S	45
5026	QUEEN VICTORIA see c1736	S	—
5027	QUEEN VICTORIA'S COURT QUADRILLES...	S	65
5028	QUEEN'S OWN, THE / Wimbledon Style	M	245
5029	QUEEN'S OWN, THE	VS	70
5030	QUEENSTOWN HARBOR	M	120
5031	QUEENSTOWN HARBOR / Cove of Cork, Ireland	S	80
5032	QUESTION SETTLED, THE	S	150
5033	RAAL CONVANIENCE, A	S	235
5034	RABBIT CATCHING / The Trap Sprung	S	700
5035	RABBIT HUNT, THE / All But Caught	S	210
5036	RABBITS IN THE WOODS	S	175
5037	RACE FOR THE AMERICAN DERBY, THE	S	350
5038	RACE FOR BLOOD, A	L	1550
5039	RACE FOR BLOOD, A	L	1350
5040	RACE FOR THE QUEEN'S CUP, THE	S	650
5041	RACE FROM THE WORD "GO," A	L	1275
5042	RACE ON THE MISSISSIPPI, A	S	355
5043	RACE TO THE WIRE, A	L	1160
5044	RACHEL	S	65
5045	RACING CHAMPIONS ON THEIR METTLE	L	1000
5046	RACING CRACKS AT THE STARTING POST	L	1350
5047	RACING KING SALVATOR, MILE RECORD 1:35 ½	S	365
5048	RACING KING SALVATOR, MILE RECORD 1:35 ½, THE	L	1275
5049	RACQUET RIVER / "Adirondacks"	S	260
5050	RADICAL PARTY ON A HEAVY GRADE, THE	M	290
5051	RAFTING ON THE ST. LAWRENCE	M	350
5052	RAIL CANDIDATE, THE	M	275
5053	RAIL SHOOTING	S	1000
5054	RAIL SHOOTING / On the Delaware	L	4610
5055	RAIL SPLITTER AT WORK REPAIRING THE UNION, THE	S	225
5056	RAILROAD SUSPENSION BRIDGE, THE / Near Niagara Falls	M	540
5057	RALLY AROUND THE FLAG / Victory at Last	S	70
5058	RAPIDS OF DUNASS / "On the Shannon"	S	60
5059	RARUS / By Conklin's Abdullah...	S	300
5060	RARUS / By Son of Old Abdullah	S	300
5061	RARUS / By Son of Old Abdullah	S	300
5062	RARUS, RECORD 2:13 ¼	VS	65
5063	RARUS AND GREAT EASTERN	S	400
5064	RASPBERRIES	S	100
5065	RASPBERRIES	S	100
5066	RASPBERRIES	S	100
5067	RATHGALLAN HEAD / Scene in the "Shaughraun"	S	35
5068	RATTLING HEAT, A	M	600
5069	RATTLING HEAT, A	M	600
5070	RAVENSWOOD / Long Island near Hallets Cove	L	1000
5071	R.B. CONKLIN'S BY GELDING RARUS, "KING OF THE TROTTERS"	L	1065

5072	R. CORNELL WHITE'S PALATIAL...STEAMER "COLUMBIA"	L	1225
5073	READING THE BIBLE	S	40
5074	READING THE BIBLE	S	40
5075	READING THE SCRIPTURES	S	40
5076	READING THE SCRIPTURES	S	40
5077	READING THE SCRIPTURES	S	45
5078	READY FOR BATTLE	S	165
5079	READY FOR A FROLIC	S	90
5080	READY FOR AN OFFER	S	50
5081	READY FOR THE RACE	L	1200
5082	READY FOR THE SIGNAL	L	1200
5083	READY FOR THE START	S	200
5084	READY FOR THE TROT / "Bring up your Horses"	L	1400
5085	READY FOR THE TROT / "Bring up your Horses"	L	1300
5086	REBECCA	S	75
5087	REBECCA	S	60
5088	REBECCA	S	60
5089	RECHABITE / Temperance, Fortitude, and Justice	S	75
5090	RECONCILIATION, THE	S	75
5091	RE-CONSTRUCTION / Or a "White Man's Government"	S	200
5092	RECORD OF BIRTH AND BAPTISM	S	85
5093	RED CLOUD / By Legal Tender...	L	1150
5094	RED CLOUD / By Legal Tender...	S	335
5095	RED HOT REPUBLICANS ON THE DEMOCRATIC GRIDIRON	S	175
5096	REDEEMER, THE	S	25
5097	REDEEMER, THE	S	25
5098	REDEMPTION—REPUDIATION	S	160
5099	REDPATH	S	250
5100	REDPATH	S	250
5101	REDPATH	S	250
5102	REFRESHING FOUNTAIN, A	S	95
5103	REGATTA OF THE NEW YORK YACHT CLUB, JUNE 1st, 1854	L	2700
5104	REGATTA OF THE N.Y. YACHT CLUB "ROUNDING THE S.W. SPIT"	L	2700
5105	REGATTA OF THE NEW YORK YACHT CLUB, THE START	L	2700
5106	REGISTER FOR COLORED PEOPLE, A	S	75
5107	REGULAR HUMMER, A!	S	225
5108	REGULAR HUMMER, A!	VS	75
5109	REINDEER POLKA	S	125
5110	REJECTED, THE	S	55
5111	REMEMBER THE SABBATH DAY TO KEEP IT HOLY	S	30
5112	REMEMBER THE SABBATH DAY TO KEEP IT HOLY	M	70
5113	RENOWNED TROTTER "PRINCE WILKES," RECORD 2:14 ¾	L	1250
5113A	REPUBLICAN BANNER FOR 1860, THE	S	200
5114	REPUBLICAN PARTY GOING TO THE RIGHT HOUSE, THE	M	265
5115	RESCUE, THE	S	330
5116	RESCUED	S	50
5117	RESCUED	S	50
5118	RESIDENCE OF LORD BYRON, THE	S	50
5119	RESIGNATION	S	55
5120	RESULT IN DOUBT, THE	S	195
5121	RESULT IN DOUBT, THE	M	225
5122	RESURRECTION, THE	M	75
5123	RESURRECTION, THE	S	30
5124	RESURRECTION OF CHRIST, THE	S	30
5125	RETURN, THE	S	75
5126	RETURN FROM EGYPT, THE	S	25
5127	RETURN FROM ELBA	L	150
5128	RETURN FROM THE PASTURE, THE	L	550
5129	RETURN FROM THE PASTURE, THE	L	550
5130	RETURN FROM THE PASTURE, THE	L	550
5131	RETURN FROM THE WOODS, THE	M	650
5132	RE-UNION ON THE SECESH-DEMOCRATIC PLAN	S	250
5133	REVENGE	S	125
5134	REV. JOHN WESLEY	S	35
5135	REV. RICHARD ALLEN	S	20
5136	REV. WILLIAM McCALLISTER	M	100
5137	REVD. CHARLES WESLEY, A.M.	S	35
5138	REVD. CHRISTOPHER RUSH, THE	S	35
5139	RHODE ISLAND	M	350
5140	RIDE TO SCHOOL, A see c1081	VS	—
5141	RIGHT MAN FOR THE RIGHT PLACE, THE	S	180
5142	RIGHT MAN FOR THE RIGHT PLACE, THE	S	180
5143	RIGHT REVD. JAMES T. HOLLY D.D.	S	20
5144	RIP VAN WINKLE'S COTTAGE / In the Catskills	S	185
5145	RIPE CHERRIES	S	90
5146	RIPE FRUIT	S	110
5147	RIPE FRUIT	S	110
5148	RIPE FRUITS see c1043	VS	—
5149	RIPE STRAWBERRIES	S	95
5150	RIPTON / ...Beat Confidence, in a match for $500 a side	L	1300

5151	RISING FAMILY, A	L	4480
5152	RIVAL CHARMS	S	50
5153	RIVAL QUEENS, THE	S	45
5154	RIVAL ROSES, THE	S	90
5155	RIVER BOAT PASSING THE PALISADES, A	S	250
5156	RIVER OF SONG	S	200
5157	RIVER ROAD, THE	S	100
5158	RIVER ROAD, THE	M	725
5159	RIVER SHANNON, THE	S	70
5160	RIVER SIDE, THE	S	160
5161	RIVER SIDE, THE	S	160
5162	RIVER SIDE, THE	S	160
5163	RIVER SIDE, THE	S	160
5164	RIVERSIDE, THE	M	160
5165	ROAD—SUMMER, THE	L	2000
5166	ROAD TEAM AT A "TWENTY GAIT," A	S	300
5167	ROAD TEAM AT A "TWENTY GAIT," A	VS	75
5168	ROAD TO THE HOLY CROSS, THE	S	25
5169	ROAD TO THE HOLY CROSS, THE	S	25
5170	ROAD TO THE VILLAGE, THE	M	200
5171	ROAD—WINTER, THE	L	7150
5172	ROAD-SIDE, THE	M	300
5173	ROADSIDE, THE	S	145
5174	ROADSIDE COTTAGE	M	300
5175	ROADSIDE MILL, THE	S	200
5176	ROBERT BLUM	S	35
5177	ROBERT BROWN ELLIOT	S	35
5178	ROBT. BURNS	M	50
5179	ROBERT BURNS AND HIS HIGHLAND MARY	S	65
5180	ROBERT BURNS AND HIS HIGHLAND MARY	S	65
5181	ROBERT BURNS AND HIS HIGHLAND MARY	S	65
5182	ROBERT BURNS AND HIS HIGHLAND MARY	S	85
5183	ROBERT EMMET	S	45
5184	ROBERT EMMET / Dublin on the 19th of Sept., 1803	S	45
5185	ROBERT EMMET / Ireland's "Martyr of Freedom"	S	45
5186	ROBERT EMMET / Ireland's "Martyr of Freedom"	S	45
5187	ROBERT EMMET'S BETROTHED	S	45
5188	ROBERT McGREGOR / By Major Edsall...	S	255
5189	ROBINSON CRUSOE AND HIS MAN FRIDAY	S	150
5190	ROBINSON CRUSOE AND HIS PETS	S	150
5191	ROBINSON CRUSOE AND HIS PETS	S	150
5192	ROBINSON CRUSOE AND HIS PETS	L	235
5193	ROCHESTER UNION GRAY'S QUICK STEP	S	80
5194	ROCK OF AGES, THE	S	25
5195	ROCKY MOUNTAINS, THE	S	400
5196	ROCKY MOUNTAINS, THE / Emigrants Crossing the Plains	L	10000
5197	ROLL OF HONOR	S	55
5198	ROMEO AND JULIET	S	75
5199	ROSANNA	S	50
5200	ROSANNA	S	50
5201	ROSANNA	S	50
5202	ROSE, THE	S	90
5203	ROSE, THE	S	90
5204	ROSE, THE	S	90
5205	ROSE	S	70
5206	ROSE, THE	S	90
5207	ROSE AND LILY	S	60
5208	ROSE AND LILY	S	60
5209	ROSE OF BEAUTY	S	60
5210	ROSE OF BEAUTY, THE	S	60
5211	ROSE OF KILLARNEY	S	55
5212	ROSE OF KILLARNEY, THE	S	65
5213	ROSE OF MAY, THE	S	60
5214	ROSE OF MAY, THE	S	60
5215	ROSES OF MAY	S	110
5216	ROSE / OF MAY, THE	S	110
5217	ROSEBUD AND EGLANTINE	S	60
5218	ROSERK ABBEY	M	80
5219	ROSES, AND ROSEBUDS	M	95
5220	ROSIE	S	55
5221	ROSS CASTLE—LAKE OF KILLARNEY	M	75
5222	ROSS TREVOR	S	165
5223	"ROUNDING A BEND" ON THE MISSISSIPPI	L	3650
5224	ROUNDING THE LIGHT SHIP	L	2100
5225	ROUTE TO CALIFORNIA / Truckee River Sierra Nevada	S	1100
5226	ROWDY BOY / Black Whirlwind of the Pacing Quartette of 1879	S	295
5227	ROWING HIM UP SALT RIVER	M	200
5228	ROY WILKES / Record 2:14 ½	S	275
5229	ROY WILKES / Record 2:08 ½	M	325
5230	ROY WILKES / Record 2:12 ¾	S	325
5231	ROYAL BEAUTY, THE	S	45
5232	ROYAL FAMILY OF ENGLAND, THE	S	45
5233	ROYAL FAMILY OF PRUSSIA, THE	S	35
5234	ROYAL MAIL STEAMSHIP "AMSTERDAM"... NETHERLANDS LINE	S	260
5235	ROYAL MAIL STEAMSHIP "ARABIA"	L	770
5236	ROYAL MAIL STEAM SHIP / "Asia"	L	1150

5237	ROYAL MAIL STEAM SHIP "AUSTRALASIAN," THE	L	1000
5238	ROYAL MAIL STEAM SHIP / Bothnia	S	275
5239	ROYAL MAIL STEAM SHIP / "Europa"	L	800
5240	ROYAL MAIL STEAM SHIP, THE / "Persia"	L	900
5241	ROYAL MAIL STEAM SHIP / "Scotia"	L	1000
5242	ROYAL MAIL STEAMSHIP "SCOTIA"	S	250
5243	ROYAL MAIL STEAMSHIP "VEENDAM"	S	250
5244	ROYAL MAIL STEAMSHIP ZAANDAM OF THE NETHERLANDS LINE	S	250
5245	R.T.Y.C. SCHR. CAMBRIA 199 TONS	L	825
5246	RUBBER, THE	S	280
5247	RUBBER, THE / "Put to his Trumps"	M	1000
5248	RUFFED GROUSE / Pheasant or Partridge	S	220
5249	RUINS, THE / The Castle see c859	VS	—
5250	RUINS OF CHEPSTOE CASTLE / South Wales	VS	40
5251	RUINS OF THE ABBEY, THE	M	115
5252	RUINS OF THE ABBEY	S	65
5253	RUINS OF THE MERCHANT'S EXCHANGE, N.Y.	S	1450
5254	RUINS OF THE PLANTERS HOTEL, NEW ORLEANS...	S	1450
5255	RUN DOWN	S	190
5256	RUN DOWN	S	190
5257	RUN OF LUCK, A	S	95
5258	RUNNING THE "MACHINE"	M	300
5259	RURAL ARCHITECTURE NO. 1	M	200
5260	RURAL ARCHITECTURE NO. 2	M	200
5261	RURAL LAKE, THE	M	280
5262	RURAL SCENERY	S	120
5263	RUSH FOR THE HEAT, A	L	1075
5264	RUSH FOR THE POLE, A	L	1075
5265	RUSTIC BASKET	S	85
5266	RUSTIC BRIDGE, CENTRAL PARK / New York	S	325
5267	RUSTIC STAND OF FLOWERS	S	85
5268	RUTHERFORD B. HAYES / Nineteenth President of the U.S.	S	85
6269	RYSDYK'S HAMBLETONIAN	S	425
5270	"RYSDYK'S HAMBLETONIAN"	S	325
5271	RYSDYK'S HAMBLETONIAN / Sired by Old Abdullah	S	325
5272	RYSDYK'S HAMBLETONIAN / The Great Sire of Trotters	S	325
5273	RYSDYK'S HAMBLETONIAN	L	1900
5274	RYE AND ROCK	S	200
5275	SACANDAGA CREEK	VS	70
5276	SACRAMENT OF ST. JAMES	S	25
5277	SCARED HEART	S	25
5278	SACRED HEART OF JESUS	S	25
5279	SACRED HEART OF JESUS	S	25
5280	SACRED HEART OF JESUS	S	25
5281	SACRED HEART OF JESUS	M	40
5282	SCARED HEART OF MARY	S	25
5283	SCARED HEART OF MARY	S	25
5284	SACRED MOTTO TOKENS	S	35
5285- 5289	SACRED TO THE MEMORY OF ————————————	S	40
5290	SACRED TOMB OF THE BLESSED REDEEMER	S	30
5291	SACRED TOMB OF THE BLESSED VIRGIN	S	30
5292	SAFE SAILING	S	55
5293	SAGE AND SMOKE, A / "Capital cigar..."	S	200
5294	SAILOR BOY, THE	S	65
5295	SAILOR-FAR-FAR- AT-SEA, THE	S	125
5296- 5301	SAILOR'S ADIEU, THE	S	150
5302	SAILOR'S BRIDE, THE	S	150
5303- 5306	SAILOR'S RETURN, THE	S	150
5307	SAINT ANNE	S	25
5308	SN. ANTHONY DE PADUA	S	25
5309	SN. BENEDICT THE MOOR	S	20
5310	ST. BRIDGET, ABBESS OF KILDARE	S	25
5311	SAINT BRIDGET	S	30
5312	ST. CATHERINE	S	25
5313	ST. CATHERINE OF SIENNA	S	25
5314	ST. CECELIA	S	25
5315	ST. CHARLES BORROMEO	S	25
5316	ST. CLOTILDE	S	20
5317	ST. ELIZABETH	S	25
5318	SAA EMELLIA — STE EMELIE	S	25
5319	ST. EMELIE	S	25
5320	ST. EMILY	S	25
5321	ST. FERDINAND, THE KING	S	30
5322	ST. FINEEN'S WELL, IRELAND	S	50
5323	ST. FRANCIS OF ASSISI	S	30
5324	ST. FRANCIS OF PAUL	S	25
5325	SN. FRANCISCO-XAVERIO	S	25
5326	ST. IGNATIUS OF LOYOLA	S	25
5327	ST. JAMES	S	25
5328	ST. JEAN BAPTISTE INSPIRE	S	25
5329	ST. JOHN N.B. RIVER / Indian Town	S	210
5330	ST. JOHN THE BAPTIST	S	25
5331	ST. JOSEPH — SN. JOSE	S	25
5332	ST. JOSEPH	S	25
5333	ST. JUAN BATTISTA	S	25
5334	ST. JULIEN / By Volunteer, dam by Sayre's Henry Clay	L	1225

5335	ST. JULIEN / By Volunteer,...	S	300
5336	ST. JULIEN	S	300
5337	ST. JULIEN / King of the Turf,...	L	1000
5338	ST. LAWRENCE	S	265
5339	ST. LAWRENCE / Rochester, Oct. 24th, 1850	L	1735
5340	ST. LOUIS, THE KING	S	25
5341	ST. LOUIS THE KING	S	25
5342	ST. LOUIS ROI / St. Louis the King	S	25
5343	ST. A MADALENA — ST. E MAGDELEINE	S	25
5344	ST. MARGARET	S	25
5345	ST. MARY — STA. MARY	S	25
5346	ST. MARY'S ABBEY see c2827	VS	—
5347	ST. MICHAEL	S	25
5348	ST. MICHAEL — SAN MIGOEL	S	30
5349	ST. MICHAEL — SAN MIGOEL	S	30
5350	ST. NICHOLAS	S	40
5351	ST. PATRICK	S	45
5352	ST. PATRICK — SAN PATRICO	S	45
5353	ST. PATRICK, THE APOSTLE OF IRELAND	S	45
5354	ST. PAUL	S	30
5355	SAINT PETER	S	30
5356	ST. PETER — SAN PEDRO	S	30
5357	ST. PETER RECEIVING THE KEYS	S	30
5358	ST. PHILOMENA	S	25
5359	ST. PHILOMENA	S	25
5360	SN. RAMON NO-NACIDO-S. RAMON NON NATO	S	25
5361	ST. RAPHAEL. SAN RAFAEL	S	25
5362	STA RITA DE CASIA — STE. RITTE DE CASIA	S	25
5363	STA RITA DE CASIA	S	25
5364	ST. ROSE OF LIMA	S	25
5365	ST. THERESA	S	25
5366	ST. VINCENT DE PAUL	S	25
5367	SALE OF THE "BLOODED STOCK," A	S	300
5368	SALE OF THE PET LAMB, THE	M	435
5369	SALE OF THE PET LAMB, THE	S	145
5370	SALMON FISHING	S	815
5371	SALMON LEAP, NEAR BALLYSHANNON / Ireland	S	75
5372	SALMON LEAP / River Shannon	M	125
5373	SAM PURDY / The Champion Trotting Stallion...	S	250
5374	SAMUEL J. TILDEN	S	65
5375	SAN ANTONIA DE PADUA	S	25
5376	SAN ANTONIO — SAINT ANTHONY	S	25
5377	SAN LUIS REY — ST. LOUIS THE KING	S	25
5378	SANCHO / A Celebrated Pointer	S	125
5379	SANCHO / A Celebrated Pointer	S	200
5380	SANCHO / A Celebrated Pointer	S	350
5381	SANCTUARY OF OUR LADY OF GUADALUPE	S	20
5382	SANTA ANNA'S MESSENGERS REQUESTING GENL. TAYLOR	S	140
5383	SANTA ANNA'S MESSENGERS REQUESTING GENL. TAYLOR TO SURRENDER	S	140
5384	SANTA CLAUS	S	125
5385	SANTIAGO, CUBA	M	150
5386	SAPPHO	VS	30
5387	SARA BERNHARDT	S	125
5388	SARAH	S	90
5389-			
5393	SARAH	S	70
5394	SARAH ANN	S	55
5395	SARATOGA LAKE see c3439	VS	—
5396	SARATOGA LAKE	S	160
5397	SARATOGA SPRINGS	S	185
5398	SARATOGA SPRINGS, N.Y.	S	185
5399	SATISFACTION!	S	90
5400	SAUCY KATE	S	65
5401	SAUCY KAT	S	85
5402	SAVED!	M	125
5403	SAVIOR OF THE WORLD, THE	S	25
5404	SAVIOR OF THE WORLD, THE	S	25
5405	SAVIOR OF THE WORLD, THE	S	35
5406	SAVIOR'S INVITATION, THE	M	50
5407	SCALES OF JUSTICE, THE	S	210
5408	SCAPULAR, THE	S	30
5409	SCARLET TANAGER see c355	VS	—
5410	SCENE IN FAIRYLAND, A	S	75
5411	SCENE IN OLD ENGLAND, A	S	95
5412	SCENE IN OLD IRELAND, A	S	95
5413	SCENE OFF NEWPORT, A	S	460
5414	SCENE ON THE LOWER MISSISSIPPI, A	S	275
5415	SCENE ON THE SUSQUEHANNA, A	S	220
5416	SCENERY OF CONNEMARA, IRELAND	S	60
5417	SCENERY OF IRELAND, THE / Upper Lake of Killarney	M	85
5418	SCENERY OF THE CATSKILL / The Mountain House	S	200
5419	SCENERY OF THE CATSKILLS	S	195
5420	SCENERY OF THE CATSKILLS / The Catskill Falls...	S	195
5421	SCENERY OF THE HUDSON / View near "Anthony's Nose"	L	1600
5422	SCENERY OF THE UPPER MISSISSIPPI / An Indian Village	S	65
5423	SCENERY OF THE WISSAHICKON / Near Philadelphia	S	185
5424	SCENERY OF WICKLOW, IRELAND / The Devil's Glen	S	90
5425	SCHOLAR'S REWARDS	S	70

5426	SCHOOL REWARDS	S	70
5427	SCHOOL REWARDS	M	85
5428	SCHOOL'S IN	VS	55
5429	SCHOOL'S OUT	VS	110
5430	SCHOONER	S	350
5431	SCHOONER YACHT CAMBRIA, 199 TONS	S	275
5432	SCHOONER YACHT "MADELINE" NEW YORK YACHT CLUB	S	275
5433	SCHOONER YACHT "MAGIC" OF THE N.Y. YACHT CLUB, THE	L	1000
5434	SCHOONER YACHT "MAGIC"	L	1000
5435	SCIENTIFIC SHAVING ON THE DARKTOWN PLAN	S	225
5436	SCORING — COMING UP FOR THE WORD	L	1200
5437	SCORING FOR THE FIRST HEAT / Ringing them back	L	1200
5438	SCOTCH BEAUTY, THE	S	50
5439	SCOTCH CUTTER MADGE, CAPTAIN DUNCAN, THE	S	265
5440	SCOTCH LADDIE	S	50
5441	SCOTTISH BORDER, THE	M	125
5442	SEA OF TIBERIAS, THE	S	300
5443	SEAL OF AFFECTION, THE	S	65
5444	SEAL OF AFFECTION, THE	S	65
5445	SEARCH THE SCRIPTURES	S	30
5446	SEARCH THE SCRIPTURES	S	30
5447	SEARCH THE SCRIPTURES	S	30
5448	SEASON OF BLOSSOMS	S	135
5449	SEASON OF BLOSSOMS	L	875
5450	SEASON OF JOY, THE	S	150
5451	"SECESSION MOVEMENT," THE	S	300
5452	SECOND BATTLE OF BULL RUN, FOUGHT AUGT. 29TH, 1862	S	165
5453	SEE MY DOGGIE?	S	55
5454	SEE MY NEW BOOTS!	S	50
5455	SEE MY NEW BOOTS!	L	125
5456	SEE MY NEW BOOTS	S	60
5457	SEE-SAW	M	145
5458	SEE-SAW	S	80
5459	SELLING OUT CHEAP	S	70
5460	SELLING OUT CHEAP!	S	150
5461	SENSATION / By Dixon's Ethan Allen...	S	280
5462	SERENADE	S	50
5463	SERGEANT JASPER OF CHARLESTON	S	335
5464	SERVICABLE GARMENT, A	M	150
5465	SET OF EIGHT, A	S	65
5466	SET OF FASHIONABLE QUADRILLES, THE	S	110
5467	SET OF THE QUEENS COUNTRY DANCES	S	60
5468	SETTER & WOODCOCK	S	375
5469	SETTERS	S	425
5470	SETTLING THE QUESTION	S	215
5471	SEVEN CHURCHES OF CLONMACNOISE	S	60
5472	SEVEN STAGES OF MATRIMONY, THE	S	125
5473	SHADE AND TOMB OF NAPOLEON, THE	S	95
5474	SHADE AND TOMB OF WASHINGTON, THE	S	125
5475	SHAKERS NEAR LEBANON	S	925
5476	SHAKESPEARE	M	65
5477	SHALL I?	VS	325
5478	SHANTYING ON THE LAKE SHORE	L	1800
5479	SHARP BRUSH ON THE LAST QUARTER, A	S	400
5480	SHARP BRUSH ON THE LAST QUARTER, A	S	400
5481	SHARP PACE FROM START TO FINISH, A	L	1500
5482	SHARP PACE FROM START TO FINISH, A	L	1500
5483	SHARP RIFLE, A / With a Bulge on the Shooter	S	250
5484	SHARPSHOOTER, A / With a Bulge on the Rifle	S	250
5485	SHAUGHRUAN, ACT II, SCENE I	M	70
5486	"SHE HAD SO MANY CHILDREN SHE DIDN'T KNOW WHAT TO DO"	S	85
5487	SHEEP PASTURE, THE	S	115
5488	SHEEP PASTURE, THE	M	155
5489	SHERIDAN'S CAVALRY AT THE BATTLE OF FISHER'S HILL	S	165
5490	SHERMAN AND HIS GENERALS	M	175
5491	SHING-GAA-BA-W'OSIN, OR THE FIGURED STONE	S	145
5492	SHIPS ANTARCTIC OF NEW YORK AND THREE BELLS	L	6950
5493	SHOEING A HORSE	S	235
5494	SHOEMAKER, THE	S	95
5495	SHOEMAKER'S CIRCUS, THE	S	150
5496	SHOOTING ON THE BAY SHORE	S	1310
5497	SHOOTING ON THE BEACH	S	975
5498	SHOOTING ON THE PRAIRIE	S	645
5499	SHORT HORNED BULL, GRAND DUKE	M	150
5500	SHORT STOP AT A WAY STATION, A	S	290
5501	SHRINE OF OUR LADY OF LOURDES	S	30
5502	SHUT THE DOOR	S	165

5503	SIBYL'S TEMPLE	S	55
5504	SICKNESS AND HEALTH	M	175
5505	SIDE WHEELER, A / "Bustin" A Trotter	S	230
5506	SIDE WHEELER "BUSTIN" A TROTTER, A	VS	100
5507	SIEGE AND CAPTURE OF VICKSBURG, MISS.	S	150
5508	SIEGE OF CHARLESTON, THE	S	295
5509	SIEGE OF CONSTANTINE, THE	S	40
5510	SIEGE OF LIMERICK, ...	S	45
5511	SIEGE OF LIMERICK, ...	S	45
5512	SEIGE OF VERA CRUZ MARCH 1847	S	200
5513	SEIGE OF VERA CRUZ MARCH 1847	S	200
5514	SIGHTS AT THE FAIR GROUNDS	L	650
5515	SIGHTS AT THE FAIR GROUNDS	L	650
5516	SIGN OF THE CROSS, THE	S	25
5517	SIGNAL FIRES OF THE SLIEVENAMAN MOUNTAINS, IRELAND	S	75
5518	SILAS WRIGHT, JR.	VS	30
5519	SILVER CASCADE see c2230	VS	—
5520	SILVER CASCADE / Near St. Anthony, Minnesota	S	175
5521	SILVER CASCADE / White Mountains	S	170
5522	SILVER CREEK — CALIFORNIA	S	315
5523	SIMPLY TO THY CROSS I CLING	S	80
5524	SIMPLY TO THY CROSS I CLING	S	80
5525	SIMPLY TO THY CROSS I CLING	L	95
5526	SINGLE	S	85
5527	SINGLE	S	85
5528	SINGLE	S	85
5529	SINKING OF THE BRITISH BATTLE SHIP VICTORIA...	S	225
5530	SINKING OF THE CUMBERLAND BY THE..."MERRIMAC"...	S	280
5531	SINKING OF THE STEAMSHIP ELBE...	M	275
5532	SINKING OF THE STEAMSHIP OREGON OF THE CUNARD LINE	S	240
5533	SINKING OF THE STEAMSHIP OREGON OF THE CUNARD LINE	M	350
5534	SINKING OF THE STEAMSHIP VILLE DU HARVE, THE	S	225
5535	SIR MOSES MONTEFIORE	S	75
5536	SIR RICHARD SUTTON'S CELEBRATED CUTTER GENESTA	S	265
5537	SISTER JENNIE	S	50
5538-			
5541	SISTERS, THE	S	75
5542	SISTERS, THE	S	95
5543	SISTER'S PRAYER, THE	S	25
5544	SIX MORAL SENTENCES	S	120
5545	SKATING CARNIVAL, THE	S	300
5546	SKATING SCENE — MOONLIGHT	S	680
5547	SKIN GAME, A	S	145
5548	SKINNER SKINNED, A	S	145
5549	SLEEPING BEAUTY, THE	S	70
5550	SLEEPY HOLLOW BRIDGE / Tarrytown, New York	S	240
5551	SLEEPY HOLLOW CHURCH / Near Tarrytown, N.Y.	M	530
5552	SLEEPY TOM, PACER RECORD 2:12 ¼	VS	65
5553	SLEEPY TOM, THE BLIND HORSE, THE PACING WONDER	S	275
5554	SLEIGH RACE, THE	S	1150
5555	SLEIGH RACE, THE	S	1150
5556	SLEIGH RACE, THE	L	1675
5557	SLEIGH RACE, THE	S	1150
5558	SLEIGH RACE, THE	S	1150
5559	SLOOP YACHT MAYFLOWER	M	450
5560	SLOOP YACHT POCAHONTAS OF NEW YORK	L	1525
5561	SLOOP YACHT "VOLUNTEER"	S	305
5562	SLOOP YACHTS MISCHIEF AND ATALANTA...	L	1525
5563	SLUGGED OUT / "Better luck next time"	S	170
5564	SLUICE GATE, THE see c2994	VS	—
5565	SMALL HOPES AND LADY MAC	L	1100
5566	SMALL PROFITS & QUICK SALES	S	150
5567	SMELLING COMMITTEE, THE	S	150
5568	SMOKER'S PROMENADE, THE	M	225
5569	SMOKING HIM OUT	S	190
5570	SMOKING RUN, A	VS	80
5571	SMUGGLER, TROTTING STALLION...	S	310
5572	SMUGGLER, RECORD 2:15 ½	S	275
5573	SMUGGLER	S	275
5574	SMUGGLER AND JUDGE FULLERTON	S	385
5575	SNAKE IN THE GRASS	VS	50
5576	SNAP APPLE NIGHT / All Hallow Eve	M	600
5577	SNIPE SHOOTING	L	3100
5578	SNIPE SHOOTING	S	545
5579	SNOW-SHOE DANCE, THE	M	1125
5580	SNOW STORM, THE	M	1140

5581	SNOWED UP / Ruffed Grouse in Winter	L	4250
5582	SNOWY MORNING, A	M	1300
5583	SOCIABLE SMOKE, A	S	165
5584	SOCIABLE SMOKE, A	VS	75
5585	SOCIAL CUP, A	M	145
5586	SOFIA	S	55
5587	SOFT THING ON SNIPE!, A	S	195
5588	SOLDIER BOY, THE / "Off Duty"	S	90
5589	SOLDIER BOY, THE / "On Duty"	S	90
5590	SOLDIER BOYS, THE / The Last Defence	S	90
5591	SOLDIER'S ADIEU, THE	S	120
5592	SOLDIER'S ADIEU, THE	S	120
5593	SOLDIER'S ADIEU, THE	S	120
5594	SOLDIER'S BRIDE, THE	S	85
5595	SOLDIER'S DREAM OF HOME, THE	S	115
5596	SOLDIER'S DREAM OF HONOR	S	90
5597	SOLDIER'S GRAVE, THE	S	90
5598	SOLDIER'S GRAVE, THE	S	75
5599	SOLDIER'S HOME, THE / The Vision	S	110
5600	SOLDIER'S MEMORIAL, THE	M	155
5601	SOLDIER'S MEMORIAL, THE	M	155
5602	SOLDIER'S MEMORIAL, THE	M	155
5603	SOLDIER'S RECORD, THE	M	165
5604	SOLDIER'S RECORD, THE	M	165
5605	SOLDIER'S RECORD, THE	M	165
5606	SOLDIER'S RETURN, THE	S	125
5612	SOLOMON'S TEMPLE	S	65
5613	SOME PUMPKINS / Trotting his mile in 2:10.	M	325
5614	SON AND DAUGHTER OF TEMPERANCE	S	85
5615	SON OF TEMPERANCE / E.L. Snow, Social Union	S	90
5616	SON OF TEMPERANCE / No brother shall make, buy...	S	90
5617	SONGS OF MADAME ANNA BISHOP	S	90
5618	SONS OF TEMPERANCE / Love, Purity, and Fidelity	S	80
5619	SONS OF TEMPERANCE	S	80
5620	SONTAG AND FLORA TEMPLE / At the Half Mile Pole...	L	1595
5621	SOPHIA	S	85
5622	SOPHIA	S	70
5623	SOPHIA	M	75
5624	SORREL DAN, PACER, RECORD 2:14	VS	70
5625	SORRY DOG, A	S	165
5626	SORRY HER LOT WHO LOVES TOO WELL	S	75
5627	SOURCE OF THE HUDSON, THE / In the Indian Pass...	S	270
5628	SOUTH CAROLINA'S "ULTIMATUM"	M	225
5629	SOUTH SEA WHALE FISHERY	S	1325
5630	SOUTHERN BEAUTY, THE	S	60
5631	SOUTHERN BELLE, THE	S	60
5632	SOUTHERN CROSS, THE	S	45
5633	SOUTHERN RIVER SCENERY	S	120
5634	SOUTHERN ROSE, THE	S	50
5635	SOUTHERN "VOLUNTEERS"	S	150
5636	SPANIEL, THE	S	210
5637	SPANIEL, THE	S	210
5638	SPANISH DANCE, THE	S	65
5639	SPANISH DANCE	S	65
5640	SPEAK MY DARLING!	S	55
5641	SPEAK QUICK	S	55
5642	SPEAKING LIKENESS, A	S	60
5643	SPEEDING ON THE DARKTOWN TRACK	S	220
5644	SPEEDING ON THE AVENUE	L	3040
5645	SPEEDING TO THE "BIKE"	L	1200
5646	SPENDTHRIFT	VS	75
5647	SPENDTHRIFT / By Imp. Australian...	S	300
5648	SPERM WHALE "IN A FLURRY," THE	S	1100
5649	"SPICE" OF THE TROTTING TRACK, THE	M	425
5650	SPILLOUT ON THE SNOW, THE	S	350
5651	"SPILL OUT" ON THE SNOW	L	1550
5652	SPIN ON THE ROAD, A	VS	70
5653	SPIRIT OF '61, THE	L	250
5654	SPIRIT OF '76, STAND BY THE FLAG, THE	S	85
5655	SPIRIT OF THE UNION, THE	S	135
5656	SPIRIT OF THE UNION, THE	S	135
5657	SPIRIT'S FLIGHT, THE	L	125
5658	SPIRIT'S FLIGHT, THE	S	75
5659	SPLENDID NAVAL TRIUMPH ON THE MISSISSIPPI..., THE	L	1000
5660	SPLENDID NEW IRON STEAMER ALBANY	S	305
5661	SPLENDID TEA	S	80
5662	SPLENDID STEAMSHIP AMERICA OF THE NATIONAL LINE	S	260
5663	SPLIT ROCK, ST. JOHN RIVER, N.B.	S	245
5664	SPLITTING THE PARTY / The Entering Wedge	S	225
5665	SPOILING A SENSATION / The Bicycle Boy on a Bull	S	250
5666	"SPONGING"	S	250
5667	SPORTS WHO CAME TO GRIEF, THE	S	250
5668	"SPORTS" WHO LOST THEIR TIN, THE	S	425
5669	"SPORTS" WHO LOST THEIR TIN, THE	VS	100
5670	SPORTMAN'S SOLACE, THE	M	300
5671	SPRING	S	175

5672	SPRING	S	150
5673	SPRING	S	55
5674	SPRING	S	55
5675	SPRING	M	235
5676	SPRING	S	115
5677	SPRING FLOWERS	M	285
5678	SPUNK VERSUS SCIENCE	VS	75
5679	SQUALL OFF CAPE HORN, A	M	600
5680	SQUALL OFF CAPE HORN, A	S	600
5681	SQUIRREL SHOOTING	S	390
5682	SQUIRREL SHOOTING	VS	100
5683	STABLE NO. 1, THE	M	350
5684	STABLE NO. 2, THE	M	350
5685	STABLE SCENES, NO. 1	S	300
5686	STABLE SCENES, NO. 2	S	300
5687	STAG AT BAY, THE	S	165
5688	STAG AT BAY, THE	L	250
5689	STAG HOUNDS	S	345
5690	STAG HUNT, AT KILLARNEY, A	M	195
5691	STANCH POINTER, A	S	275
5692	STANCH POINTER, A	S	275
5693	STAR OF BEAUTY, THE	S	55
5494	STAR OF LOVE, THE	S	50
5695	STAR OF LOVE, THE	S	50
5696	STAR OF THE EAST, THE	S	45
5697	STAR OF THE NIGHT, THE	S	50
5698	STAR OF THE NORTH	S	60
5699	STAR OF THE NORTH, THE	S	60
5700	STAR OF THE OPERA, THE	S	50
5701	STAR OF THE ROAD, THE	S	565
5702	STAR OF THE SOUTH	S	45
5703	STAR OF THE SOUTH, THE	S	50
5704	STAR OF THE WEST, THE	S	55
5705	STAR POINTER / Record 1:59 ¼	S	325
5706	STAR SPANGLED BANNER, THE	S	85
5707	STAR SPANGLED BANNER, THE	S	85
5708	STARS OF THE TROTTING TRACK	L	1275
5709	STARS OF THE TURF—NO. 1	L	1100
5710	STARS OF THE TURF—NO. 2	L	1100
5711	STARTING OUT ON HIS METTLE	S	215
5712	STARTLING ANNOUNCEMENT, A	S	185
5713	STARUCCA VALE / N.Y. & Erie R.R.	M	235
5714	STATE STREET, BOSTON	S	540
5715	STATEN ISLAND AND THE NARROWS FROM FORT HAMILTON	L	1400
5716	STATUE UNVEILED, THE / or the Colossus of Roads	S	200
5717	STAUNCH POINTER, A	S	275
5718	STAUNCH POINTER, A	S	275
5719	STEADFAST IN THE FAITH	S	35
5720	STEAM CATAMARAN—H. W. LONGFELLOW	S	320
5721	STEAM YACHT ANTHRACITE...	S	265
5722	STEAM YACHT CORSAIR...	L	1125
5723	STEAM YACHT NAMOUNA	L	900
5724	STEAM YACHT POLYNIA...	L	1575
5725	STEAMBOAT "EMPIRE"	S	575
5726	STEAMBOAT ISAAC NEWTON / The Largest in the...World	S	550
5727	STEAM-BOAT KNICKERBOCKER	S	450
5728	STEAMBOAT PEERLESS / Lake Superior Line	L	885
5729	STEAMBOAT PRISCILLA	S	350
5730	STEAMBOAT RACE ON THE MISSISSIPPI / Act IV...	S	475
5731	STEAMBOATS PASSING AT MIDNIGHT ON LONG ISLAND SOUND	S	475
5732	STEAMER "DREW"	S	300
5733	STEAMER "DREW"	S	300
5734	STEAMER "MASSACHUSETTS"	S	275
5735	STEAMER MESSENGER NO. 2	S	300
5736	STEAMER PENOBSCOT	L	1000
5737	STEAMER PILGRIM	L	1125
5738	STEAMER PILGRIM— FLAGSHIP OF THE FALL RIVER LINE	S	325
5739	STEAMER TEMPEST	S	265
5740	STEAMSHIP ADRIATIC, 5,888 TONS, 1,350 HORSE POWER	L	1250
5741	STEAMSHIP ADRIATIC, WHITE STAR LINE	S	300
5742	STEAMSHIP ALASKA OF THE GUION LINE	S	285
5743	STEAMSHIP ALLER	S	250
5744	STEAMSHIP AMERICA	S	275
5745	STEAMSHIP ANTHRACITE	S	250
5746	STEAMSHIP ASSYRIAN MONARCH OF THE MONARCH LINE	S	235
5747	STEAMSHIP AUGUSTA VICTORIA, HAMBURG AMERICAN PACKET CO.	S	245
5748	STEAMSHIP BELGENLAND OF THE RED STAR LINE	S	250
5749	STEAMSHIP "BORUSSIA" REGULAR PACKET...	S	275
5750	STEAMSHIP BOTHNIA OF THE CUNARD LINE, THE	S	275
5751	STEAM SHIP CALIFORNIA OF THE ANCHOR LINE	S	275
5752	STEAMSHIP CEPHALONIA	S	225
5753	STEAM SHIP "CITY OF BALTIMORE" 2367 TONS	S	325
5754	STEAMSHIP "CITY OF BERLIN" OF THE INMAN LINE	S	250

5755	STEAMSHIP "CITY OF MONTREAL" OF THE INMAN LINE	S	250
5756	STEAM SHIP CITY OF WASHINGTON	S	325
5757	STEAMSHIP DENMARK	S	200
5758	STEAM SHIP EGYPT OF THE NATIONAL LINE	S	250
5759	STEAMSHIP "EGYPTIAN MONARCH" WILSON LINE	S	250
5760	STEAMSHIP EIDER	S	200
5761	STEAMSHIP ETRURIA	S	200
5762	STEAMSHIP FLORIDA, BALTIMORE AND NORFOLK LINE	S	250
5763	STEAMSHIP "FRANKLIN"	S	275
5764	STEAMSHIP FRIESLAND	S	275
5765	STEAM SHIP FRISIA	S	200
5766	STEAMSHIP GAANDAM	S	200
5767	STEAMSHIP "GALILEO" WILSON LINE	S	265
5768	STEAMSHIP GREAT NORTHERN	S	275
5769	STEAMSHIP HAMMONIA	S	275
5770	STEAMSHIP HERMANN	S	250
5771	STEAM-SHIP "HERMANN"	S	250
5772	STEAMSHIP IN A GALE	S	315
5773	STEAMSHIP LAHN	S	195
5774	STEAMSHIP MAJESTIC, WHITE STAR LINE	S	225
5775	STEAMSHIP "MINNESOTA"...	S	225
5776	STEAMSHIP MISSISSIPPI	S	250
5777	STEAMSHIP NOORDLAND	S	220
5778	STEAM-SHIP OCEANIC / White Star Line	S	300
5779	S. S. OREGON OF THE CUNARD LINE, THE	L	1000
5780	STEAMSHIP OREGON OF THE CUNARD LINE, THE	S	300
5781	STEAMSHIP PAVONIA	S	280
5782	STEAM-SHIP "PERIERE"	S	230
5783	STEAMSHIP "PERSIAN MONARCH"	S	265
5784	STEAM SHIP PRESIDENT	S	300
5785	STEAMSHIP PRESIDENT, THE	S	300
5786	STEAMSHIP PRESIDENT, THE / The Largest in the World	S	300
5787	STEAMSHIP "PURITAN" FALL RIVER LINE	S	275
5788	STEAMSHIP "RHODE ISLAND"	S	275
5789	STEAMSHIP ROTTERDAM	S	200
5790	STEAMSHIP "SAALE"	S	200
5791	STEAMSHIP "ST. PAUL"	S	225
5792	STEAMSHIP SCYTHIA, CUNARD LINE	S	200
5793	STEAMSHIP SERVIA	S	175
5794	STEAMSHIP "SPAIN" OF THE NATIONAL LINE	S	275
5795	STEAMSHIP SPREE	S	225
5796	STEAMSHIP "TEUTONIC" OF THE WHITE STAR LINE	S	225
5797	STEAMSHIP TRAAVE	S	190
5798	STEAMSHIP "VANDERBILT" 5,268 TONS, 2,500 HORSE POWER	S	975
5799	STEAM SHIP "VILLE DE PARIS"	S	300
5800	STEAM SHIP WASHINGTON, THE	S	300
5801	STEAMSHIP WASHINGTON, THE	S	300
5802	STEAMSHIP "WASHINGTON," CAPT. FITCH, THE	S	300
5803	STEAMSHIP "WESTERNLAND"	S	215
5804	STEAMSHIP WILLIAM PENN	S	225
5805	STEAMSHIP "ZEENDAM"	S	200
5806	STEAM YACHT "CORSAIR"...	L	1150
5807	STEEL CRUISER PHILADELPHIA	S	300
5808	STEEPLE CHASE CRACKS	S	210
5809	STEEPLE-CHASER, A	S	250
5810	STELLA	S	50
5811	STELLA AND ALICE GRAY— LANTERN AND WHALEBONE	L	1475
5812	STEPHEN FINDING "HIS MOTHER"	M	275
5813	STEPHEN FINDING "HIS MOTHER"	M	275
5814	STEPPING STONES, THE	M	245
5815	STILL HUNTING ON THE SUSQUEHANNA	M	475
5816	STOCK FARM, THE	S	150
5817	STOCKS DOWN	S	250
5818	STOCKS UP	S	250
5819	STOLEN INTERVIEW, THE	S	100
5820	STOLEN INTERVIEW, THE	S	100
5821	"STOPPING PLACE" ON THE ROAD, A	L	2650
5822	STORMING OF FORT DONALDSON, THE	S	165
5823	STORMING OF FORT DONALDSON, TENN. ...	S	165
5824	STORMING OF FORT DONALDSON, TENN. ...	L	725
5825	STORMING OF THE BISHOP'S PALACE	S	160
5826	STORMING OF THE FORTRESS OF CHAPULTAPEC	S	160
5827	STORMING OF THE CASTLE	S	75
5828	STORMING OF THE CASTLE / "Old Abe" on guard	M	265
5829	STORMING OF THE HEIGHTS OF CERRO GORDO	S	130
5830	STORMING OF THE HEIGHTS OF CERRO GORDO	S	130

5831	STORMING OF THE HEIGHTS OF MONTEREY	S	140
5832	STORY OF THE FIGHT, THE	M	175
5833	STORY OF THE FIGHT, THE	S	125
5834	STORY OF THE GREAT KING, THE	S	25
5835	STORY OF THE REVOLUTION, THE	S	125
5836	STRATFORD ON AVON	S	70
5837	STRAW-YARD WINTER, THE	M	710
5838	STRAWBERRIES	S	140
5839	STRAWBERRIES	S	140
5840	STRAWBERRY FEAST	S	65
5841	STRAWBERRY SEASON	S	125
5842	STRICTLY CONFIDENTIAL	S	55
5843	STRIDE OF THE CENTURY, THE	M	250
5844	STRIPED BASS	S	165
5845	STYLE OB DE ROAD, DE	S	300
5846	SUBURBAN GOTHIC VILLA, MURRAY HILL, THE	S	100
5847	SUBURBAN RETREAT, A	S	125
5848	SUFFER THE LITTLE CHILDREN TO COME UNTO ME	S	35
5849	SUMMER	S	150
5849A	SUMMER	S	55
5850	SUMMER	M	100
5851	SUMMER	S	55
5852	SUMMER	S	135
5853	SUMMER EVENING	S	135
5854	SUMMER FLOWERS	S	125
5855	SUMMER FLOWERS	S	125
5856	SUMMER FLOWERS	M	285
5857	SUMMER FRUITS	M	385
5858	SUMMER FRUITS	S	125
5859	SUMMER FRUITS AND FLOWERS	VS	120
5860	SUMMER GIFT, THE	S	100
5861	SUMMER IN THE COUNTRY	S	190
5862	SUMMER IN THE COUNTRY	S	190
5863	SUMMER IN THE COUNTRY	S	190
5864	SUMMER IN THE COUNTRY	L	1000
5865	SUMMER IN THE HIGHLANDS	L	525
5866	SUMMER IN THE WOODS	S	150
5867	SUMMER LANDSCAPE	L	450
5868	SUMMER LANDSCAPE / Haymaking	M	365
5869	SUMMER MORNING	S	200
5870	SUMMER MORNING	M	325
5871	SUMMER NIGHT	S	135
5872	SUMMER NOON	S	115
5873	SUMMER NOON	S	115
5874	SUMMER RAMBLE, A	M	225
5875	SUMMER RETREAT, A	M	255
5876	SUMMER SCENES IN NEW YORK HARBOR	L	2875
5877	SUMMER SHADES	L	460
5878	SUMMER TIME	M	350
5879	SUMMER TIME, THE	S	125
5880	SUMMER'S AFTERNOON, A	L	350
5881	SUMMIT OF HAPPINESS	S	75
5882	SUMBEAM, THE	S	50
5883	SUNDAY IN THE OLDEN TIME	S	155
5884	SUNDAY MORNING — IN THE OLDEN TIME	M	435
5885	SUNDAY SCHOOL CERTIFICATE	S	45
5886	SUNDAY SCHOOL EMBLEMS	S	40
5887	SUNLIGHT / The Castle	VS	195
5888	SUNNY HOUR, THE	S	85
5889	SUNNY MORNING	M	100
5890	SUNNY SOUTH, THE	S	145
5891	SUNNYSIDE see c3439	VS	—
5892	SUNNY SIDE /The Residence of the late Washington Irving	L	575
5893	SUNNYSIDE — ON THE HUDSON	S	165
5894	SUNOL TO SULKY RECORD 2:08 1/4	VS	75
5895	SUNRISE ON LAKE SARANAC	L	3650
5896	SUNSET TREE, THE	M	245
5897	SURE HORSE FOR THE FIRST MONEY, A	L	1175
5898	SURE OF A BITE	S	225
5899	SURE THING, A	S	200
5900	SURPRISE, THE	L	3000
5901	SURPRISE PARTY, A	S	275
5902	SURRENDER OF CORNWALLIS / At Yorktown, Va. ...	S	325
5903	SURRENDER OF CORNWALLIS AT YORKTOWN, VA....	S	325
5904	SURRENDER OF CORNWALLIS AT YORKTOWN, VA. 1781	S	325
5905	SURRENDER OF CORNWALLIS AT YORKTOWN, VA. OCT. 1781	S	325
5906	SURRENDER OF CORNWALLIS AT YORKTOWN, VA. ...	L	4200
5907	SURRENDER OF GENERAL BURGOYNE AT SARATOGA, N.Y.	L	3875
5908	SURRENDER OF GENL. JOE JOHNSTON NEAR GREENSBORO...	S	170
5909	SURRENDER OF GENL. LEE, AT APPOMATTOX C.H. VA.	S	140
5910	SURRENDER OF GENERAL LEE AT APPOMATTOX, C.H. VA.	S	140
5911	SURRENDER OF GENERAL LEE / At Appomattox C.H. Va.	S	140
5912	SURRENDER OF LORD CORNWALLIS / At Yorktown, Va.	S	265

5913	SURRENDER OF LORD CORNWALLIS / At Yorktown, Va.	S	275
5914	SURRENDER OF NAPOLEON III	L	95
5915	SURRENDER OF PORT HUDSON, LA.	S	190
5916	SUSAN	S	50
5917	SUSAN	S	65
5918	SUSAN	S	60
5919	SUSAN	S	50
5920	SUSAN	S	50
5921	SUSAN	S	60
5922	SUSAN	S	50
5923	SUSANNA	S	70
5924	SUSANNA	S	70
5925	SUSIE	VS	50
5926	SUSIE	S	45
5927	SUSSEX VALE / New Brunswick	S	160
5928	SWEET SIXTEEN	S	75
5929	SWEET SPRING TIME	M	185
5930	SWEETSER / The Pacing Whirlwind...	S	325
5931	SWEETSER — SLEEPY GEORGE AND LUCY	S	325
5932	SWELL SMOKER — GETTING THE SHORT END, A	S	260
5933	SWELL SMOKER — GIVING LONG ODDS, A	S	260
5934	SWELL SPORT ON A BUFFALO HUNT, A	S	350
5935	SWELL SPORT STAMPEDED, A	S	325
5936	SWIFT PACER ARROW, BY A. W. RICHMOND, THE	S	275
5937	SWING OF THE FIRST HEAT, THE	S	250
5938	SYLVAN LAKE / New York	S	110
5939	SYLVAN LAKE	S	125
5940	SYLVAN LAKE, THE	S	135
5941	"TABLE D'HOTE," THE	S	90
5942	TACONY / Union Course, L.I., July 14th, 1853	L	1700
5943	TACONY AND MAC / Hunting Park Course, Phila....	L	1800
5944	TAKE A PEACH	S	80
5945	TAKE A PINCH	S	115
5946	"TAKE BACK THE HEART THAT THOU GAVEST"	S	70
5947	TAKE CARE!	S	45
5948	TAKE YOUR CHOICE	S	45
5949	TAKE YOUR CHOICE	S	45
5950	TAKING A BREATH	S	50
5951	TAKING A REST	S	50
5952	TAKING A SMASH	S	190
5953	TAKING A "SMILE"	S	175
5954	TAKING BREATH	VS	75
5955	TAKING COMFORT	VS	75
5956	TAKING COMFORT	VS	75
5957	TAKING COMFORT	S	175
5958	TAKING COMFORT	M	215
5959	TAKING IT EASY	VS	70
5960	TAKING OFF HIS AIRS	S	120
5961	TAKING THE BACK TRACK / A Dangerous Neighborhood	L	7000
5962	"TAKING THE STUMP" OR STEPHEN IN SEARCH OF HIS MOTHER	M	250
5963	TALKED TO DEATH	S	75
5964	TALLYRAND	VS	75
5965	TALLULAH FALLS, GEORGIA	S	190
5966	TAMBOURINE DANCE, THE	S	55
5967	TANTALLON CASTLE / Coast of Scotland	M	185
5968	TASTE FOR THE FINE ARTS, A	S	300
5969	TEA PARTY, THE	S	65
5970	TEA WITH DOLLY	S	65
5971	TEAM FAST TO THE POLE, A	S	300
5972	TEAM FAST ON THE SNOW, A	S	300
5973	TEAM ON THE SNOW, A	M	430
5974	TEAM THAT TAKES NO DUST, A	S	250
5975	TEE-TO-TAL SOCIETY, THE	S	85
5976	TELASCO AND AMARILLI	S	135
5977	TEMPLE OF JUPITER, AEGINA	S	40
5978	TEMPLE OF SOLOMON	S	80
5979	TEMPLE OF SOLOMON, THE	S	80
5980	TEMPLE OF CHRIST, THE	S	35
5981	TEMPTED	S	300
5982	TEMPTING FRUIT	S	125
5983	TEMPTING LUNCH, A	S	125
5984	TEMPTING THE BABY	M	195
5985	TEN BROECK / By Imp. Phaeton...	S	315
5986	TEN / COMMANDMENTS, THE	S	125
5987	TEN COMMANDMENTS, THE	M	40
5988	TEN VIRGINS, THE	S	45
5989	TENNY / By Rayon D'Or...	S	240
5990	TENNY / By Rayon D'Or...	L	1050
5991	TENNY	S	240
5992	TERRA COTTA / By Harry O'Fallon...	S	250
5993	TERRIBLE COLLISION BET. THE STEAMBOATS STONINGTON...	S	300
5994	TERRIFIC COLLISION BET. THE STEAMBOATS DEAN RICHMOND	S	300
5995	TERRIFIC COMBAT...MONITOR 2 GUNS, & MERRIMAC 11 GUNS	S	415
5996	TERRIFIC COMBAT...MONITOR 2 GUNS & MERRIMAC 11 GUNS	S	425
5997	TERRIFIC COMBAT...MONITOR 2 GUNS & MERRIMAC 10 GUNS	S	460

5998	TERRIFIC ENGAGEMENT BETWEEN "MONITOR" 2 GUNS & "MERRIMAC"...	L	1040
5999	TEXT WITH MODERN IMPROVEMENTS	S	70
6000	THAT BLESSED BABY	S	50
6001	THAT BLESSED BABY	S	70
6002	THATCHED COTTAGE, THE	S	135
6003	THATCHED ROOF, THE	S	125
6004	"THAT'S WHAT'S THE MATTER"	S	180
6005	THEODORE FRELINGHUYSEN / Hurrah! Hurrah!...	S	90
6006	THEODORE FRELINGHUYSEN / Nominated for...	S	90
6007	THEY'RE SAVED! THEY'RE SAVED!	S	50
6008	THIRD DAY OF THE SIEGE OF MONTEREY	S	135
6009	THIRD HEAT IN TWO SIXTEEN, A	L	1385
6010	THIS CERTIFIES THAT . . . HAS BEEN A MEMBER . . .	S	75
6011	THIS CERTIFIES THAT... / Fire Department	L	450
6012	THIS CERTIFIES / That..... / Fire Department	L	555
6013	THIS CERTIFIES / That..... / Fire Department	L	555
6014	THIS CERTIFIES / That..... / Ladies Loyal Union League	S	100
6015	THIS CERTIFIES / That..... / The Loyal Union League	S	145
6016	THIS CERTIFIES / That..... / Sunday School	S	45
6017	THIS CERTIFIES / That..... / Sunday School	M	50
6018	THIS CERTIFIES THAT / The Rite of / Holy Matrimony	S	60
6019	THIS MAN FORGOT TO SHUT THE DOOR	M	175
6020	THIS MAN WAS TALKED TO DEATH	S	200
6021	"THISTLE" / Cutter Yacht...	L	1200
6022	THOMAS CORWIN / The Wagon Boy of Ohio	S	70
6023	THOMAS F. MEAGHER	S	65
6024	THOMAS F. MEAGHER	S	65
6025	THOMAS FRANCIS MEAGHER	S	65
6026	THOMAS JEFFERSON / Third President of the U.S.	S	150
6027	THOMAS JEFFERSON / "The Black Whirlwind of the East"	L	950
6028	THOMAS JEFFERSON / "The Black Whirlwind of the East"	S	275
6029	THOMAS WILDEY / Father...Order of Odd Fellowship	S	30
6030	THOU GAV'ST BE A BRIGHT SWORD, LADY	S	35
6031	THOU HAST LEARNED TO LOVE ANOTHER	S	200
6032	THOU SHALT NOT STEAL	S	55
6033	THREE FAVORITES, THE	S	115
6034	THREE GRACES, THE	S	65
6035	THREE GREEDY KITTIES / After the Feast	S	110
6036	THREE GREEDY KITTIES, THE / At the Feast	S	110
6037	THREE HOLY WOMEN, THE	S	20
6038	THREE JOLLY KITTENS, THE / After the Feast	S	95
6039	THREE JOLLY KITTENS, THE / At the Feast	S	110
6040	THREE LITTLE MAIDS FROM SCHOOL	L	85
6041	THREE LITTLE SISTERS, THE	M	80
6042	THREE LITTLE WHITE KITTIES / Fishing	S	95
6043	THREE LITTLE WHITE KITTIES / Fishing	S	95
6044	THREE LITTLE WHITE KITTIES / Their First Mouse	S	90
6045	THREE SISTERS, THE	S	60
6046	THREE SORRY KITTIES, THE / After the Feast	S	100
6047	THREE WHITE KITTENS, THE / Peace	M	125
6048	THREE WHITE KITTENS, THE / War	M	125
6049	THROUGH EXPRESS, THE	S	1700
6050	THROUGH THE BAYOU BY TORCHLIGHT	S	300
6051	THROUGH TO THE PACIFIC	S	850
6052	THROW IF YOU DARE!	VS	325
6053	THY KINGDOM COME	S	40
6054	THY WILL BE DONE	S	45
6055	THY WORD IS A LIGHT UNTO MY PATH	S	25
6056	TICK-TICK-TICKLE	S	60
6057	TICKLE! TICKLE!	S	70
6058	TIME IS MONEY	S	120
6059	TIME IS PRECIOUS	S	125
6060	TIME WORN ABBEY, THE	S	65
6061	TIP-TOP	S	165
6062	TIP-TOP	S	165
6063	TIP-TOP	VS	70
6064	TIRED SOLDIER, THE	S	35
6065	T. J. JACKSON / Lieut. Genl. Stonewall Jackson	S	75
6066	TO AVOID A SMASH - WE SELL FOR CASH	M	265
6067	TO THE GOVERNOR'S GUARD 2nd REGT. N.Y. ARTILLERY	S	150
6068	TO THE GRAND ARMY OF THE REPUBLIC	L	150

6069-			
6072	**TO THE / MEMORY OF**	S	45
6073	**TO THE MEMORY OF . . .**	S	60
6074	**TO THE MEMORY OF . . .**	S	45
6075	**TO THE MEMORY OF . . .**	S	40
6076	**TO THE MEMORY OF . . .**	S	45
6077	**TO THE MEMORY OF / W. H. HARRISON**	S	125
6078	**TO THE MEMORY OF WM. H. HARRISON...**	S	125
6079	**TO THE RESCUE**	S	45
6080	**TO THE RESCUE!**	M	125
6081	**TO THY CROSS I CLING**	S	20
6082	**TOBOGANNING IN THE ALPS**	S	450
6083	**TOBOGANNING ON DARKTOWN HILL — GETTING A HIST**	S	250
6084	**TOBOGANNING ON DARKTOWN HILL — AN UNTIMELY MOVE**	S	250
6085	**TOCSIN OF LIBERTY, THE**	S	285
6086	**TOILETTE, THE**	S	65
6087	**TOLL-GATE, JAMAICA PLANK ROAD**	S	320
6088	**TOLL-GATE, JAMAICA PLANK ROAD**	S	320
6089	**TOLL-GATE, JAMAICA L.I.**	S	345
6090	**TOM BOWLING**	VS	65
6091	**TOM BOWLING** / by Lexington, dam Lucy Fowler...	S	275
6092	**TOM OCHILTREE** / By Lexington, out of Katona	S	240
6093	**TOM PADDOCK**	M	300
6094	**TOM SAYERS** / Champion of England	S	250
6095	**TOM SAYERS** / Champion of England	M	340
6096	**TOM SAYERS** / Champion of England	S	250
6097	**TOM SAYERS** / Champion of England	S	250
6098	**TOMB AND SHADE OF NAPOLEON, THE**	S	95
6099	**TOMB AND SHADE OF NAPOLEON, THE**	S	95
6100	**TOMB AND SHADE OF WASHINGTON, THE**	S	100
6101	**TOMB OF GENL. W. H. HARRISON** / North Bend, Ohio	S	190
6102	**TOMB OF GENL. W. H. HARRISON** / North Bend, Ohio	M	275
6103	**TOMB OF KOSCIUSKO, THE /** West Point	S	140
6104	**TOMB OF KOSCIUSKO, THE /** West Point	S	140
6105	**TOMB OF LINCOLN, THE /** Springfield, Illinois	S	150
6106	**TOMB OF NAPOLEON, ST. HELENA, THE**	S	90
6107	**TOMB OF WASHINGTON, MOUNT VERNON, VA., THE**	S	85
6108	**TOMB OF WASHINGTON, THE** / Mount Vernon, Va.	S	85
6109	**TOMB OF WASHINGTON, THE** / Mount Vernon, Va.	S	85
6110	**TOMB OF WASHINGTON, THE** / Mount Vernon, Va.	M	240
6111	**TOMB OF WASHINGTON, THE** / Mount Vernon, Va.	L	300
6112	**TOMB OF WASHINGTON, THE** / Mount Vernon, Va.	S	85
6113	**TOMMY TATEISH ONEJERO**	S	35
6114	**TONSORIAL ART IN THE DARKTOWN STYLE**	S	225
6115	**TOO SWEET FOR ANYTHING**	S	50
6116	**TOP OF THE HEAP**	S	130
6117	**TORONTO CHIEF, GENERAL BUTLER AND DEXTER**	L	1300
6118	**TOWER OF SOLOMON, THE**	S	80
6119	**TOY BRIDGE, THE**	S	70
6120	**TRAINING A TROTTER**	VS	75
6121	**TRAINING DAY**	M	185
6122	**TRANSFIGURATION, THE**	S	30
6123	**TRAPPER'S CAMP FIRE, THE**	L	1775
6124	**TRAPPER'S CAMP FIRE, THE /** A Friendly Visitor	L	1775
6125	**TRAPPER'S LAST SHOT, THE**	M	675
6126	**TRAPPERS ON THE PRAIRIE /** Peace or War?	L	7500
6127	**TRAVELING ON HIS BEAUTY**	S	125
6128	**TREE OF DEATH, THE**	S	85
6129	**TREE OF DEATH, THE**	S	95
6130	**TREE OF EVIL, THE**	S	120
6131	**TREE OF GOOD, THE**	S	120
6132	**TREE OF INTEMPERANCE, THE**	S	125
6133	**TREE OF INTEMPERANCE, THE**	S	125
6134	**TREE OF LIFE, THE**	S	95
6135	**TREE OF LIFE, THE**	S	110
6136	**TREE OF LIFE, THE** / On each side of the river...	S	110
6137	**TREE OF LIFE, THE**	L	150
6138	**TREE OF LIFE, THE — THE CHRISTIAN**	S	125
6139	**TREE OF TEMPERANCE, THE**	S	125
6140	**TREE OF TEMPERANCE, THE**	S	125
6141	**TRENTON FALLS, NEW YORK**	S	170
6142	**TRENTON HIGH FALLS** / New Jersey	S	170
6143	**TRIAL BY JURY—THE JUDGE'S CHARGE**	S	200
6144	**TRIAL BY JURY — THE VERDICT**	S	200

163

6145	TRIAL OF EFFIE DEANS, THE	L	135
6146	TRIAL OF PATIENCE, THE	M	175
6147	TRIAL OF THE IRISH PATRIOTS AT CLONMEL...	S	30
6148	TRIBUTE MONEY	S	35
6149	TRIBUTE TO AUTUMN, THE	S	145
6150	TRINKET	S	235
6151	TRINKET RECORD 2:10 ¾	VS	65
6152	TRINKET / By Princeps, dam Quida	S	235
6153	TRINKET / Record 2:14	S	235
6154	TRINKET / By Princeps, Dam Quida...	L	850
6155	TRIUMPH OF FAITH, THE	M	45
6156	TRIUMPH OF THE CROSS, THE	S	25
6157	TROJAN QUICK STEP	S	80
6158	TROLLING FOR BLUE FISH	L	3845
6159	TROPICAL AND SUMMER FRUITS	L	475
6160	TROPICAL AND SUMMER FRUITS	S	150
6161	TROT "FOR THE GATE MONEY," A	L	1500
6162	TROT, WITH MODERN IMPROVEMENTS, A	S	250
6163	TROTTERS	L	1850
6164	TROTTER'S BURIAL, THE	S	175
6165	TROTTERS ON THE GRAND CIRCUIT / Warming Up	L	1250
6166	TROTTERS ON THE SNOW	VS	100
6167	TROTTERS ON THE SNOW	S	525
6168	"TROTTING CRACKS" AT HOME / A Model Stable	L	3100
6169	"TROTTING CRACKS" AT THE FORGE	L	3100
6170	"TROTTING CRACKS" ON THE SNOW	L	4000
6171	TROTTING FOR A GREAT STAKE	L	1265
6172	TROTTING GELDING BILLY D WITH RUNNING MATE, THE	L	1000
6173	TROTTING GELDING CLINGSTONE, RECORD 2:14	S	250
6174	TROTTING GELDING FRANK WITH J.O. NAY...	L	1200
6175	TROTTING GELDING HARRY WILKES, BY GEORGE WILKES	S	285
6176	TROTTING GELDING PRINCE WILKES, BY RED WILKES	S	290
6177	TROTTING GELDING ST. JULIEN, RECORD 2:11 ¼	S	275
6178	TROTTING GELDING STEVE MAXWELL, BY OLE BULL, JR.	S	250
6179	TROTTING HORSE DARBY, BY DELMONICO	S	225
6180	TROTTING HORSE GEORGE PALMER	L	1500
6181	TROTTING HORSE JUDGE FULLERTON	M	750
6182	TROTTING KING ST. JULIEN, RECORD 2:11 ¼	VS	80
6183	TROTTING MARE AMERICAN GIRL	L	1325
6184	TROTTING MARE "AMERICAN GIRL"...	S	325
6185	TROTTING MARE "AMERICAN GIRL"...	L	1300
6186	TROTTING MARE BELLE HAMLIN, RECORD 2:12 ¾	S	300
6187	TROTTING MARE BELLE HAMLIN, RECORD 2:12 ¾	S	300
6188	TROTTING MARE BELLE HAMLIN, RECORD 2:12 ¾	S	300
6189	TROTTING MARE GOLDSMITH MAID	L	1275
6190	TROTTING MARE "LUCY"...	S	350
6191	TROTTING MARE MARTHA WILKES, RECORD 2:08	S	275
6192	TROTTING MARE NANCY HANKS BY HAPPY MEDIUM	S	275
6193	TROTTING MARE NANCY HANKS, RECORD 2:04	S	300
6194	TROTTING MARE SUNOL, RECORD 2:08 ¼	S	275
6195	TROTTING ON THE ROAD / Swill against Swell	S	250
6196	TROTTING QUEEN ALIX, RECORD 2:03 ¾	L	1150
6197	TROTTING QUEEN ALIX, BY PATRONAGE	S	250
6198	TROTTING QUEEN MAUDE S., RECORD 2:08 ¾	S	295
6199	TROTTING QUEEN MAUDE S, RECORD 2:10 ¾	VS	75
6200	TROTTING QUEEN NANCY HANKS, RECORD 2:04	L	1400
6201	TROTTING STALLION ALCRYON, BY ALCYONE	S	320
6202	TROTTING STALLION COMMODORE VANDERBILT	L	1050
6203	TROTTING STALLION DAN RICE	L	1050
6204	TROTTING STALLION DIRECTUM BY DIRECTOR	L	1100
6205	TROTTING STALLION GEORGE M. PATCHEN JR. OF CALIFORNIA	L	1400
6206	TROTTING STALLION GRAY EAGLE OF KENTUCKY	L	1175
6207	TROTTING STALLION / Hambletonian Mambrino	S	300
6208	TROTTING STALLION HANNIS...	S	260

6209	TROTTING STALLION HANNIS...	S	260
6210	TROTTING STALLION MAMBRINO CHAMPION	L	1200
6211	TROTTING STALLION MAMBRINO GIFT	S	365
6212	TROTTING STALLION MAMBRINO GIFT	S	365
6213	TROTTING STALLION MONROE CHIEF, BY JIM MONROE	S	295
6214	TROTTING STALLION NELSON BY YOUNG ROLFE	M	350
6215	TROTTING STALLION NELSON, RECORD 2:10	S	250
6216	TROTTING STALLION NELSON BY YOUNG ROLFE	M	350
6217	TROTTING STALLION PALO ALTO, BY ELECTIONEER	S	290
6218	TROTTING STALLION PATRON, RECORD 2:14 ¼	S	975
6219	TROTTING STALLION PHALLAS...	L	1325
6220	TROTTING STALLION SANTA CLAUS, BY STRATHMORE	S	235
6221	TROTTING STALLION SMUGGLER...	S	300
6222	TROTTING STALLION SMUGGLER...	S	300
6223	TROTTING STALLION STAMBOUL, BY SULTAN	S	285
6224	TROTTING STALLION STEAMBOAT	S	250
6225	TROTTING STALLION TOM MOORE...	L	1250
6226	TROTTING STALLION WEDGEWOOD BY BELMONT	S	300
6227	TROUT BROOK, THE	M	530
6228	TROUT FISHING	L	2325
6229	TROUT POOL, THE	S	800
6230	TROUT STREAM, THE	L	2500
6231	TROUT VERSUS GOUT	S	250
6232	TROY FIRE COMPANY	S	175
6233	TRUE DAUGHTER OF THE NORTH, THE	S	60
6234	TRUE DAUGHTER OF THE SOUTH, THE	S	60
6235	TRUE FRIENDS, THE	S	50
6236	TRUE ISSUE, OR "THAT'S WHAT'S THE MATTER," THE	S	185
6237	TRUE PEACE COMMISSIONER, THE	S	85
6238	TRUE PORTRAIT OF OUR BLESSED SAVIOR, THE	S	25
6239	TRUE PORTRAIT OF OUR VIRGIN MARY, THE	S	25
6240	TRUE YANKEE SAILOR, THE	S	135
6241	TRUST / IN THE LORD	S	85
6242	TRUST ME TILL I SELL MY DOG?	S	200
6243	TRY OUR CLAMS	S	175
6244	TRYING IT ON	S	175
6245	TSHU-GUE-GA / A Celebrated Chief...	S	175
6246	TUG OB WAR, DE!	S	195
6247	"TUMBLED TO IT"	S	265
6248	TURN OF THE TUNE, THE	S	255
6249	'TWAS A CALM STILL NIGHT	VS	60
6250	'TWAS A CALM STILL NIGHT	S	95
6251	T. W. DORR / ...Governor of Rhode Island	S	40
6252	"TWERE VAIN TO TELL THEE ALL I FEEL"	S	175
6253	TWILIGHT HOUR, THE	S	115
6254	TWIN BROTHER, THE	S	60
6255	TWIN MONKEYS, THE	S	55
6256	TWIN MONKEYS, THE / "Darwin's Theory"	S	85
6257	TWIN SCREW S.S. KENSINGTON / Of the Red Star Line	S	200
6258	TWIN SCREW STEAMER CAMPANIA OF THE CUNARD LINE	S	200
6259	TWIN SCREW STEAMER DEUTSCHLAND...	S	200
6260	TWIN SCREW STEAMER LUCANIA OF THE CUNARD LINE	S	200
6261	TWO BEAUTIES, THE	S	65
6262	TWO LITTLE "FRAID CATS"	S	105
6263	TWO LITTLE FRAID CATS	S	105
6264	"TWO MINUTE CLIP, A"	M	360
6265	TWO PETS, THE	S	65
6266	TWO PETS, THE	S	65
6267	TWO PETS, THE	M	125
6268	TWO PETS, THE	S	55
6269	TWO SISTERS, THE	S	55
6270	TWO SISTERS, THE	S	55
6271	"TWO SOULS WITH BUT A SINGLE THOUGHT"	S	215
6272	TWO TO GO!	S	225
6273	TWO TO GO!	L	500
6274	TWO TO GO	S	200
6275	"TWO TWENTY" ON THE ROAD	S	325
6276	TWO WATCHERS, THE	S	55
6277	UEBERGABE DES KAISERS NAPOLEON III...	S	50
6278	UNBOLTED	S	190
6279	"UNCLE SAM" MAKING NEW ARRANGEMENTS	S	215
6280	UNCLE TOM AND LITTLE EVA	S	180
6281	UNCONSCIOUS SLEEPER, THE	S	85

6282	UNDER CLIFF — ON THE HUDSON	S	180
6283	UNDER THE ROSE	S	50
6284	UNION IRON CLAN MONITOR "MONTAUK", THE	S	300
6285	UNION LEAGUE OF AMERICA CERTIFICATE	S	85
6286	UNION PALACE HOTEL, / Union Square, New York	S	850
6287	UNION SOLDIER'S DISCHARGE CERTIFICATE, THE	S	100
6288	UNION VOLUNTEER, THE	S	75
6289	UNION VOLUNTEER, THE / Home from the War	L	150
6290	UNION VOLUNTEER, THE / Off for the War	L	150
6291	UNITED AMERICAN / Patriotism, Charity & Harmony	S	80
6292	UNITED STATES ARMY LEAVING THE GULF SQUADRON...	S	425
6293	UNITED STATES CAPITOL, THE	S	230
6294	UNITED STATES CAPITOL / Washington, D.C.	S	230
6295	UNITED STATES FRIGATE "ST. LAWRENCE" 50 GUNS, THE	S	325
6296	UNITED STATES, LATE HOLT'S HOTEL	M	800
6297	UNITED STATES MAIL STEAMSHIP / "Baltic"	L	1125
6298	U.S. BRIG-OF-WAR SOMERS, THE	S	625
6299	U.S. BRIG PORPOISE IN A SQUALL, THE	S	350
6300	U.S. CRUISER "NEW YORK"	L	600
6300A	U.S. DRAGOONS / Cutting...a Mexican Ambuscade	S	135
6301	U.S. DRAGOONS / Cutting...a Mexican Ambuscade	S	135
6302	U.S. DRAGOONS / Cutting...a Mexican Ambuscade	S	150
6303	U.S. FRIGATE CONSTITUTION	S	450
6304	U.S. FRIGATE CONSTITUTION	S	450
6305	U.S. FRIGATE CUMBERLAND, 54 GUNS	S	450
6306	U.S. FRIGATE CUMBERLAND, 54 GUNS	S	450
6307	U.S. FRIGATE INDEPENDENCE, 64 GUNS	S	450
6308	U.S. FRIGATE "ST. LAWRENCE", 50 GUNS, THE	S	375
6309	U.S. FRIGATE "ST. LAWRENCE", 50 GUNS, THE	S	375
6310	U.S. FRIGATE "SAVANNAH" 60 GUNS	S	375
6311	U.S. FRIGATE UNITED STATES CAPTURING H.B.M. MACEDONIAN	S	400
6312	U.S. MAIL STEAMSHIP "ADRIATIC"	S	335
6313	U.S. MAIL STEAMSHIP "ARCTIC"	M	400
6314	U.S. MAIL STEAM SHIP / Arctic	L	965
6315	U.S. MAIL STEAM SHIP / Atlantic	S	325
6316	U.S. MAIL STEAM SHIP ATLANTIC	S	325
6317	U.S. MAIL STEAM SHIP ATLANTIC	S	325
6318	U.S. MAIL STEAM SHIP ATLANTIC	M	425
6319	U.S. MAIL STEAM SHIP ATLANTIC	L	1000
6320	U.S. MAIL STEAM SHIP BALTIC	S	350
6321	U.S. MAIL STEAM SHIP / Baltic	L	1125
6322	U.S. MAIL STEAM SHIP "CALIFORNIA"	S	275
6323	U.S. MAIL STEAM SHIP / Pacific	L	1000
6324	U.S. MAIL STEAM SHIP / Pacific	S	325
6325	U.S. MILITARY ACADEMY, WEST POINT	M	640
6326	U.S. POST OFFICE, NEW YORK	S	300
6327- 6330	U.S. SHIP NORTH CAROLINA	S	450
6331	U.S. SHIP OF THE LINE "DELAWARE"	S	445
6332	U.S. SHIP OF THE LINE IN A GALE	S	330
6333	U.S. SHIP OF THE LINE OHIO, 104 GUNS	S	500
6334	U.S. SHIP OF THE LINE PENNSYLVANIA, 140 GUNS	S	470
6335	U.S. SHIP OF THE LINE PENNSYLVANIA, 140 GUNS	S	470
6336	U.S. SLOOP OF WAR ALBANY, 22 GUNS	S	475
6337	U.S. SLOOP OF WAR IN A GALE	S	350
6338	U.S. SLOOP OF WAR "KEARSARGE"...SINKING... "ALABAMA"	S	450
6339	U.S. SLOOP OF WAR "KEARSARGE"...SINKING... "ALABAMA"	S	450
6340	U.S. SLOOP OF WAR VINCENNES, 20 GUNS	S	375
6341	U.S. STEAM FRIGATE "MISSISSIPPI"	S	375
6342	U.S. STEAM FRIGATE "MISSISSIPPI" IN A TYPHOON	L	1225
6343	U.S. STEAM FRIGATE "NIAGARA"	S	350
6344	U.S. STEAM FRIGATE "NIAGARA"	L	1300

6345	U.S. STEAM FRIGATE, PRINCETON	S	400
6346	U.S. STEAM FRIGATE "PRINCETON"	S	400
6347	U.S. STEAM FRIGATE "WABASH" 60 GUNS	S	350
6348	"UNSER KARL" / Prinz Friedrich Karl	S	20
6349	UP IN A BALLOON	S	250
6350	UP THE HUDSON	S	265
6351	UPPER AND LOWER BAY OF NEW YORK / From the Battery	S	475
6352	UPPER CANADA COLLEGE	M	750
6353	UPPER LAKE OF KILLARNEY, THE	S	65
6354	VALKYRIE / Challenger for the America's Cup	M	250
6355	VALLEY FALLS, VIRGINIA	S	170
6356	VALLEY OF THE BLACK WATER, IRELAND	S	65
6357	VALLEY OF THE SHENANDOAH, THE	L	700
6358	VALLEY OF THE SUSQUEHANNA, THE	L	670
6359	VAN AMBERG & CO'S TRIUMPHAL CAR	S	600
6360	VANTILE MACK, THE INFANT LAMBERT OR / GIANT BABY!	S	150
6361	VASE OF FLOWERS, THE	S	120
6362	VASE OF FLOWERS, THE	S	120
6363	VASE OF FLOWERS, THE	S	120
6364	VASE OF FRUIT, THE	M	225
6365	VELOCIPEDE, THE	S	415
6366	VENICE / From the Canal of the Guidecca	L	200
6367	VENICE / From the Canal of the Guidecca	L	200
6368	VERY REV. FATHER THOS. N. BURKE C.P.	S	25
6369	VERY REVEREND, THE / Theobold Mathew	S	25
6370	VERY REVEREND, THE / Father Theobold Mathew	S	25
6371	VERY WARM CORNER, A	S	250
6372	VICTORIOUS ATTACK ON FORT FISHER, N.C.	L	800
6373	VICTORIOUS BOMBARDMENT OF PORT ROYAL, S.C.	S	290
6374	VICTORY DOUBTFUL	S	150
6375	VICTORY OF ROANOKE, FEB. 8TH, 1862, THE	S	165
6376	VIEW DOWN THE RAVINE / At Trenton Falls, N.Y.	M	325
6377	VIEW DOWN THE RIVER see c3439	VS	—
6378	VIEW FROM FORT PUTNAM / West Point, Hudson River	S	220

6379	VIEW FROM FORT PUTNAM / West Point, Hudson River	S	220
6380	VIEW FROM FORT PUTNAM / West Point, Hudson River	S	220
6381	VIEW FROM PEEKSKILL, HUDSON RIVER, N.Y.	M	575
6382	VIEW FROM THE ROCK OF GIBRALTER...BURNING... MISSOURI	S	400
6383	VIEW FROM WEST POINT	S	350
6384	VIEW FROM WEST POINT / Hudson River	S	350
6385	VIEW IN DUTCHESS COUNTY, N.Y.	L	1150
6386	VIEW IN SWITZERLAND see c4610	VS	—
6387	VIEW NEAR HIGHBRIDGE / Harlem River, N.Y.	M	725
6388	VIEW OF ASTORIA, L.I.	M	1390
6389	VIEW OF BALTIMORE	S	650
6390	VIEW OF BOSTON	S	435
6391	VIEW OF BUNKER HILL & MONUMENT JUNE 17, 1843	S	310
6392	VIEW OF CHAPULTEPEC AND MOLINO DEL REY	S	175
6393	VIEW OF CHICAGO	S	550
6394	VIEW OF ESOPUS CREEK	S	200
6395	VIEW OF HARPER'S FERRY, VA.	L	915
6396	VIEW OF KING STREET CITY OF TORONTO, N.C.	M	350
6397	VIEW OF MAUCH CHUNK FROM THE NARROWS	S	375
6398	VIEW OF MADISON THE CAPITAL OF WISCONSIN	M	300
6399	VIEW OF NEW YORK	S	525
6400	VIEW OF NEW YORK	S	475
6401	VIEW OF NEW YORK	S	475
6402	VIEW OF NEW YORK / From Brooklyn Heights	M	820
6403	VIEW OF NEW YORK / From Brooklyn Heights	M	820
6404	VIEW OF NEW YORK / From Weehawken	S	575
6405	VIEW OF NEW YORK / From Weehawken	L	2000
6406	VIEW OF NEW YORK / Jersey City, Hoboken and Brooklyn	L	1500
6407	VIEW OF NEW YORK BAY / From Staten Island	S	295
6408	VIEW OF PHILADELPHIA	S	325
6409	VIEW OF SAN FRANCISCO, CALIFORNIA	L	5475
6410	VIEW OF SANTIAGO / Cuba	S	125
6411	VIEW OF THE DISTRIBUTING RESERVOIR / Murray's Hill	S	565
6412	VIEW OF THE FEDERAL HALL OF THE CITY OF NEW YORK	M	565

6413	VIEW OF THE GREAT CONFLAGRATION OF DEC. 16th...	M	650
6414	VIEW OF THE GREAT CONFLAGRATION OF DEC. 16th...	M	650
6415	VIEW OF THE GREAT CONFLAGRATION AT NEW YORK...	S	875
6416	VIEW OF THE GREAT CONFLAGRATION AT NEW YORK...	S	875
6417	VIEW OF THE GREAT RECEIVING RESERVOIR	S	385
6418	VIEW OF THE GREAT RECEIVING RESERVOIR	S	385
6419	VIEW OF THE HIGH FALLS AT TRENTON	S	250
6420	VIEW OF THE HOUSES OF PARLIAMENT...	M	375
6421	VIEW OF THE HUDSON RIVER / From Ruggles House	S	295
6422	VIEW OF THE PARK, FOUNTAIN & CITY HALL	S	375
6423	VIEW OF THE PARK, FOUNTAIN & CITY HALL, NEW YORK	S	375
6424	VIEW OF THE PARK, FOUNTAIN & CITY HALL, N.Y. 1851	S	375
6425	VIEW OF THE TERRIFIC EXPLOSION...FIRE OF NEW YORK	S	690
6426	VIEW OF WATERBURY, CONN.	L	875
6427	VIEW OF WEST END, ST. CROIX WEST INDIES	S	200
6428	VIEW OF WEST POINT	S	265
6429	VIEW OF WEST ROCK / Near New Haven, Conn.	L	1000
6430	VIEW ON BROADWAY, N.Y.	L	1200
6431	VIEW ON ESOPUS CREEK	S	255
6432	VIEW ON FULTON AVENUE, BROOKLYN, L.I.	S	200
6433	VIEW ON HUDSON RIVER / From Ruggle's House, Newburgh	S	295
6434	VIEW ON HUDSON RIVER / From Ruggle's House, Newburgh	S	330
6435	VIEW ON LAKE GEORGE, N.Y.	L	895
6436	VIEW ON LAKE GEORGE	S	550
6437	VIEW ON LONG ISLAND, N.Y.	L	1250
6438	VIEW ON MONTGOMERY CREEK / Near the Hudson	S	300
6439	VIEW ON THE DELAWARE / Near Easton Pennsylvania	S	300
6440	VIEW ON THE DELAWARE / "Water Gap" in the distance	L	1185
6441	VIEW ON THE HARLEM RIVER, N.Y. / The High Bridge	L	1475
6442	VIEW ON THE HARLEM RIVER, N.Y. / The High Bridge	L	950
6443	VIEW ON THE HOUSATONIC	L	910
6444	VIEW ON THE HUDSON	L	1350
6445	VIEW ON THE HUDSON	L	1350
6446	VIEW ON THE HUDSON see c3439	VS	—
6447	VIEW ON THE HUDSON / Crow's Nest	S	285
6448	VIEW ON THE HUDSON / Crow's Nest	S	285
6449	VIEWS ON THE POTOMAC / Near Harper's Ferry	L	800
6450	VIEW ON THE RHINE	S	95
6451	VIEW ON THE RONDOUT	M	340
6452	VIEW ON THE ST. LAWRENCE / Indian Encampment	S	230
6453	VIEW UP THE RIVER see c3439	VS	—
6454	VIGILANT AND VALKYRIE IN A "THRASH TO WINDWARD"	L	1425
6455	"VIGILANT" / Defender of the "America's Cup"	S	350
6456	VILLA, DESIGNED FOR DAV. CODWISE, ESQ.	S	70
6457	VILLA ON THE HUDSON, A	M	275
6458	VILLA ON THE HUDSON, A	S	200
6459	VILLAGE BEAUTY, THE	S	50
6460	VILLAGE BLACKSMITH, THE	M	480
6461	VILLAGE BLACKSMITH, THE	M	480
6462	VILLAGE BLACKSMITH, THE	L	1000
6463	VILLAGE CHAPEL, NEAR PARIS see c3438	VS	—
6464	VILLAGE STREET, THE	M	400
6465	VILLAGE STREET, THE	M	400
6466	VIOLA	L	90
6467	VIOLET AND DAISY	S	45
6468	VIRGIN & CHILD	S	25
6469	VIRGIN & CHILD, THE	S	25
6470	VIRGIN MARY, THE	S	25
6471	VIRGIN MARY, THE	S	25
6472	VIRGINIA	S	55
6473	VIRGINIA	S	55
6474	VIRGINIA HOME IN THE OLDEN TIME	S	210
6475	VIRGINIA WATER, WINDSOR PARK	S	75
6476	VIRTUE, LOVE AND TEMPERANCE	S	175
6477	VISION, THE	S	30
6478	VOLTAIRE / By Tattler, dam Young Portia	S	300
6479	VOLUNTARY MANNER...SOUTHERN VOLUNTEERS ENLIST	S	180
6480	VOLUNTEER CROSSING THE FINISH LINE	L	1350

6481	VOLUNTEER / Modelled by Edward Burgess...	L	1200
6482	VOLUNTEER / The Great Sire of Trotters	S	325
6483	VOLUNTEER	S	325
6484	WAA-NA-TAA, OR THE FOREMOST IN BATTLE	S	175
6485	WACHT AM RHEIN, DIE	S	50
6486	WAIT FOR ME!	S	65
6487	WAIT YOUR TURN	S	65
6488	WAITING FOR A BITE	S	250
6489	WAITING FOR A DRINK	S	165
6490	WAKING UP THE OLD MARE	L	900
6491	WAKING UP THE WRONG PASSENGER	S	235
6492	WALKED HOME ON HIS EAR!	S	85
6493	WALK IN!	S	50
6494	WAR	S	100
6495	WAR PRESIDENT, A / Progressive Democracy	S	175
6496	WARMING UP	S	150
6497	WARMING UP	S	150
6498	WARMING UP	L	1100
6499	WARREN MILLER	M	60
6500	WARWICK CASTLE, / On the Avon	M	150
6501	WASHINGTON	L	185
6502-6505	WASHINGTON	S	125
6506	WASHINGTON	M	145
6507	WASHINGTON	M	145
6508	WASHINGTON see c4025	VS	—
6509	WASHINGTON AND HIS CABINET	S	175
6510	WASHINGTON AND LINCOLN / The Father And Savior...	M	125
6511	WASHINGTON, APPOINTED COMMANDER-IN-CHIEF	S	160
6512	WASHINGTON AS A MASON	S	125
6513	WASHINGTON AS A MASON	S	125
6514	WASHINGTON AT HOME	L	275
6515	WASHINGTON AT MOUNT VERNON 1789	S	425
6516	WASHINGTON AT PRAYER	S	90
6517	WASHINGTON AT PRAYER	S	100
6518	WASHINGTON AT PRINCETON, JANUARY 3RD, 1777	S	650
6519	WASHINGTON AT VALLEY FORGE, DEC. 1777-8	S	245
6520	WASHINGTON COLUMNS, THE / Yo-Semite Valley	S	245
6521	WASHINGTON / Crossing the Delaware	S	170
6522	WASHINGTON CROSSING THE DELAWARE	S	150
6523	WASHINGTON CROSSING THE DELAWARE	S	400
6524	WASHINGTON CROSSING THE DELAWARE	S	150
6525	WASHINGTON CROSSING THE DELAWARE	S	150
6526	WASHINGTON / Driven by Joel Conklin...	L	1450
6527-6531	WASHINGTON FAMILY (black & white)	S	65
6527-6531	WASHINGTON FAMILY (hand colored)	S	105
6532	WASHINGTON FAMILY	S	100
6533	WASHINGTON / First in valor, wisdom and virtue	S	95
6534	WASHINGTON / First in valor, wisdom and virtue	S	95
6535-6540	WASHINGTON / First in War, First in Peace...	S	100
6541	WASHINGTON / From the President's House	S	165
6542	WASHINGTON IN THE FIELD	S	190
6543	WASHINGTON, McCLELLAN, AND SCOTT	M	500
6544	WASHINGTON, SHERMAN, AND GRANT	M	500
6545	WASHINGTON TAKING COMMAND OF THE AMERICAN ARMY	S	250
6546	WASHINGTON TAKING COMMAND OF THE AMERICAN ARMY	S	250
6547	WASHINGTON TAKING LEAVE OF THE OFFICERS OF HIS ARMY	S	450
6548	WASHINGTON'S DREAM	L	345
6549	WASHINGTON'S ENTRY INTO NEW YORK	M	1100
6550	WASHINGTON'S FAREWELL TO THE OFFICERS OF HIS ARMY	S	250
6551	WASHINGTON'S HEADQUARTERS, AT NEWBURGH...	S	225
6552	WASHINGTON'S RECEPTION ON THE BRIDGE AT TRENTON in 1789	S	155
6553	WASHINGTON'S RECEPTION ON THE BRIDGE AT TRENTON IN 1789	S	155
6554-6559	WASHINGTON'S RECEPTION BY THE LADIES...	S	155
6560	WATCH ON THE RHEIN, THE	S	70
6561	WATCHERS, THE	S	65
6562	WATER FOWL SHOOTING	S	440
6563	WATER JUMP, THE	L	1300

6564	WATER JUMP AT JEROME PARK, THE	L	1275
6565	WATER LILLY, THE	M	125
6566	WATER NYMPH, THE	S	95
6567	WATER RAIL SHOOTING	S	745
6568	WATER-RAIL SHOOTING	S	550
6569	WATER-RAIL SHOOTING	S	550
6570	WATERFALL — MOONLIGHT	L	200
6571	WATERFALL, THE see c2	VS	—
6572	WATERFALL — TIVOLI, ITALY	S	70
6573	WATKIN'S GLEN / New York	S	280
6574	WAVERLY HOUSE	M	1000
6575	WAY THEY COME FROM CALIFORNIA, THE	M	800
6576	WAY THEY CROSS "THE ISTHMUS," THE	M	800
6577	WAY THEY GET MARRIED IN CALIFORNIA, THE	M	800
6578	WAY THEY GO TO CALIFORNIA, THE	M	850
6579	WAY THEY RAISE A CALIFORNIA OUTFIT, THE	M	800
6580	WAY THEY WAIT FOR "THE STEAMER" AT PANAMA	M	800
6581	WAY TO GROW POOR, THE — THE WAY TO GROW RICH	S	175
6582-			
6586	WAY TO HAPPINESS, THE	S	45
6587	WAYSIDE INN, THE	L	1275
6588	"WE MET BY CHANCE: OR WAITING FOR THE SWELL"	S	250
6589	"WE PARTED ON THE HILLSIDE"	VS	60
6590	"WE PARTED ON THE HILLSIDE" / "Amid the Winter's Snow"	S	350
6591	WE PRAISE THEE, O LORD	S	30
6592	WE SELL FOR CASH	S	150
6593	WE TRUST	S	150
6594	WEARING OF THE GREEN	S	40
6595	WEDDING, THE	S	70
6596	WEDDING DAY, THE	S	70
6597	WEDDING DAY, THE	S	75
6598	WEDDING DAY, THE	S	85
6599	WEDDING DAY, THE	S	70
6600	WEDDING DAY, THE	S	70
6601	WEDDING EVENING, THE	S	65
6602	WEDDING MORNING, THE	S	65
6603	WEDGEWOOD, RECORD 2:19	VS	85
6604	WELCOME	S	75
6605	WELCOME HOME	S	40
6606	WELCOME / Take a drink	S	125
6607	WELCOME TO OUR HOME	S	75
6608	WELL-BRED SETTER, A	S	250
6609	WELL-BRED SETTER, A	S	250
6610	WELL-BRED SETTER, A	S	250
6611	WELL-BROKEN RETRIEVER, A	S	250
6612	WELL BUNCHED AT THE LAST HURDLE	L	1200
6613	WELL — I'M BLOWED	S	255
6614	"WELL TOGETHER AT THE FIRST TURN"	L	1000
6615	"WELL TOGETHER AT THE FIRST TURN"	L	1200
6616	"WELL TOGETHER AT THE FIRST TURN"	L	1295
6617	WEST POINT FOUNDRY, COLD SPRING	M	435
6618	WESTERN BEAUTY, THE	S	50
6619	WESTERN FARMER'S HOME, THE	S	300
6620	WESTERN RIVER SCENERY	M	450
6621	WE'VE HAD A HEALTHY TIME!	S	200
6622	WHALE FISHERY / Attacking a right whale	S	1280
6623	WHALE FISHERY, THE / Attacking a right whale...	L	8600
6624	WHALE FISHERY, THE. CUTTING IN	S	1200
6625	WHALE FISHERY, THE. "IN A FLURRY"	S	1250
6626	WHALE FISHERY, THE. "LAYING ON"	S	1200
6627	WHALE FISHERY, THE / The sperm whale in a flurry	L	8600
6628	WHALE FISHERY, THE. SPERM WHALE "IN A FLURRY"	S	1300
6628A	WHAT IS IT ? OR "MAN MONKEY" ON EXHIBITION...	S	150
6629	WHAT SHALL THE HARVEST BE?	S	75
6630	WHAT'S SAUCE FOR THE GOOSE IS SAUCE FOR THE GANDER	M	250
6631	WHEAT FIELD, THE	S	150
6632	WHEAT FIELD, THE	S	150
6633	"WHEELMEN IN A RED HOT FINISH"	M	475
6634	WHEN SHALL WE THREE MEET AGAIN?	S	140
6635	WHEN THE FLOWING TIDE COMES IN	S	170
6636	WHERE DO YOU BUY YOUR CIGARS?	S	150
6637	WHERE DO YOU BUY YOUR CIGARS?	VS	75
6638	WHICH DONKEY WILL I TAKE?	S	200
6639	WHICH OF US WILL YOU MARRY?	S	50
6640	WHITE DOGGIES INTO MISCHIEF	S	85
6641	WHITE DOG'S GOT HIM, DE!	S	175
6642	WHITE FAWN, THE	S	110
6643	WHITE HALL, BRISTOL COLLEGE, PA.	M	150

6644	WHITE SQUADRON, U.S. NAVY, THE	L	1040
6645	WHO COMES HERE!	S	85
6646	WHO GOES THERE	S	85
6647	WHO SPEAKS FIRST?	S	75
6648	WHO'S AFRAID OF YOU?	S	85
6649	WHO SAID RATS?	S	60
6650	WHO WILL LOVE ME?	S	50
6651	WHOSE CHICK ARE YOU?	S	65
6652	WHY DON'T HE COME?	S	45
6653	WHY DON'T HE COME? / First at the Rendezvous	S	55
6654	WHY DON'T YER COME ALONG?	S	180
6655	WHY DON'T YOU TAKE IT?	S	50
6656	WICKLOW — IRELAND	M	105
6657	WIDE AWARE	S	60
6658	WIDE PATH, THE	S	65
6659	WIDOW'S SON, THE	S	45
6660	WIDOW'S TREASURE, THE	S	50
6661	WIDOWER'S TREASURE, THE	S	50
6662	WI-JUN-JON — THE PIGEON'S EGG HEAD	M	500
6663	WILD CAT BANKER, A, OR A "CIRCULATING MEDIUM"	S	225
6664	WILD CAT TRAIN, A	S	300
6665	WILD DUCK SHOOTING	S	325
6666	WILD DUCK SHOOTING	S	325
6667	WILD DUCK SHOOTING	S	325
6668	WILD DUCK SHOOTING / #53	S	325
6669	WILD DUCK SHOOTING	L	2875
6670	WILD DUCK SHOOTING / A Good Day's Sport	L	3825
6671	WILD DUCK SHOOTING / On the Wing	S	360
6672	WILD DUCK SHOOTING / On the Wing	S	360
6673	WILD DUCK SHOOTING / On the Wing	S	360
6674	WILD FLOWERS	S	125
6675	WILD HORSES AT PLAY ON THE AMERICAN PRAIRIE	M	1200
6676	WILD IRISHMAN / By Glencoe, dam Mary Morris	L	3000
6677	WILD TURKEY SHOOTING	S	600
6678	WILD WEST IN DARKTOWN, THE / Attack on the...Coach	S	300
6679	WILD WEST IN DARKTOWN, THE / The Buffalo Chase	S	300
6680	WILHELM I / Konig von Preussen	S	20
6681	WILL HE BITE?	M	150
6682	WILL YOU BE TRUE?	S	45
6683	WILLIAM	S	50
6684	WILLIAM A. GRAHAM / Whig Candidate...	S	100
6685	WILLIAM AND SUSAN	S	50
6686	WILLIAM BIGLER / Governor of Pennsylvania	S	45
6687	WILLIAM C. BOUCK	VS	25
6688	WILLIAM F. JOHNSTON / Governor of Pennsylvania	S	55
6689	WM. H. SEWARD	VS	40
6690	WILLIAM HENRY HARRISON	S	115
6691	WILLIAM HENRY HARRISON / Ninth President of the U.S.	S	115
6692	WILLIAM HENRY HARRISON / Ninth President of the U.S.	S	115
6693	WILLIAM HENRY HARRISON / Ninth President of the U.S.	S	115
6694	WM. L. MARCY	VS	50
6695	WM. O. BUTLER / Democratic Candidate...	S	75
6696	WM. P. DEWEES, M.D.	S	500
6697	WM. PENN'S TREATY WITH THE INDIANS...	S	200
6698	WM. PENN'S TREATY WITH THE INDIANS...	S	200
6699	WM. PENN'S TREATY WITH THE INDIANS...	S	200
6700	WILLIAM PRINCE OF ORANGE LANDING AT TORBAY, ENGLAND	S	35
6701	WILLIAM R. KING / Democratic Candidate...	S	85
6702	WILLIAM R. KING / Democratic Candidate...	S	85
6703	WILLIAM SHAKESPEARE	M	75
6704	WM. SMITH O'BRIEN / Ireland's Patriot, 1848	S	35
6705	WILLIAM STEDDING. THE GERMAN SAILOR WHO CAPTURED...	S	65
6706	WILLIAM TELL / Death of Gessler	S	100
6707	WILLIAM TELL / Escaping from the Tyrant	S	100
6708	WILLIAM TELL ESCAPING FROM THE TYRANT	S	100
6709	WILLIAM TELL / Replying to Gessler	S	100
6710	WILLIAM TELL / Replying to the Governor	S	100
6711	WILLIAM TELL / Shooting the Apple on His Son's Head	S	150
6712	WILLIAM TELL / Shooting the Apple on His Son's Head	S	150
6713	WILLIAM TELL'S CHAPEL / Lake of Geneva	VS	45
6714	WM. TILLMAN, THE COLORED STEWARD	S	135
6715	WILLIAM W. BROWN	S	40
6716	WILLIE AND MARY	S	65
6717	WILLIE AND ROVER	S	60
6718	WILLIE'S LITTLE PETS	S	75
6719	WINDMILL, THE see c2002	VS	—
6720	WINDSOR CASTLE AND PARK	M	250

6721	WINE TASTERS, THE	S	95
6722	WINFIELD SCOTT	M	150
6723	WINFIELD SCOTT / The People's Choice...	S	125
6724	WINFIELD SCOTT / Whig Candidate...	S	125
6725	WINNING CARD, THE	L	1000
6726	WINNING "HANDS DOWN" WITH A GOOD SECOND	L	1500
6727	WINNING HORSES OF THE AMERICAN TURF	L	1200
6728	WINNING IN STYLE	M	850
6729	WINTER	S	250
6730	WINTER	S	55
6731	WINTER	L	100
6732	WINTER	S	65
6733	WINTER	S	50
6734	WINTER EVENING	M	1450
6735	WINTER EVENING	M	1450
6736	WINTER IN THE COUNTRY / A cold morning	L	8800
6737	WINTER IN THE COUNTRY / Getting Ice	L	9000
6738	WINTER IN THE COUNTRY / The Old Grist Mill	L	9000
6739	WINTER MOONLIGHT	M	1700
6740	WINTER MORNING	M	1270
6741	WINTER MORNING / Feeding the Chickens	L	4225
6742	WINTER MORNING IN THE COUNTRY	S	855
6743	WINTER PASTIME	M	1515
6744	WINTER PASTIME	M	1400
6745	WINTER SCENE	VS	200
6746	WINTER SCENE IN THE COUNTRY	L	1500
6747	WINTER SPORTS — PICKEREL FISHING	S	860
6748	WINTER TWILIGHT	VS	160
6749	WISE CHILD, A	S	50
6750	WITH MALICE TOWARD NONE - WITH CHARITY FOR ALL	S	135
6751	WIZARD'S GLEN, THE	M	115
6752	WOMAN TAKEN IN ADULTRY	S	25
6753	WOMAN'S HOLY WAR / Grand Charge on the Enemy's Works	S	325
6754	WOMEN OF '76, THE / "Molly Pitcher"	S	325
6755	WOMEN OF '76, THE / "Molly Pitcher"	S	325
6756	WON!	S	150
6757	WON BY A DASH	M	290
6758	WON BY A FOOT	S	200
6759	WON BY A NECK	L	1550
6760	WON BY A NECK	M	775
6761	WON BY A NECK / Lady Thorn, Goldsmith Maid...	L	1650

6762	WONDERFUL ALBINO FAMILY, THE	S	95
6763	WONDERFUL ALBINO FAMILY, THE	S	95
6764	WONDERFUL ELIOPHOBUS FAMILY...	S	95
6765	WONDERFUL MARE MAUD S. RECORD 2:10 ¾, THE	S	340
6766	WONDERFUL MARE MAUD S. RECORD 2:10 ¼, THE	S	340
6767	WONDERFUL MARE MAUD S. THE PROPERTY OF...	S	350
6768	WONDERFUL STORY, THE	S	70
6769	WOOD DUCKS	S	250
6770	WOODCOCK	S	325
6771	WOODCOCK / Scolopax Minor	S	325
6772	WOODCOCK SHOOTING	S	500
6773	WOODCOCK SHOOTING	S	665
6774	WOODCOCK SHOOTING	L	2940
6775	WOODCOCK SHOOTING	S	475
6776	"WOODING UP" ON THE MISSISSIPPI	L	3750
6777	WOODLAND GATE	M	375
6778	WOODLANDS IN SUMMER, THE	S	200
6779	WOODLANDS IN WINTER	S	400
6780	WOODS IN AUTUMN, THE	M	310
6781	WORD AND THE SIGN, THE	S	25
6782	WORKING MEN'S BANNER, THE	S	185
6783	"WOUND UP"	S	190
6783A	WOUND UP	S	185
6784	WOUNDED BITTERN, THE	S	75
6785	WREATH OF FLOWERS, A	S	100
6786	WRECK OF THE ATLANTIC, THE	S	165
6787	WRECK OF THE ATLANTIC, THE	S	165
6788	WRECK OF THE SHIP "JOHN MINTURN"	S	550
6789	WRECK OF THE STEAMSHIP "CAMBRIA"	S	175
6790	WRECK OF THE STEAMSHIP "SCHILLER"	S	175
6791	WRECK OF THE U.S.M. STEAMSHIP "ARCTIC" OFF CAPE RACE	L	4200
6792	WRECKED BY A COW CATCHER	S	350
6793	WRONG WAY — RIGHT WAY	S	200
6794	W. W. BROWN	S	45
6795	YACHT "COUNTESS OF DUFFERIN"...	S	265
6796	YACHT "DAUNTLESS" OF N.Y. 268 TONS, THE	S	300
6797	YACHT "DAUNTLESS" OF NEW YORK, THE	L	1375

6798	YACHT "FLEETWING" OF NEW YORK, 212 TONS	S	285
6799	YACHT "HAZE" 87 TONS, THE	L	1400
6800	YACHT "HENRIETTA" 205 TONS, THE	L	1400
6801	YACHT "HENRIETTA" 205 TONS, THE	L	1400
6802	YACHT "HENRIETTA" 205 TONS, THE	S	250
6803	YACHT "MADELEINE" N.Y. YACHT CLUB, THE	S	250
6804	YACHT "MALLORY" 44 TONS, THE	L	1245
6805	YACHT "MARIA" 216 TONS, THE	L	1175
6806	YACHT "METEOR" OF N.Y. 293 TONS	S	310
6807	YACHT "METEOR" OF N.Y. / Leaving Sandy Hook	L	1500
6808	YACHT "MOHAWK" OF NEW YORK, THE	L	1450
6809	YACHT "NORSEMAN" OF NEW YORK	L	950
6810	YACHT "PURITAN" OF BOSTON	L	650
6811	YACHT "PURITAN" / Winner of the...American Cup	M	650
6812	YACHT "REBECCA" 75 TONS, THE	L	1000
6813	YACHT "SAPPHO" OF N.Y. 210 TONS	S	275
6814	YACHT "SAPPHO" OF N.Y. 210 TONS	S	275
6815	YACHT "SAPPHO" OF NEW YORK, THE / Leaving Sandy Hook	L	1000
6816	YACHT SQUADRON AT NEWPORT, THE	L	2100
6817	YACHT "VESTA" OF N.Y. 210 TONS, THE	S	310
6818	YACHT "VOLUNTEER"	L	900
6819	YACHTSMAN'S SOLACE, THE	S	280
6820	YACHTSMAN'S DELIGHT, THE	S	75
6821	YACHTS ON A SUMMER CRUISE	L	2150
6822	YANKEE DOODLE ON HIS MUSCLE	S	245
6823	YANKEE LOCKE / The Distinguished Yankee Comedian	L	250
6824	YANKEE TAR, THE	S	175
6825	YEAR AFTER MARRIAGE, A	S	50
6826	YEAR AFTER MARRIAGE, A / The Mother's Jewel	S	50
6827	YEAR BEFORE MARRIAGE / The Bride's Jewel	S	50
6828	YES OR NO?	S	55
6829	YOSEMITE FALLS / California	S	255
6830	YOSEMITE VALLEY — CALIFORNIA / The Bridal Veil Fall	L	1625
6831	YOU DON'T MEAN IT?	S	60
6832	YOU WILL! WILL YOU?	S	85
6833	YOUNG AFRICAN, THE	S	50
6834	YOUNG AMERICA	S	65
6835	YOUNG AMERICA	S	65
6836	YOUNG AMERICA / "Celebrating the Fourth"	S	125
6837	YOUNG AMERICA "CELEBRATING" / Fourth of July	L	125
6838	YOUNG AMERICA / The Child of Liberty	S	70
6839	YOUNG BLOOD IN AN OLD BODY	S	190
6840	YOUNG BROOD, THE	S	90
6841	YOUNG BROOD, THE	L	200
6842	YOUNG CADETS, THE	VS	70
6843	YOUNG CAVALIER, THE	S	55
6844	YOUNG CHIEFTAIN, THE	S	50
6845	YOUNG CHIEFTAIN, THE	S	50
6846	YOUNG CIRCASSIAN, THE	S	50
6847	YOUNG CIRCASSIAN, THE	S	50
6848	YOUNG COMPANIONS, THE	S	60
6849	YOUNG COMPANIONS, THE	S	60
6850	YOUNG CONTINENTAL, THE / The Spirit of '76	S	200
6851	YOUNG ENGLAND	S	50
6852	YOUNG FULLERTON RECORD 2:20 ¾	L	1295
6853	YOUNG GEORGIAN	S	50
6854	YOUNG GEORGIAN, THE	S	50
6855	YOUNG HOPEFUL	S	60
6856	YOUNG HOUSEKEEPERS, THE	S	55
6857	YOUNG HOUSEKEEPERS, THE / A Year after Marriage	S	55
6858	YOUNG HOUSEKEEPERS, THE / The Day after Marriage	S	55
6859	YOUNG LOVERS, THE	S	55
6860	YOUNG MOTHER, THE	S	45
6861	YOUNG MOTHER, THE	S	65
6862	YOUNG NAPOLEON	S	45
6863	YOUNG NAPOLEON / Contemplating his Father's Sword	S	45
6864	YOUNG NAVIGATOR	M	120
6865	YOUNG PROTECTOR, THE	S	60
6866	YOUNG RUFFED GROUSE	S	370
6867	YOUNG SAILOR, THE	S	75
6868	YOUNG SCOTLAND	S	45
6869	YOUNG SHEPHERDESS, THE	S	45
6870	YOUNG SOLDIER, THE	S	75
6871	YOUNG STUDENTS, THE	S	55
6872	YOUNG VOLUNTEER, THE	S	50
6873	"YOUR PLAN OR MINE"	S	200

6874 **ZACHARY TAYLOR** / The Nation's Choice...	S	115
6875 **ZACHARY TAYLOR** / The Nation's Choice...	S	115
6876 **ZACHARY TAYLOR** / People's Candidate...	S	125
6877 **ZACHARY TAYLOR** / People's Candidate...	S	115
6878 **ZACHARY TAYLOR** / The People's Choice...	S	115
6879 **ZACHARY TAYLOR** / Twelfth President of the U.S.	S	125

ADDENDA

AMERICAN RAILROAD SCENE	S	1000
AMERICAN RAILROAD SCENE	S	1000
AMERICAN WINTER SCENE — THE FALLS	S	250
BIRD'S EYE VIEW OF THE GREAT SUSPENSION BRIDGE	L	1400
CIRCULAR PLEASURE RAILWAY. IN HOBOKEN, N.J.	S	800
GOV. BENJ. GRATZ BROWN OF MISSOURI...	S	95
GREAT RACE ON THE MISSISSIPPI, THE	L	3850
HON. HENRY WILSON, NATIONAL REPUBLICAN...	S	85
IL GRANDE PONTE SOSPESO DELL "EAST RIVER"	L	875
JOHNNY AND BESSIE	S	50
NEPTUNE HOUSE, NEW ROCHELLE, WESTCHESTER COUNTY	L	1500
SAILOR'S RETURN, THE	S	150
STEAM SHIP ROYAL WILLIAM...	L	2500
VIEW OF THE HIGH FALLS OF TRENTON...	L	775
VIEW ON THE RONDOUT	S	165
VISTA DE LA CIUDAD DE NEW YORK...	L	1150
WEST POINT, FROM PHILLIPSTOWN	L	2000

Appendix A

The list following is by no means a complete compendium of current suppliers of conservation or archival quality materials used in the matting, framing, and storage of works of art on paper. The entries in this list reflect those companies that responded to inquiries made by the author. They have been divided into four categories in accordance with the nature of their product-line offerings.

Comprehensive General Line Archival Suppliers
(Including mat boards, document storage materials, framing supplies, and photographic supplies.)

Light Impressions Corp.
439 Monroe Avenue
P.O. Box 940
Rochester, NY 14603

S & W Framing Supplies, Inc.
120 Broadway
P.O. Box 340
Garden City Park, NY 11040

TALAS
213 West 35th St.
New York, NY 10001-1996

University Products
P.O. Box 101
South Canal St.
Holyoke, MA 01041

Conservation Materials, Ltd.
240 Freeport Blvd.
Box 2884
Sparks, NV 89431
(distributors of University Products lines)

Mat Boards

Chas. T. Bainbridge's Sons, Inc.
50 Northfield Avenue
Edison, NJ 08818
or
6144 Peachtree St.
Commerce, CA 90040

Rising Paper Company
Housatonic, MA 01236

Fine Art Papers / Mat Boards

Andrews / Nelson / Whitehead
31-10 48th Avenue
Long Island City, NY 11101

Works of Art on Paper; Document and Photographic Storage Materials

Conservation Resources International, Inc.
8000 H Forbes Place
Springfield, VA 22151

The Hollinger Corporation
3810 South Four Mile Run Dr.
P.O. Box 6185
Arlington, VA 22206

Appendix B

Individuals desirous of embarking on a comprehensive study in the field of conservation of works of art on paper will discover an extraordinary resource upon contacting:

The American Institute for Conservation of Historic and Artistic Works
The Klingle Mansion
3545 Williamsburg Lane, N.W.
Washington, D.C. 20008

The AIC is "a non-profit professional organization whose purpose is to advance the knowledge and practice of the conservation of cultural property. Its membership includes professional conservators, as well as scientists, students, administrators, cultural institutions and others who share its goals."

The AIC "exists to advance [theoretical, philosophical, and scientific] knowledge and to encourage and maintain high standards among conservators. Through its meetings, publications, and professional Code of Ethics and Standards of Practice, the AIC strives to upgrade the quality of conservation services generally and to disseminate information related to the many specializations in the conservation field."

The AIC offers an exhaustive, 39-page bibliography entitled: "Reading List for Students in Conservation of Historic and Artistic Works on Paper and on Photographs." The cost is $4.50 plus shipping (approximately $.90).

Inquiries regarding membership in the AIC, its list of publications (including the directory of membership) and a brochure, "Guidelines for Selecting a Conservator," may be forwarded to the address above.

Selected Bibliography

Antreasian, Garo Z. and Clinton Adams. *The Tamarind Book of Lithography: Art & Techniques*. New York: Harry N. Abrams, Inc., 1970.

Banks, Paul N. "Matting and Framing Documents and Art Objects on Paper." Chicago: The Newberry Library, 1978.

Baragwanth, Albert K. *100 Currier and Ives Favorites*. New York: Crown Publishers, Inc., 1978.

Buchsbaum, Ann. *Practical Guide to Print Collecting*. New York: Van Nostrand Reinhold Company, 1976.

Clapp, Anne F. *Curitorial Care of Works of Art on Paper*. Oberlin, Ohio: Intermuseum Conservation Association, 1973.

Cliffe, Henry. *Lithography: A Complete Handbook of Modern Techniques*. New York: Watson-Guptill Publications, 1967.

Conningham, Frederic A. *Currier & Ives Prints: An Illustrated Check List*. revised by Colin Simkin. New York: Crown Publishers, Inc., 1970.

Crouse, Russell. *Mr. Currier and Mr. Ives — A Note on Their Lives and Times*. New York: Garden City Publishing Company, Inc., 1930.

Eichenberg, Fritz. *The Art of the Print*. New York: Harry N. Abrams, Inc., 1976.

Glaser, Mary T. "Framing and Preservation of Works of Art on Paper." New York: Sotheby Parke Bernet, Inc., n.d.

Hilberry, John D. and Susan K. Weinberg. "Museum Collections Storage." *Museum News,* Mar/Apr, 1981.

Kenyon, Douglas M. "Framing and Conservation of Works of Art on Paper." Chicago: Douglas Kenyon, Inc., n.d.

King, Roy and Burke Davis. *The World of Currier & Ives*. New York: Random House, 1968.

Knigin, Michael and Murray Zimiles. *The Contemporary Lithographic Workshop Around the World*. New York: Van Nostrand Reinhold Co., 1974.

Marzio, Peter C. *The Democratic Art*. Boston: David R. Godine Publisher, Inc., 1979.

Newman, Ewell L., and Ladd MacMillan. *A Guide for Collecting Currier and Ives*. New York: Pyramid Books, 1975.

Newman, Harry S. *Best Fifty Currier & Ives Prints, Large Folio Size*. New York: The Old Print Shop, 1933.

Newman, Harry S. *Best Fifty Currier & Ives Prints, Small Folio Size*. New York: The Old Print Shop, 1934.

Peters, Harry T. *Currier and Ives, Printmakers to the American People*. Garden City, New York: Doubleday, Doran & Co., Inc., 1942.

Peterson, John. *Investing for Pleasure and Profit*. Princeton, New Jersey: Dow Jones Books, 1977.

Pratt, John L., editor. *Currier & Ives — Chronicles of America*. Maplewood, New Jersey: Hammond Inc., 1968.

Rawls, Walton. *The Great Book of Currier and Ives' America*. New York: Abbeyville Press, 1979.

Reps, John. *Views and Viewmakers of Urban America: Lithographs of Towns and Cities in the United States and Canada*. Columbia: University of Missouri Press, 1984.

Schonberg, Jeanne. "Questions to Ask Your Framer and Answers You Should Get," revised by Judith Booth. Albuquerque, New Mexico: Tamarind Institute, 1973.

Schurre, Jacques. *Currier & Ives Prints: A Checklist of Unrecorded Prints*. New York: Jacques Schurre, 1984.

Searjeant, Robert L. "Currier and Ives Prints: Quality Guidelines for Collectors." Rochester, New York: Searjeant's Historical Prints & Restoration, Ltd., 1980.

————"Currier and Ives: 25 Years of Collecting." Rochester, New York: Searjeant's Historical Prints & Restoration, Ltd., 1979.

Shapiro, Cecil and Lauris Mason. *Fine Prints: Collecting Buying and Selling*. New York: Harper & Row Publishers, Inc., 1977.

Simkin, Colin, editor. *Currier and Ives' America*. New York: Crown Publishers, Inc., 1952.

Smith, C. Carter and Kathy Cashion, editors. *Currier & Ives, A Catalogue Raisonne: Gale's Comprehensive Catalogue to the Lithographs of Nathaniel Currier, James Ives & Charles Currier, 1834-1907*. Detroit: Gale Research Company, 1984.

Smith, Merrily A. *Matting and Hinging of Works of Art on Paper* Washington, D.C.: Library of Congress, National Preservation Program Office, 1981.

Stapleton, Constance. "How Do You Know What You've Got?" *Connoisseur*, November, 1982, pp.92-96.

Stout, George L. *The Care of Prints*. New York: The Columbia University Press, 1948.

Thompson, Gary. *The Museum Environment*. London: Butterworth Series on Conservation, 1978.

Weaver, Warren A. *Lithographs of N. Currier and Currier & Ives*. New York: Holport Publishing Company, 1925.

Weber, Wilhelm. *A History of Lithography*. New York: McGraw-Hill Book Company, 1966.

Weidner, Marilyn K. "Damage and Deterioration of Art on Paper Due to Ignorance and the Use of Faulty Materials." *Studies in Conservation*, 12: 5-25, 1967.

Wengenroth, Stow. *Making a Lithograph*. New York: Studio Publications, 1936.

Zigrosser, Carl and Christa M. Graehele. *A Guide to the Collecting and Care of Original Prints*. New York: Print Council of America / Crown Publishers, Inc., 1965.

Index

About the Author

Craig McClain is currently a Research Specialist/Instructor at the University of South Dakota School of Medicine. The development of his book resulted from the combination of his computer-research background and enjoyment of Art History studies as an undergraduate student in Vermont. The author finds the study of the conservation and restoration of works of art on paper a most interesting and important pursuit. He also enjoys researching and collecting the works of twentieth century American etchers and lithographers such as John Sloan and Stow Wengenroth. Craig and his wife, Nona, and their sons, Morgan and Alec, are avid weekend "treasure hunters," taking every opportunity to search for prints, Hallmark Christmas ornaments, glassware, china, and comic books.